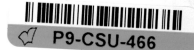
MATERIAL WORLD

A GLOBAL FAMILY PORTRAIT

BY PETER MENZEL

INTRODUCTION BY PAUL KENNEDY TEXT BY CHARLES C. MANN

PHOTO EDITING BY SANDRA EISERT

SPECIAL THANKS TO THE UNITED NATIONS POPULATION FUND,

THE UNITED NATIONS DEVELOPMENT PROGRAMME, AND

THE UNITED NATIONS INTERNATIONAL YEAR OF THE FAMILY

SIERRA CLUB BOOKS
SAN FRANCISCO

The Sierra Club, founded in 1892 by John Muir, has devoted itself to the study and protection of the earth's scenic and ecological resources — mountains, wetlands, woodlands, wild shores and rivers, deserts and plains. The publishing program of the Sierra Club offers books to the public as a nonprofit educational service in the hope that they may enlarge the public's understanding of the Club's basic concerns. The point of view expressed in each book, however, does not necessarily represent that of the Club. The Sierra Club has some sixty chapters coast to coast, in Canada, Hawaii, and Alaska. For information about how you may participate in its programs to preserve wilderness and the quality of life, please address inquiries to Sierra Club, 730 Polk Street, San Francisco, CA 94109.

Published by Sierra Club Books
100 Bush Street
San Francisco, CA 94104

First published in the United States, 1994

Text copyright © 1994 Charles C. Mann
Photographs copyright © 1994 Material World
Sierra Club Books paperback edition: 1995

10 9 8 7 6 5 4 3 2 1

MATERIAL WORLD is produced by Mandarin Offset
Printed in Hong Kong

Library of Congress Cataloging-in-Publication Data
Menzel, Peter 1948-
Material World/ by Peter Menzel; text by Charles C. Mann; introduction by Paul Kennedy.
p. 256 cm.
ISBN 0-87156-430-0

1. Material culture — Cross-cultural studies. 2. Family — Cross-cultural studies. 3. Economic development — Cross-cultural studies. 4. Material culture — Pictorial works. 5. Family — Pictorial works. I. Mann, Charles C. II. Title.
GN406.M45 1994
306.85 — dc20

94-8588
CIP

This book is dedicated to my parents,
and to my sons and their future children.

MATERIAL WORLD

A GLOBAL FAMILY PORTRAIT

13

1

25

20

27

7

21

12

11

30

5

2

IMAGE © 1990 TOM VAN SANT/THE GEOSPHERE™ PROJECT

SHINKA, BHUTAN
PHOTO BY PETER MENZEL

tained one or two additional children — meaning mouths to feed, minds to educate, and workers to employ. Although the individual families from developing countries generally appear happy to be photographed for *Material World*, they and their statistically average neighbors are battling against what the United Nations Children's Fund calls the "PPE spiral" — the vicious downward drag of poverty, population growth, and environmental degradation, only faintly captured by our cameras. Not all developing countries are so affected, of course, and the various U.N. agencies have reported many an improvement in the human condition over the past few years, such as the spread of democracy in Africa and Latin America, improvements in the condition of women in parts of Asia, reductions of infant-mortality rates in many poor countries, the abandonment of environmentally disastrous "slash-and-burn" policies in tropical forests. While each and every indication of progress is to be welcomed, the deficits in achieving decent health care for all the world's children or socio-economic rights for female members of society are still enormous — and ought to be a special concern in this Year of the Family.

This brings us to the final point about *Material World*, one so obvious that it hardly needs stating except that it is of such overwhelming importance. As the careful observer will have noticed, the greatest difference between rich and poor countries that emerges from this work lies not in their relative possession of material goods but in something that is far more profound: it is in the size and structure of the families themselves. Of course wealth plays a role here. Societies that possess high standards of living have almost invariably gone though a "demographic transition," by which a variety of causes (urban living, changing role of women) combine to reduce average fertility rates. By contrast, in predominantly agrarian developing countries where economic conditions are desperate and unpredictable, infant/child mortality rates remain high, women marry young and have a distinctly lower status than men, family size is much larger. In addition, it is still common to see "extended" families in developing societies; the families in Bhutan, China, Cuba, South Africa, and Western Samoa are good examples here. In more industrialized societies, however, the nuclear family is shrunken indeed — in Italy's case the parents are rearing a single child, with the once-familiar resident grandmother no longer in evidence.

What these photos and statistics do, then, is to remind us that our global society is heading into the twenty-first century with a relatively small number of richer societies possessing stable or even declining populations while a much larger number of poorer, resource-depleted countries continue to have high fertility rates even if the global averages drop steadily from decade to decade. As we celebrate our common humanity, we need to always ensure that such demographic differences do not accentuate the misunderstandings between rich and poor. And that implies that the related issues of population, environment, and social justice gain a far higher place on the global agenda of our present decade than they were given in the 1980s.

INTRODUCTION

PAUL KENNEDY

W HAT FOLLOWS IS a bold and imaginative experiment — an attempt to capture, through photos and statistics, both the common humanity of the peoples inhabiting our Earth and the great differences in material goods and circumstances that make rich and poor societies. It is a gripping contribution by Peter Menzel's creative and dedicated team to the United Nations' International Year of the Family, 1994. Over and above that, it is also an extraordinary work of photographic art that will remain of value long after this year has passed away.

It is tempting to say that these photographs speak for themselves. Yes, they do, but only if the reader looks carefully and keenly at the wealth of detail presented on every page, noting the different landscapes, the dwellings, the family sizes, the dress, and above all, the dramatic array of each family's material goods, large or small, laid out in front of the house. Finally, there are the faces of our fellow human beings, expressing pride, sadness, weariness, curiosity, and all the other emotions that the camera can capture. Although far less eye-catching and dramatic, the statistical profiles are also of great value, providing in factual form a confirmation of and complement to what we see in the photographs. Again, the real benefit to learning that the reader can extract from this project depends upon going into the details, especially on a *comparative* basis. New kinds of valuable inquiry can be generated by such detailed observation: How does the annual cost of living of the "statistically average family" in Japan compare with its equivalent in the United States or Germany? How much space has each family member? What is the family's health-care system? In which developing countries do families have access to television? Which have animals as *material* possessions?

Take a closer look still. This is a series of superbly historical images of our world in 1994, with all its triumphs and its sorrows, its material excesses, its deeper poignancies. Why is a soldier standing guard above the Demirovic-Bucalovic family in Sarajevo? (Is the family still there *now?*) Why in Mali do the women take care of all the work at home and most of the work in the fields? Why is it that the possessions of the Kalnazarov family in Uzbekistan overwhelmingly consist of carpets? Does our average Icelandic family play so much music because of the long winter nights? How is the Russian family coping after the father was found murdered in an act of apparently random violence on Christmas Day of 1993? Will the murderer be found and brought to justice? Why did the United States family choose to hold a Bible, whereas the European families did not? What other evidence of religious practices can be seen in these pages, from Korans to statues of the Virgin, reminding us that even in our *Material World*, most human beings feel a deep need for the transcendent and the intangible? It is all too easy to focus upon the material differences, precisely because that is what is most evident to the reader of this splendid volume. Who will not be struck, for example, by the contrast between the four shiny new automobiles (including one Mercedes) belonging to the "statistically average" Abdulla family in Kuwait and the single donkey possessed by the Cakoni family in Albania? Yet there are other aspects of our global society that the photographs will *not* capture, such as the missing children, those now deceased because of malnutrition and starvation. In developing countries, children under five years of age are dying at an average rate of more than 100 for every 1,000 babies born each year; in poverty-stricken Niger, the ratio is an appalling 320 per 1,000. Had infant and child mortality rates worldwide reached Nordic levels (say, 7 per 1,000), many of the families of developing countries photographed here would have con-

else's place. As human consumption patterns look more and more alike, the marching billions all with their cheeseburgers and Levi 501s, that unique place becomes ever harder to find. Things feel scary; people hunker down. Some retreat into their dialects, others into their national clothes, others into religion or guns. Even as the world unifies, its constituent parts fragment into halves, and the halves into quarters. Unity or division, which will win out? The answer is part of the wager humanity has placed on its future.

Because consumption occurs in the home, merchants direct their efforts at women whenever possible. When the market rushes in, women gain options they've never had before. The option to space children, or not have them at all. The option to work for pay, thus gaining their own income. The option to live away from the home, as men have always done. The option to buy a car, to own a gun, to reject demands, to sue, to vote, to read. Changes radiate out, branching and splitting; they fragment domestic life.

For millennia, great deeds occurred against a background of overworked women. Men proclaimed, invented, and slaughtered, while women created the homes that nourished children and thus allowed society to continue. Now comes the market, sweeping away old roles for women in a tide. Women seem to like the change, by and large; so do some men. Still, the homes shake. It is not clear that homes can exist in any traditional sense without the assumption that some figure will automatically spend most of the day maintaining them. But if nobody minds the children, the strands of human life will unravel. Can these opposites be reconciled? Here is a second part of the wager.

The third part concerns the nonhuman environment. Three decades ago, when the first pictures of the floating Earth appeared, they were accompanied by dire predictions that population pressure would soon drive Asia into barbarism; that the world's raw materials would soon be used up, bringing industrial society to a halt; that starvation would overwhelm the globe in less than twenty years. None of these terrible things happened. Instead, people learned to grow more food and conserve or discover new sources of energy. For now, at least, a smaller percentage of humanity is hungry than ever before — astonishing, given that this massive increase in well-being came at a time of unprecedented population growth.

Still, the fears have not gone away. They've just been replaced by their more sophisticated cousins. Pessimists today concede that birth rates can be reduced, that engineers and scientists can find substitutes for scarce raw materials, that careful breeding can provide farmers with fantastically productive new crops. People are incredible about solving problems, the Cassandras admit. But none of these things can create new water, or bring back extinct species, or restore huge tracts of soil destroyed by overirrigation. The global impoverishment of the biosphere, say the Cassandras, will get us in the end.

The Candides, counterparts and opposites, naturally disagree. Humankind can learn to use water more efficiently or draw it from the seas, they say. The species that are lost can be replaced by others that perform the same ecological functions. Better irrigation will avoid soil destruction. And so on. Solutions are available. And doubtless the Candides are right — if, that is, our societies have the wit to enact the solutions. Do they have the right stuff? Implicitly, we are betting on yes.

Until recently, humanity could always escape from itself, packing up the kids and going to the world's empty places. Now those places are filling up, and we have no choice but to confront ourselves; our responsibility for the future is inescapable.

Everywhere the Earth is habitable, it is inhabited. Homes stipple the landscape from Capetown to Nome. In each of them are mothers, fathers, and children— a billion families in total, perhaps, each full of wants and needs. It is foolish to imagine that they will not seek to fulfill them, surely immoral to try to block them from doing so. Yet satisfying their needs benignly will require enormous wisdom, if we are to keep people feeling whole, to treat all fairly, and to be graceful stewards of our natural environment. Can all the people on Earth have all the things they want? The dice with the answer are still rattling in the cup, but one should never rule out the possibility of winning the game.

BETTING THE PLANET

CHARLES C. MANN

WHEN ASTRONAUTS first photographed the Earth from space almost thirty years ago, it was the first time that humankind saw the planet as a whole. At the time, the likeness of the great blue-and-white ball spinning through the black of space was a healthy shock. In the way that only photographs can, it forcefully reminded us that our world has natural limits which cannot be escaped. Since then, the image of Spaceship Earth has become part of the furniture of contemporary life — a beacon to environmental advocates, an upscale marketing logo for advertisers.

The image is incomplete, though. Something of vital importance is missing from those magnificent photographs of our planet: the human beings swarming over its surface. Today the global landscape is shaped by a single species, *Homo sapiens*, and its multifarious works. In a way that our ancestors could not have imagined, we have made the exhortation in Genesis come true: we exercise dominion over the Earth. The single most important factor in the future of the blue-and-white ball is us.

In effect, the human race has entered into a great wager. We are, so to speak, betting the planet. On the one side is the ferment of human ingenuity, which in the space of a century has lifted countless lives from misery and almost doubled the average life span. On the other are the repercussions of these accomplishments. Decreasing the death rate led the human population to triple, soaring past the five billion mark in the 1980s. As a result, more people are buying, trading, and wanting things for longer periods than ever before. Taken together, this demographic and economic surge is transforming the surface of the Earth into a single, interconnected, unimaginably complex social object. The bet is whether all the parties involved will like the result, or even survive it. No one knows how it will come out.

The bet has at least three aspects. Most immediately apparent is the stream of corporate capitalism that now washes over the globe, inundating everyone from Mali to Malibu in boomboxes, baseball caps, and Batman movies. Markets in Tunisia carry radios made in Mexico by corporations based in Singapore; department store shelves in Kansas City groan beneath merchandise from China with faux-French labels; assembly lines make computer chips in twenty nations and sell to twenty others. Presiding over this ceaseless exchange is the television tube, dragging families away from the dinner table in Mongolia, mesmerizing Albanians with dubbed Italian versions of "Starsky and Hutch," funneling Los Angeles gangsta rap to families walled inside the invisible barriers around Soweto, South Africa. The pace of advance is startling; the tone it creates, a bit surreal, sometimes violent, always fast-paced, not what anybody expected.

The wash of goods and images is there because people want it, not because anyone is forcing the pace (though people do, of course, try to force the pace). No one twists the arms of the Vietnamese teenagers who greet returning U.S. soldiers with requests for cassette tapes of Michael Jackson. Nobody holds a gun to the heads of the villagers in Africa who ask photographer Peter Menzel for batteries, plastic bags, and menthol-scented shaving cream. Televisions, blue jeans, matched beige vinyl living-room sets — people desire these things. Absent catastrophe, they're going to get them. Or their children will.

Yet the same people who want to satisfy their desires also resist the consequences of satisfaction. They want to have what everyone else has, but still be aggressively themselves — a contradictory enterprise. Floating in the capitalist stream, they reach down with their feet, looking for solid ground. To be a good place to stand, it must be their own, not somebody

METHODOLOGY

PETER MENZEL

DATA EXPERTS AT the U.N. and World Bank helped determine what an average family actually is in a country according to location (urban, rural, suburban, small town, village), type of dwelling, family size, annual income, occupation, and religion.

Thirty countries were chosen from the 183 U.N. member nations to reflect a cross-section of the world with special emphasis on:

- Fast-growing Pacific Rim economies
- Former enemies of the United States
- Countries in the news
- Countries that are useful for a standard comparison
- Countries that have something we can learn from and that I wanted to see

We had help from many expert and novel sources in finding the families, but the most common method used was to visit typical neighborhoods with a locally knowledgeable and respected person. Together we knocked on doors of typical houses, looking for cooperative families that fit the statistics and lived in a location that would make a good Big Picture. That was the easy part. Moving 30 families' precious belongings into the open for the world to see was a bit trickier.

Once the family was chosen, the photographer moved in with or very near to them. During the course of a week, a database on the family was assembled from a list of 66 questions. Examples:

- What is each family member's most valued possession?
- What is a typical breakfast?
- Have they ever been robbed?
- How many hours of TV do they watch per day?
- What kind of future do they see for their children?

Because many families were understandably reluctant to have their precise income revealed, we promised not to publish it—substituting instead the nation's per capita income, which was a close match.

In addition to a medium-format Big Picture portrait and 35mm Daily Life coverage, each photographer shot an average of four hours of Hi-8 video per family.

Special thanks to all the families in this book who had the courage to share their lives with the world so that we can better understand one another.

VARANASI, INDIA *photograph by Peter Ginter*

A F R

I C A

BOYS ON BANK OF NIGER RIVER
KOUAKOUROU, MALI
PHOTOGRAPH BY PETER MENZEL

Dirt Poor

The Natomo Family

6:30 A.M., MARCH 27, 1993
KOUAKOUROU, MALI

PHOTOGRAPHS BY PETER MENZEL

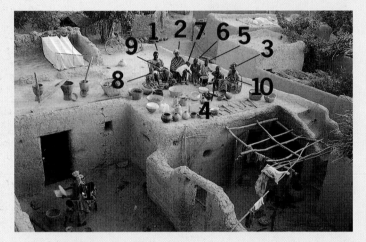

KEY TO BIG PICTURE

1. Soumana Natomo, father, 39
2. Pama Kondo, 1st wife, 28
3. Fatouma Niangani Toure, 2nd wife, 26

(1st wife's household)

4. Pai Natomo, 2nd daughter, 11
5. Kontie Natomo, 1st son, 9
6. Mama Natomo, 2nd son, 6
7. Mamadou Natomo, 3rd son, 3

(not pictured) Tata Natomo, 1st daughter, 13

(2nd wife's household)

8. Toure Natomo, 1st daughter, 5
9. Fatoumata Natomo, 2nd daughter, 3
10. Mama Natomo, son, 1
11. Cia Niento, wife of father's brother (in blue, with children — not part of household)

OBJECTS IN PHOTO

(Roof, left to right)

- Mortars and pestles (3, for pounding grains)
- Sieves for sifting grain (2)
- Ritual cane (at roof edge)
- Musket (broken, inherited from father's father)
- Mosquito netting (covers bed)
- Bicycle
- Broken pot
- Basket (with clothes)
- Washing tubs (5, plastic and aluminum)
- Broken bark basket (with rags, scraps)
- Cooking pot (with ladle)
- Plastic water containers (2)
- Water kettles (2)
- Watering cans (2, one broken)
- Ceramic pots (5)

- Rectangular adobe brick mold (with sample brick)
- Battery-powered radio/cassette-tape player
- Folded blanket (between father and 1st wife)
- Sweet rice mush (near children, in cookpot fitted with firepot)
- Wooden condiment container
- Cultivating implements (hoes, shovel, knife, broad axe)

(Lower wall and open kitchen)

- Fishing net
- Wooden rack (for shade, drying clothes)
- Cooking fire
- Water (in big clay pot)

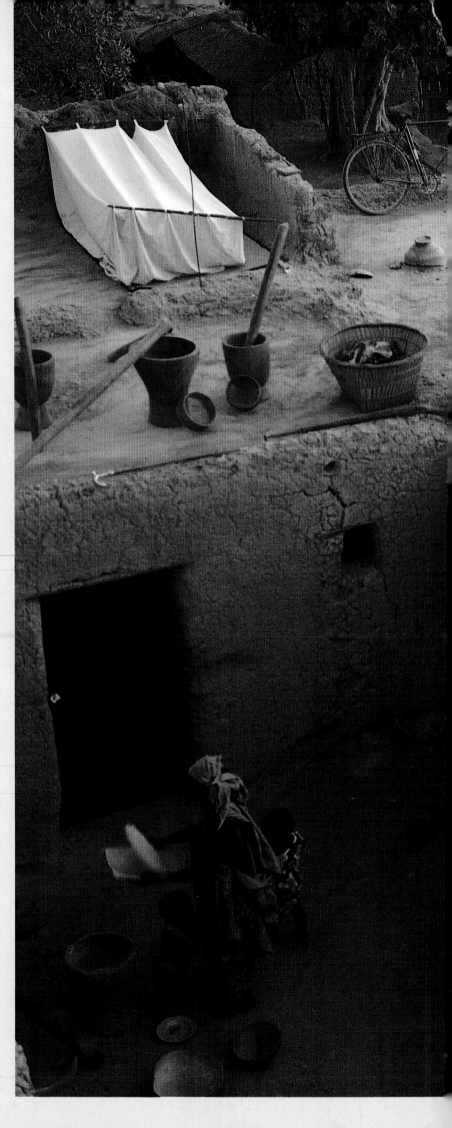

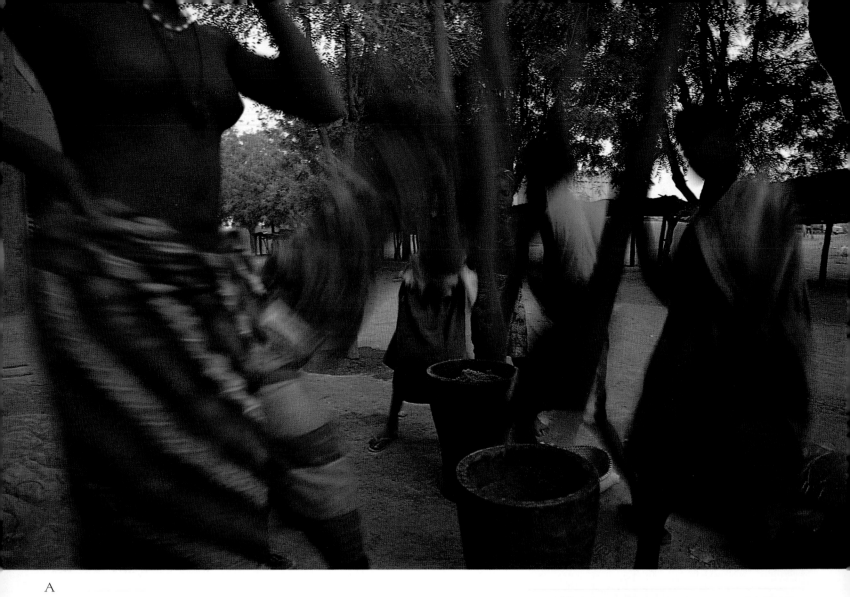

A

NATOMO FAMILY

Size of household
7 (1st house, including father)
4 (2nd house)

Size of dwelling
540 sq. ft. (50 sq. m.) 1st house
450 sq. ft. (42 sq. m.) 2nd house

Workweek
112 hours (Father)
112 hours (Both mothers — all
inside home)

Number of
Radios: 1, Telephones: 0
Televisions: 0, VCRs: 0,
Bicycles: 1, Automobiles: 0

Most valued possessions
Bicycle (Father)

Per capita income ($US)
$251

Wishes for future
Irrigation system, motorcycle,
enclosed garden

ON MARKET DAY in Kouakourou village, Soumana Natomo goes to purchase rice, which he buys in bulk and later resells. After haggling with the female wholesalers (B), he returns with two sacks of rice to store in the house that he shares with his first wife, Pama. The second, Fatouma, is two years younger than Pama and lives in a small one-bedroom apartment up an alley 250 feet (80 m.) away. Returning from the market, Soumana hears the muffled thumping of women pounding grain to make flour (A). Because it is Ramadan, the month when Muslims fast during the daylight hours, everyone is working at a slower pace than usual. Indeed, some men use the occasion to lounge about for hours, dazzling passersby with their most elegant outfits (D). The Natomos dress up, too, expending their yearly clothing budget at this time. Part of the reason is that after the fast ends at sunset, Kouakourou fills with food and music — Ramadan is also the month for weddings, dances (C), and other social activities.

D

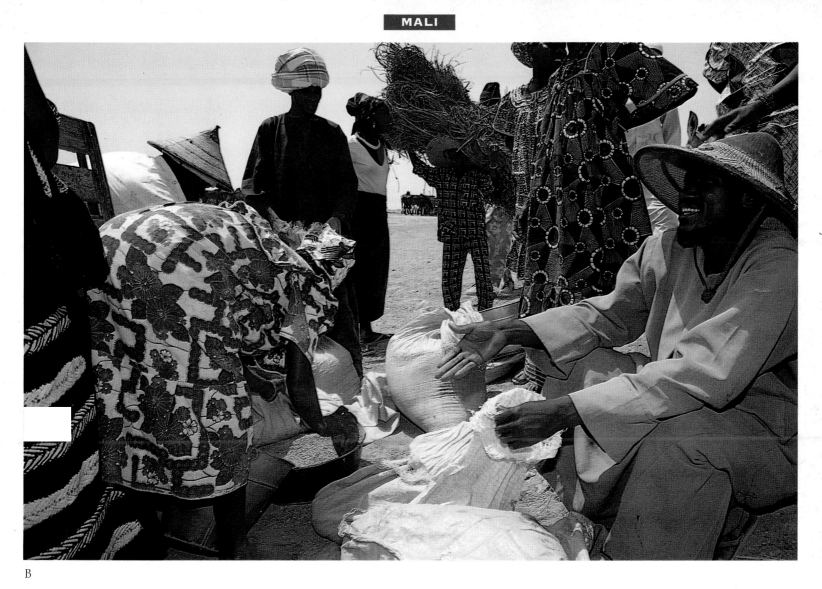

B

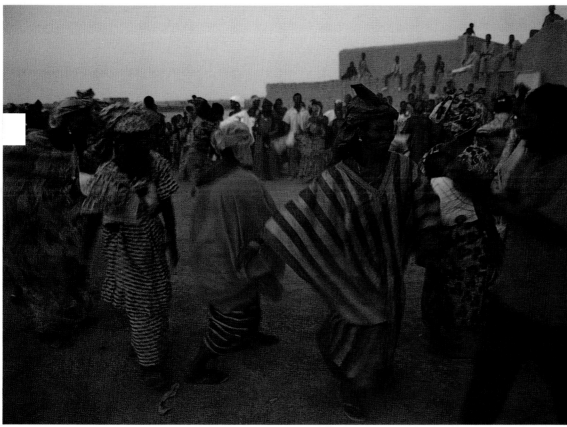

C

STATS

Area
478,841 sq. mi.
(1,240,189 sq. km.)

Population
10.8 million

Total fertility rate
7.1 children per woman

Population doubling time
22.2 years

Percentage urban/rural
27% urban, 73% rural

**Percentage of forest lost
between 1981-90**
0.8%

Life expectancy
Female: 50, Male: 47

Infant mortality
159 per 1,000 births

Population per physician
19,450

Literacy rate
Female: 24%, Male: 41%

**Rank of affluence
among the 183 U.N. members**
162

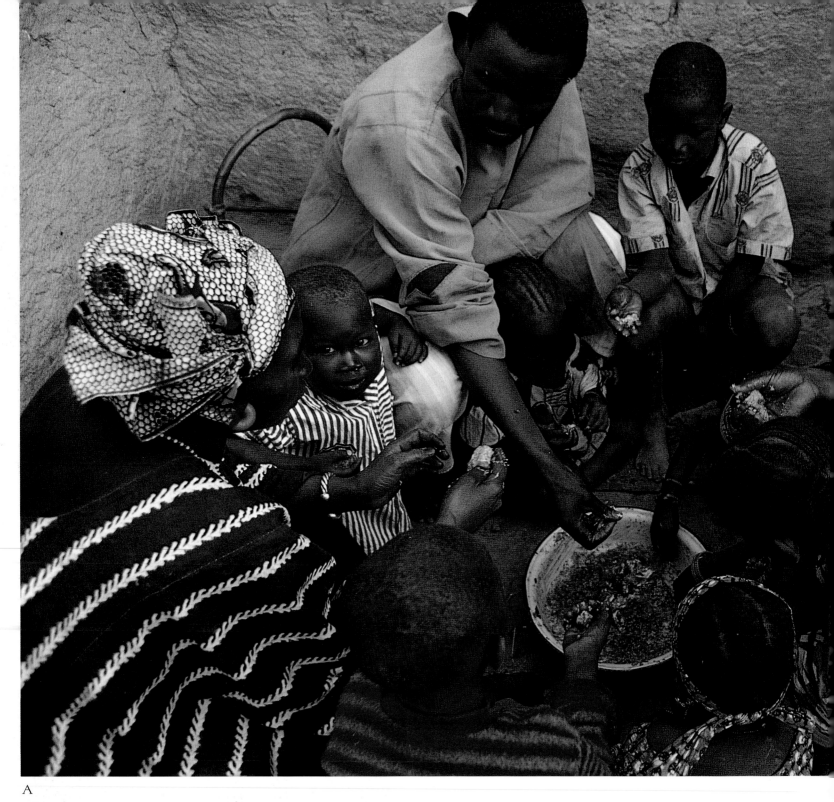

A

E

SHARING THEIR DINNER of fish and rice from a communal pot (A), the children and adults in the two households of the Natomo household squat in the shady kitchen area of the main house. With daylight activity slowed by Ramadan, the afternoon becomes a social period among the women, six of whom visited Pama, the older wife, in the afternoon (E, *one friend with baby, 11-year-old Pai standing in background*). Not to say that Pama's workload stopped entirely — because Fatouma, the younger wife, is still nursing 1-year-old Mama, she must carry all the water from the well (B). This morning the water has an immediate use: bathing the children (C, *scrubbing 3-year-old Mamadou*). Soon after the bath, Mamadou earns a reprimand as he climbs over his father, who is listening to a soccer game on the family radio (D).

NEXT SPREAD: Four hours' walk away from Kouakourou is the city of Djenné, renowned for its mud-walled Great Mosque, built 90 years ago on the ruins of a 13th-century mosque (B). Market days in the city draw thousands of people (A, *woman carrying water in plastic teapot for the journey*).

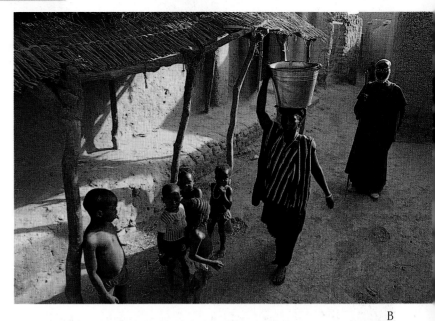

B

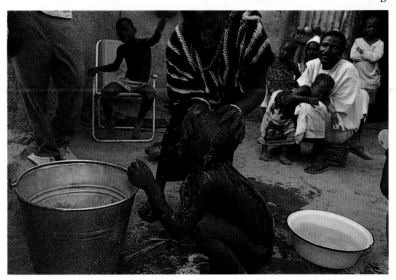

C

MALI

From the 13th to the 16th century, Mali was one of the greatest kingdoms in West Africa, a fabulously rich crossroads between the Islamic cultures to the north and the African cultures to the south. Today, though, Mali is poor, struggling, and sparsely populated. Long ruled by the French, the country found itself in dire straits when it became independent in 1960 — landlocked, possessing little arable land, in economic thrall to its former colonial masters, riven by tension among the speakers of its five major languages. Unsurprisingly, independence was accompanied by political confusion, socialist proclamations, and, in 1968, a coup (bloodless). The new leader, Moussa Traoré, stayed in power for 23 years, presiding over a variety of constitutional frameworks. Traoré's lack of economic expertise and a punishing drought in the 1970s and 1980s ensured that his regime was a time of economic lassitude. Eventually he was overthrown in 1991, which led to elections in 1992, and another coup in 1993. Prospects seem mixed, to say the least. The nation's greatest hope for the future is its great mineral wealth, as yet untapped, and its extraordinarily vital culture — the famous Bambara sculpture, the songs in Malinke and Songhai that fill village streets, the adobe architecture of Djenné and the Bandiagara Cliff.

D

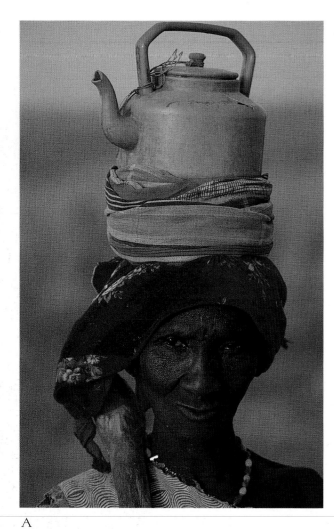

A

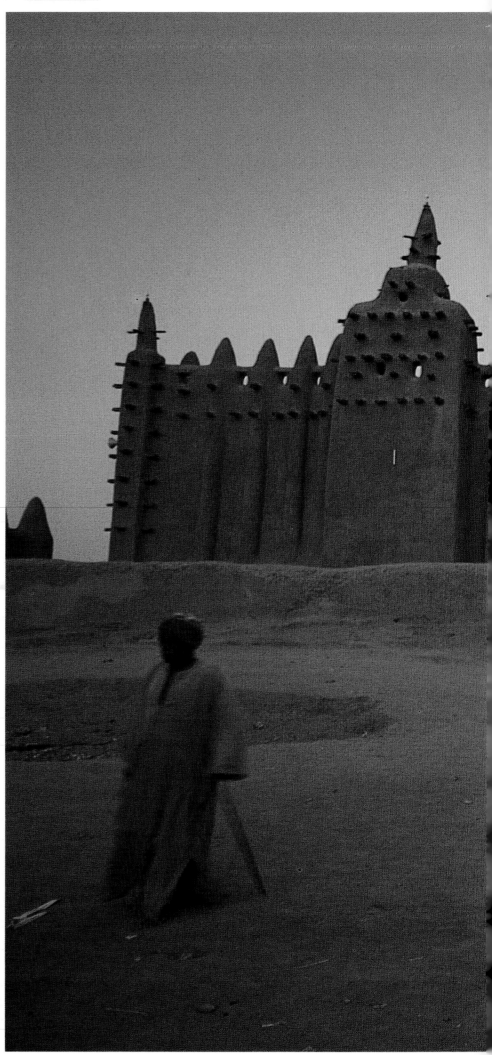

PHOTOGRAPHER'S NOTES
PETER MENZEL

I've long wanted to go to southern Mali because I'd heard about the architecture — cities entirely made from adobe with 200,000 people in them. Because it was the month of Ramadan, schedules were variable. Instead of taking a ferry across the Niger, I had to drive through the river, guided by children who hopped from sand bar to sand bar. I stayed six days in Kouakourou, where the Natomos live. Its labyrinthine alleys vibrate with a constant background noise of animal cries and the thump of women pounding millet and the sound of drums and Ramadan songs. Boomboxes, too, unfortunately; in a town with no electricity, cars, or paved streets, I was surprised to see so many men lounging around listening to music or the soccer games. I was with Soumana when he found that someone had stolen the mangoes from his trees. I thought he might swear furiously and vow to put up fences or get his ancient musket fixed, but he just shrugged and said that was life. The closest I ever saw him come to losing his temper was when Mamadou, his precocious three-year-old son, kept bothering him during a particularly crucial soccer game. I want to go back —when it's not so hot. The heat and dust in this part of Mali are unremitting, but it is also a beautiful place whose inhabitants deserve more than they are getting.

B

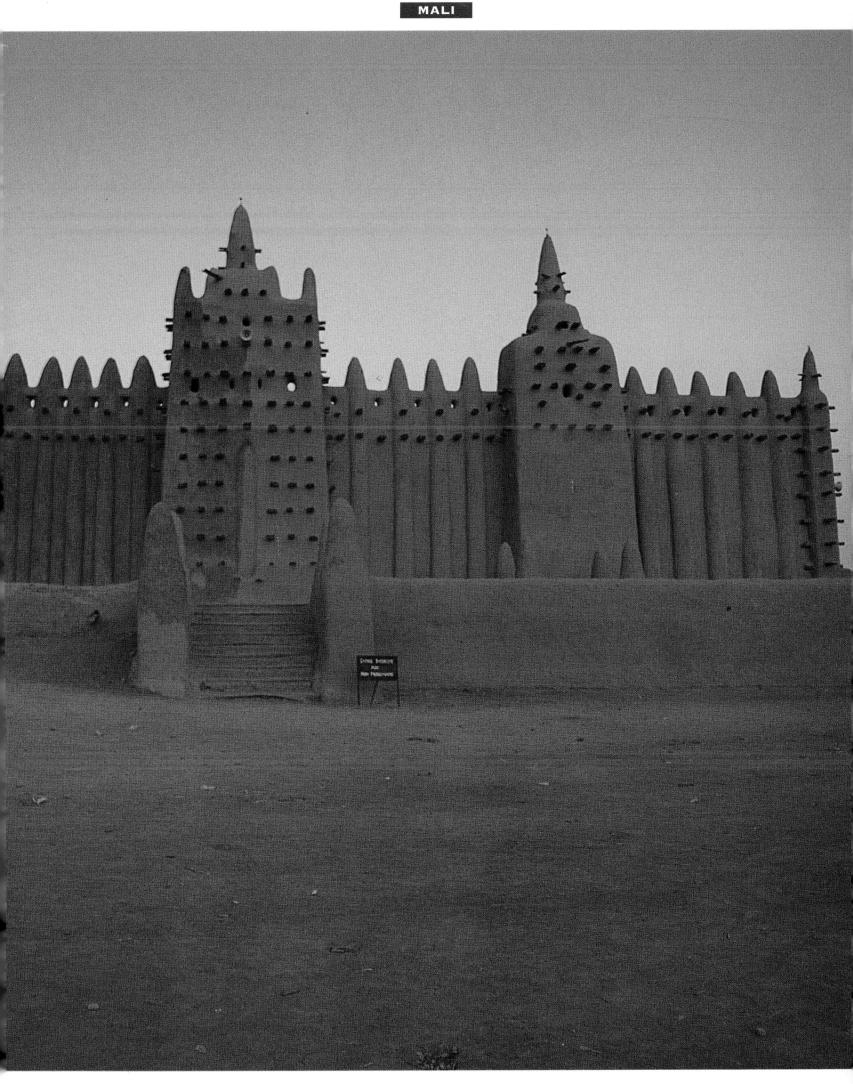

Continental Divide

The Qampie Family

6:00 P.M., MARCH 15, 1993
SOWETO, SOUTH AFRICA

PHOTOGRAPHS BY PETER MENZEL

KEY TO BIG PICTURE

1. Simon Qampie, father, 48
2. Poppy Nosizwe Qampie, mother, 36
3. Pearl Qampie, 1st daughter, 14 (lives with aunt in another township)
4. Irene Qampie, 2nd daughter, 11
5. George, 1st son, 4
6. Mateo, 2nd son, 2
7. Leah, mother's mother, 64
8. Anna, mother's sister, 18

OBJECTS IN PHOTO

(Outside fence, around family)

- Armchair (beneath father)
- Tomatoes, onions, pumpkin, green vegetables (in wire basket)
- Gas stove
- Teapots and cooking pots (2 of each, on stove)
- Electric refrigerator
- Ironing board and iron
- Kitchen table (with sugar bowl, creamer, plates)
- Kitchen chairs (4, beneath family members)
- Tricycles (2, beneath children)

(Inside fence, clockwise from lower left)

- Double bed with headboard (used by parents, 2nd son)
- Mirrored clothes dresser (with vase and flowers)
- Wardrobes (2)
- Plastic wash basin (on wardrobe, used in lieu of sinks and showers)
- Low cabinet
- Telephone, television, ceramic tiger, vase, stereo (on low cabinet)
- Armoire
- Plastic laundry basket
- Glass china cabinet with dishware
- 2nd bed (used by mother's mother, mother's sister, 2nd daughter, 1st son)
- Desk
- 2nd plastic wash basin
- Mailbox
- Dining room table
- Swivel chairs (4)
- Potted plant (on table)

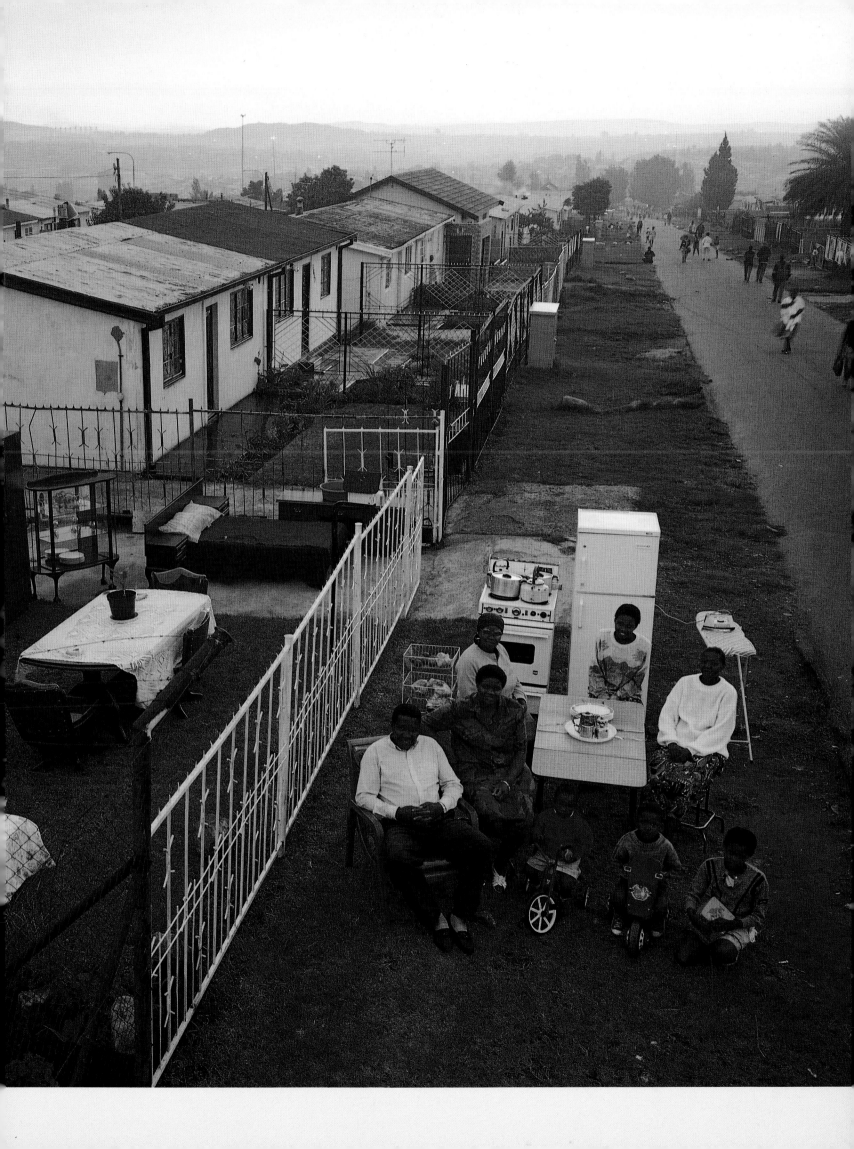

A

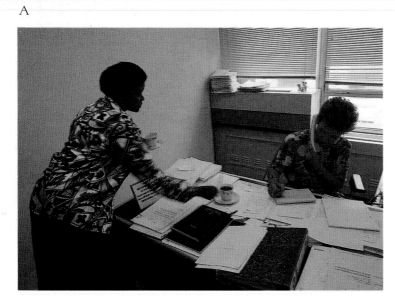

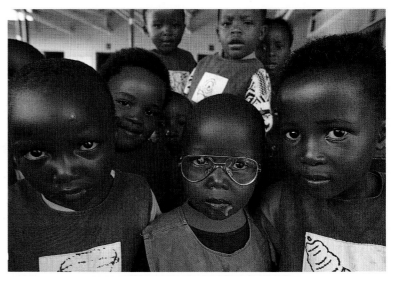

E D

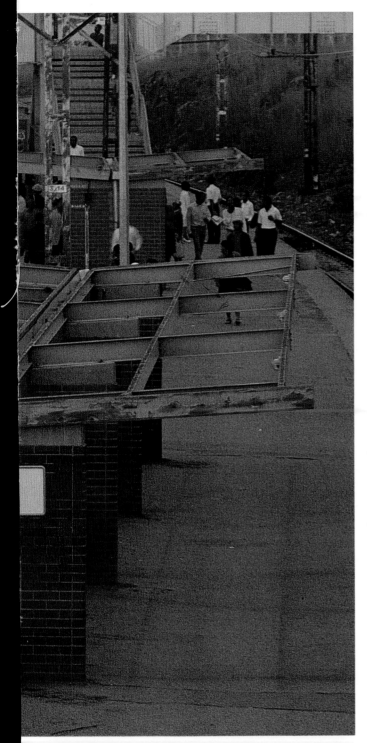

B

GETTING TO WORK is a scary daily business for Simon, because the train that picks him up at the Phomolong station (A) in Soweto is often boarded by machete- and gun-wielding thugs. But he has no alternative form of transportation; the suburban department store in which he works as a security guard is too far away. His wife, Poppy, is luckier. Her job as an office assistant (E, *serving coffee*) is in the glittering canyons of Johannesburg, which are easily accessible by a private "taxi" — actually, a crowded minivan. Still, she cannot stay late in the afternoon, because she must be out of the city by dark (B). Similarly, all shopping (C) must occur during the day, because security considerations keep the stores closed in the evening. In a way, this last is no burden. The Qampies' main purchase at the supermarket is always corn meal, which they mix with water to form pap (D, *seen on faces at the day-care center used by Simon's two sons*).

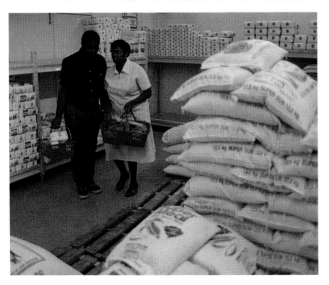

C

SOUTH AFRICA
UMZANTS AFRICA, SUID-AFRIKA

STATS

Area
471,429 sq. mi.
(1,220,992 sq. km.)

Population
42.7 million

Population density
90.6 per sq. mi. (35 per sq. km.)

Total fertility rate
4.1 children per woman

Population doubling time
29.6 years

Percentage urban/rural
51% urban, 49% rural

Life expectancy
Female: 66, Male: 59

Infant mortality
53 per 1,000 births

**Rank of affluence
among the 183 U.N. members**
58

Although people have inhabited what is now South Africa for as long as 100,000 years, the ancestors of today's Xhosa and Zulu probably did not appear until 2,000 years ago. Living in big towns, they farmed millet and sorghum and raised sheep, goats, and cattle. In 1652 Dutch colonists arrived. Within a century they had created a closed, rigid society based on slave labor from the East Indies. As South Africa's great stores of diamonds and gold were ascertained, complex struggles erupted among Dutch colonists, Xhosa farmers, Zulu invaders, British administrators (who had annexed the colony), and Mfengu (refugees from intra-African wars to the north). After much conflict, the white parties formed the Union of South Africa in 1910. The African majority — more than 80 percent of the population — was blocked by apartheid laws from participation in political life and the nation's rapid economic growth. Social tensions inexorably accumulated, transforming Africa's richest nation into a battleground. In the 1990s South Africa repealed apartheid and held its first multiracial elections, but no one knows how much time its people will need to learn to live with one another.

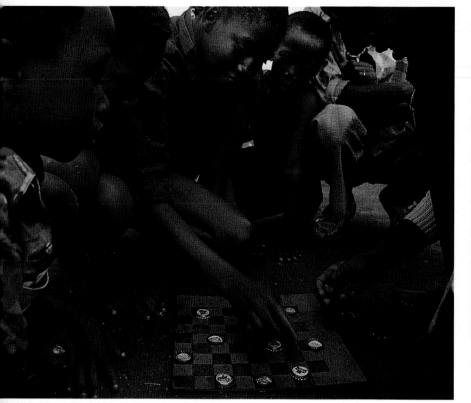

A

B

PHOTOGRAPHER'S NOTES

PETER MENZEL

I've never been to another place like Johannesburg. It's a big city ringed by what look like mesas, except that they are huge slag heaps from the gold mines. Outside the slag heaps are the townships. Soweto (*South Western Township*), the biggest, has more than a million people and is larger than the city. Crime and violence saturate Soweto. The family gets inside by 8:00 p.m. and locks up so tight that the house becomes suffocatingly hot. They don't even walk outside to the outhouse, but pee in bedpans. I spent the night sweating on their floor, where I was chewed up by some kind of spider that I'm apparently allergic to. The welts swelled up so much that I ended up in a Jo'burg hotel, commuting to Soweto like Simon and Poppy. The rush hour is incredible as crowds of black people get out of the city before sundown. It was the middle of the rainy season when I was there, and it poured almost every afternoon, including three times while shooting the Big Picture. The storms cleared the air in Soweto, but not the atmosphere.

QAMPIE FAMILY

Size of household
7

Size of dwelling
400 sq. ft. (37.2 sq. m.)

Workweek
40 hours (Father)
40 hours (Mother — plus housework)

Number of
Radios: 1, Telephones: 1 (broken), Televisions: 1, VCRs: 0, Automobiles: 0

Per capita income ($US)
$2,543

Percentage of Qampie family income spent on food
34%

On rent
0%
(2-1/2 year old rent boycott)

Wishes for future
Computer, typewriter (Children)
House, car (Adults)

Expectations of future
"It will be bad" (Father)

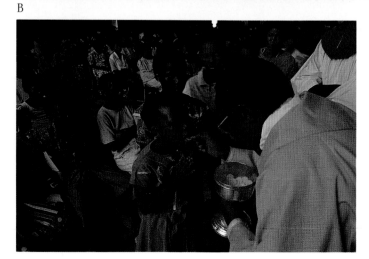

D

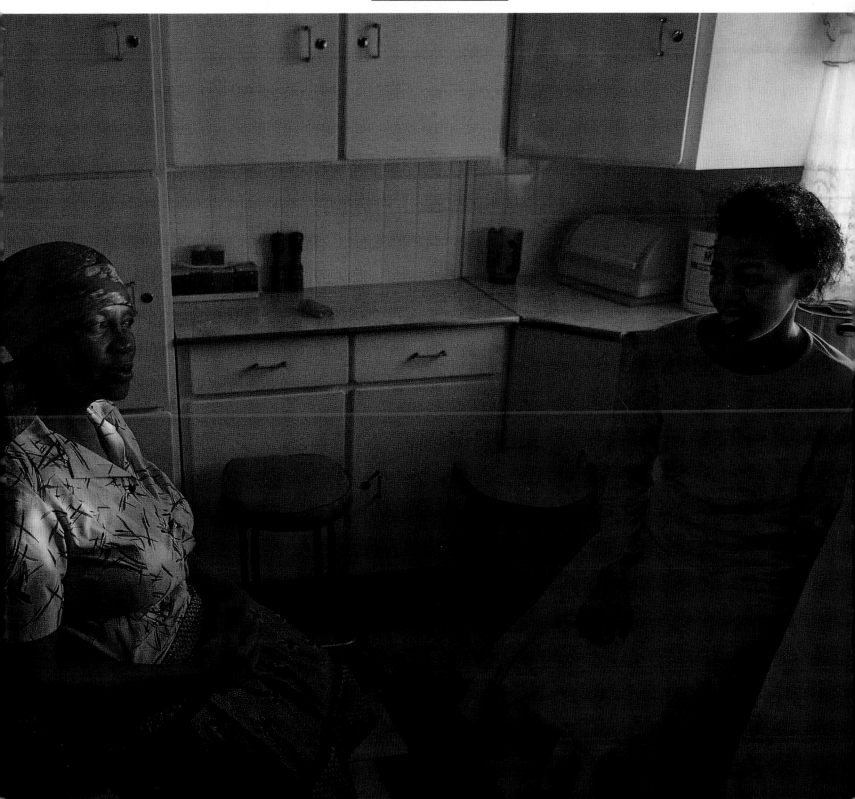

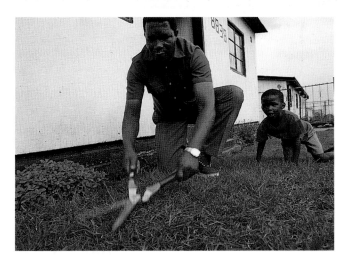

LIVING IN A DANGEROUS PLACE, the Qampie family tends to pass much of the time inside or around the house. On weekends, Simon watches soccer games on the television; at halftime, he rushes out to clip the grass *(C, with 2-year-old Mateo following)*. Meanwhile, Leah and Anna, Poppy's mother and aunt, visit in the kitchen *(B)*. On a nearby street kids play checkers *(A)* with an improvised set made from a Masonite board and the caps of old beer bottles. Further away, the bells of Regina Mundi ring, calling the faithful to Soweto's largest Roman Catholic church *(D)*. But even there it is impossible to escape the overtones of South Africa's predicament. When the white government banned all political assemblies, Masses became de facto anti-apartheid rallies.

ETHIOPIA

Constant Struggle

The Getu Family

8:30 A.M., FEBRUARY 12, 1994
MOULO, ETHIOPIA

PHOTOGRAPHS BY SHAWN G. HENRY

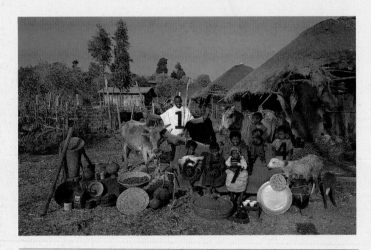

KEY TO BIG PICTURE

1. Getu Mulleta, father, 30
2. Zenebu Tulu, mother, 25
3. Teshome Getu, 1st son, 10
4. Like Getu, 1st daughter, 8
5. Mamoosh Getu, 2nd son, 7
6. Mulu Getu, 2nd daughter, 3
7. Kebebe Getu, 3rd son, 8 months

OBJECTS IN PHOTO

(Foreground, left to right)

- Basket
- Mortar and pestle (for pounding grain)
- Frying pans (2, one on ground next to house)
- Plastic containers (one for coffee beans, one for water)
- Iron frying tool
- Salt (in can)
- Plastic bowl and plate
- Clay cooking pot
- Wooden storage box (with clothes)
- Gourd jar (holds butter)
- Baskets (3, for milk and other food)
- Tin cans (2, for drinking)
- Oxen (2, one with yoke)
- Basket (on low table, full of *endod*)
- Shallow basket (leaning on table, for serving)
- Clay pot

- Halter (for horse)
- Bed (with wool blanket)
- Basket with lid
- Chicken (1 of 8 owned by family)
- Coffee set
- Tea kettle
- Serving tray
- Partially completed basket
- Clay water jar
- Sheep and lamb
- Horse (1 of 3)
- Cowhide (used as cushion)
- Umbrella (hanging from building)

(Background, left to right)

- Corral with cattle (5)
- House of father's brother
- Brother's cook house
- Family house
- Father's parents' house

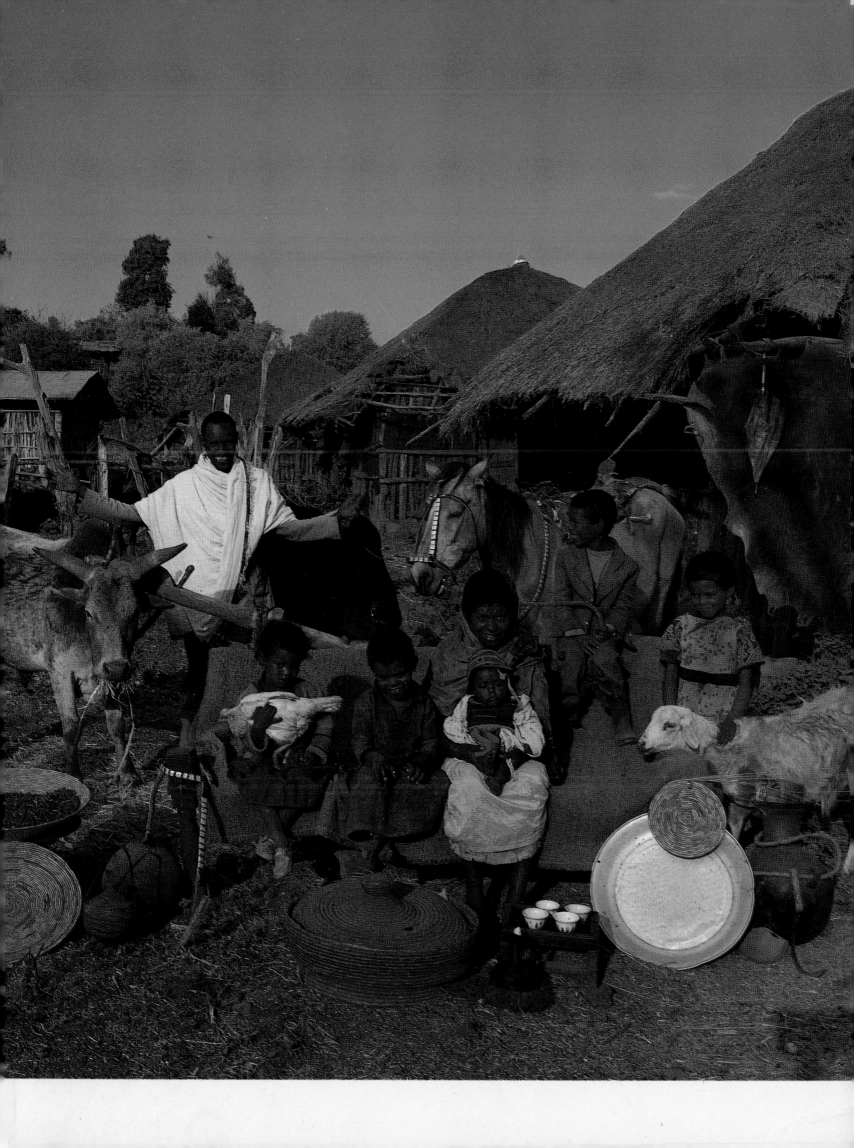

A

D C

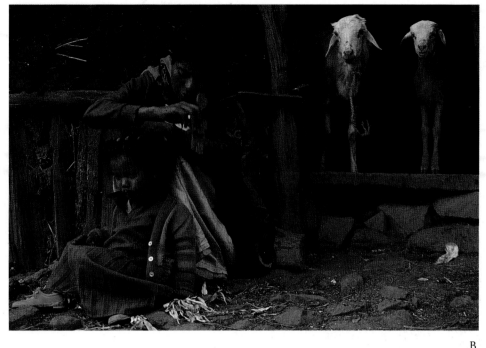

B

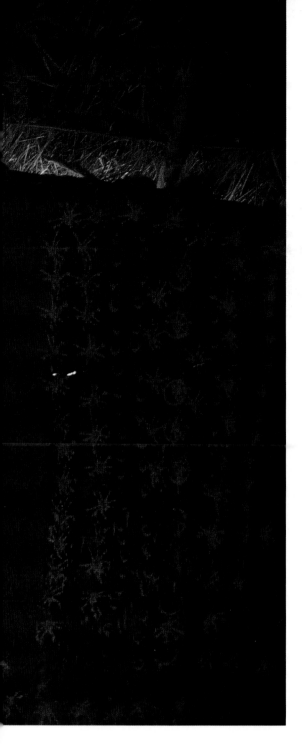

IN A SITUATION with few resources, the Getus depend heavily on cattle dung. Every morning, Zenebu collects fresh dung from the corral and mixes it with straw into a paste. Some of the paste is used to plaster the walls of the house (A, *decorations printed with a mixture of ashes and water*). She flattens the rest into wide patties that are dried, broken into pieces, and used for fuel. At other times families scavenge the fields and bring home dried dung (C). Working with dung takes up much of Zenebu's time. Other tasks include attending to the children (B, *combing daughter Mulu's hair*) and preparing coffee for the men. The latter may happen several times a day. Three times a day, relatives congregate at each other's houses, having a bit of coffee in a coffee ceremony (D, *Getu's father, Mulleta, having a cup at Getu's house, while his sister, Bezu, threads cotton*). With good reason: The strong, richly flavored coffee of Ethiopia is celebrated by coffee aficionados — the province of Kaffa in southwestern Ethiopia is reputed to be its birthplace.

ETHIOPIA
ETIYOP'IYA

STATS

Area
471,815 sq. mi.
(1,221,991 sq. km.)

Population
58.0 million

Total fertility rate
7.0 children per woman

**Percentage of couples
using contraception**
4.0%

Population doubling time
23.1 years

Percentage urban/rural
13% urban, 87% rural

**Government debt
as percentage of GNP**
51%

Ratio of people to automobiles
875 to 1

Ratio of people to cattle
2 to 1

Life expectancy
Female: 50, Male: 47

**Percentage of rural population
without safe drinking water**
89%

**Rank of people per physician
among the 183 U.N. members**
183

**Rank of affluence
among the 183 U.N. members**
180

A home to humankind for at least 1.5 million years, Ethiopia is the only African nation never ruled by foreigners (except for a brief, chaotic incursion by Italy, 1935-41). Its history made it into a proud emblem of African independence, with the Organization of African Unity having its headquarters in Addis Ababa, the capital. In recent years, though, Ethiopia has become a symbol of civil strife and ecological devastation. A famine from 1972 to 1974 led to a coup that ended the almost-50-year reign of Emperor Haile Selassie. The new dictator, Lieut. Col. Mengistu Haile Mariam, waged war for years on many fronts: within Ethiopia, against rebel groups; in the south, against Somalia; and especially in Eritrea, a northern area annexed illegally in 1962. Economically, he followed the Soviet model. In the 1980s his government forcibly resettled 500,000 farmers and used food as a weapon against areas with rebels. Added to a series of droughts, these policies led to famines that consumed 2 million lives. The collapse of Communism coincided with the victory of rebels in Eritrea and within Ethiopia. Mengistu was overthrown in 1991. A coalition government took the reins, letting Ethiopians return to their homes and trying to restart the economy. Many troubles remain. Use of wood as fuel and the nation's abundance of livestock have caused some of the world's worst deforestation and erosion. As a result, this ancient place will simultaneously have to become more prosperous and transform its relationship to the environment — a daunting prospect.

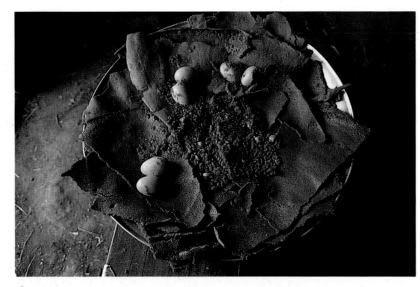

A

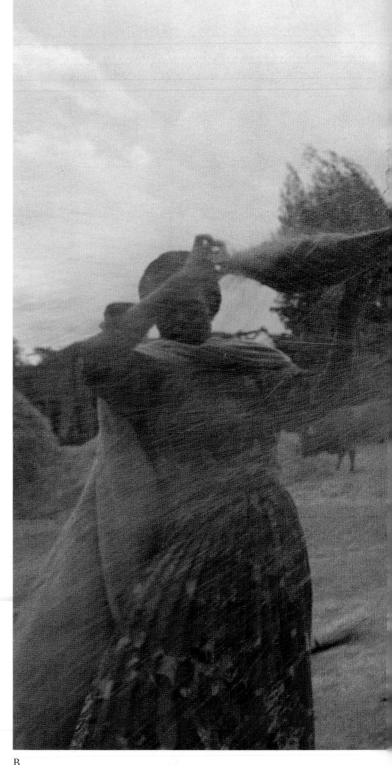

B

PHOTOGRAPHER'S NOTES
SHAWN G. HENRY

Amazingly, the Getus live only two hours by car from Addis Ababa, Ethiopia's Westernized capital. No running water, no plumbing, no gas, no electricity — the only hints of urbanization are the high-voltage lines that run through the valley behind the family's homestead on their way from a hydro-electric project to Addis. Everyone in the family, immediate and extended, was wonderfully generous to me despite their economic hardship. At least three times a day, my guide and I were called into one of the manure-plastered homes for rounds of sweetened or salted coffee and fried grain. Nor was their generosity solely limited to foreigners. One night while I was having grain and coffee with Getu and Zenebu we heard a call from the darkness. A lone traveler had failed to reach his destination by nightfall and was seeking a place to sleep. Getu welcomed the "sunset guest," as they are called in Ethiopia, and the family shared its coffee, grain, and firelight. It was slack season during my stay with the Getus, so the men did little work in the fields, except for Shamalis, the orphaned relative living in the brother's cook house, who tended each family's animals. The women do not have a slack season, though. They kept fetching water, cooking meals, cleaning the corrals, fashioning dung into patties used as fuel — all the while eating after the men, drinking their coffee after the men, and so on. When my cup ran dry of coffee or tea, the men would call for a woman to refill it, even when the pot was directly in front of them. Nonetheless, what surprised me most during my stay was Getu's message for the world. This man, who sometimes goes hungry, passionately wished for peace to spread throughout his war-torn country and the world. From the remote highlands of a struggling nation where one would assume people to be focused only on their own very pressing concerns, Getu told me that only peace everywhere would enable everyone everywhere to share in life's bounty.

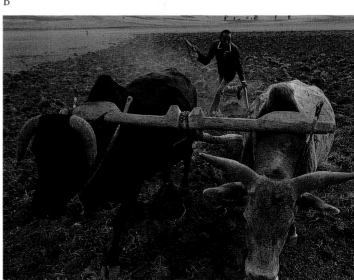

D

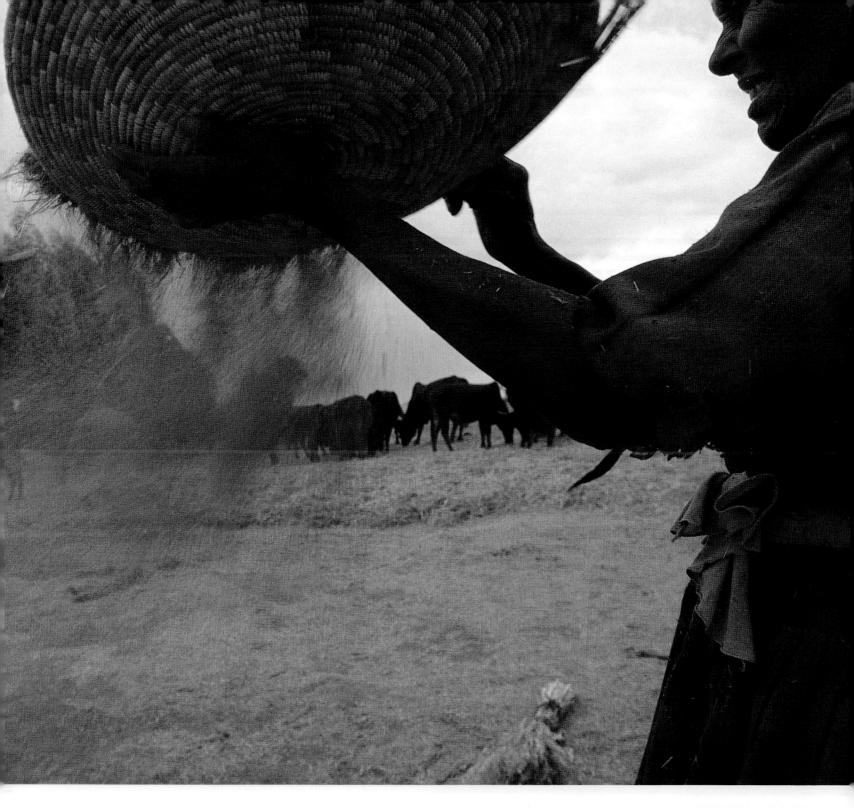

TEFF, A CEREAL GRAIN indigenous to Ethiopia, is one of Getu's most important crops. Farmers plant it twice a year *(D, Getu behind the plow)* and water the crop with pails fetched from a well. After harvest, farmers separate the sesame-seed-sized seeds from their husks by marching cattle over the grain. The results are then winnowed *(B)* by women who toss the seed in baskets, letting the breeze blow away the chaff. To make *injara*, the flat Ethiopian bread, women pound *teff* into flour, mix in water and spices, and spread the result on a shallow, wok-like pan on the smoky dung fire that burns almost constantly in Ethiopian homes *(C, Getu's mother, Dinkneck Dimime, and seven-year-old Mamoosh, his son). Injara* is always served with *wat*, a saucy blend of spices and foods such as eggs or vegetables *(A)*.

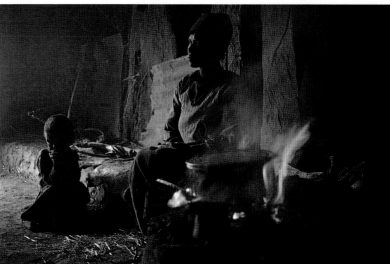

C

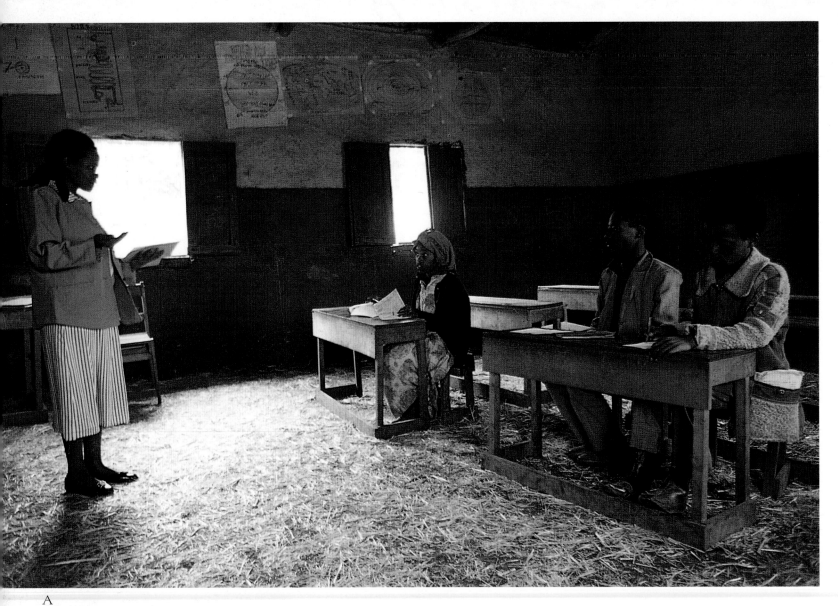

A

C

GETU FAMILY

Size of household
7

Size of dwelling
320 sq. ft. (30 sq. m.)
Cooking and dining room,
food storage room

Workweek
80 hours (Father)
126 hours (Mother— includes
18 hours daily housework)

Number of radios
1 (Batteries dead)

Most valued possessions
Oxen (Father and mother)

Per capita income ($US)
$123

Form of birth control
None (But willing to use if
source is provided)

Wishes for future
More animals, 2nd set of clothes,
better seed stock, farm imple-
ments, peace in area and in world

SURVIVAL IS IMPOSSIBLE in the long run for the children if they continue to be farmers, Getu and Zenebu believe. Education, in their view, is all-important — which is why they find it so painful that the local school is inaccessible. Although the school itself is free, the children are required to buy school clothes and supplies that would cost perhaps a third of the family's annual income. In addition, classes are taught only in the Oromo spoken by the Getus and their neighbors, rather than in the official Amharic that they need to work and get ahead in the city. Combining all of these things, fewer than a hundred children attend the Moulo village school (A) in a catchment area of more than 10,000 people. The rules are typical of the confusing web of regulation imposed by successive regimes since the relative stability and indifference of Emperor Haile Selassie's long regime ended two decades ago (C, *a neighbor in a leftover imperial policeman's uniform*). Solace in a life that is often painful and frustrating comes mainly from the family's Ethiopian Orthodox Christian beliefs. Getu and Zenebu abstain from meat on Wednesday and Friday, as per tradition, and attend services at the nearby Burso Medhane Alen church (*facing page, the priest there*) when their farming schedule permits.

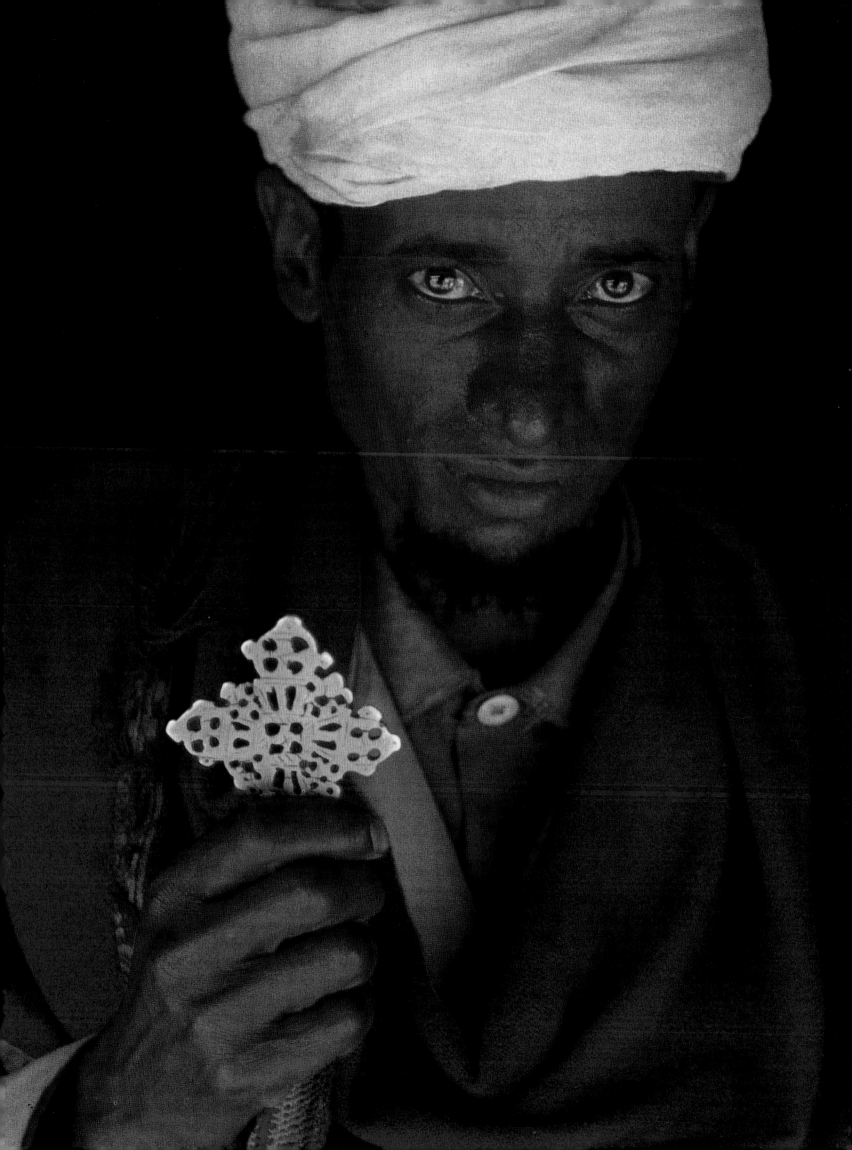

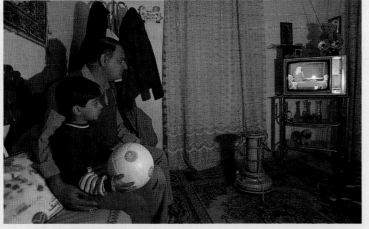
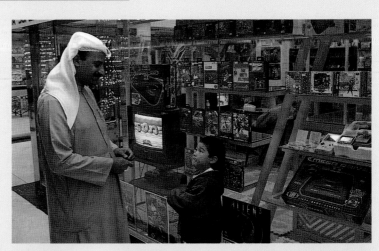
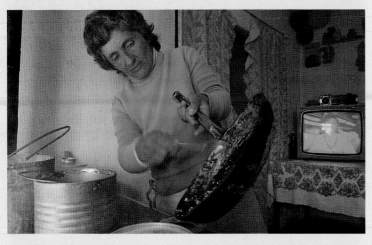
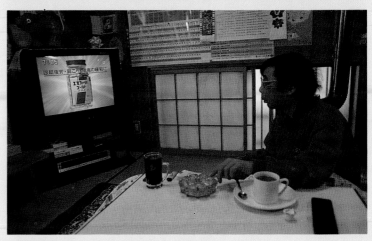

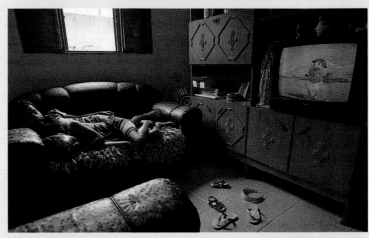

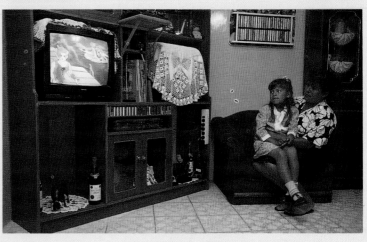

IRAQ
THAILAND
ALBANIA
GREAT BRITAIN

KUWAIT
BRAZIL
JAPAN
MEXICO

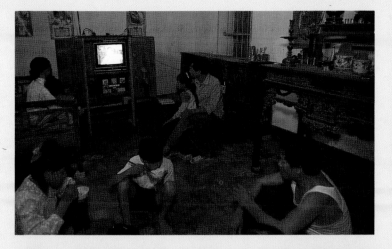

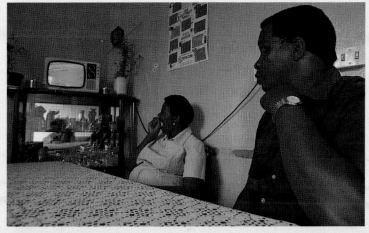

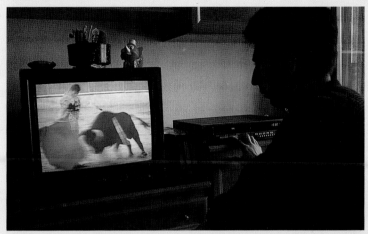

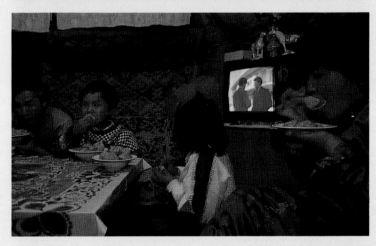

VIETNAM
ITALY
RUSSIA
BOSNIA

SOUTH AFRICA
SPAIN
MONGOLIA
KUWAIT

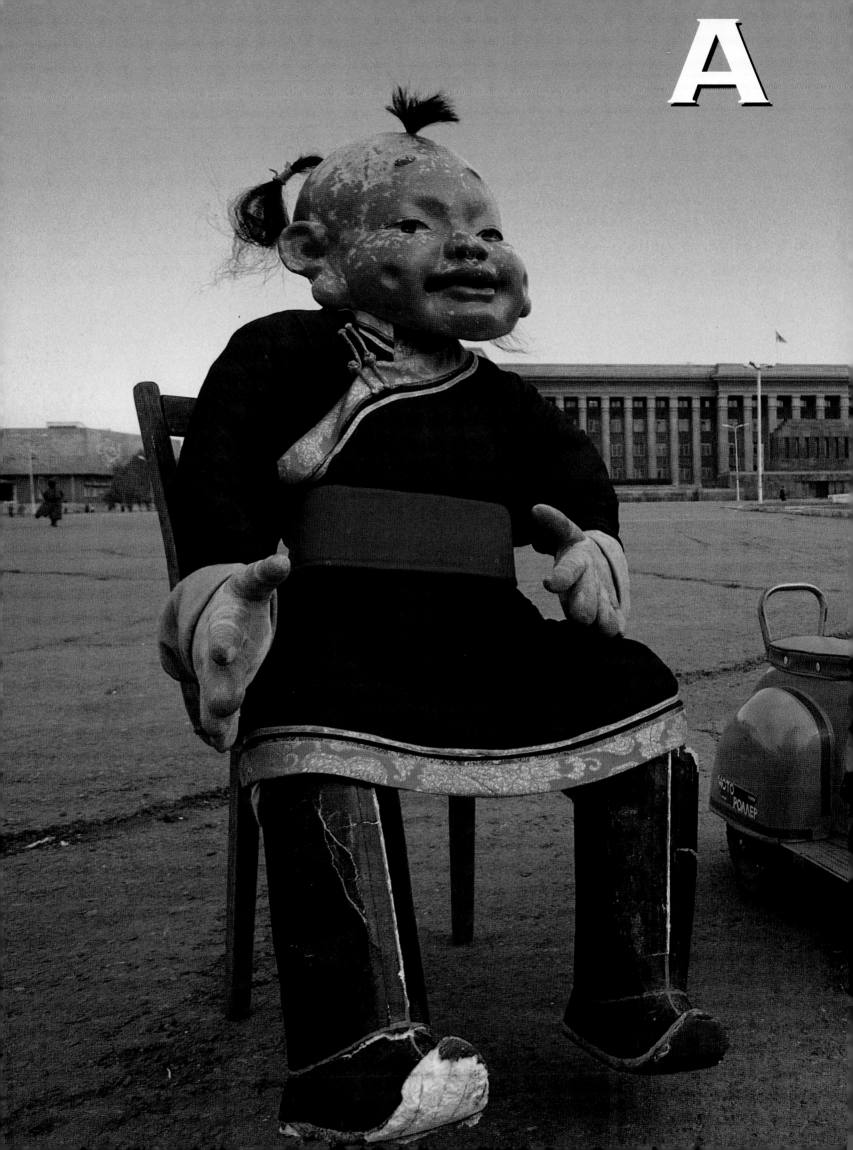

A

S I A

PROPS FOR SOUVENIR PICTURES
ULAANBAATAR, MONGOLIA
PHOTOGRAPH BY LEONG KA TAI

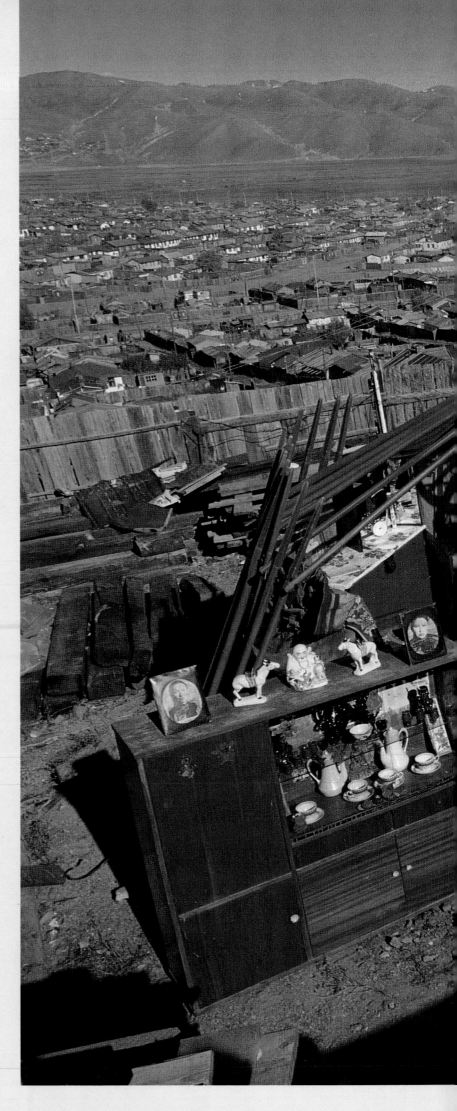

MONGOLIA

Reconstruction

The Regzen Family

4:00 P.M., SEPTEMBER 28, 1993
ULAANBAATAR, MONGOLIA

BIG PICTURE BY LEONG KA TAI
AND PETER MENZEL

DAILY LIFE PHOTOGRAPHS
BY LEONG KA TAI

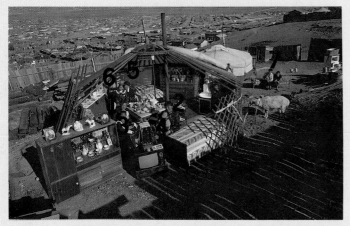

KEY TO BIG PICTURE

1. Regzen Batsuury, father, 37
2. Lkhamsuren Oyuntsetseg, mother, 31
3. Batsuury Khorloo, daughter, 9
4. Batsuury Batbileg, son, 5
5. Oyunjargal, father's sister, 33
6. Yeruultzul, her daughter, 12
7. Mother's sister with husband and son (seated on bed, next to their *ger*)

OBJECTS IN PHOTO

(Clockwise from left)

- China cabinet with stickers of Chip 'n' Dale Rescue Rangers cartoon characters
- Family portraits (2), ceramic horses (2), ceramic Buddha (atop cabinet)
- Tea sets (2), small bronze Buddha (in cabinet)
- Poles used to form structure of *ger*, family dwelling
- Dresser with alarm clock and vanity mirror
- Twin bed with woven coverlet, extra bedding (folded)
- Dining table
- Tomatoes, hard cheese, teapot, jar of preserves, figurines (2), soft drinks (6 bottles), bowls of cookies, condiments, and candy (7) (atop dining table)
- Electric hot plate, electric kettle (on table to right)
- Enamel plates (2, hanging on wall, each decorated by many clothespins)

- Fluorescent light fixture, incandescent bulb (hanging from peak of *ger*)
- 2nd china cabinet
- Trays (2), teapots (2), china statuary (in cabinet)
- Washbasin (white, on wooden box)
- Photograph
- 2nd twin bed with coverlet
- Television (black-and-white, with Chip 'n' Dale Rescue Rangers sticker)
- Incense holder, carved wooden Buddha in glass case (on television)

(Outside ger)

- Sheep (tethered to right)
- *Ger* and bed of mother's sister's family
- Icebox, barrel, water containers
- Outhouse (left of gate)
- Used railroad ties and lumber intended to build permanent winter house (behind and left of main *ger*)

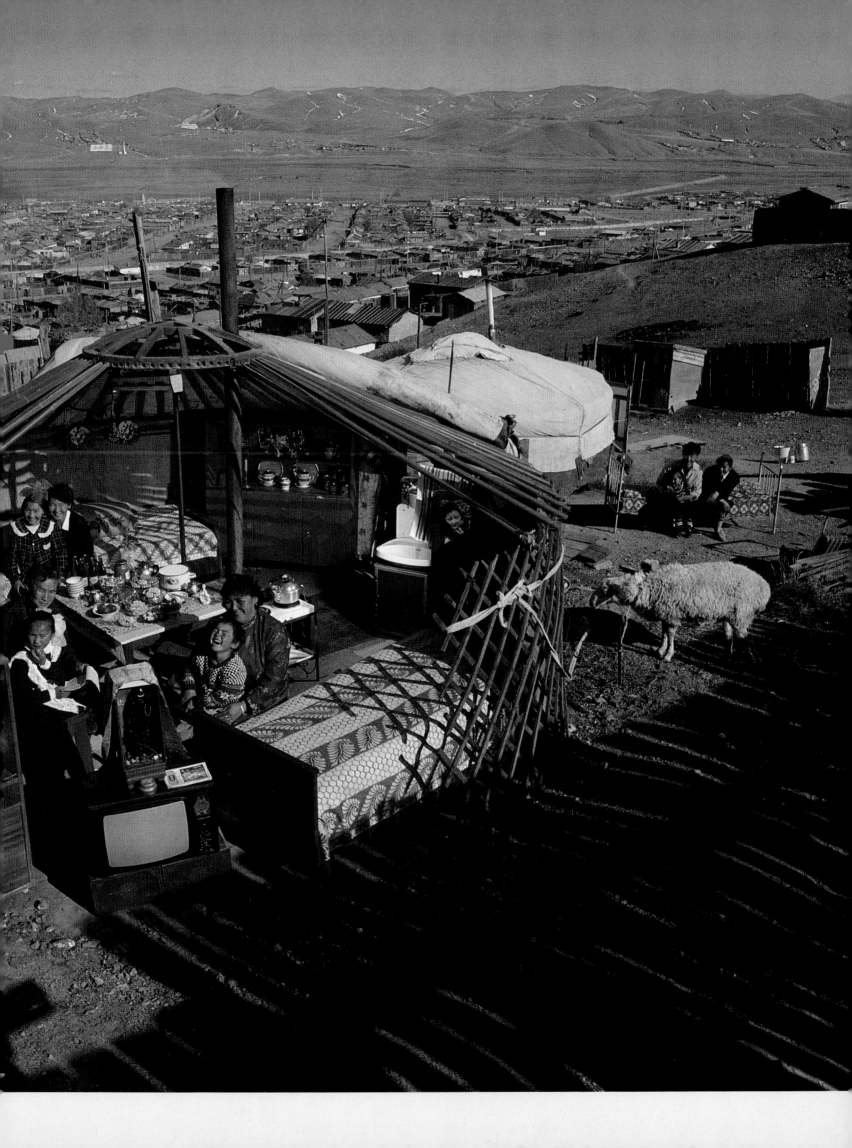

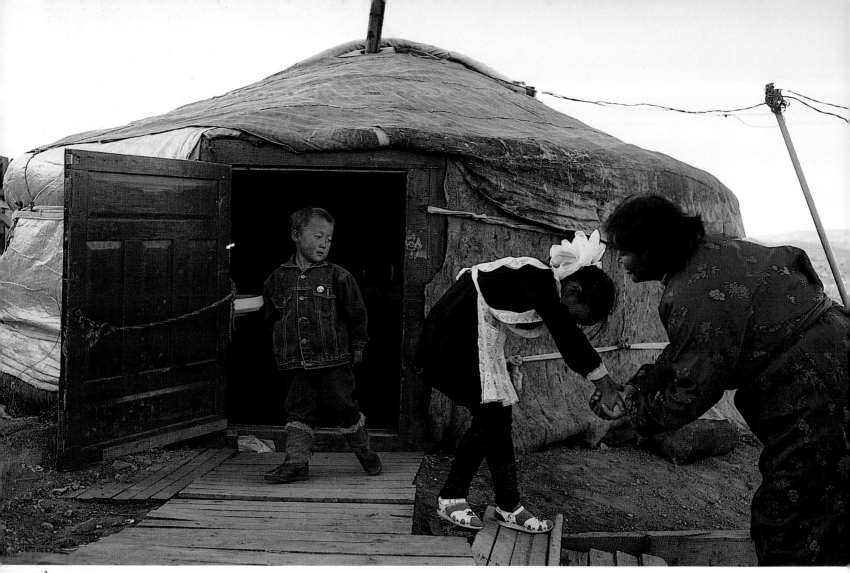

A

HORSING AROUND in her black-and-white school uniform, 9-year-old Khorloo wrestles with her mother *(A)* before school on the steps of the *ger* (tent-like Mongolian house). Watching the commotion enviously is a next door neighbor, who is too young for school. On the way, Khorloo walks with her 12-year-old cousin Yeruultzul down the steep hill by their house to their school *(C, Khorloo in pink jacket)*, a distance of about a mile (2 km). The Regzens moved from the countryside to Ulaanbaatar five years before — or, rather, to the peripheral zone around the central city. In central Ulaanbaatar most people live in the massive concrete apartment blocks that are the apparently inevitable legacy of Communist central planning. Another legacy: the polluted haze created by the city's big coal-fired power plants *(D, smokestack and 3 cooling towers in background)* and the countless small coal-burning stoves in the periphery. One of these heats the neighboring *ger* of Oyuntsetseg's sister and her family on a snowy September weekend morning *(B)*.

MONGOLIA
MONGOL ULS

STATS

Area
604,250 sq. mi.
(1,564,995 sq. km.)

Population
2.5 million

Population density
4.1 per sq. mi. (1.6 per sq. km.)

Total fertility rate
4.6 children per woman

Population doubling time
27 years

Percentage urban/rural
61% urban, 39% rural

Life expectancy
Female: 64, Male: 61

Infant mortality
60 per 1,000 births

Literacy rate
Female: 86%, Male: 93% (1980)

**Rank of affluence
among the 183 U.N. members**
80

One of the most thinly populated places in the world, Mongolia first became a state when Genghis Khan unified its scattered tribes in the early 13th century. Although Genghis's empire stretched from the Danube to the South China Sea, its glory was short-lived. By the late 14th century, Mongolia was under attack by China, which gradually consolidated control; when the Chinese grip weakened in this century, the nation regained its independence, only to become a vassal of the Soviet Union. Under Moscow's guidance, Mongolia began to industrialize, though it remained dependent on its millions of sheep, goats, cattle, and horses. The revolutionary changes in Eastern Europe in 1989 led to protests against Soviet dominance in Ulaanbaatar, Mongolia's capital and largest city. The Communist party resigned power, renounced its ideology, changed its name, and held elections, which it won. The transition to a market system has been painful, with the effects of falling output and rising unemployment exacerbated by unusually devastating winters. International aid was needed to keep the lights on in Ulaanbaatar. As a consequence, the reformist president, Punsalmaagiyn Ochirbat, was rejected by his own party. He joined the opposition, and Mongolians re-elected him in 1993. With some support from the West, the nation is now trying to raise its standard of living while cleaning up Ulaanbaatar's dirty air and avoiding the grazing-induced erosion that often accompanies husbandry.

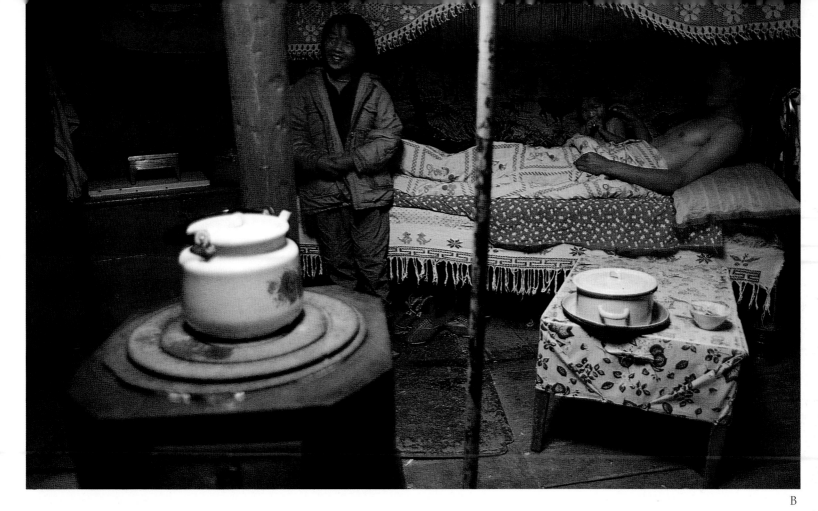

B

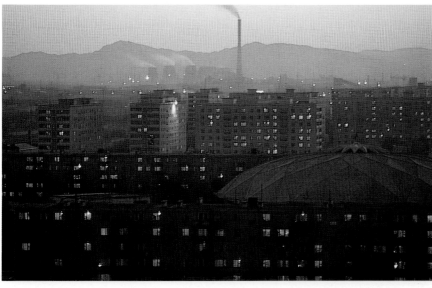

D

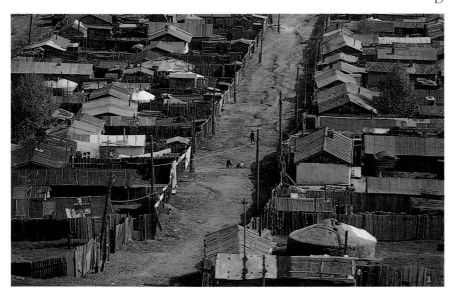

C

PHOTOGRAPHER'S NOTES
PETER MENZEL

Ulaanbaatar, Mongolia's capital, was in a state of excitement because the state museum was displaying the ashes of the Buddha (something that would have been impossible under Communism). People — including the Regzens — waited in line all day to see them. Photographer Leong Ka Tai and I approached this family with what might be called statistical trepidation. Mongolia is evenly split between urbanites and the herdspeople in the steppes. Their lives are very different — which to choose? With help from the U.N., we decided to split the difference. We looked in the outskirts of Ulaanbaatar, where families still live like country dwellers in a *ger* but commute to city jobs in Mongolia's super-crowded buses. Because the *ger* is meant to be portable, dismantling one for the Big Picture turned out to be a breeze. We were nervous when there were only a few hours of good light remaining and the family had done nothing. Then, an hour before the picture, they jumped up, peeled back the side of the *ger*, and were ready to go. For the festivities afterward, Batsuury slaughtered a sheep by slitting its stomach, reaching inside almost elbow-deep, and pinching the artery between its heart and its brain. The sheep closed its eyes peacefully. It was on the fire in an hour. The treat of the meal was the bladder, which they filled with blood, tied off, and boiled — something I'd never had before. On the way back to Beijing our airplane was delayed for half an hour on the runway. There were a lot of armed guards, a brass band, and a big red carpet. Eventually the door opened, and in came a monk with an entourage. He sat down and placed a silk pillow on his lap. On it rested the container with the ashes of the Buddha.

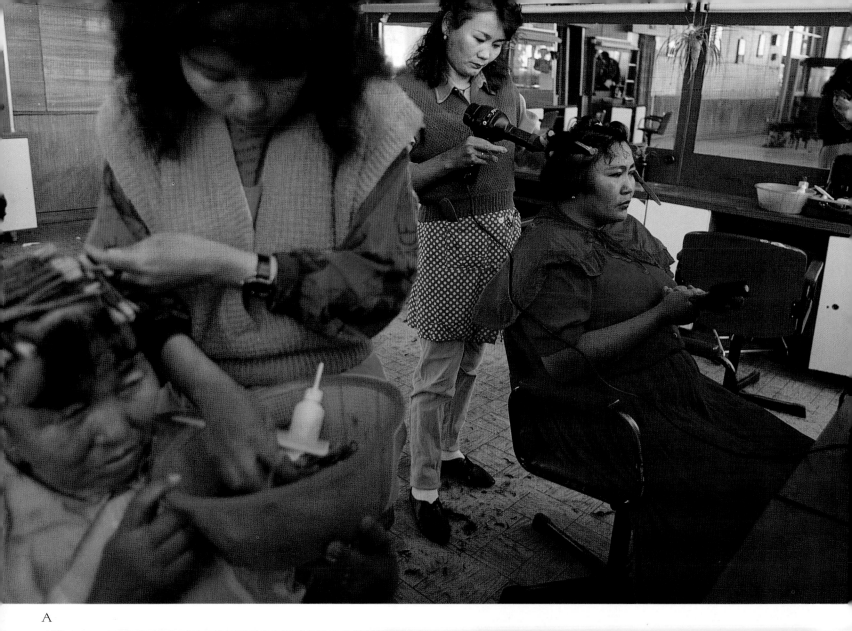

A

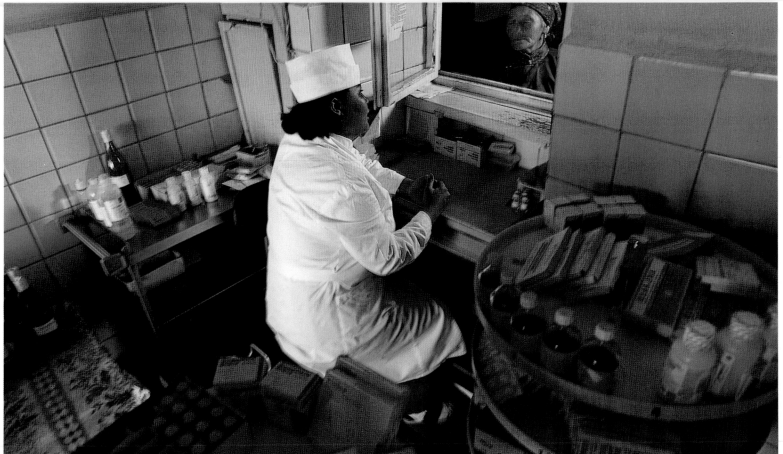

D

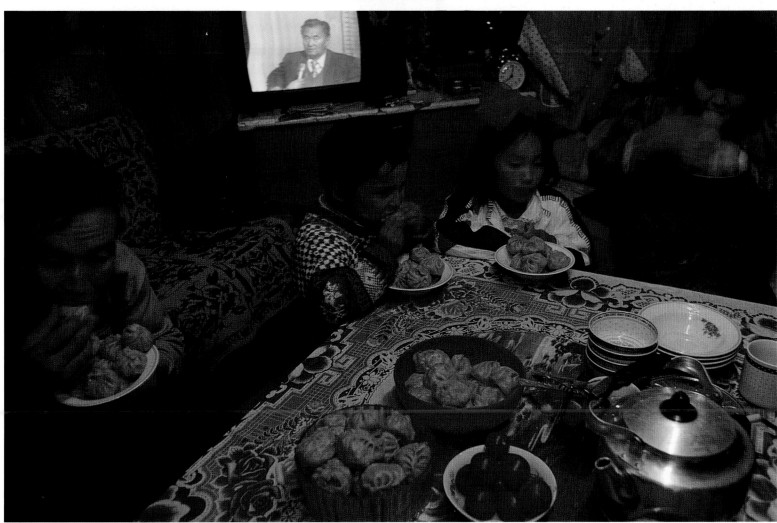

B

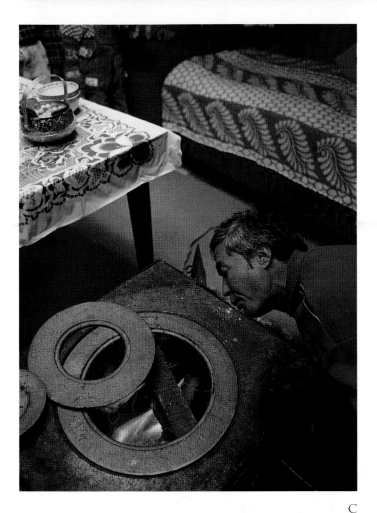

C

REGZEN FAMILY

Size of household
6

Size of dwelling
200 sq. ft. (19 sq. m.)
One-room tent

Workweek
50-60 hours (Father, truck driver,
free-lance construction worker)
64 hours (Mother, 40 at work
plus 24 for housework)

Number of
Radios: 0, Telephones: 0,
Televisions: 1, Automobiles: 0

Most valued possessions
TV (Father)
Statue of Buddha inherited from
grandfather (Mother)

Per capita income ($US)
$1820

**Percentage of Regzen family
income spent on food**
68%

On vodka, cigarettes
4%

Wishes for future
A permanent house for all seasons
made of wood and cement with a
corrugated iron roof. Family would
like to plant a garden inside the
fence.

MAKING A FIRE from scrap wood, Batsuury blows into the stove *(C)* that doubles as the family's heat source. Because the *ger* — developed as a portable house when Mongols lived as nomads — has no separate kitchen, Oyuntsetseg and Batsuury place big cutting boards on the beds. There the couple, who share cooking duties, roll out the dough for the beef dumplings that are the centerpiece of that night's dinner *(B)*. Dividing household duties is a necessity — Oyuntsetseg spends a full 40-hour workweek at the downtown hospital where she dispenses pharmaceutical products to patients *(D)*. By negotiating her schedule, she is occasionally able to take an afternoon off to get her hair done at a nearby salon *(A)*.

NEXT SPREAD: An emblem of the changes sweeping Mongolia, the former black market in Ulaanbaatar is jammed by buyers, sellers, and traders despite this September blizzard. The institutions of the market are still so new that few merchants have stalls — instead they walk about with a few goods in their arms, hoping to come across a buyer.

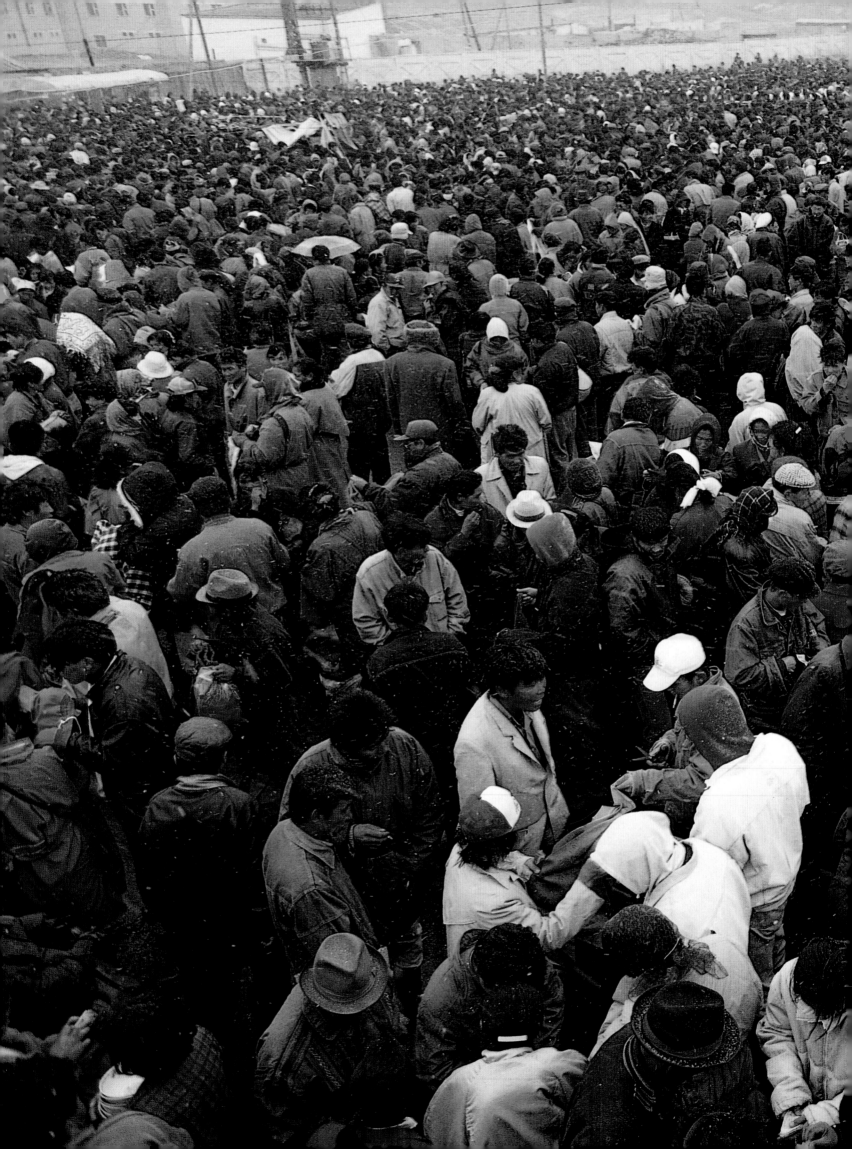

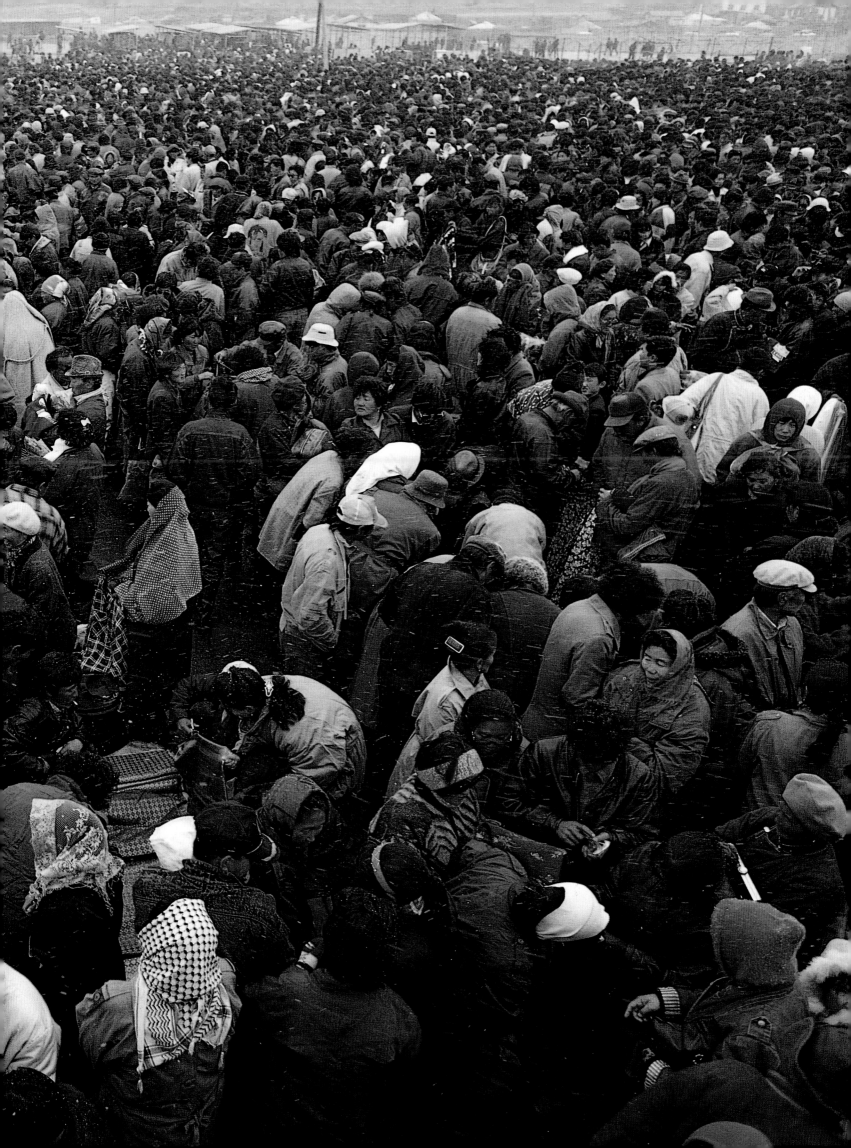

JAPAN

Paradoxical Affluence

The Ukita Family

4:30 P.M., DECEMBER 16, 1992
TOKYO, JAPAN

PHOTOGRAPHS BY PETER MENZEL

KEY TO BIG PICTURE

1. Kazuo Ukita, father, 45
2. Mio Ukita, daughter, 9
3. Sayo Ukita, mother, 43
4. Maya Ukita, daughter, 6

OBJECTS IN PHOTO

(Selected items, left to right)

- Unicycle, books, dolls, pogo stick, clock, miscellaneous toys
- Stacking basket for toys
- Clothes racks (2) with backpacks, hats
- Bookcases (3) with books, dolls
- Clothes (hanging on carport)
- Desk and chair (with stuffed animal, doll)
- Car (Toyota minivan)
- Suitcases (2, atop car)
- Dressers (2)
- Video-game player (on small dresser)
- Swimming trophies (2, on tall dresser)
- Electric piano and bench (with books)
- Crutches (behind piano)
- Shoes (28 pairs)
- Rubber rafts (2), ball, pool mask, snorkel, ice chest
- Refrigerator
- Coffee table (with thermos, rice cooker, tomatoes)
- End table (with telephone, family portraits)
- Color television (with ceramic rooster)
- Pots and pans (on end table)
- China cabinet (with china, microwave oven, toaster oven, liquor bottles)
- Papier-mâché animal (on cabinet, school project)
- Bed (behind cabinet)
- Dressing table with mirror (behind bed)
- Umbrellas (by dressing table)
- Dining table (with family)
- Fire extinguisher (on wall)
- Dog house (on steps)
- Dog (named Izumaru)
- Bunk beds (with blankets, video cassettes, toys)
- Clothes rack (with woman's suit)
- Entrance gate (right half, black metal, with mail slot)
- Butcher block table (with cooking utensils)
- Food-storage unit (by washer)
- Electric washer/dryer
- Cleaning supplies (in basket, on plastic shelf unit)
- Tub toys (by bathmat)
- Skateboards (2, leaning on shelf)
- Bicycles (3, in far right background)
- Child's chair

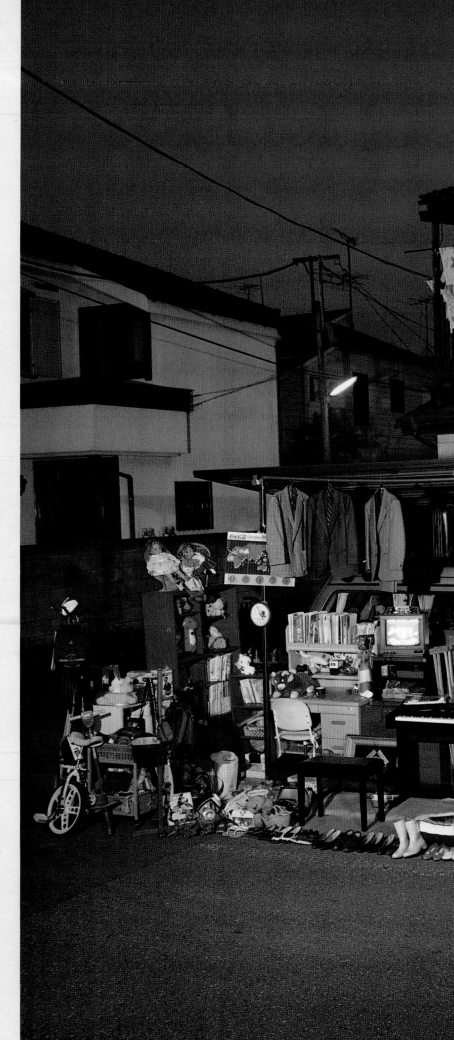

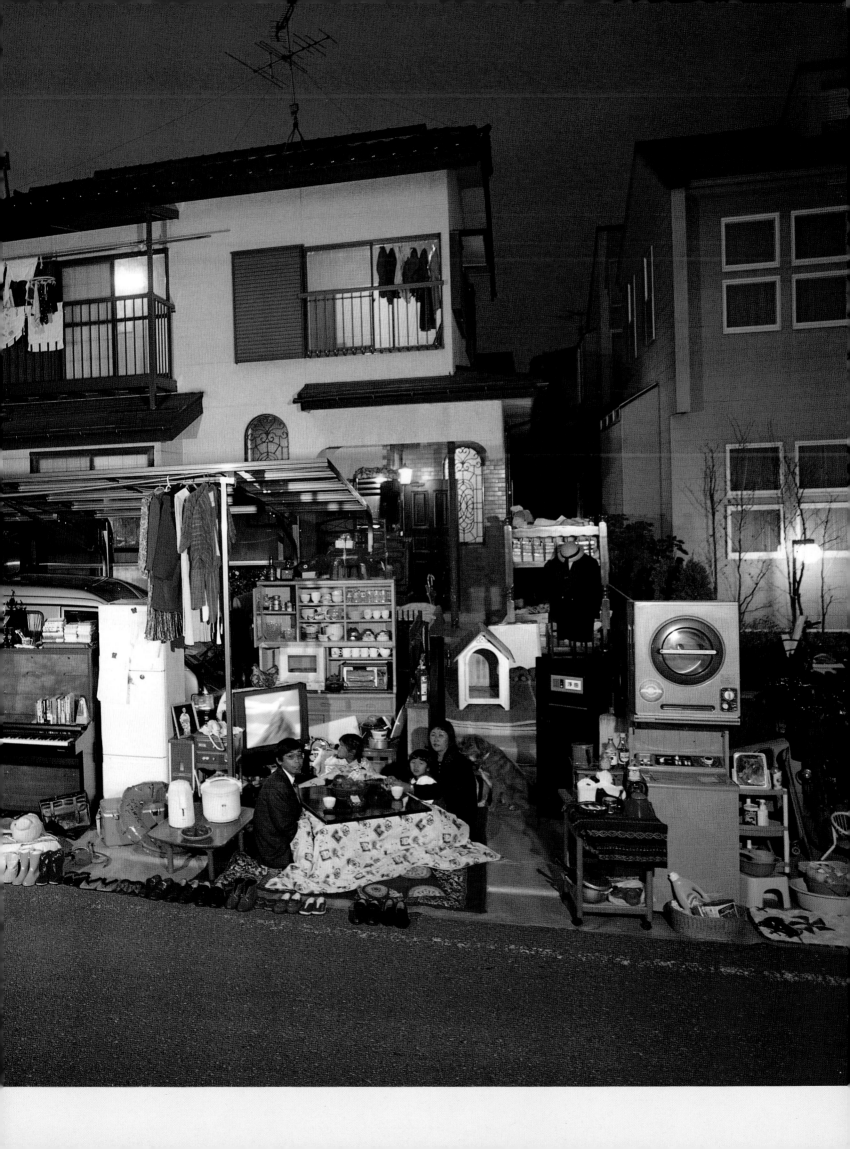

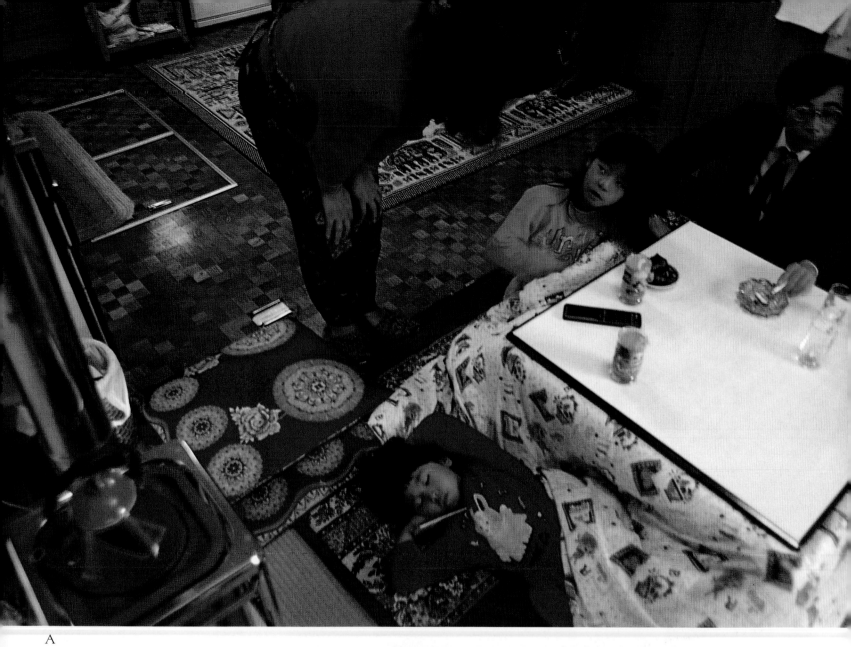

A

BREAKFAST is the purview of the supremely organized Sayo, who rises half an hour before anyone else in the family. After waking up her sleepy husband and children, she puts together the meal *(E, with 6-year-old Maya)*, dresses the kids, collects the homework, and gathers the family at the morning table *(A)*. Kazuo leaves home to catch the train *(B, snatching glance at newspaper on platform beneath clock)* for his job at the Yohan book and magazine distribution company. He dons a navy blue suit for the hour-long commute, but changes into company work clothes for his actual work loading and moving boxes in the warehouse *(C)*. Several times a week he relaxes after an exhausting day by stopping in at a karaoke bar *(D)* for a cigarette, a glass of sake, and a crack at the microphone.

NEXT SPREAD: Saturday night at the Ukitas'.

E

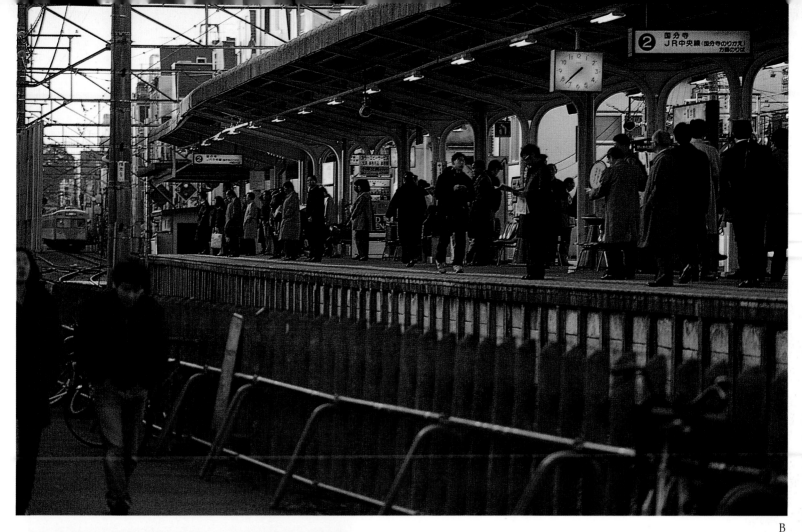

B

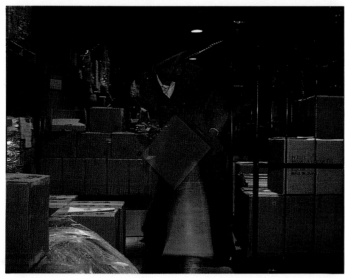

C

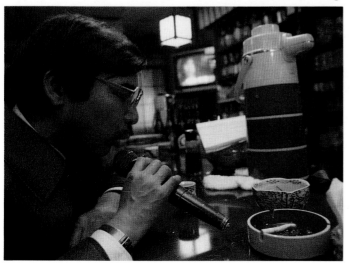

D

JAPAN
NIHON

STATS

Area
145,946 sq. mi.
(377,997 sq. km.)

Population
125.9 million

Population density
862.7 per sq. mi.
(333.1 per sq. km.)

Total fertility rate
1.7 children per woman

Population doubling time
183 years

Percentage urban/rural
78% urban, 22% rural

Life expectancy
Female: 82, Male: 76

Infant mortality
5 per 1,000 births

**Rank of infant mortality
among world nations**
Lowest

Literacy rate
Female: 99%, Male: 99%

**Rank of affluence
among the 183 U.N. members**
2

More than four-fifths of Japan is mountainous, and its people are therefore concentrated into immense urban complexes along the coast. Here an explosion of economic growth has occurred, transmuting Japan in a century from a closed rural society dominated by hereditary aristocrats to a Westernized industrial power dominated by educated bureaucrats. After the Second World War, the conservative Liberal Democrat government championed the interests of small farmers and large corporations, blocking food imports and promoting commercial exports. The system seemed to guarantee growth and stability, albeit at the cost of corruption, pollution, and surprisingly low standards of living. Now it has broken down. Recession and scandal have shaken the vaunted bureaucracy; meanwhile, the citizenry is demanding more of the fruits of prosperity. Under pressure, the Liberal Democrats splintered. In 1991 an opposition leader became prime minister for the first time since the war. The future seems likely to demand still more change from a culture that has already experienced enormous transformations.

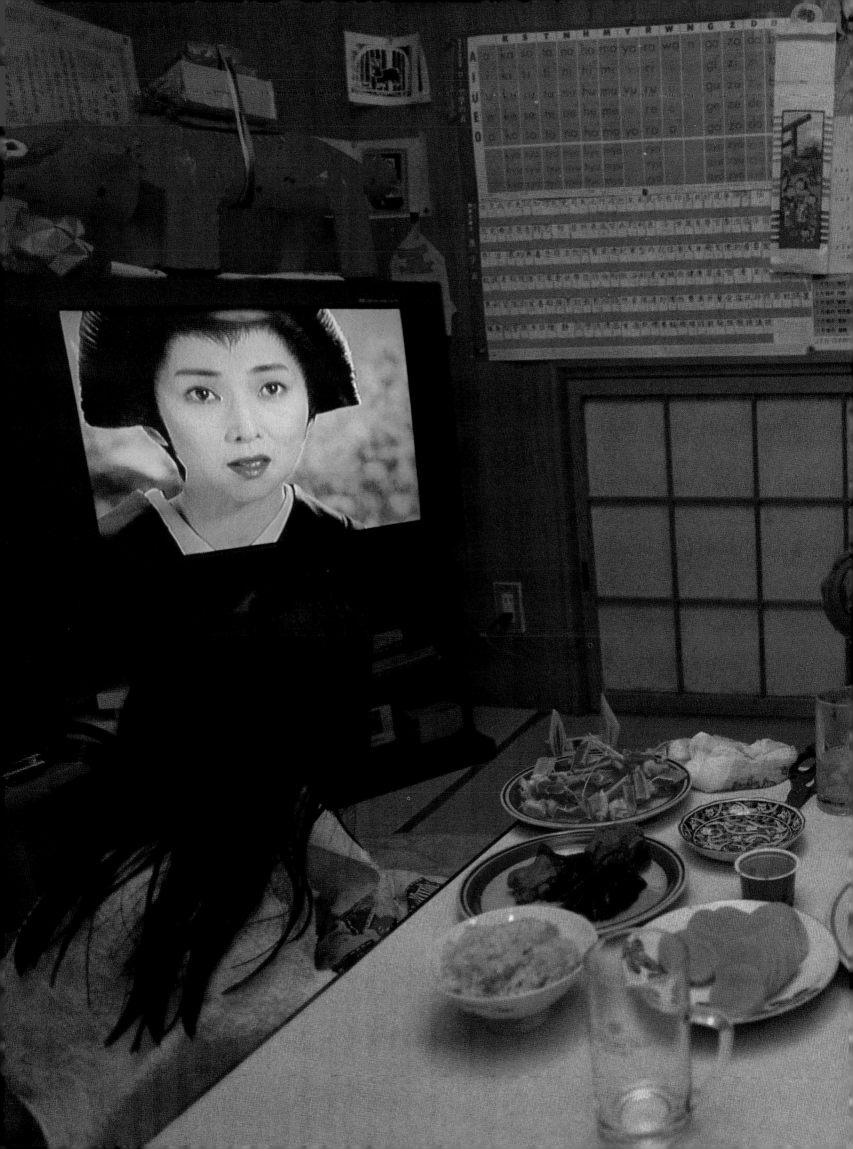

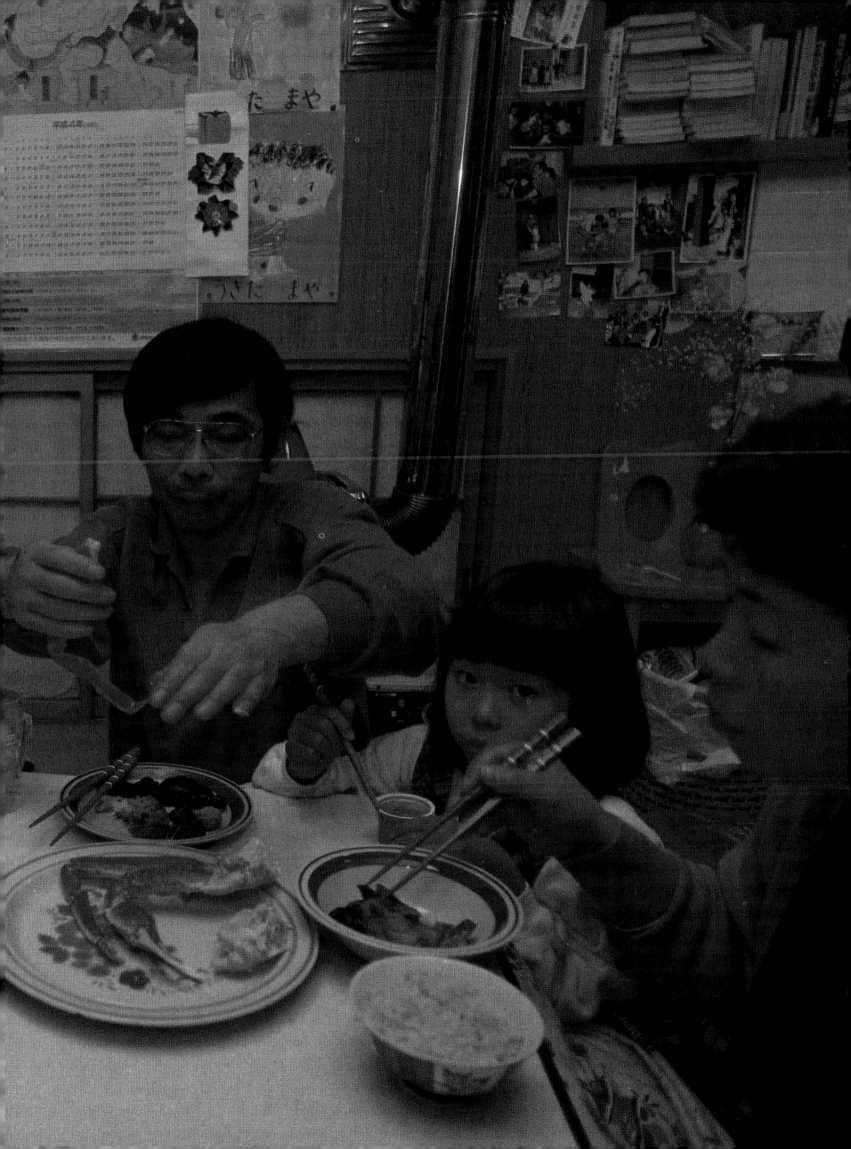

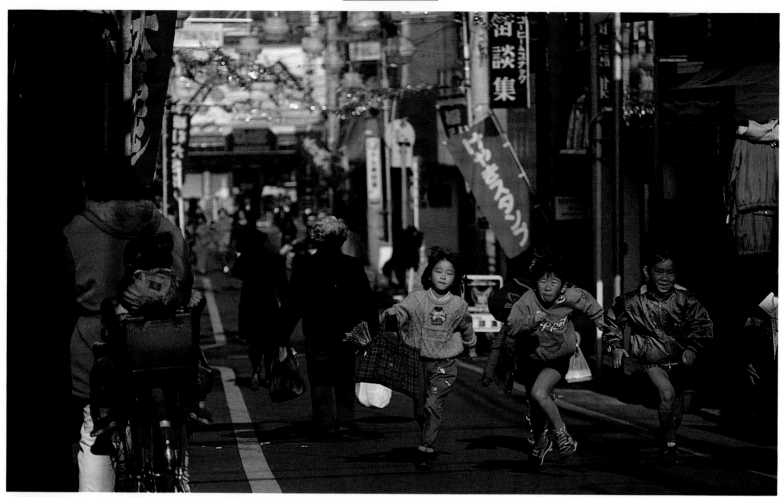

A

B

TAKING A BREAK from routine, children run down the main shopping street of the Ukitas' neighborhood *(A)* in far-western Tokyo. For the Ukita children, such moments are rare — their lives are frenetically busy. Nine-year-old Mio wants to be in the Olympics, so four or five times a week she bicycles to the People health club to do laps in the pool *(B)* for 2 hours. The health club is conveniently located next to her *juka*, the Saturday-morning cram school that many Japanese children attend to prep for the country's rigid national exams. Maya *(facing page, in school uniform)* is in kindergarten and therefore too young to be swept up into the worry about exams. Rather than study, she uses the time before school to skip rope and play with the dog.

UKITA FAMILY

Size of household
4

Size of dwelling
1421 sq. ft. (132 sq. m.)
Living room, dining room,
kitchen, bath

Workweek
40 hours (Father)
60 hours (Mother, at home)

Number of
Radios: 3, Telephones: 1,
Televisions: 1, VCRs: 1,
Microwave ovens: 1, Computers: 1,
Bicycles: 3, Automobiles: 1

Most valued possessions
Family (Father)
Heirloom ring from grandmother,
heirloom pottery from grandfather
(Mother)

Per capita income ($US)
$26,824

**Percentage of Ukita family
income spent on food**
30%

Wishes for future
Larger house, 2nd apartment or
house for rental income

PHOTOGRAPHER'S NOTES
PETER MENZEL

Coming to bustling, electric Japan straight from my previous assignment in the Australian outback was a shock. The Ukitas live in Tokyo but reaching their house from the center of the city took three trains and an hour and a half. After they agreed to help out *Material World*, I spent a week with a family that has morning down to a science. Kazuo wakes up at the last possible second, has a healthful breakfast — 2 Pepsis, 2 cigarettes, 1 cup of coffee, 1 vitamin — and walks out the door at 7:28 sharp. He times himself with a little clock on the TV screen. Then he walks to the station, arriving 45 seconds before the train (which is exactly on time, this being Japan). After work, Kazuo and I hit the bars together, me with the still and video cameras, him with the microphone to sing karaoke. The next day I went with the two girls to what was either the best dentist in the world or the worst: He gave each a filling in 2 minutes flat. Sayo, a wonderful cook, was unflappable about hosting a photographer who spoke no Japanese. She didn't blink when a crew of nine dismantled her home for the Big Picture. That evening, we all sat down in a daze and watched TV — a truly multicultural experience. The Ukitas had a dial on the remote control that allowed them to play either the original soundtrack (English, in this case) or the Japanese dubbing. To let me listen, the family politely set the dial to play both at the same time. As a result, nobody understood a word of dialogue. It was all right, though, because of what we were watching — a TV action film that spoke the universal language of guns, breaking glass, and car chases.

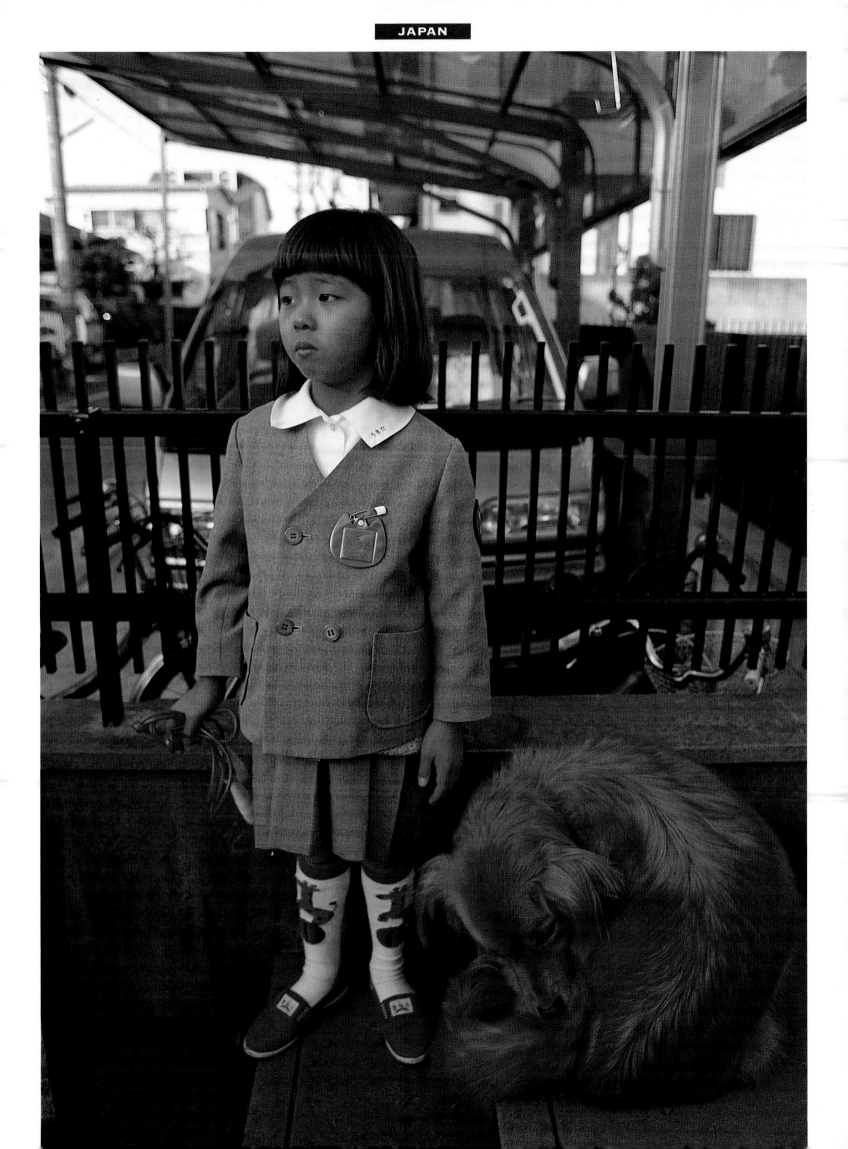

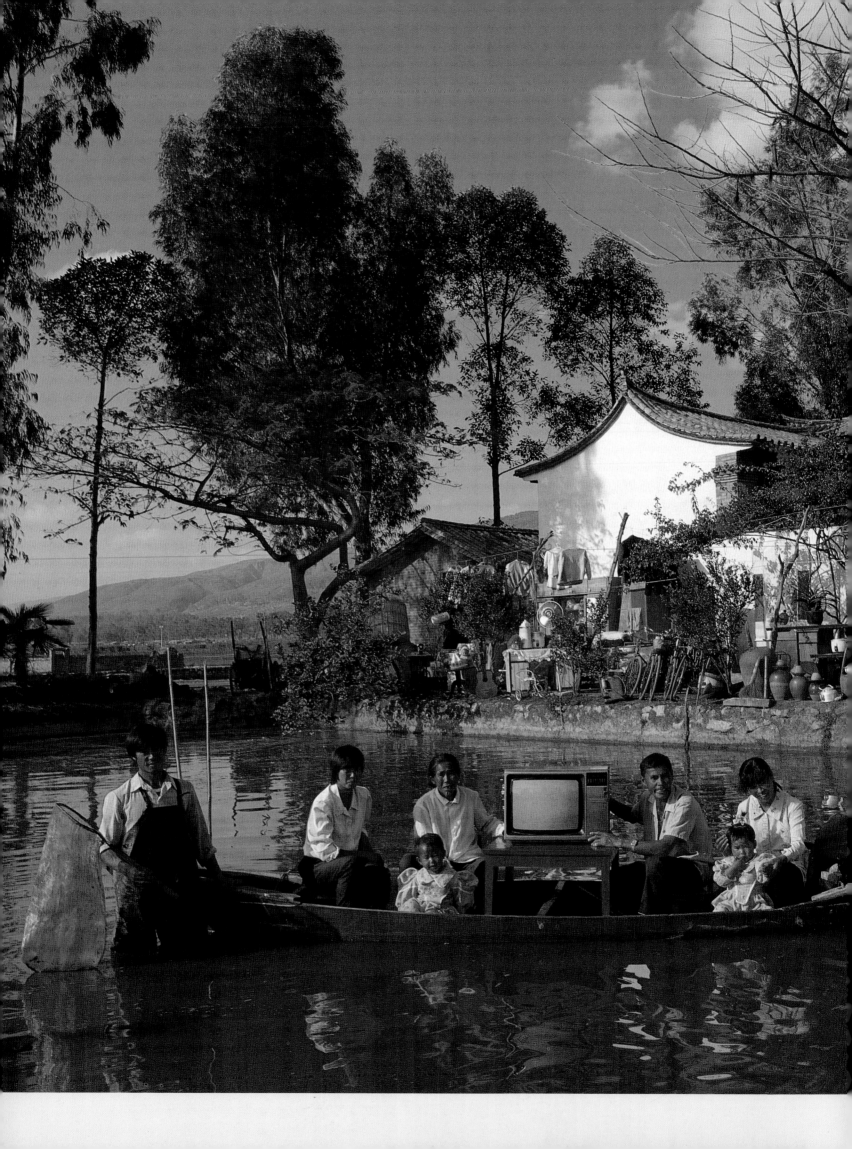

One-Fifth of Humanity

The Wu Family

3:00 P.M., NOVEMBER 26, 1993
SHIPING, YUNAN, CHINA

PHOTOGRAPHS BY LEONG KA TAI

KEY TO BIG PICTURE

Parents' household
1. Wu Ba Jiu, father, 59
2. Guo Yu Xian, mother, 57

(1st son's household)
3. Wu Wen De, 1st son, 30
4. Li Jian Chun, 1st son's wife, 28
5. Wu Dong, their son, 8
6. Wu Xi, their daughter, 3

(2nd son's household)
7. Wu Wen Bin, 2nd son, 25
8. Li Rong, 2nd son's wife, 25
9. Wu Xue, their daughter, 3

OBJECTS IN PHOTO

(On boat)

- Table, television, net (held by 2nd son)

(Onshore, L to R)

- Push cart
- Sewing machine (treadle type)
- End table
- Guitar
- Doll
- Tricycle
- Desk
- Hot-water bottle
- Rice cooker
- Fan
- Insecticide sprayer
- Wardrobe
- Bicycles (5)
- Broom
- Jars (4, for preserved vegetables)
- Scrolls (2, on wall)
- Rice cooker, bowls, flower vase (on desk)
- Kettle (on table)
- Rice basket

- Paintings (2, left of entrance)
- Metal cans (2, for beans)
- Wicker seat
- Bed (1st son's family, against wall, in red)
- Paintings of ancestors (2, right of entrance)
- Bicycle
- Tricycle
- Sewing machine and table
- Rice cooker (on sewing machine)
- Dress (hanging)
- Wash basins (4, stacked)
- Chairs
- Clothes rack and suit
- Doll (standing, at rear)
- Wardrobe (opened, by wall)
- Dinnerware (on table)
- Clothes (hanging)
- Sofa

Objects to left side of house generally belong to 2nd son's family; objects to right side of house generally belong to 1st son's family.

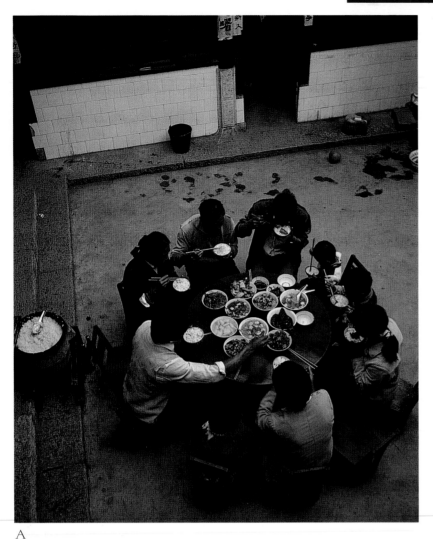

A

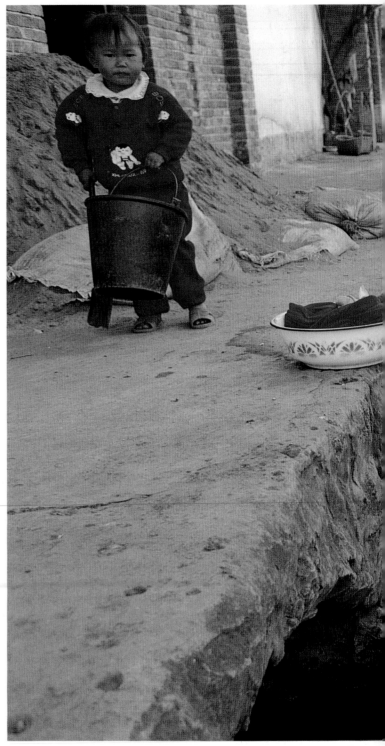

B

STATS	WU FAMILY
Area 3,696,100 sq. mi. (9,572,825 sq. km.)	**Size of household** 9
Population 1,238.3 million	**Size of dwelling** 600 sq. ft. (55 sq. m.) Kitchen, living room, 3 bedrooms, 5 storage rooms
Population density 335.0 per sq. mi. (129.4 per sq. km.)	**Workweek** 60 hours (Adults, busy season)
Total fertility rate 2.2 children per woman	**Number of** Radios: 2, Portable tape-cassette players: 2,Telephones: 0, Televisions: 1, Automobiles: 0
Population doubling time 49.2 years	
Percentage urban/rural 30% urban, 70% rural	**Most valued possessions** TV (Mother, father, 1st son) Bicycle (2nd — because can travel) Gold necklaces (Daughters-in-law— received as wedding presents)
Life expectancy Female: 71, Male: 67	
Infant mortality 27 per 1,000 births	**Possessions most likely to be stolen** Fish in fish pond (at harvest time family takes turns sleeping by water)
Population per physician 730	
Adult literacy rate Female: 62%, Male: 84%	**Per capita income ($US)** $364
Rank of number of soldiers Most in world (3.0 million)	**Average daily TV consumption** 2-4 hours per person
Rank of affluence among the 183 U.N. members 149	**Wishes for future** TV with 30" screen, VCR, refrigerator, more tools, drugs to combat diseases in fish breeding

STIRRING A SIZZLING WOK, Yu Xian mixes tofu and cabbage into a clear broth for soup *(D)*. Beside her as she works in Wen De's kitchen is a big wooden drop-lid used to cover the wok. As it happens, soup is but one component of a family lunch *(A)* in the central courtyard of the compound. The menu: soup, lotus root, Chinese icicle radish, fish, cooked celery, two types of beans, hot sauce, and, of course, rice — the last taken from the family's big wooden steamer *(left of table)*. That afternoon daughters-in-law Jian Chun *(B, center)* and Rong do the laundry at the brook by the house. Near them plays Wu Xue, Rong's daughter. Because the brook feeds through a gate into the pond in which they raise carp, the women shut the gate to block off the flow of soapy water. After a few hours of scrubbing, the two women are glad that evening to join everyone else on the couches in front of the cathode-ray tube *(C)*.

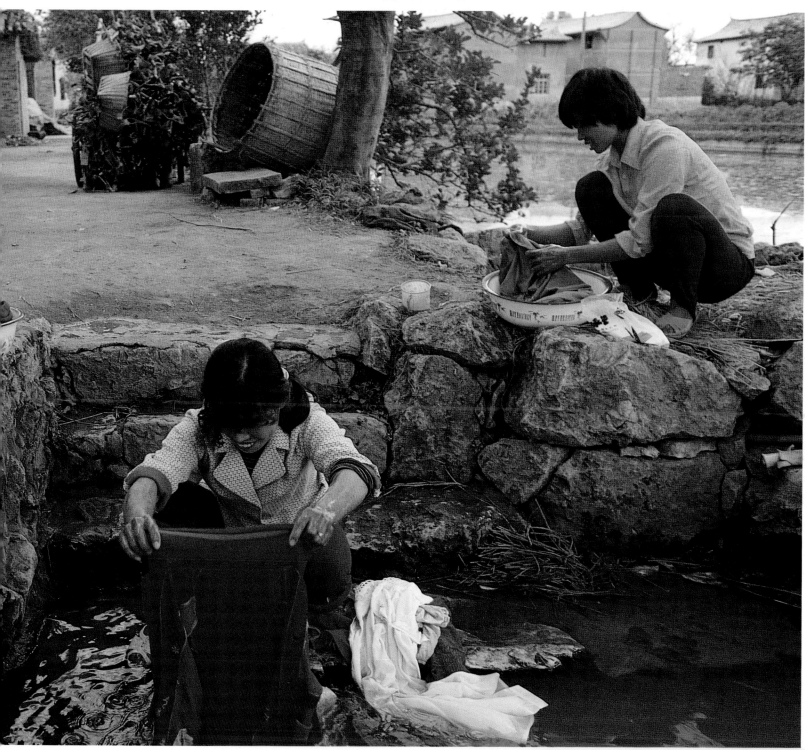

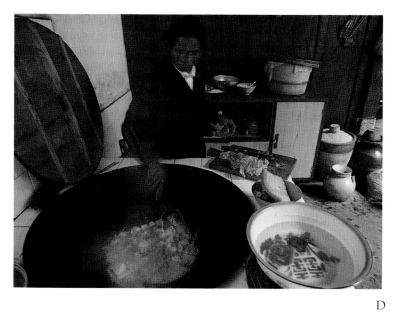

D C

CHINA
ZHONGHUA

China is the only nation that has endured throughout recorded history. Empires rose and fell elsewhere, but China always remained — one reason that its ruling dynasties considered China the center of the world and paid little attention to lands outside. The isolation was disastrous. In the 19th century, China was overwhelmed by technologically superior European forces. Their incursions led to convulsive social changes that culminated in 1949 with the victory of Communist rebels. Led by Mao Zedong, the new government both forced China to modernize and curbed its high birthrate, although at a staggering human cost. (One failed program, the Great Leap Forward of the 1950s, is said to have killed more people than any single event this century, except the Second World War.) After Mao's death in 1976, his successors dismantled many socialist programs, though kept tight overall control; the economy grew even more rapidly. Still, China faces daunting obstacles. Despite harsh population-control programs, the population will probably rise to 1.5 billion by 2025. Providing food, power, and health care to these people will strain the productive capacities of ecosystems already reeling from overexploitation. China's huge size and population means that the outcome will help determine the future of humankind and the Earth itself.

A

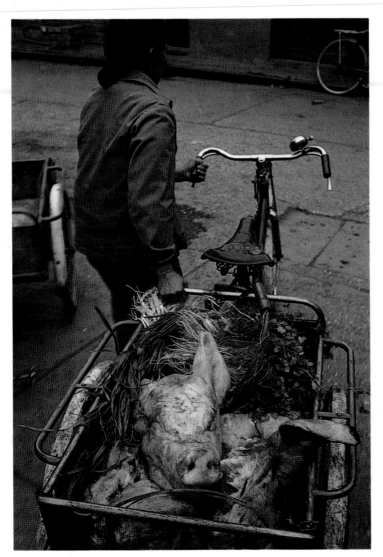

IN A CROWDED PLACE, resources are not wasted. Both of Ba Jiu's sons' families have their own bathroom facility, because they recycle the collected waste as fertilizer in their fields. Wen De's family outhouse shares space with the pig sty *(C, Jian herding pig)* to facilitate collection from both human and porcine sources. The morning deposition of nightsoil is a familiar sight in the Yunan province countryside *(B, boy in field of onions and cabbages near schoolyard)*. The Wus are lucky enough to live near a lake, Yu Long Wu (Jade Dragon Lake). Every three days family members pole out through the mesh cages of fish farmers to collect water hyacinth *(A)*, which is chopped into pig feed. The end result is wheeled to the Sunday market in Shiping village by Yu Xian *(D, with scallions, coriander, and pig heads)* and Ba Jiu, who are credited by the family with possessing the honest, straightforward demeanors that choosy Chinese shoppers prefer. In fact, Ba Jiu is a retired local official well known to his friends for his adroit maneuvering through the local political system.

D

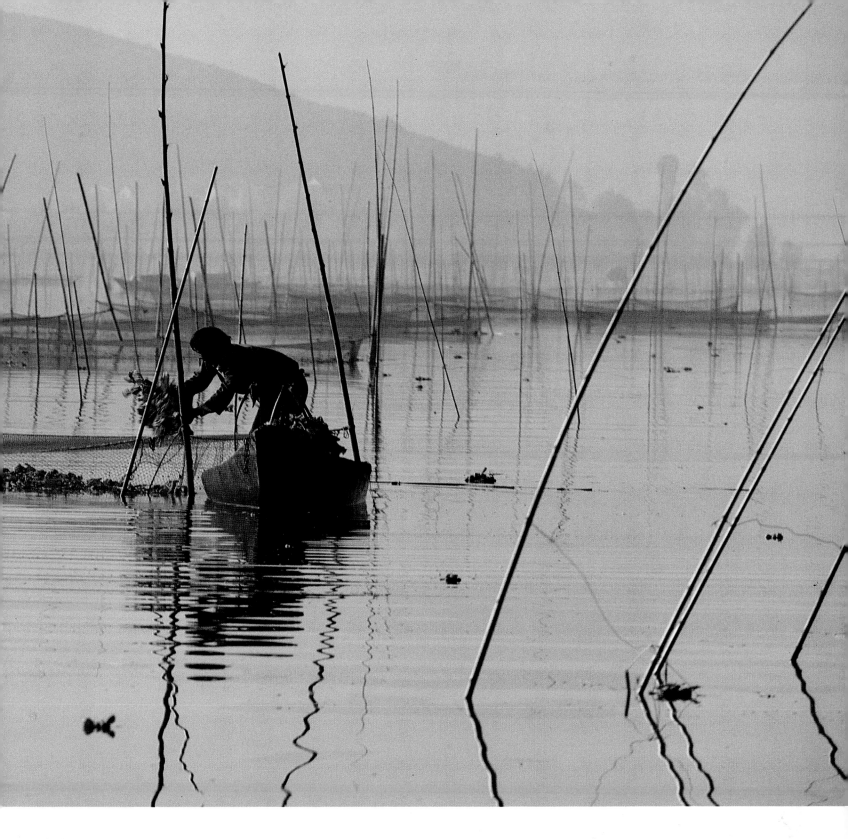

C　B

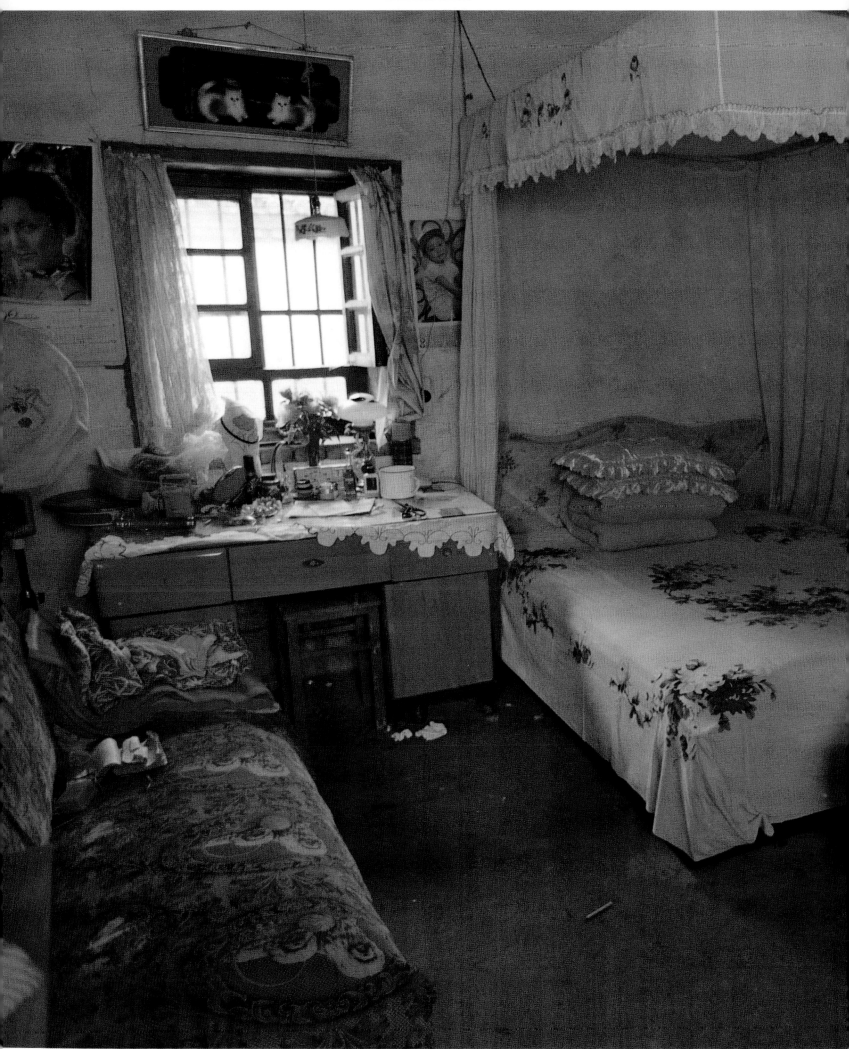

WU DONG'S MORNING is devoted to school. He leaves at 7:15 a.m., walking to school with moments to spare before the beginning of classes at 7:30. He attends one of the better schools in the area — it has some athletic facilities, for instance — but the teachers are exhausted from the strain of overcrowded classrooms and broken-down or nonexistent facilities. Still, the routine continues: math, Chinese, and (most important) recess, where the children do their calisthenics and relaxation routines *(B)*. Once home, Dong has the run of the compound *(A, searching for a toy in the armoire in his parents' bedroom).*

B

PHOTOGRAPHER'S NOTES

LEONG KA TAI

In China nothing can be done without personal contact. A friend in the provincial capital, Kunming, introduced me to a guide, who then introduced me to his friend, who spent a month going to villages and making contacts before I came. All in all, I was lucky to have found the Wu family. They are exceptionally good-natured people — always telling jokes that I couldn't understand because of the dialect. Good nature is a necessity — life for the Wus means exploiting every scrap of opportunity that comes their way. The Big Picture was hard. The Chinese are packrats and we had three families' worth of stuff, so more and more things kept coming out. They balked at moving the father's closet down from the second floor, but I insisted and they took the thing apart to get it down. In addition, we had to cut down a tree, which gave me a twinge. Still, the Wus enjoyed the video I made while it was all happening. And I realized things had gone well when Ba Jiu, the father, urged me to settle in the village. He promised to find me a good house and a bride who would "cook, look after me, and give me children." A 17-year-old, no less. I declined, with regret.

A

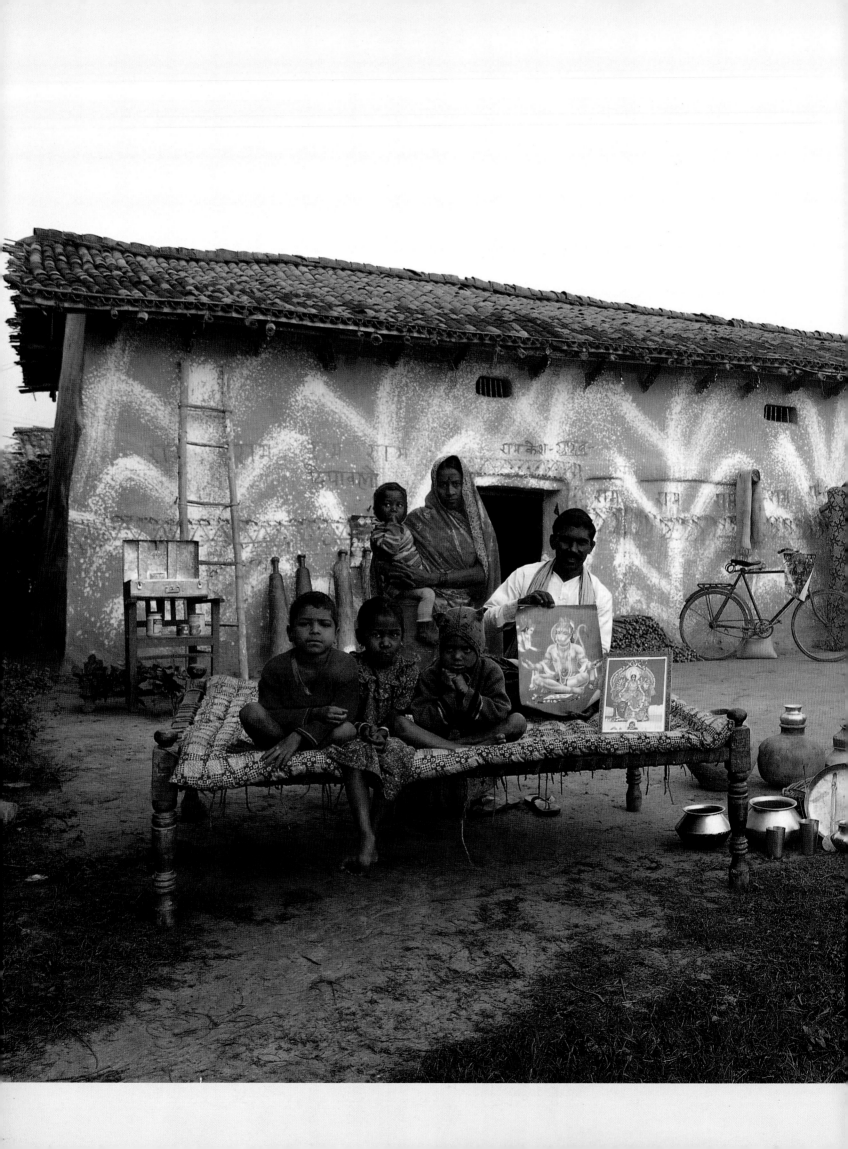

Fragmented Giant

The Yadav Family

7:30 A.M., FEBRUARY 2, 1994
AHRAURA VILLAGE, UTTAR PRADESH, INDIA

PHOTOGRAPHS BY PETER GINTER

KEY TO BIG PICTURE

1. Bachau Yadav, father, 32
2. Mishri Yadav, mother, 25
3. Bhola Yadav, son, 9
4. Guddi Yadav, daughter, 8
5. Manoj Yadav, 2nd son, 7
6. Arti Yadav, 2nd daughter, 2

OBJECTS IN PHOTO

(Left to right)

- Wooden chair
- Jars (3, contain spices)
- Metal case (contains family papers, pictures, valuables)
- Ladder
- Wooden weights (4, used for wrestling practice)
- Print (on wall by weights)
- Bed (under family, used as couch during the day)
- Pictures of Hindu gods (2, being held by family)
- Firewood (to right of door)
- Bicycle (broken)
- Hindu print (hanging on bicycle)
- Metal pots (7), glasses (2), trays (4)
- Ceramic pots (2, behind metal pots)
- Basket of crockery (between metal and ceramic pots)
- Basket (with rice)
- Bags of rice (3, harvested last season)
- 2nd bed (leaning against wall)
- Blankets (3, draped on 2nd bed)

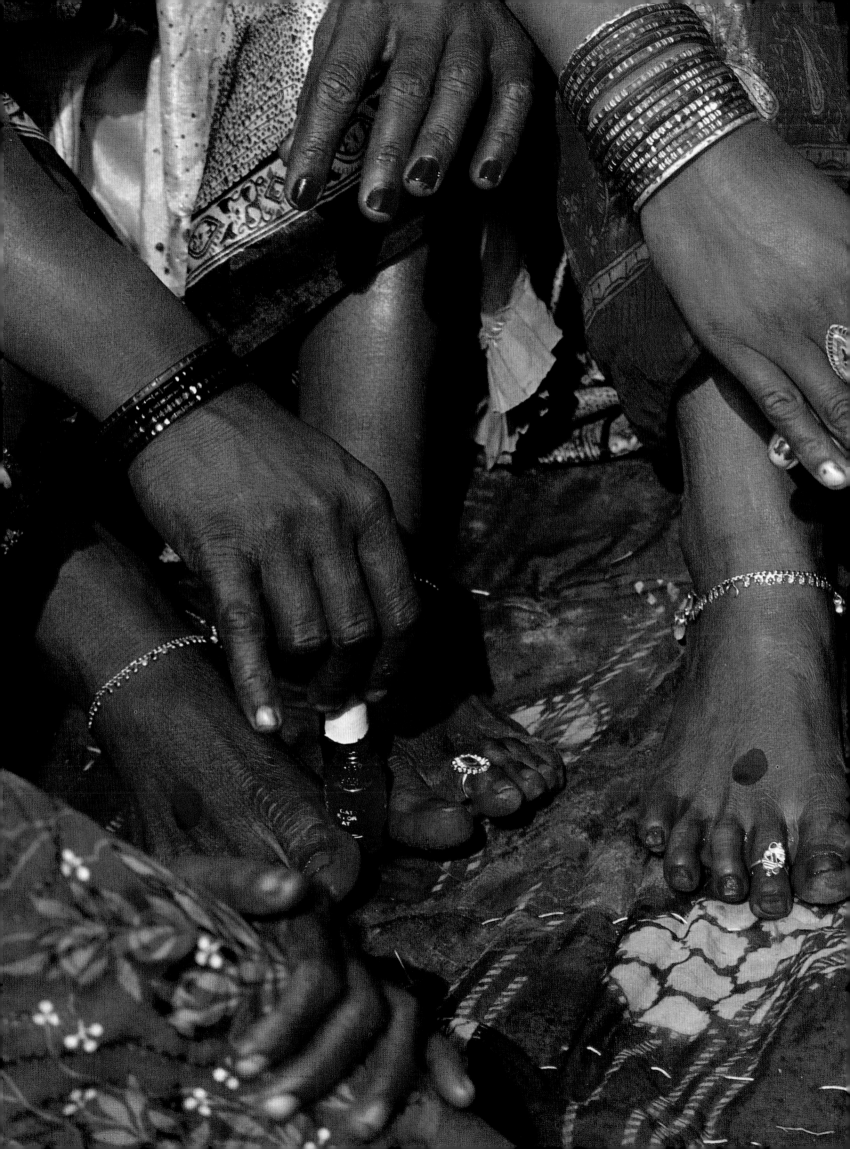

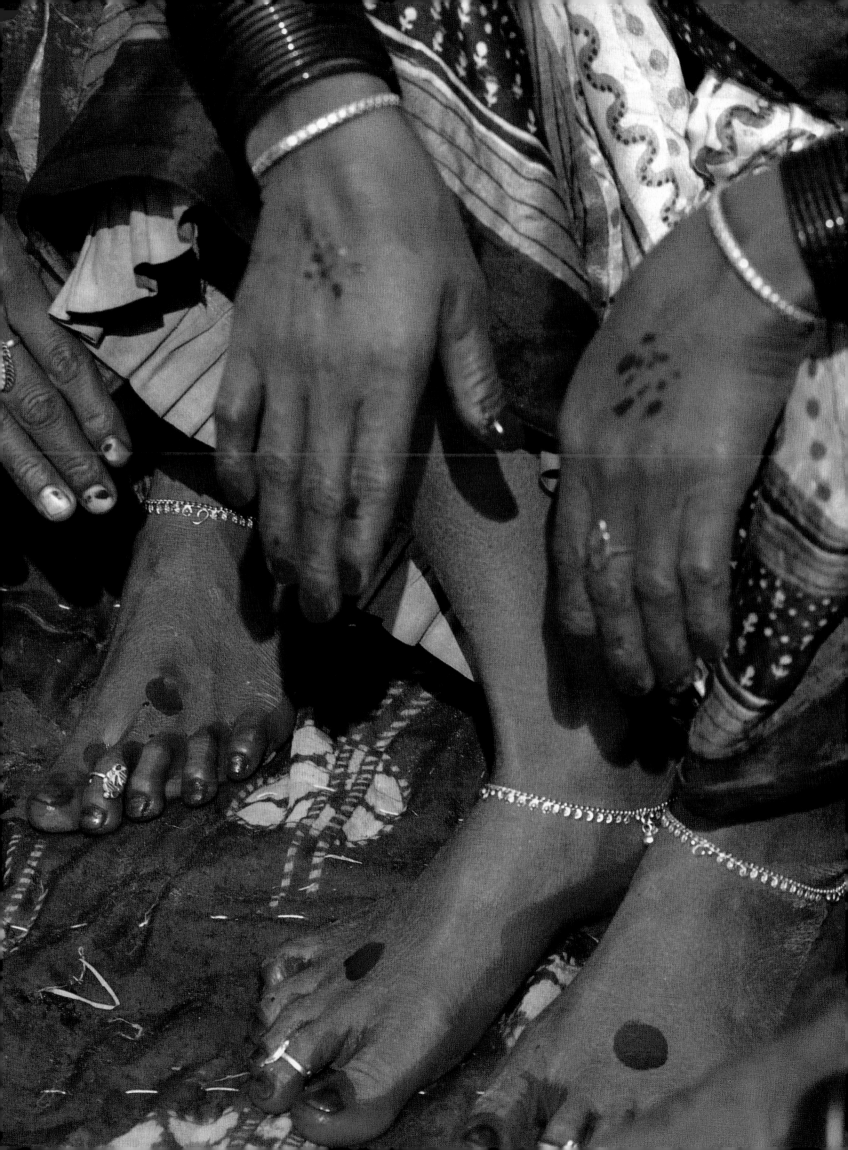

A

INDIA
BHARAT

STATS

Area
1,269,498 sq. mi.
(3,287,974 sq. km.)

Population
931 million

Population density
733.4 per sq. mi. (283.2 per sq. km.)

Total fertility rate
3.9 children per woman

**Ratio of abortion rates,
U.S. to India**
22 to 1

Population doubling time
37.1 years

Percentage urban/rural
27% urban, 73% rural

**Percentage of rise in food
production per capita between
1981 and 1992**
21%

**Percentage of population
without adequate nutrition in 1992**
40%

**Percentage of population
without adequate nutrition in 1972**
51.5%

Life expectancy
Female: 60, Male: 60

Literacy rate
Female: 34%, Male: 62%

**Rank of affluence
among the 183 U.N. members**
152

A crowded, ancient place, India is cut across by great rivers, especially the Ganges; more than 60 percent of its land is arable. These favorable conditions have ensured the subcontinent's attraction to foreign invaders. Aryans, Muslims, Portuguese, English — all wanted India. It was the centerpiece of the British Empire until Mohandas K. Gandhi began a program of noncooperation with imperial rule. Britain granted independence in 1947, but India immediately split into two parts, Hindu India and Muslim Pakistan (the latter subsequently splitting into two more nations, Pakistan and Bangladesh). The world's biggest foray into democracy, India has had to fight continuously against its own tendency to fragment into a mosaic of fighting peoples and creeds, all the while engaging in near-constant belligerency with Pakistan and battling to contain the world's second-largest population. Some successes have been achieved, though each has its paradoxical aspect. The nation that struggled to survive a famine in the 1960s now grows enough food to feed its people, but the inadequate distribution system means that occasional hunger is still widespread. The nation that was founded by an advocate of nonviolence now has the third-biggest army in the world. And, possibly most alarming, the nation whose natural abundance has attracted humans for thousands of years is now threatened by deforestation, water pollution, salinization of soil from overirrigation, and many of the other all-too-familiar ecological ills of poor nations.

D

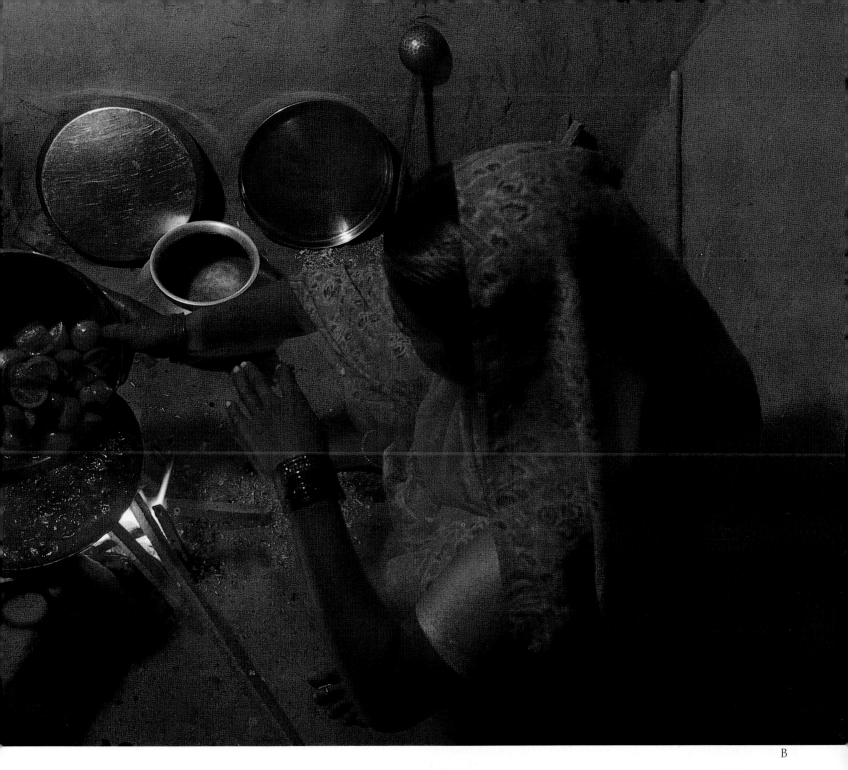

B

JUST AFTER DAWN is the time for visiting on slow winter days in the village of Ahraura, where the Yadavs live. Friends and neighbors congregate around Bachau and his son Bhola (*A, center*) in the living room. Mishri (*B*) cooks up a breakfast of tomatoes and rice in the 6' x 9' (2m. x 3m.) kitchen at the other end of the house. (Because the kitchen has no windows, it is much darker than it appears in this picture; the photographer used a flash and a 2-second time exposure.) Even in the off season, though, Mishri walks to the village market (*C*) every day. And Bachau's father, who lives in the family compound, must scatter fertilizer (*D*), handful by precious handful, through the irrigated rice fields.

PREVIOUS SPREAD: Mishri's workday runs from dawn to dusk seven days a week, but she can take a few moments in the afternoon to visit with friends. As they talk, the women paint their jeweled toes — both with the traditional dyes and the newer bottled nail polish.

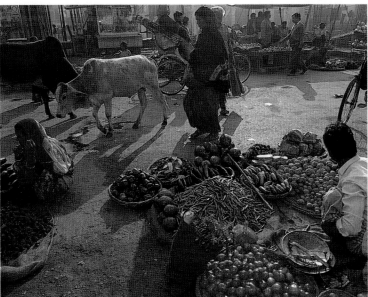

C

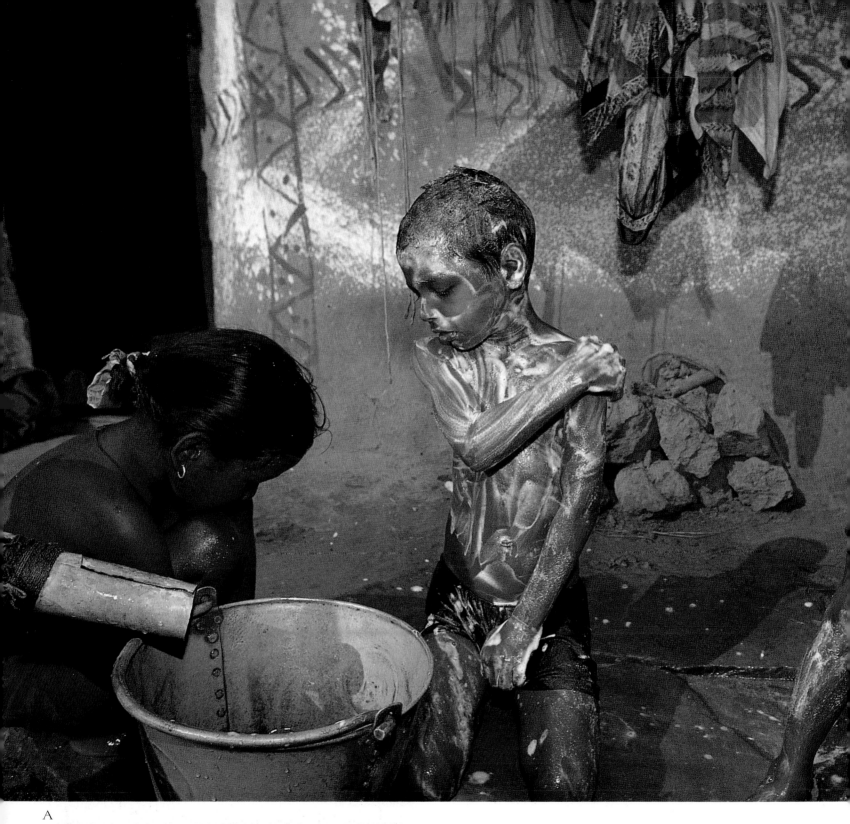

A

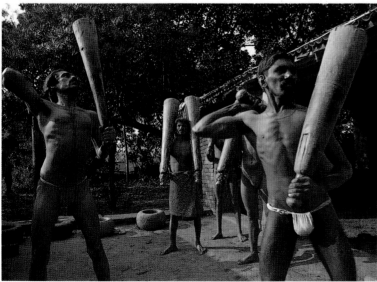

D

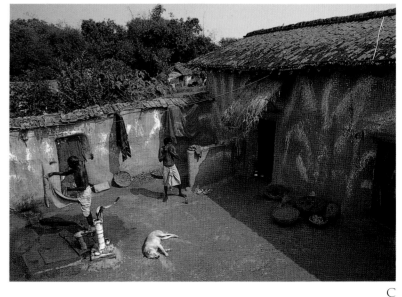

C

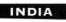

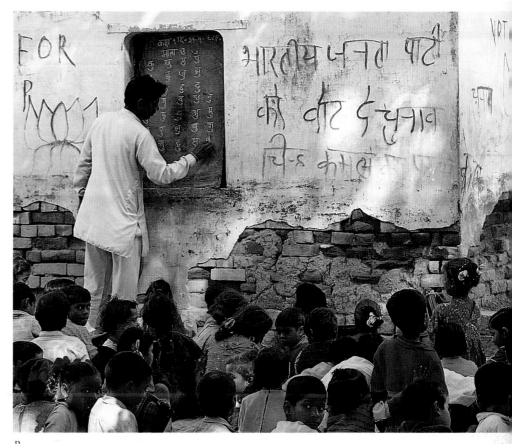

B

BEING CLEAN is essential to the family's image of itself. Every day before school, the three older children scrub themselves down with rough soap and water from the well (A, *spigot at left, over bucket*). After they leave, Bachau and his father take their turn (C); Mishri and the baby, who are last, finish by sweeping the courtyard. The school, a 4-minute walk away, is too small to accommodate all the children. As a result, all lessons are outside (B), in groups of 20 to 40. The younger children sit in the shade, while the older ones sit close to the blackboard, in the sun. The children, who have no books, write on slates. When the workload permits, Bachau, an enthusiastic amateur wrestler, visits the local wrestling club two or three times a week (D). A preferred training routine is to swing two 35-lb. (15-kg.) bats for a few minutes, take a break, and then swing them again, repeating as many times as possible.

YADAV FAMILY

Size of household
6

Size of dwelling
344 sq. ft. (32 sq. m.)

Workweek
56 hours (Father, when he can find work)
84 hours (Mother, all work inside home)

Number of
Radios: 0, Telephones 0, Televisions: 0, VCRs: 0, Bicycles: 1, Automobiles: 0

Most valued possessions
Print of Hindu gods seen in Big Picture (Father)
Sculptures of gods and goddesses of power and strength, who will protect family and home (Mother)

Per capita income ($US)
$330

Wishes for future
1 or 2 new cows for milk

PHOTOGRAPHER'S NOTES
PETER GINTER

Halfway through my visit I realized how big a chance the Yadavs took when they let me visit them. When I took pictures the neighbors came to watch, which brought in still more people, until poor Bachau was the center of a crowd. Eventually, a couple of people got mad at him about it — small-town life is the same everywhere — and a few stones sailed over the fence and into the yard. There was no damage, nor were there further incidents, but Bachau was rattled. Here he had agreed to help in an experiment in global cooperation and the people at home would have none of it. Because the Yadavs have no savings, they live from day to day. In bad times they sometimes go for two weeks without much food. "It's in the hands of God," Bachau told me. "There's nothing we can do about it." His life, he said, is better than his parents' lives, and that is probably enough. He was good-humored about the inevitable cultural misunderstandings my presence entailed. I kept getting up at the end of a meal to thank his wife, Mishri, for cooking it, as I would do at my home in Germany. Bachau would not accept that. And Mishri herself would hardly speak to me. She would talk to my sister, who came along to help, but not to me. I had to shoot the Big Picture twice, because the first time we had set it up Mishri left to go to the market, assuming that whatever Bachau and I were up to had nothing to do with her.

BHUTAN

Resisting Cultural Change

The Namgay Family

4 P.M., JUNE 7, 1993
SHINKA, BHUTAN

PHOTOGRAPHS BY PETER MENZEL

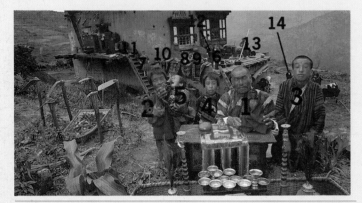

KEY TO BIG PICTURE

1. Namgay, father, 50
2. Nalim, mother, 47
3. Kinley, 1st son, 17
4. Bangum, 2nd daughter, 14
5. Zekom, 2, 3rd daughter
6. Sangaym, 29, 1st daughter
7. Sangay Khandu, 33, her husband (their children listed next)
8. Choeda, 9, their 1st daughter
9. Chato Namgay, 7, their 1st son
10. Sangay Zam, 5, 2nd daughter (on porch, near steps)
11. Chato Gyeltshen, 3, 2nd son
12. Tandin Gyeltshen, 2, 3rd son
13. Kinley Dorji, 61, mother's brother (unmarried)
14. Kado, 27, father's cousin, (visiting monk, on ground)

OBJECTS IN PHOTO

(Foreground, left to right)

- *Bumpas* (2, with peacock feathers, hold water in purification rituals)
- *Jeles* (2, double-reeded ceremonial clarinets)
- *Choeps* (14, metal bowls for water offerings)
- Book of Buddhist teachings
- *Chodom* (table used by visiting religious functionaries)
- *Troe* (on *chodom*, cast bronze ceremonial vessel)
- Statue of Nämtose, god of wealth (on *chodom*)
- Lamp (on *chodom*, uses butter as fuel)
- Shakyamuni Buddha statue with silk robe (on *chodom*)

(Left of family)

- Corn plants
- Hoes and cultivators (9)
- Basket for winnowing grain (with drying red peppers)

(Ledge on house, left to right)

- Basket and bag of rice (2)
- Ladder to attic (hewn from tree)
- Clay pot for water
- Pantry cabinet (left of door)
- Wind socks for temple decoration (3, hanging from rope)
- Storage chests (3, for clothes)
- Blankets (3, folded)
- Sewing machine (treadle type)
- Pig (tied under steps)

Porch (behind family, left to right)

- Rugs (5, for altar room)
- Wheat (for making bread and alcohol)
- Pitch fork (wooden)
- Butter churn and cooking pots (by 1st daughter)
- Storage baskets (11)
- Wood (being hewn with adz into yoke for bulls)
- Pumpkin

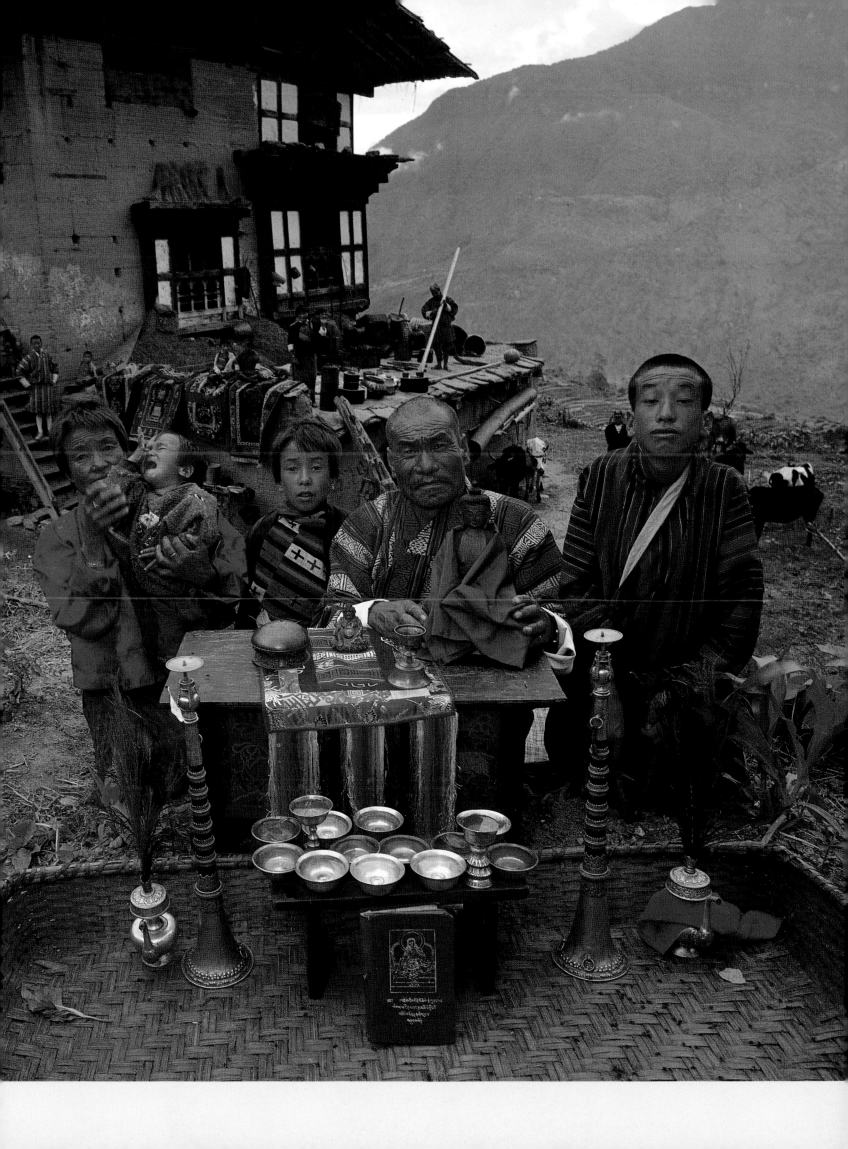

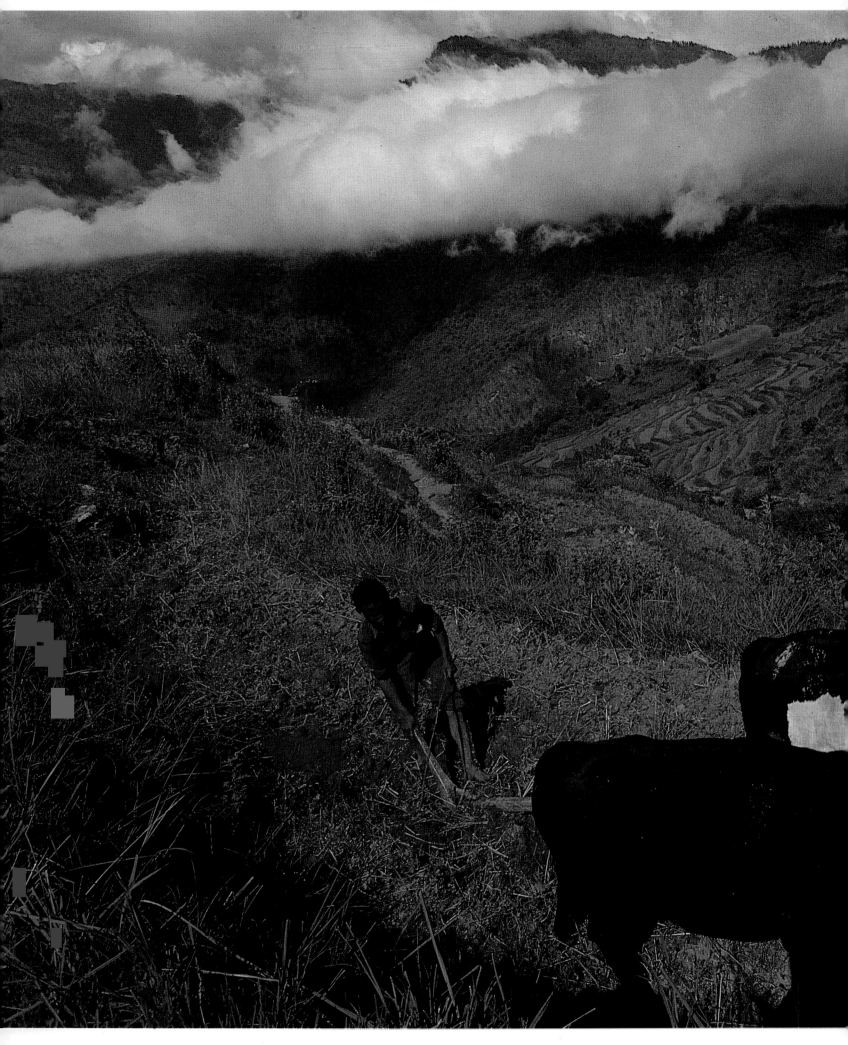

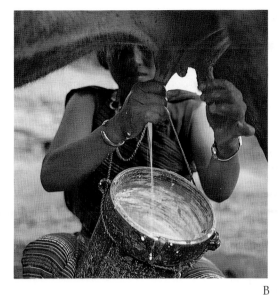

B

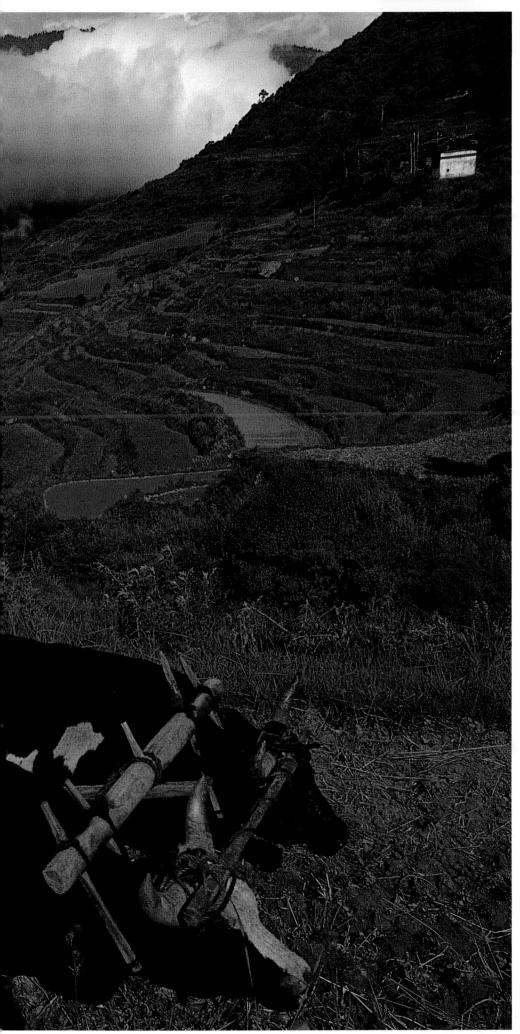

HUSBAND AND WIFE, Sangay Khandu and Sangaym, spend much of their day with the family cattle. One of Sangaym's morning duties is milking the cows into a wooden bucket *(B)*. Sangay Khandu uses the bulls to plow the field, readying it for rice planting *(A)*. He moves gingerly around the beasts, which are notoriously bad-tempered. The Namgay household owns 5 acres (2 ha.) of land, scattered in terraced strips through the hills, each strip being devoted to one crop: wheat, rice, chilies, or potatoes. The wheat harvest *(C)*, now in full swing, is assigned to the women. They take two long, dowel-like sticks, pinch a fistful of wheat heads between them, and then pull up, snapping off the heads. For long-term storage, they cut the whole stalk, bind it into elegant sheaves, and store the result in the attic, from where it is threshed little by little, as the family needs it.

A　　C

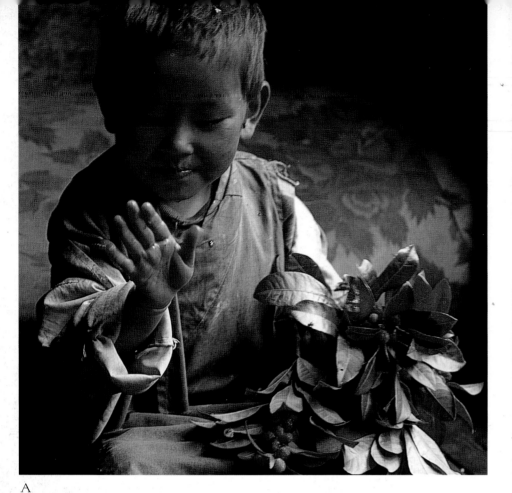

A

B

D

BHUTAN
DRUK-YUL

STATS

Area
18,147 sq. mi. (47,000 sq. km.)

Population
1.7 million

Population density
93.7 per sq. mi.
(36.2 per sq. km.)

Total fertility rate
5.9 children per woman

Population doubling time
30.1 years

Percentage urban/rural
6% urban, 94% rural

**Percentage of land
covered by forest**
59.7%

**Percentage increase in number
of cattle since 1980-82**
34%

Life expectancy
Female: 49, Male: 47

**Rank of affluence
among the 183 U.N. members**
174

Sandwiched between the Assam Plain of India and the crest of the Himalayan range in Tibet, Bhutan long avoided contact with foreigners. Only in the 1960s did King Jigme Dorji Wangchuk permit a road to be constructed from the Indian frontier. His son, King Jigme Singye Wangchuk, continued his policies, trying to modernize the economy while protecting its special, Buddhist-dominated culture from the West. It has been a delicate balancing act. Bhutan has restricted foreign visitors to 2,000 a year, prohibited Western clothing (on Bhutanese), and, to halt deforestation, set up many national parks. At the same time it created secular schools, developed irrigation to improve agricultural yields, and encouraged the development of a manufacturing belt along the Indian border. The result has been a startling upheaval in a country that had no currency — only a barter system — until the 1960s. Today most Bhutanese still live in small villages scattered through the nation's mountain valleys. By world standards, life expectancy is low; infant mortality is dismaying even by south Asian standards; the incidence of malaria, influenza, tuberculosis, and parasitic infections is high; and the nation's growing herds and rising demand for fuel threaten to strip its valleys bare. On the other hand, life is still dominated by traditional Buddhist monasteries, called *dzongs*. The sound of Tibetan horns and monk chants still hangs in the air — and will continue to do so, if the Bhutanese government can balance development, culture, and environment.

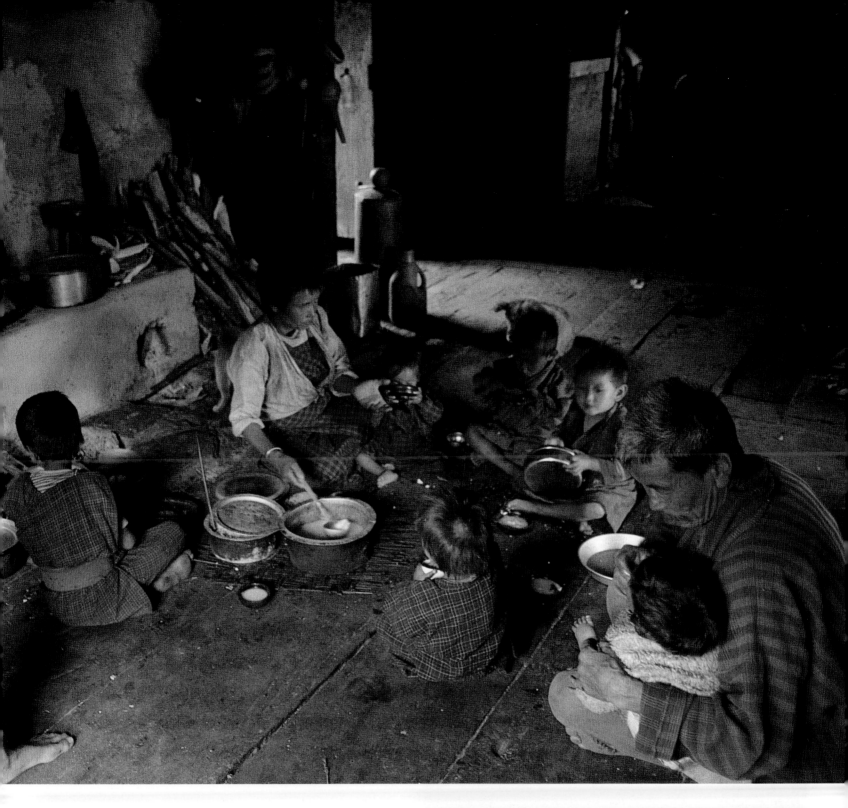

UNCLE KINLEY DORJI cuts firewood every morning in the hills. Almost always he brings back a treat for the children — in this case, berries for 3-year-old Chato Gyeltshen (A). Especially fond of the children, he has given up marriage to help with childcare. A typical task: feeding a weekend breakfast of sweet, thick rice soup to Tandin Gyeltshen, one of the 2-year-olds (B). His namesake and nephew, Kinley (standing at left), observes the jumble of children from the lofty distance of his 17 years. A student at a boarding school an hour's walk away, he is home only for weekends. After the meal is finished, Nalim — Kinley Dorji's sister and Namgay's wife — will plop the other 2-year-old, her son Zekom, into a hand-fashioned sling and work at the butter churn (C). The baby will watch alertly, then be put down for a nap. Because the animals live on the ground floor of the house, flies (D) are a constant nuisance. Perhaps more than a nuisance — they may help spread the skin diseases and diarrhea that afflict most members of the family.

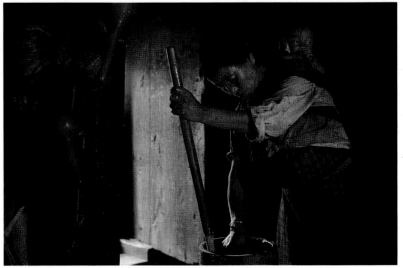

C

PHOTOGRAPHER'S NOTES
PETER MENZEL

For six days I lived with the Namgay family in a twelve-house village an hour's walk from a 7-mile dirt road off a small paved road four hours from Thimphu, the capital. The Namgays had never seen a TV, an airplane, or for that matter a live American before and were as curious about me as I was about them. I had dinner with a different family every night, the same basic good food that I ate gladly with one hand as my legs ached from sitting cross-legged on the floor. (My other hand fanned the flies from my food.) Wild marijuana grows everywhere, but villagers feed it to their pigs after boiling it. The sounds were incredible: women singing in the fields as they harvested wheat, the murmur of monks chanting, the squeal of children playing, all without the haze of electronic noise I have unfortunately come to take for granted. On the other hand, all was not paradisical. Animals and people excreted just outside the house and the family cooked inside on an open fire. The combination of smoke and flies was the worst I have seen anywhere. All the kids had diarrhea and runny noses, and most had some kind of skin infection. One night Karma Jigme, my interpreter, woke with bad chest pains at 3 a.m. I gave him aspirin though he said the pain was probably caused by an evil spirit. Yet the village seems to work as a place to live. Namgay, with his club foot, his hunchbacked son Kinley, his dwarf-like daughter Bangum, would be lost or socially savaged in most Western societies, but these sweet people belong in these mountains with their all-encompassing Buddhist beliefs.

NAMGAY FAMILY

Family size
13 (3 children, 1 married daughter with husband and 5 children, wife's unmarried brother)

Size of dwelling
3-story house
726 sq. ft. (67 sq. m.) living space, 1134 sq. ft. (105 sq. m.) basement/barn, 726 sq. ft. (67 sq. m.) storage attic

Workweek
49 hours (7 hours a day, 7 days a week for adults)

Number of
Radios: 1, Telephones: 0, Televisions: 0, Automobiles: 0

Most valued possessions
Religious book
(Father, Mother, 1st daughter)
Schoolbooks (1st son)
Jump rope (2nd daughter)

Per capita income ($US)
$174

Percent of income spent on food
16%

On clothing
33%

"EDUCATION is everything," says Namgay. But in the twelve-house village of Shinka, schooling is not always easy to acquire. Pressured by the need to help with the farm, his fourteen-year-old daughter Bangum is only now attending first-year classes at Kinley's school (A, *an English lesson, Bangum outside picture frame*). She is not alone in her plight: Kids in her class range from age 6 to 17, depending on when they were able to begin attending school. The school is an hour away; much closer at hand is the Shinka monastery, which each year holds a two-day ceremony (C) to bless the village in the coming year. To a continuous background of chanting, the monks fill the valley with long, slow, deep notes from their horns. The drum, in the center, tolls with a deep, resonant, almost ringing sound. Villagers come by, after washing their feet (B, *Sangaym using a gourd*), bow to the altar, and sprinkle water, a symbol of life, on the ground. When the monks are done, Shinka suddenly returns to normal, and for a while the village feels as fresh as if it had just passed through a spring rain.

C

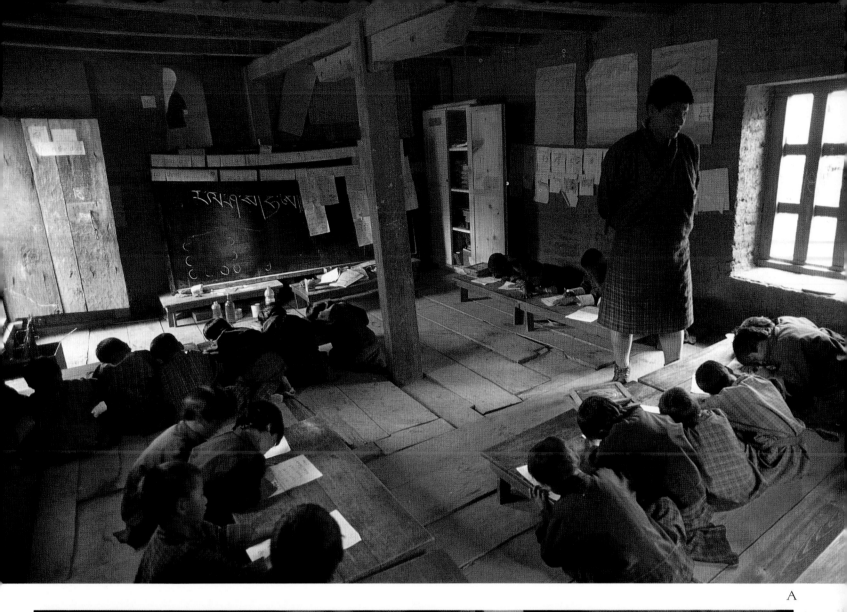

A

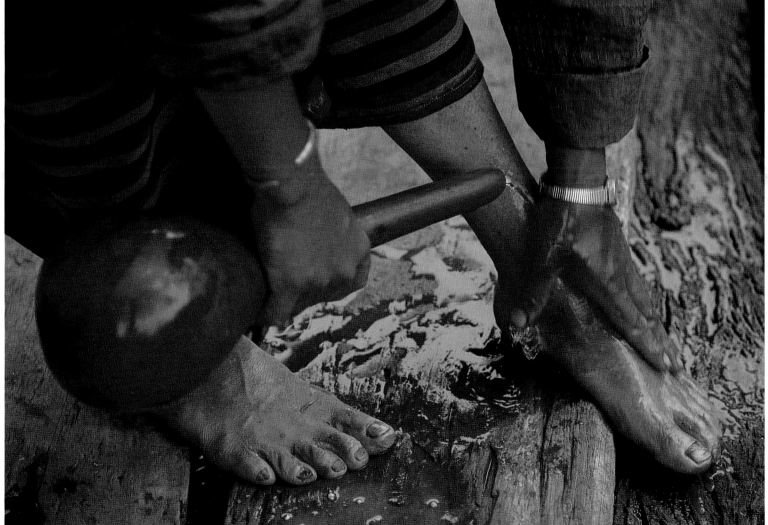

B

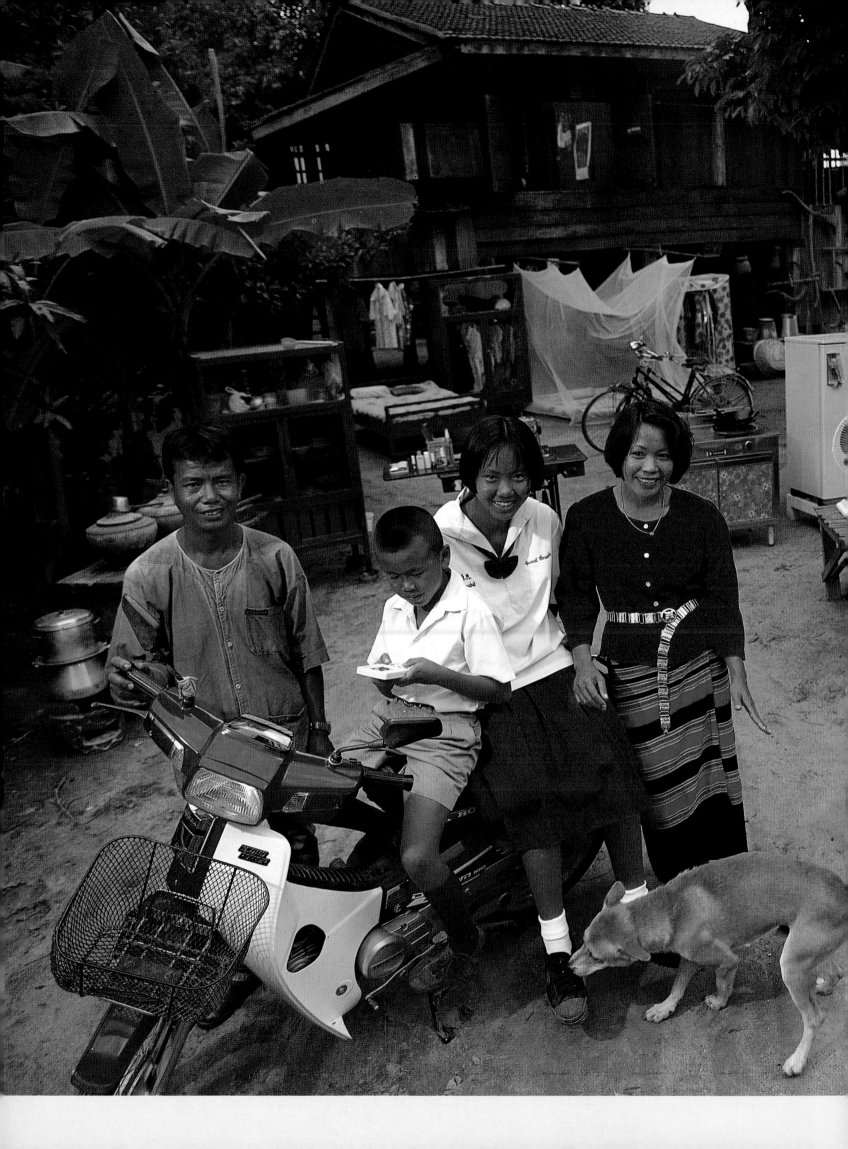

Buddha with a Walkman

The Kuankaew Family

5:30 P.M., MAY 31, 1993
BAN MUANG WA, THAILAND

PHOTOGRAPHS BY PETER MENZEL

KEY TO BIG PICTURE

1. Boontham Kuankaew, father, 39
2. Bourphet Kuankaew, mother, 36
3. Jiraporn Kuankaew, daughter, 14
4. Visit Kuankaew, son, 9
5. Vichai Sadub (Dang), father's brother, 37

OBJECTS IN PHOTO

(Clockwise from lower left)

- Motorscooter
- Hand-held video game (in son's hand)
- Ceramic cookpot (atop fire-pot)
- Ceramic water containers (2, with ladle)
- Banana trees (2)
- Screened food-storage cabinet (legs in bowls of insecticide to block ants)
- Plastic ladle (on cabinet)
- Parents' bed (with pillows)
- Clothes (hanging above bed)
- Wardrobe (with clothing)
- Electric sewing machine (behind daughter)
- Children's bed (with mosquito netting)
- Print (visible through window)
- Plastic hanging closet (with clothes)
- Children's bicycles (2)
- Gas stove (with wok)
- Wash basin and buckets (3)
- Ploughs, yokes, rice farming equipment (on wall)
- Water buffalo (2, held by father's brother, Dang)
- Rice field (in background)
- China cabinet (family portraits taped to door)
- Electric refrigerator
- Television (black-and-white, on stand)
- Ice bucket (below stand)

(On bamboo table)

- Electric fans (2)
- Electric iron
- Electric hair dryer
- Electric radio
- Electric hot plate
- Rice canister
- Portable cassette-tape player

(Foreground)

- Family dog (has no name)
- Chickens (under wicker cage)

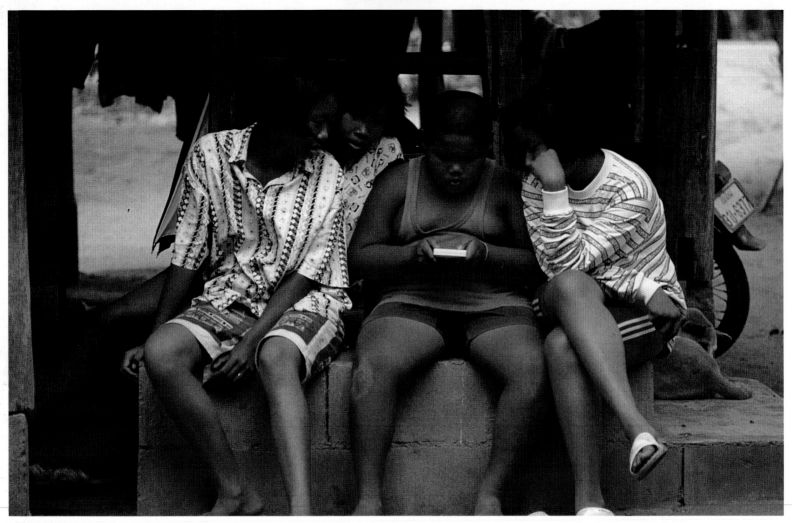

A

THAILAND
PRATHET THAI

STATS

Area
198,070 sq. mi. (512,997 sq. km.)

Population
58.3 million

Population density
294.3 per sq. mi.
(113.6 per sq. km.)

Total fertility rate
2.2 children per woman

Population doubling time
55 years

Percentage urban/rural
25% urban, 75% rural

**Percentage of forest lost
between 1981-90**
2.9%

Life expectancy
Female: 72, Male: 66

Infant mortality
26 per 1,000 births

Literacy rate
Female: 90%, Male: 96%

**Rank of affluence
among the 183 U.N. members**
87

While its neighbors in southeast Asia were torn apart by riot and invasion, Thailand remained relatively stable, quadrupling its GNP between 1970 and 1990. Its military governments pushed literacy up and infant mortality down. The human advance came at a heavy ecological price, though. Logging ransacked the nation's tropical forests while fishing consumed once-plentiful fish populations in the Gulf of Thailand. Bangkok swelled to about 9 million people and became choked with traffic, sewage, and pollution. Such trade-offs are common for Thailand, where the Buddhist monarchy opened itself to Western ideas in the 19th century and was overthrown as a result in 1932. Since then the army has usually held the reins, though the current government is civilian. Chuan Leekpai, chosen as premier after elections in 1992, faces daunting obstacles. Like other rapidly developing economies, Thailand must satisfy popular desires to increase incomes while channeling the means of satisfying those desires into areas that will not result in ecological collapse.

ON A SLOW SATURDAY in Ban Muang Wa, the hottest action in the village is behind the Kuankaews' porch (A). Three weeks before, Boontham and Bourphet gave 9-year-old Visit a hand-held video game, and the household has been filled with its beeps and buzzes ever since. Visit keeps it constantly in his hands, but when his parents summon him to help with the animals he is willing to let (from left) his sister Jiraporn, his best friend, and his sister's friend step in. The parents can hardly object to this new addiction — both Boontham and Bourphet have been caught game in hand, with their thumbs pumping away at the little red buttons. At the same time, Boontham and Bourphet do not take this as evidence of overwhelming Westernization. Their lives — like those of more than two-thirds of their fellow citizens — are dominated by traditional agricultural rhythms and the sounds of Buddhist chanting. In their home, and the homes of their neighbors, the most important image is not Luigi, from the Super Mario Brothers video game, but Buddha (facing page, a bas-relief from the Grand Palace in Bangkok).

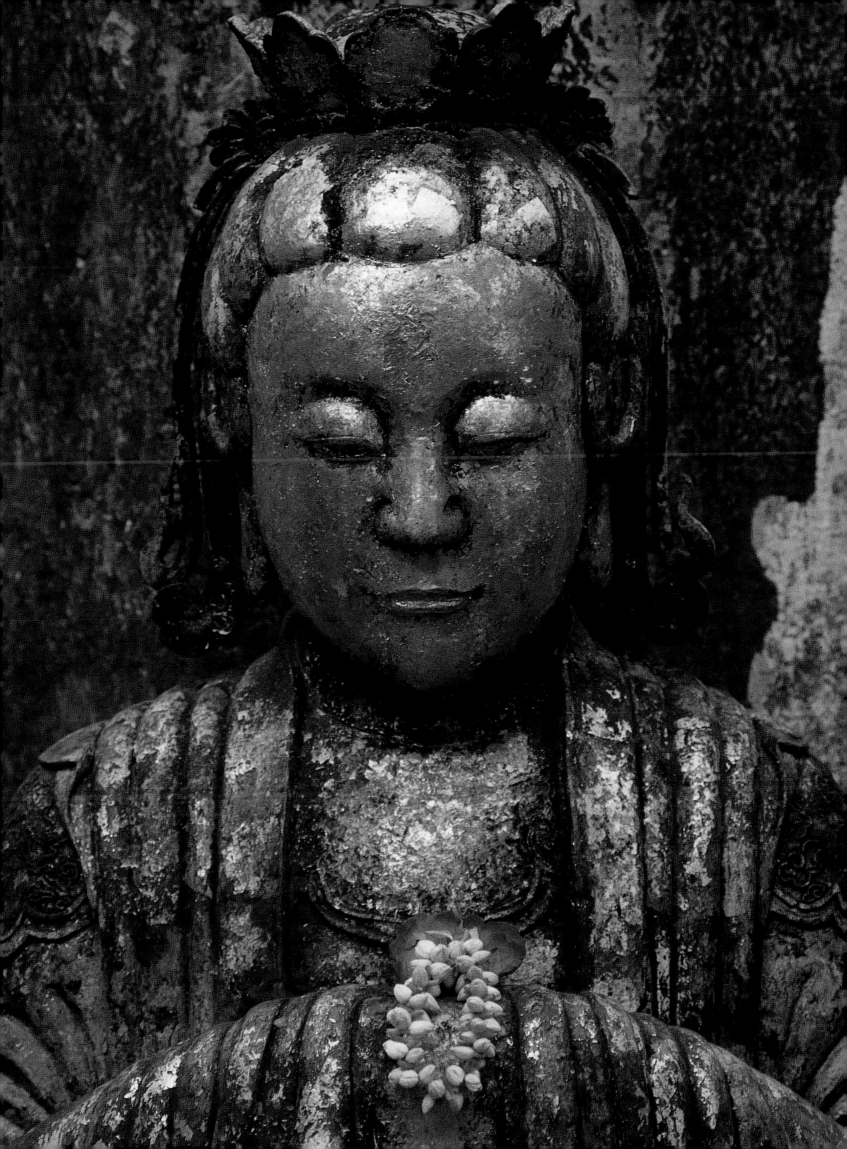

A

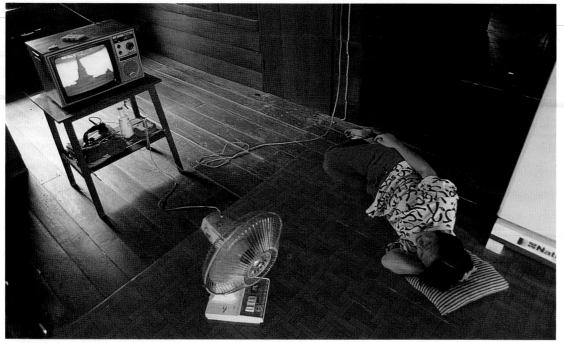

E

BEFORE THE RICE HARVEST, Boontham places an offering of cucumbers, red pork, bamboo-shoot stew, shrimp-paste dip, and rice before the old spirit house in his yard (*D*). Spirit houses are the abodes of the many spirits that Thais regard as integral parts of the land. Because the spirits have the power to cause trouble, Boontham periodically placates them by lighting candles, placing a good meal on a stool, sprinkling a little rice on the ground, and positioning some flowers on the spirit house. Meanwhile, his neighbors down the road are already at work. They cut the rice with a scythe, let it dry on the ground for several days, then bundle it into sheaves (*B*) with stalks of stiff grass. Because the Kuankaews' rice is not quite ready to harvest, the family has a little down time. Bourphet avoids the afternoon heat by dozing on the teak floor in front of the television (*E*), which is showing one of her favorite local soap operas. The rest is well earned: She has already spent the morning on the never-ending task of scrubbing the family clothes (*C*). Nine-year-old Visit is at school, working on his mathematics problems (*A*, *at left with two fingers raised*).

KUANKAEW FAMILY

Size of household
5

Size of dwelling
728 sq. ft. (68 sq. m.)
(2 bedrooms, living room,
basement kitchen)

Workweek
42 hours (Each adult — more
during the harvest)

Number of
Radios: 1, Telephones: 0,
Televisions: 1, VCRs: 0,
Motorscooters: 1

Most valued possessions
Motorscooter (Father, speaking for
family — "It gives us the convenience
of going anywhere we want, even
Chiang Mai")

Consumption of television
3 hours per day (Father)
5 hours per day (Mother)

Per capita income ($US)
$1,697

**Percentage of Kuankaew family
income spent on food**
77%

Form of birth control
Mother sterilized

Wishes for future
Stereo, color TV, automobile
(All to be financed by sale of rice field
adjacent to house)

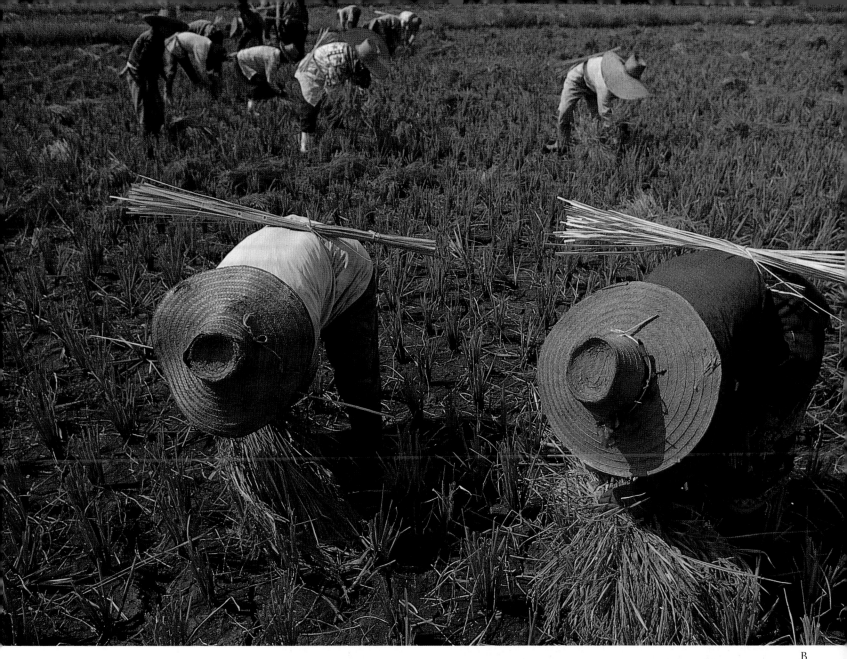

B

D

C

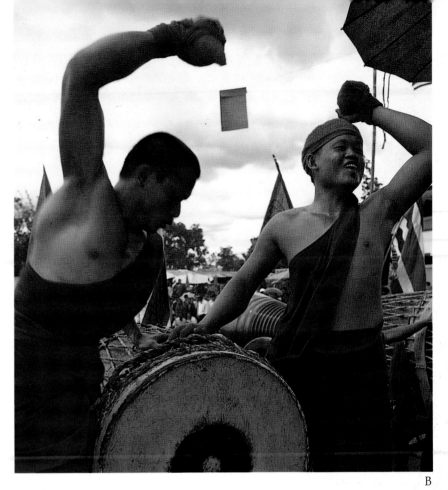

B

AFTER THE DEATH of the 72-year-old man who lived across the road from the Kuankaews, his family bought a castle-like, wood-and-crepe-paper bier and placed the body on top. Then the village held a two-day wake, complete with tents, music, gambling, and outdoor barbecues. Gifts were piled atop the casket. Afterward, the men carried the bier on long bamboo poles to the cemetery. The family posed for photographs in front of the bier, said good-bye to the dead man, and left the cemetery-keeper to burn the remains (A). A similar mixture of rowdy fun and serious purpose can be seen in the temple drumming contests (B) that the Kuankaews dote on, in which teams from as many as 30 local temples compete for honors in the middle of a bustling carnival.

PHOTOGRAPHER'S NOTES
PETER MENZEL

The Kuankaews see no contradiction between Buddhism and attempting to placate the possibly malevolent spirits of their land, a tolerant stance that seems to go along with the wonderful natural abundance of this country. I loved all the fruit trees in the Kuankaews' yard. Just around the house were bananas, coconuts, mangos, *lam-ohts* (which resemble big kiwis), jack fruit (huge pulpy things with a sticky fruit inside), and *rambutans* (which look like red-skinned lichee nuts). I was there for the first hard rain of rainy season, when inch-long red ants called *maeng man* emerge from their burrows for their mating flight. All the Kuankaews squatted in the steaming heat as the insects emerged, grabbing them just before they took off. There was an art to it — the ants are covered with tiny white baby ants, and the baby ants bite, so you have to shake them off quickly and drop the big ants into a bottle. Afterward, Bourphet stir-fried them. They had this great junk-food taste, like bits of fat that crunched in your mouth. The Kuankaews were really tickled that I helped them pick ants. I was the first foreigner they had close contact with, and at first everyone was cautious. My first two visits to Jiraporn's school were canceled when her shyness led to tears. The third time, I watched the flag-raising that begins the school day. A thousand kids in uniform lined up to hear the principal lecture them with a bullhorn. Then a gym teacher walked through with an electric hair-clipper. Any boy with hair longer than a crewcut got a hack job on the spot.

A

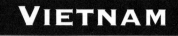

VIETNAM

Communist Free Market

The Nguyen Family

2:30 P.M., NOVEMBER 10, 1993
VIET DOAN, VIETNAM

PHOTOGRAPHS BY LEONG KA TAI

KEY TO BIG PICTURE

1. Nguyen Duy Ha, father, 33
2. Nguyen Thi Canh, mother, 31
3. Nguyen Thi Huong, daughter, 9
4. Nguyen Duy Hung, son, 7
5. Nguyen Thi Hai, daughter, 3 (trying unsuccessfully to blow up balloon)
6. Extended family (4 aunts, 4 uncles, grandparents, various children

OBJECTS IN PHOTO

(Clockwise from bottom left)

- Bicycles (2, 1 Vietnamese, 1 Czech)
- Pith helmet (on low wall)
- Insecticide pump sprayer
- Kettle (on wall by sprayer)
- Beds (2)
- Pigs (2), chicken, rooster
- Haystack (behind left bed)
- Bedding (on left bed)
- Slippers (2 pair, below bed)
- Wheels for cart
- Earthenware urn
- Tall metal pot
- Chair (partly obscured by fan blade)
- House (built by grandparents; land still owned by them)
- Desk with Huong and Hung's books (along house)
- Hoes, rakes, other farm implements
- Attached kitchen (directly behind the Nguyen family)
- Bamboo bench (family sitting on it)
- Sideboard with china behind glass doors
- Thermos (on sideboard, Chinese-made)
- Tea set (on sideboard)
- Electric fan (on sideboard, base wrapped in plastic)
- Ceiling fan (on sideboard, Chinese-made)
- Basket of miscellaneous china (behind fan)
- Serving trays (leaning against sideboard)
- Basket of pots, pans, and bowls
- Stools (2, one behind trays)

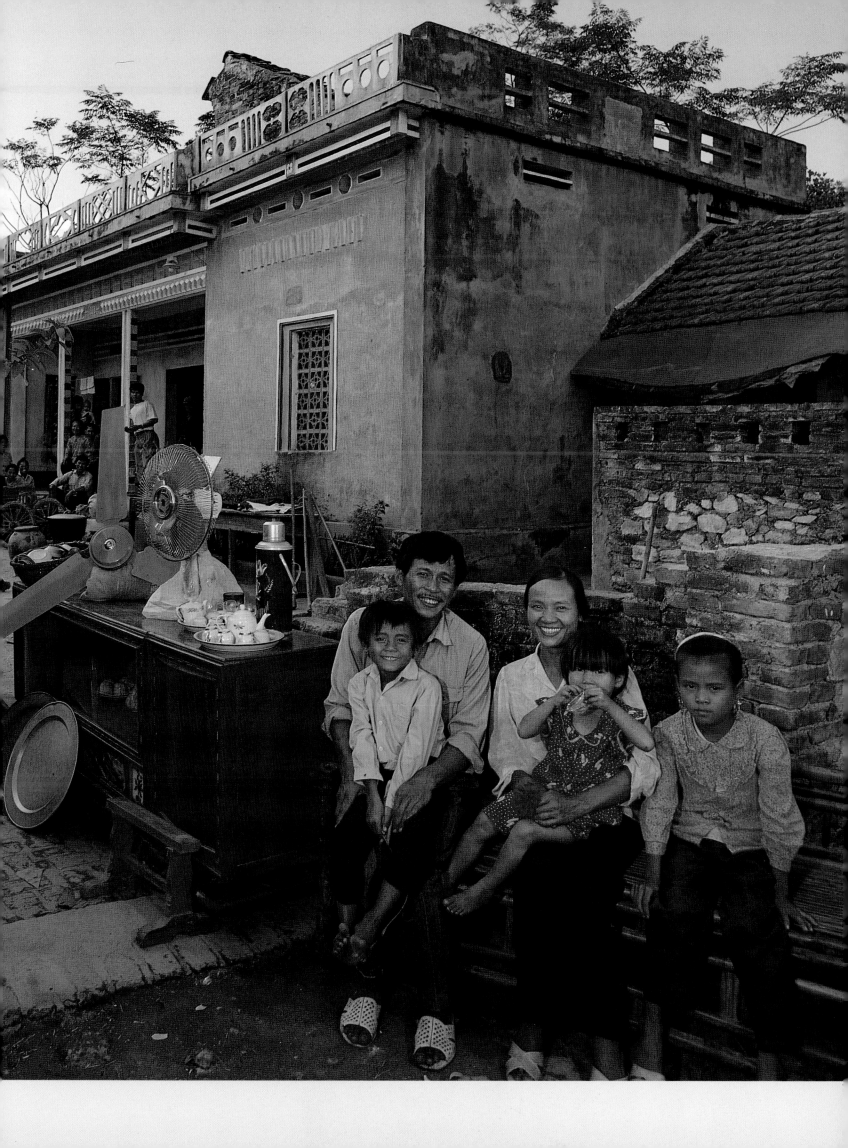

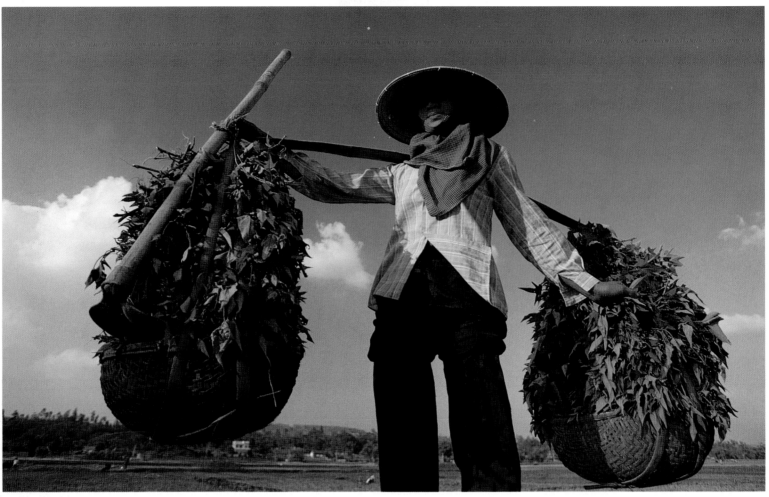

A

BECAUSE VIETNAM is at the edge of a time zone, dawn comes at an especially early hour. In the Nguyen household, children and adults both are up and dressed before 6:30 a.m. Before breakfast, the pigs must be fed, the eggs collected from beneath the laying hens, and the house straightened for the day. Breakfast is usually leftovers from the night before: eggs, pork, vegetables, and rice. The morning mist still hangs over the village of Viet Doan at 7:30, when Hung (*facing page, center*) leaves for 2nd grade. Huong's 4th-grade class begins half an hour later — enough time for her to piggy-back 3-year-old Hai to nursery school. After they leave, Ha goes to the rice paddies, checking the irrigation levels and talking about water schedules with the manager of the pump station. His wife Canh goes to another field on the commune with her baskets and hoe to harvest greens (*A*). Often she stays till 7:00 p.m., 2 hours after sunset during the wet season, knowing that Hung and Huong will take care of minding the toddler.

VIETNAM
VIET NAM

STATS

Area
127,400 sq. mi.
(329,963 sq. km.)

Population
73.8 million

Population density
579.3 per sq. mi.
(223.7 per sq. km.)

Total fertility rate
3.9 children per woman

Population doubling time
34.5 years

Percentage urban/rural
21% urban, 79% rural

Percentage of forest lost between 1981-90
1.4%

Life expectancy
Female: 69, Male: 64

Infant mortality
36 per 1,000 births

Literacy rate
Female: 84%, Male: 92%

Rank of affluence among the 183 U.N. members
165

After more than a century of violent turmoil, Vietnam seems ready to become the next Asian nation to explode with economic growth. At the same time, though, it will face huge challenges: suspicion from its neighbors; the region's fastest-growing population; and the staggering human and ecological toll of war. Its culture, a fusion of Indonesian, Thai, and Chinese traits, emerged 2,000 years ago, only to be overrun by China. Indeed, China controlled most of Vietnam for a millennium, despite constant rebellion. Independence came in 939 but Chinese incursion remained a perpetual threat and Vietnam was torn by dynastic feuds. France invaded in 1858. As ever, the Vietnamese resisted fiercely. In 1954, France left, humiliated by defeats from the Communist forces of Ho Chi Minh. In an attempt to stave off defeat, France and its allies bisected Vietnam, giving Ho the north and establishing a U.S.-backed republic in the south. When north invaded south, the United States joined the fray. The long brutal struggle that followed resulted in hundreds of thousands of deaths and huge ecological devastation. Vietnam was reunited under Communist rule in 1976. It soon sought dominion over its neighbors, taking over Laos, Cambodia, and bits of Thailand. In the 1980s international anger and domestic troubles led to a change of course. The U.S. opened commercial contacts with its former enemy in 1994. Foreign investment began to soar, and with trepidation Vietnam's neighbors awaited the creation of a new power that by A.D. 2025 will have the population of Japan.

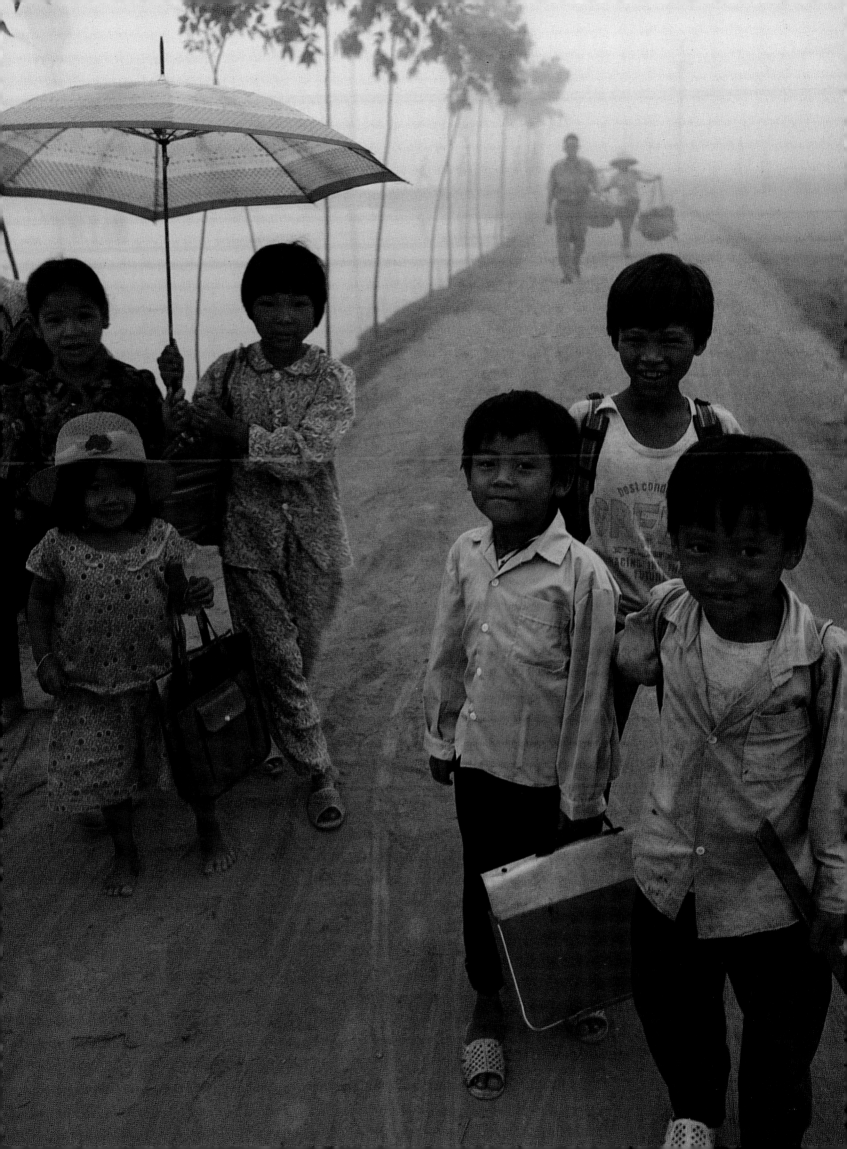

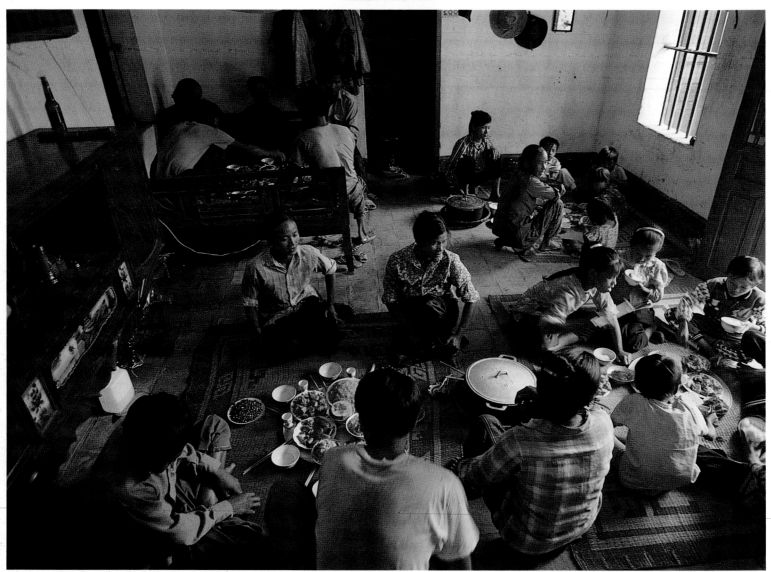

A

BEFORE THE BIG PICTURE, the Nguyens cook up a feast (A) for everyone in the extended family — a sizable gathering, as Ha is the youngest child in a family of four brothers and one sister. Early in the morning Canh (B, *light blue shirt*) has begun by soaking the vegetables and washing up, as Ha and Hai offer their services. Hours later, the meal opens with an offering by Ha's father to the family Buddhist altar (not shown). Then the women carry in five trays of food: one on the wooden bed for Ha, his brothers, and his mother (center of group); three on the floor for women, children, and adolescents; and a fifth (not shown) for Ha's father and the foreign guests. The room fills with cheerful voices, the clatter of the electric fan, and the smells of roasted peanuts, stir-fried chicken, deep-fried bean curd, home-made spring rolls, and, of course, rice. Like other communal farms, Phat Tich commune, where the Nguyens live, grows, harvests, and polishes (C) its own rice.

NEXT SPREAD: Although Vietnam is mostly Buddhist, many young couples choose on the big day to wear clothes that would not be out of place in any Christian church in Europe or the Americas. The ceremony itself, though, is not usually religious. Celebrated in a village about 7 miles from the Nguyens' house, this wedding blended in yet a third cultural strain — Marxism — as the local Communist party leaders met with the couple to congratulate them before the ceremony.

NGUYEN FAMILY

Size of household
5

Size of dwelling
860 sq. ft. (80 sq. m.)

Workweek
119 hours (Father, mother—17
hours a day; no holidays)

Number of
Radios: 0, Telephones: 0,
Televisions: 1 (shared with rela-
tives)

Most valued possessions
House (Father—"When you have a
good house, you have a good life")
Children's health (Mother)

Per capita income ($US)
$215

**Percentage of Nguyen family
income spent on food**
55%

Means of waste disposal
None (Family throws nothing away)

Wishes for future
A TV, a radio, new beds, a motor-
cycle. "These are only dreams,
though."

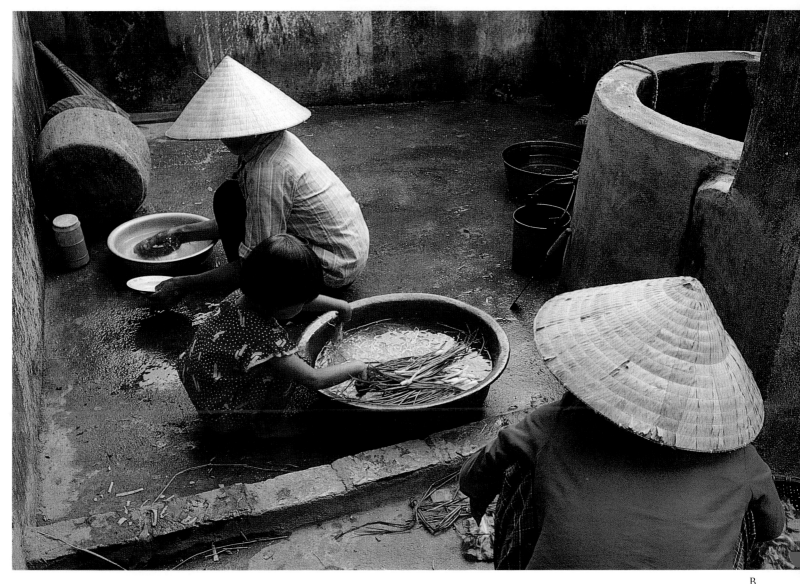

B

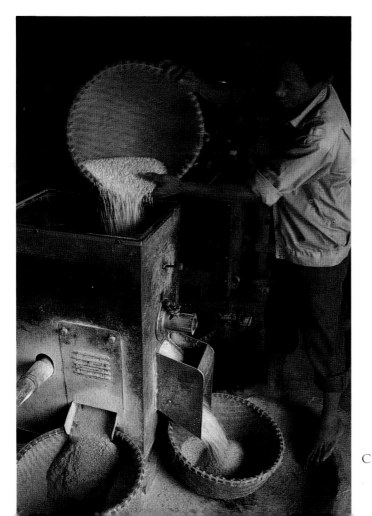

C

PHOTOGRAPHER'S NOTES
LEONG KA TAI

Hanoi felt like China in 1986 or 1987. The country was just opening to the rest of the world and was intoxicated with the possibilities of the future. It may work out better here than in China, because the country is smaller and the government less paranoid. Vietnam has the proverbial easy-going tropical attitude as against the uptight snow-bound northerners in China. Still, I got the full bureaucratic treatment when I went to Tien Son, about 15 miles outside Hanoi. Just like in China, I had to have tea with everybody. I ended up looking for my family as part of a group of ten! Eventually I found the right family. They work incredibly hard but were willing to take me on — except for one thing. The Nguyens have a field in front of their house that would have been perfect for the Big Picture. But Ha refused to move the furniture there. In this way I learned that in Vietnam it is considered extremely bad luck to move the beds through the front gate. It only happens in case of death or divorce. We decided to cram everything into the front yard. I invited everybody in the extended family so nobody would get jealous — it also made a good photo op. Then I drove them all crazy waiting for the sun to stop playing hide-and-go-seek in the clouds so the light would be right. I was sad to leave. The Nguyens are good, decent people. They don't have much and they know it. They are not necessarily content, but they accept and make the best of it. At the end, Ha's sister-in-law offered me her baby, to take back with me to my home in Hong Kong. Then the local obstetrician told me that Quin, considered the pretty girl of the village, wanted to come, too. Instant family!

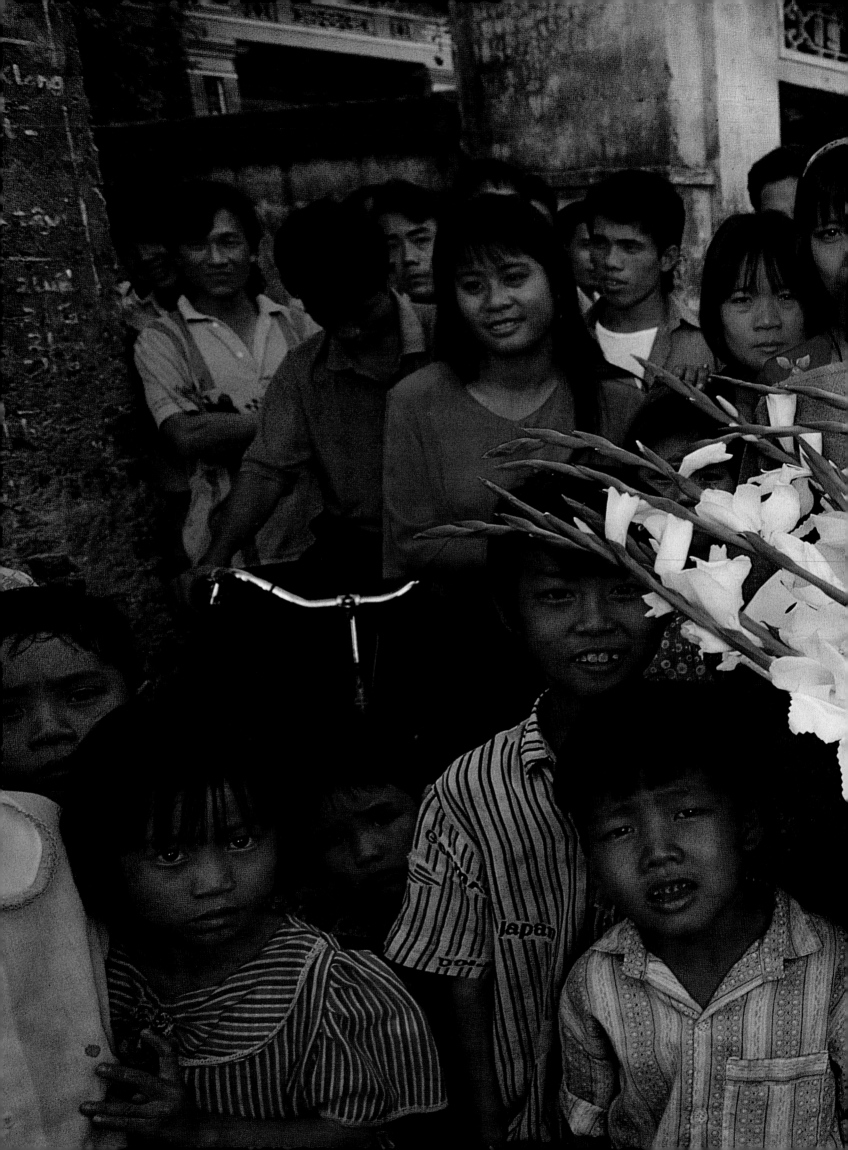

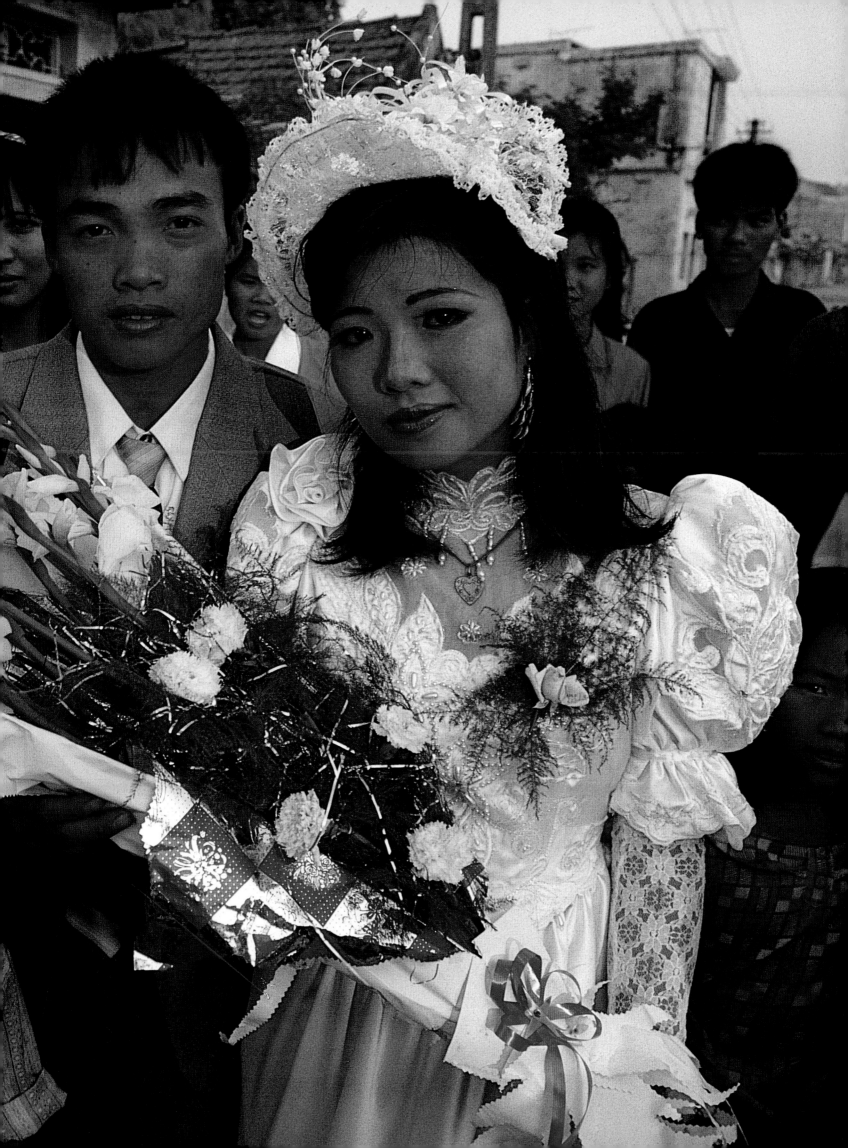

UZBEKISTAN

An ancient place but a new nation, Uzbekistan is flat and arid. Most people live in a long, winding tongue of land that curls into the Fergana Valley. Located between the high Tien Shan and Gissar-Alay Mountains, the Fergana Valley is among the more fertile and populous areas in central Asia, and a center of Sunni Islam. Indeed, modern Uzbekistan is the descendent of a series of Islamic kingdoms that traced their origin to the empire of Genghis Khan. These had declined by the 19th century, leaving Uzbekistan split among weak, feuding principalities. Russian armies easily moved in, capturing the capital, Tashkent, in 1865, but the czar's rule had little long-term impact. By contrast, the effects of the Soviet revolution in 1917 were seismic. After the area was incorporated into the new Soviet Union Lenin pushed the area's small farmers into big collective farms that grew cotton for export. This created a big industry — Uzbekistan became the world's third-largest source of cotton — but disastrously lowered overall agricultural productivity. Because the profits went to Moscow while the declines in productivity stayed at home, Uzbekistan was impoverished. Worse, the cotton industry's overuse of fertilizers, defoliants, and irrigation damaged soils and watersheds throughout the area. Indeed, irrigation drained so much water from the Amu Darya River that the loss actually began drying up the Aral Sea, which is on Uzbekistan's northwestern edge. When the Soviet government collapsed in 1991, Uzbekistan declared its independence. Elections at the end of that year gave the presidency to the former Communist leader, Islam Karimov. He ended Soviet restrictions on Islam, but cracked down on religious militants. Karimov announced plans to exploit his nation's great mineral wealth, but this will be no easy task in a nation beset by internal strife and under international attack for its record on human rights and the environment.

Legacy of Lenin

The Kalnazarov Family

2:00 P.M., DECEMBER 5, 1993
OUTSIDE TASHKENT, UZBEKISTAN

BIG PICTURE BY LOUIS PSIHOYOS
AND JOHN KNOEBBER

DAILY LIFE PHOTOGRAPHS BY SCOTT THODE

KEY TO BIG PICTURE

1. Serik Kalnazarov, father, 44
2. Saliha Kalnazarov, mother, 40
3. Usen Kalnazarov, 1st son, 19
4. Bakhit Kalnazarov, 2nd son, 18
5. Assiya Kalnazarov, 1st daughter, 17
6. Zulphiya Kalnazarov, 2nd daughter, 14
7. Akhmediar Kalnazarov, 4th son, 9
8. Makhsud Kalnazarov, 3rd son, 12

OBJECTS IN PHOTO

(Clockwise from lower left)

- Dogs (2, 1 held by 4th son, 1 not shown)
- Chests for quilt and rug storage (4, beneath quilts and rugs)
- Quilts and rugs (29, on top of chests)
- Winter house (to left, behind tree)
- Summer house (behind main house, with white wall visible)
- China cabinet (beneath eaves, with china)
- Armoire (beneath eaves, contains more quilts)
- Dining table (with table settings)
- Chairs (4)
- Butter churn (behind table)
- Barn (with hay in hayloft)
- Cow
- Bicycle (behind cow, leaning against barn)
- Rugs (4, 1 in front of family)
- Bed (brass, with quilts, cover)
- Pillow

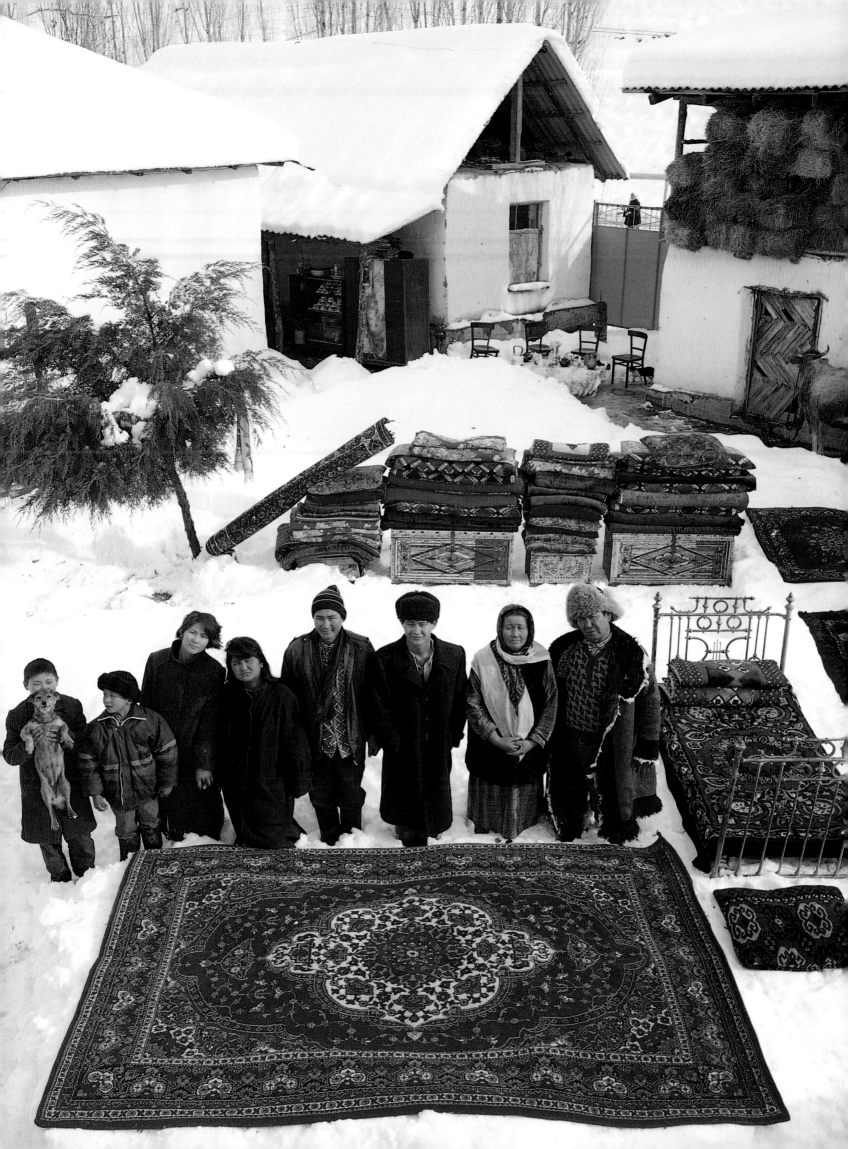

A

D

B

WORK NEVER STOPS in winter for the Kalnazarov household. Saliha often begins the morning by making bread, carrying the loaves (A) to the main kitchen in the family compound. The stove, made from stone, is shaped like a dome. A wood fire burns on its floor; Saliha sticks the loaves to the ceiling, and peels them away when they are cooked. The children, too, are pressed into service when not at school. Seventeen-year-old Assiya chops wood; 14-year-old Zulfiya watches the animals; and 12-year-old Makhsud (B), daydreaming his way through the day, distractedly pitches hay from the hayloft into the mangers of the waiting beasts below. After a few hours of this, a meal (C) is welcome. A typical menu: rice *pilau* with liver and vegetables, tomatoes canned by Saliha the previous summer, bread made by Saliha that morning, tomato juice, and tea. In the winter, the family moves to the smaller, heated house in the compound. Because it has just two rooms for eight people, the sexes sleep separately, men in one room (D), women in the other. Upon waking, they roll up the quilts, exposing brilliantly patterned carpets.

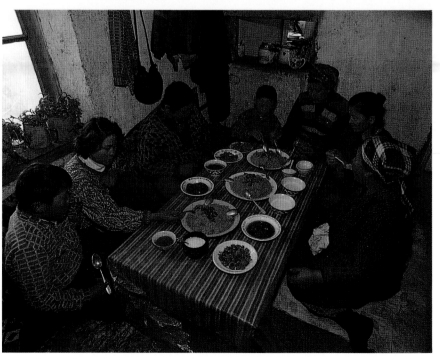

C

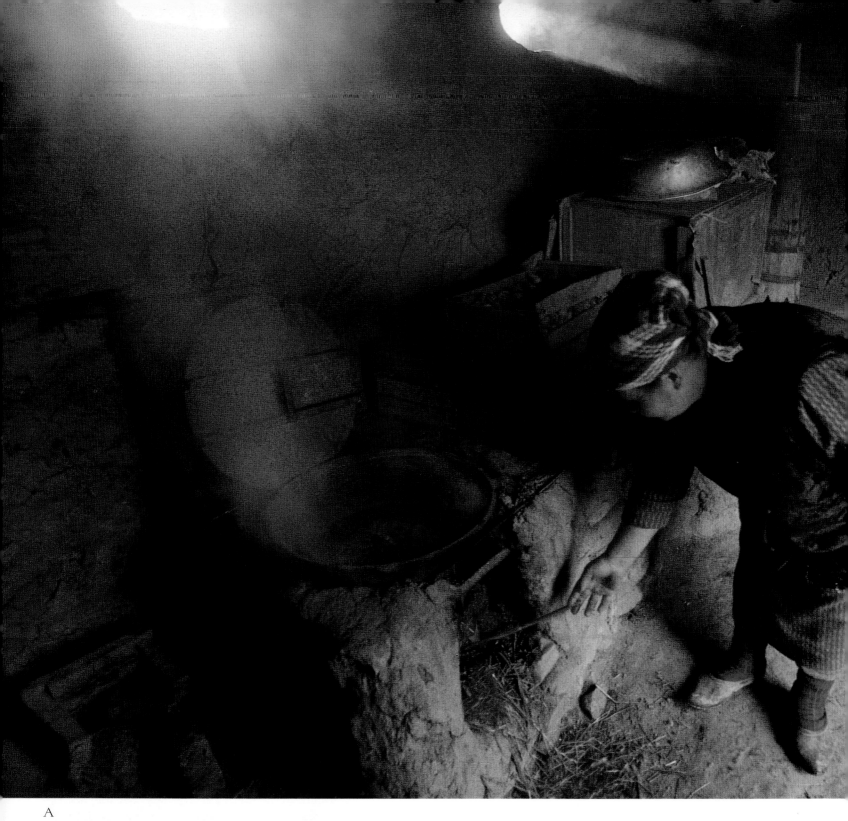

A

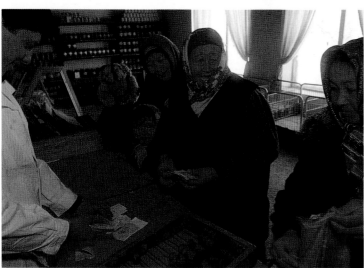

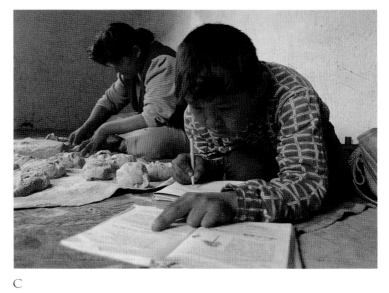

D C

THE KALNAZAROVS live in three places: a small, heated winter house with two rooms; a bigger, unheated summer house with four rooms; and a separate kitchen building that contains the bread oven and a stove (A, *being lighted by mother Saliha*). Whatever the family cannot grow itself must come from the local store, an establishment that Saliha (D, *at counter*) views with suspicion. Much of the canned food is long expired; the best goods are sometimes kept beneath the counter for favored customers. Still, she and her husband Serik believe that the future will be brighter — that while they work at the collective farm, their children will acquire the education necessary to have more affluent lives. Getting that education is sometimes a struggle. The school is tough in many ways for the children. It is unheated, and on especially cold days Akhmediar (B, *standing*) has to wear his coat and gloves indoors. And combining schoolwork and farm chores is not easy for Makhsud, who finds himself finishing his last problems while his sister Assiya kneads the morning bread dough (C).

NEXT SPREAD: A common Uzbek version of polo — one rider drapes a sheep over his pony, and his friends try to remove it.

PHOTOGRAPHER'S NOTES
SCOTT THODE

KALNAZAROV FAMILY

Size of household
8

Size of dwelling
1,000 sq. ft. (93 sq. m.)
summer house, 600 sq. ft. (56
sq. m.) winter house

Workweek
48 hours (Father)
48 hours (Mother)

Number of
Radios: 0, Telephones: 0,
Televisions: 1 (broken),
VCRs: 0,
Automobiles: 0

Most valued possessions
None (Father, Mother)
Bicycle (3rd son, 4th son)

Bathing arrangements
Collective bath 1 mile (2 km.)
away, open two days a week
for each sex; bucket of snow
(for washing hands between
baths)

Per capita income ($US)
$978

**Percentage of Kalnazarov
family income spent on food**
70%

Wishes for future
New TV, radio, VCR, car

Flying here from Russia was a shock. Despite its relative affluence, Moscow seemed bleak in spirit, whereas Tashkent was poor but full of warmth. The Fergana Valley is beautiful, with the surrounding mountains jumping up everywhere you look. Life is split between worlds — cars and buses whiz by women carrying water and men in donkey-drawn carts. The Kalnazarovs have a poster of Arnold Schwarzenegger but that's about it for their contact with Western Capitalism. When they saw my business card, they asked what a fax was. They are not Uzbeks but Kazakhs, a minority group here. In that way they're not typical, though socioeconomically they are average. In other ways the Kalnazarovs are remarkable. They were constantly busy: cutting wood, feeding cattle, getting water from the well across the road, walking to the collective bath a mile away. Saliha is incredibly hard-working. I didn't see one minute of down time. No, there was one — she just put her head in her hand and sat for a moment. Then she was stirring, cooking, picking something up, ordering one kid or another to do something. On the last day it snowed. When we drove up to the Kalnazarov house on Lenin Street a gossamer white blanket covered the yard and trees. What had been a field of mud was as beautiful as anything I'd ever seen.

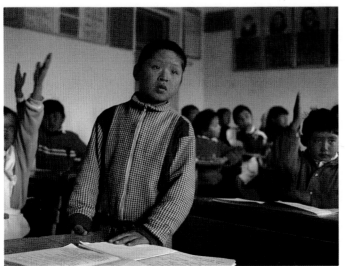

B

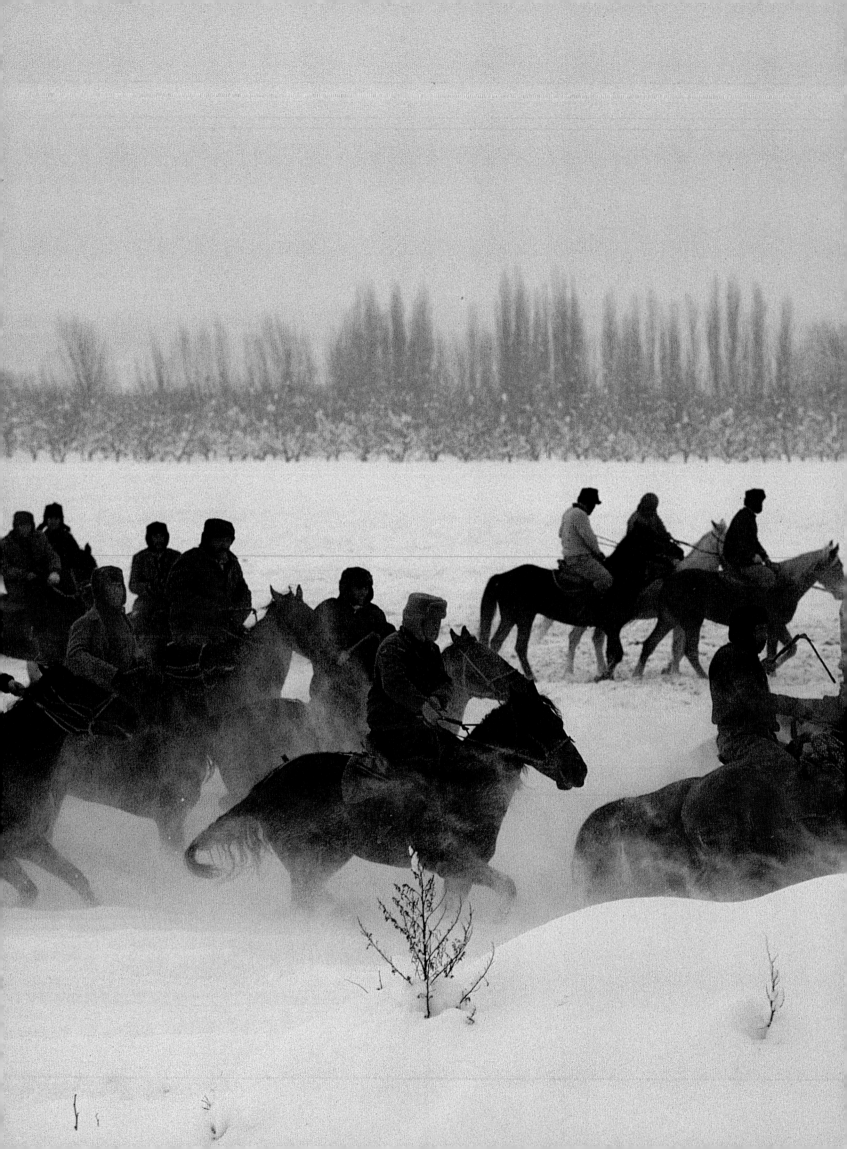

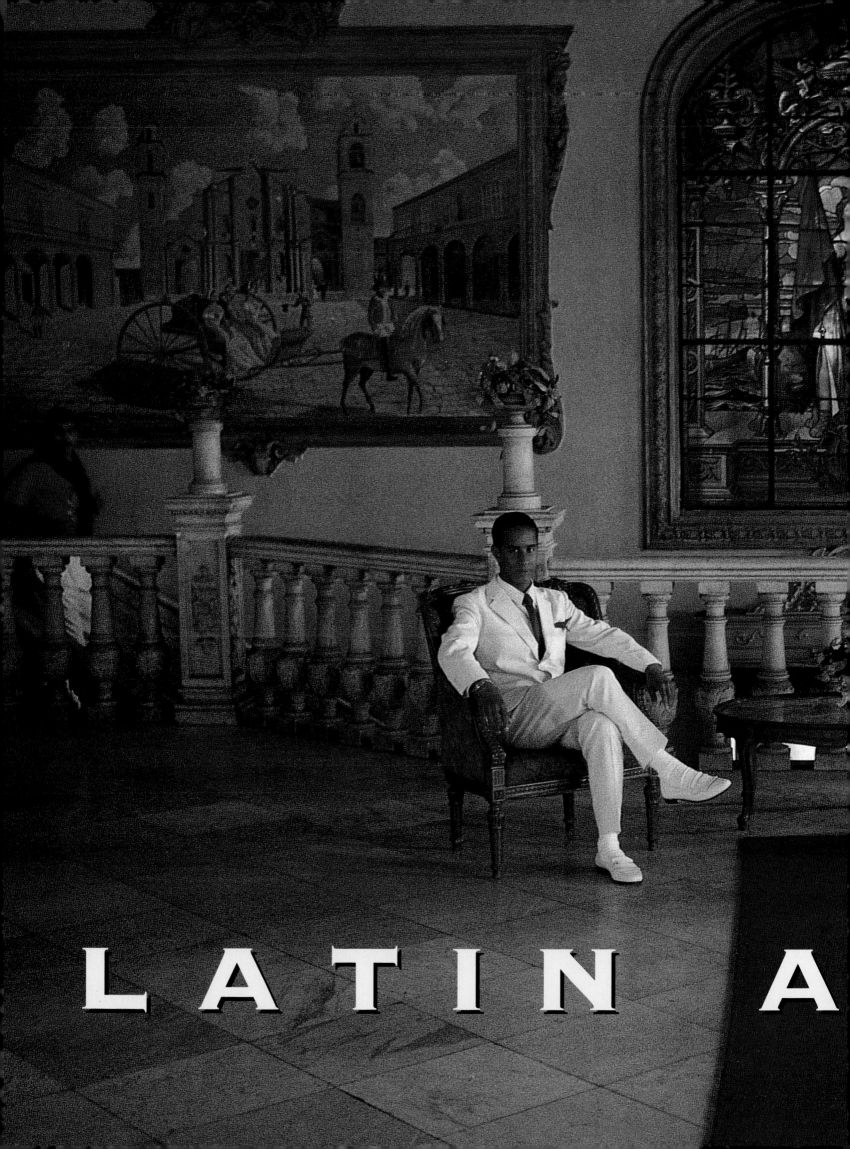

LATIN A

MERICA

PALACIO DE MATRIMONIO
(GOVERNMENT WEDDING CENTER)
HAVANA, CUBA
PHOTOGRAPH BY PETER MENZEL

Cuba Libre?

The Costa Family

3:30 P.M., JANUARY 23, 1994
HAVANA, CUBA

BIG PICTURE BY PETER MENZEL

DAILY LIFE PHOTOGRAPHS
BY PHILLIPPE DIEDERICH

KEY TO BIG PICTURE

1. Euripides Costa Cairo, father, 75
2. Angelina Allouis Gallert, mother, 65
3. Eulina Costa Allouis, daughter, 35
4. Iris Garcia Costa, her daughter, 7
5. Jesus Javier Garcia Costa, her son, 8
6. Montecristi Garcia Moreira, her husband, 40
7. Sandra Reymond Mundi, son's wife, 31
8. Ramon Costa Allouis, son, 32
9. Lisandra Costa Reymond, their daughter, 8

OBJECTS IN PHOTO

(On porch, left to right)

- Televisions (2, on cabinet)
- Stereo and speakers (on TV)
- Photograph of Castro
- Green metal cabinet
- Refrigerator (with vase)
- Lantern (used in blackouts)

(On sidewalk, left to right)

- Neighbors (5)
- Potted plants (2)
- Dogs (2, chained to weight)
- Portraits of children (3)
- Chairs (3, one rocking chair)
- Table (with burner and pot)
- 2nd refrigerator (with pitcher and glasses)
- Mirror
- Potted plant
- Bicycles (4)

(On street, foreground to rear)

- Rocking chairs (2)
- Sofa
- Pulled plants (2, by sofa)
- Kitchen table, chairs (4, and place settings)
- End table (with flower pot)
- Ironing board and iron
- Sideboard (with glass swans and plastic flowers)
- China cabinet (with blender)
- Sewing machines with tables (2, one electric, one treadle)
- Rectangular table with chairs and place settings
- Loveseat (behind sewing machines)
- Bed with nightstands (2)
- Electric fans (2, on night-stands)
- Portable radio/cassette player (on bed)
- 2nd kitchen table with plastic chairs (3)
- Children's beds (3, with dolls)
- End tables (2, with lamp and radio/tape player)
- Electric fan
- Plastic and aluminum rocking chairs (4)

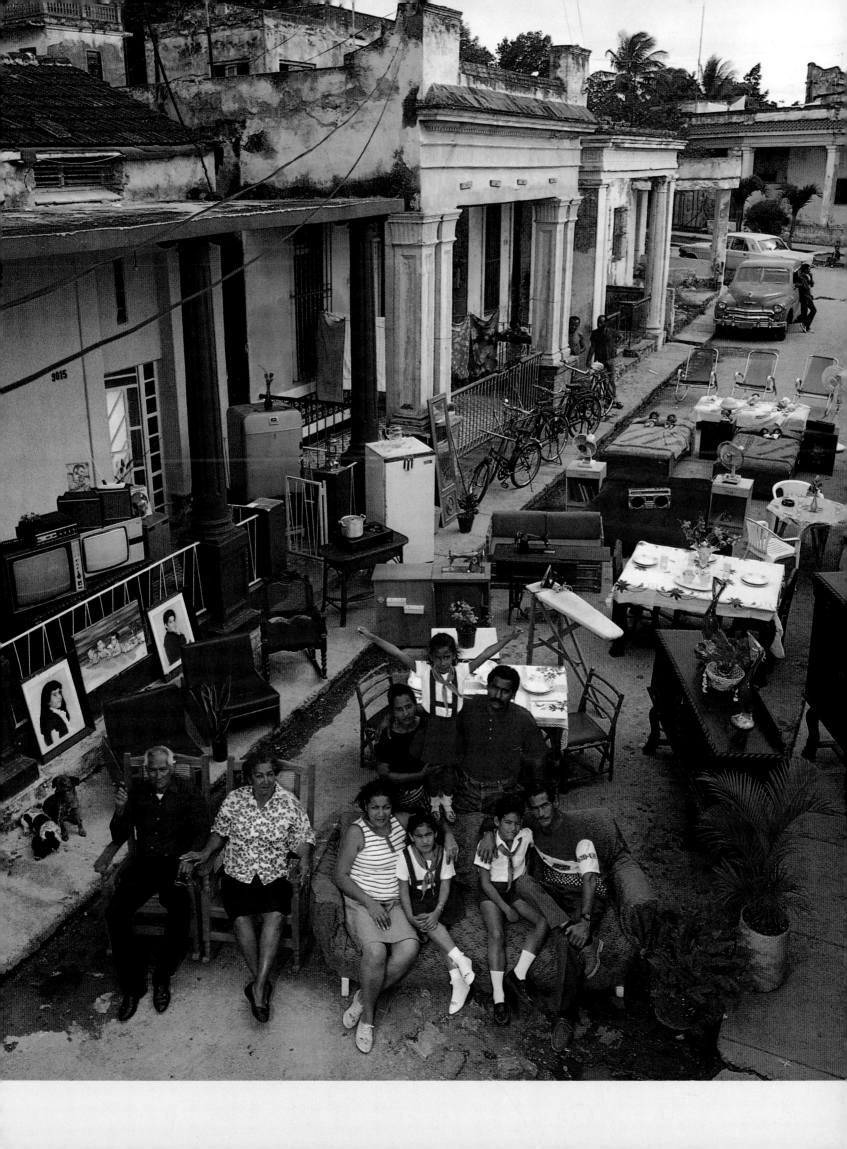

A

CUBA

STATS

Area
42,830 sq. mi.
(110,929 sq. km.)

Population
11.1 million

Total fertility rate
1.9 children per woman

Population doubling time
78.2 years

Percentage urban/rural
76% urban, 24% rural

Percentage of official foreign aid lost since fall of Communism
93%

Life expectancy
Female: 79, Male: 74

Rank of child immunizations among nations in Western Hemisphere
2

Rank of affluence among the 183 U.N. members
74

With its warm climate, rich soil, and large population of African slaves, Cuba became the world's leading sugar producer in the 19th century. It also became the object of a tug-of-war between Spain, its colonial master, and the United States, which wanted to become its colonial master. After a war in 1898, the United States won Cuba's nominal independence. A series of inept regimes ensued. In 1959 Fidel Castro seized power and set up the first socialist state in the Americas. Cubans gained the best health and education systems in Latin America; they also acquired one-man rule and a harsh U.S. trade embargo. Unfortunately, the market for Cuban sugar — the nation's major export product — disintegrated, a victim of the embargo, artificial sweeteners, and lowered costs elsewhere. Cuban socialism was forced to depend on Soviet subsidies. The fall of Communism ended the aid and the aging Castro was challenged as never before. With the embargo pinching harder, he reiterated his faith in socialism. Cuba, he said, would survive this "special period." The hundreds of thousands of anti-Castro exiles disagree. With unconcealed impatience, they are waiting for his end.

D

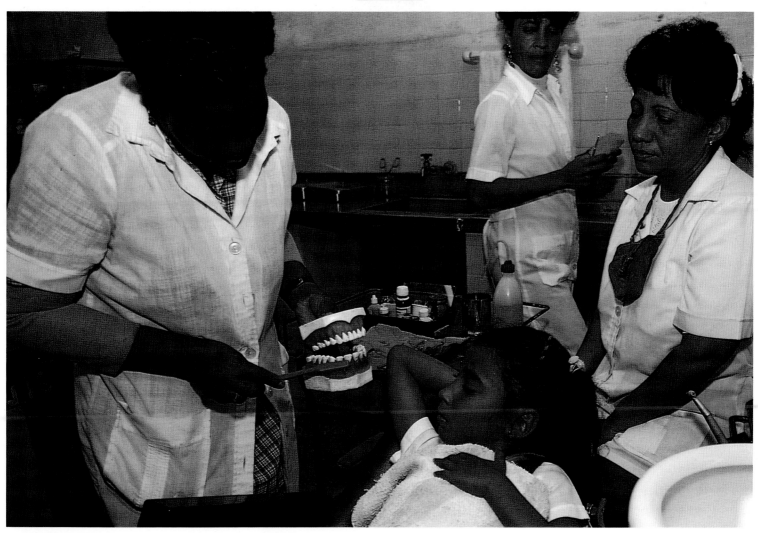

B

CHILDREN CAN ATTEND the huge Cuidad Libertad school complex from the age of six months, when they can enroll in its day-care programs. Students can remain there through high school — all the while using its free medical and dental clinics. Two or three times a year, Lisandra's class troops in for a fluoride treatment *(B)*. Afterward, the children head for a lunch of rice, beans, and tomatoes in one of the school's enormous dining areas *(C, Iris in foreground at left)*. Classes are followed by after-school activities for each child: Javier takes swimming, Iris performs gymnastics, and Lisandra learns synchronized swimming *(D, class stretching at poolside)*. Even as the kids do their exercises, Euripides *(A)* marches with the bust of patriotic hero Jose Martí to the office of the local Communist party chief, who had asked the Costa family to include the statue in the Big Picture (they refused and left it in a sink).

C

A

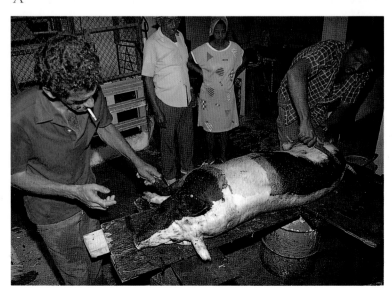

THE DAILY ROUTINE for the family is marked, directly and indirectly, by the ever-more complicated political situation that faces Cuba. With the fall of Communism, the nation lost many of its markets, and things are tight everywhere. Montecristi, the civil engineer who subdivided the family house into three homes, doesn't have much work now; he spends the day trying to find things to do, and is happy to oblige when a neighbor asks him to fix her hot plate (C). In the evenings the household's three generations gather in Montecristi's home. to watch television (A). Montecristi's wife, Eulina, has been laid off outright during what the government calls the "special period." Sandra, Montecristi's sister-in-law, still takes the two girls (B, Lisandra in front, Iris behind, partially blocked) to school every morning at 8:00 a.m. But the shopping afterward is now harder than ever before. On the other hand, the family is not overwhelmed. They still throw a party when the occasion calls for it, slaughtering a pig (D) in the courtyard of their city dwelling.

D

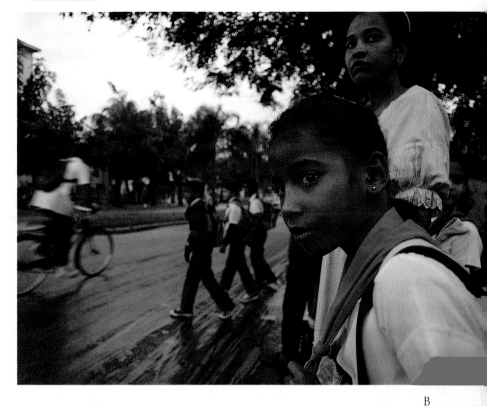

B

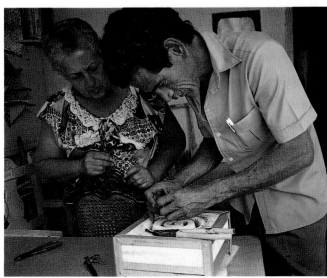

COSTA FAMILY

Size of household
9

Size of dwelling
1400 sq. ft. (130 sq. m.)
(House divided into 3 house-
holds — 1st household: living
room, dining room, bedroom,
bathroom, kitchen; 2nd house-
hold: living room, 2 bedrooms;
3rd household: living room, 2
bedrooms, bathroom, kitchen)

Workweek
0 hours (Father — retired)
72 hours (Son)
40 hours (Son's wife — recently
took maternity leave)
40 hours (Daughter — recently
laid off due to "special period")
60 hours (Daughter's husband)

Number of
Radios: 3 (one in each home),
Stereos: 2 (one each in son's
and daughter's home),
Telephones: 0, Televisions: 3
(one in each home), VCRs: 1,
Bicycles: 4, Automobiles: 0

Most valued possessions
Family is most valued for all
members

Per capita income ($US)
$2,000

Wishes for future
Car, video-game player

PHOTOGRAPHER'S NOTES

PHILLIPPE DIEDERICH

Working with the Cuban government was
both a hindrance and a help. It was a struggle
to get in, a struggle to work freely, and a strug-
gle to get the family we chose approved. After
many letters, phone calls, and begging visits,
though, they caved in — and then they were a
terrific help. When the government smiled on
us, all doors opened. More important, the
Costas were overwhelmingly kind and hos-
pitable. Although they always have rice and
beans, they spend a lot of time searching for
yucca, meat, and fish to buy. Still Eulina or
Sandra insisted that I have seconds at every
meal — "Don't be shy! Have some more!"
They did not mind talking about the difficul-
ties in their lives but proudly did not want me
to photograph anything that was in bad order
at home (the broken fridge, for example). Peter
Menzel and I set up the Big Picture under the
threat of rain, which was scary — I didn't
want to face the Costas, who would have been
dismayed about their soaked possessions but
too polite to say anything (which is worse than
being yelled at). When we finished, they
popped everything back in before we even
broke down the equipment. Then we could
relax. Inevitably, it turned into a celebration,
with lots of rum and salsa music.

GUATEMALA

Traditionally Endangered

The Calabay Sicay Family

5:30 P.M., SEPTEMBER 15, 1993
SAN ANTONIO DE PALOPÓ, GUATEMALA

PHOTOGRAPHS
BY MIGUEL LUIS FAIRBANKS

KEY TO BIG PICTURE

1. Vicente Calabay Pérez, father, 29
2. Lucia Sicay Choguaj, mother, 25
3. Mario Calabay Sicay, son, 8
4. Olivia Calabay Sicay, daughter, 6
5. Maria Calabay Sicay, daughter, 4

OBJECTS IN PHOTO

(Foreground)

- Family bed (beneath family)
- Religious painting (held by father)

(Rear, from left to right)

- Sneakers (1 pair, high-top)
- Spinning wheel
- Plastic horse, plastic rooster, dolls (3)
- Large loom
- Finished fabric and family-woven shirts in traditional styles (hanging from large loom)
- Small loom with woven table-cloth
- Family house (adobe brick)
- Chair (in doorway)
- Machetes (3), sickle, shoulder bags (2), old calendar, religious pictures (6), hat (all hanging on house)
- Tables (3) with wooden trunk, small bowls, plastic flowers, Guatemalan flag, portable cassette-tape player
- Toilet (visible through bathroom doorway)
- Detached kitchen (adobe brick)
- Fuel supply (firewood)
- Axe (leaning against kitchen)
- Thermos, strainer, aluminum pan (hanging on kitchen)
- Red plastic wash basin, grill, plastic cups
- Clay firepot (beneath cups)
- Stone *matate* (for grinding corn to make tortillas)
- Wicker basket, clay bowls (4), ceramic pitcher
- Hoes (4)

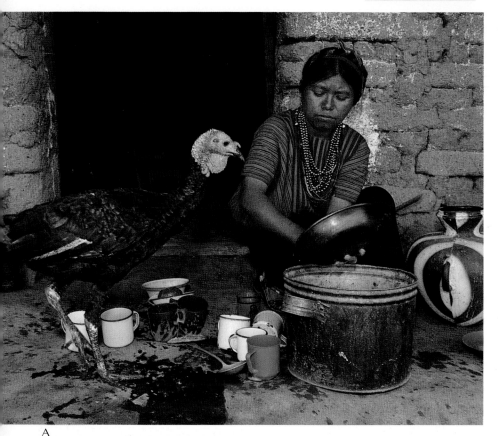

A

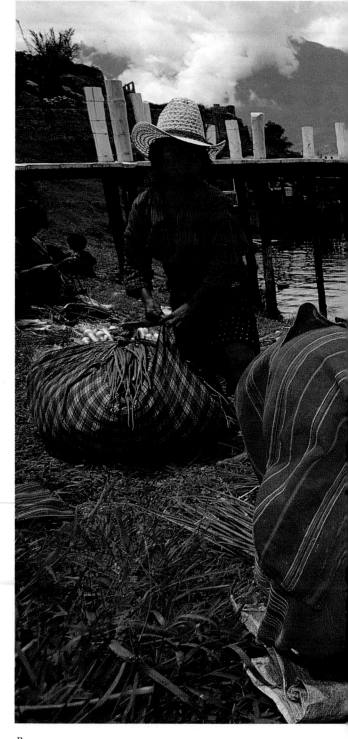

B

GUATEMALA

STATS

Area
42,085 sq. mi. (108,999 sq. km.)

Population
10.6 million

Population density
251.9 per sq. mi.
(97.3 per sq. km.)

Total fertility rate
5.4 children per woman

Population doubling time
24.4 years

**Percentage urban/
rural population**
42% urban, 58% rural

**Percentage of forest lost
between 1981-90**
1.6%

Life expectancy
Female: 66, Male: 61

Leading causes of death
Communicable diseases
Maternal/perinatal conditions

**Ratio of per capita energy use,
United States to Guatemala**
45 to 1

**Rank of affluence among
the 183 U.N. members**
114

Suffering from the aftermath of a civil war that lasted more than three decades, Guatemala now must balance the needs of its people (poor and rapidly increasing in numbers) and its natural heritage (especially the tropical forests that cover its northern half). For more than a century the nation has been controlled by its powerful army and a small number of wealthy families of European descent. On the bottom are the indigenous Mayans, who work Guatemala's famous coffee plantations and make up more than half the population. Most still speak their language, despite government efforts to promulgate Spanish. The inevitable social antagonisms are one reason that the government has been overthrown 23 times since Guatemala became independent in 1821. A long-standing civil war exploded in the 1980s, leading to more than 100,000 deaths — about one out of every twenty people in Guatemala. The army destroyed more than 400 villages; perhaps 100,000 people fled to refugee camps in Mexico. Although the conflict seems to have sputtered out, the list of tensions remains long: slumping coffee prices, large numbers of refugees, illegal logging in the tropical forests, rapid increases in population, high levels of drug smuggling, and continuing income disparities. The list continues.

D

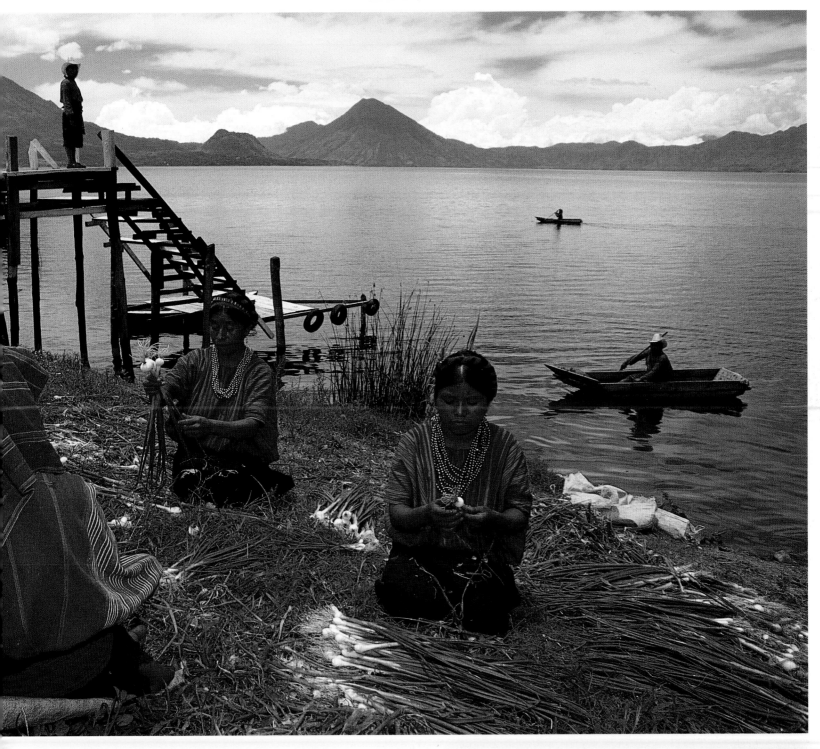

TRANSFORMING WORK into a time to catch up on the local news, Lucía Sicay Choguaj *(B, at right, in foreground)* plaits the green onions she's grown into neat bundles for the market in Solola, the nearest big town. Below her glitters Lake Atitlán, a volcanic lake admired by tourists for its beauty and by residents for its perch. In a while, the break will be over; as usual, the dishes await *(A)*. Without running water, Lucía washes them by the cookhouse, where the family's pet turkey, Jon Pipin, comes over, wondering if the dishwater would be good to drink. When there's time, Lucía weaves *(D)* wristbands and bags on the smaller of the family's two handmade looms. Her husband, Vicente, uses the bigger one to weave items like the blankets that cover *(C, from left)* Maria, Olivia, and Mario. Sleeping, the girls clutch their favorite little blonde dolls.

NEXT SPREAD: Vicente walks at dawn to his garden on a path by the shore. Behind him are Mario, his son, and Santos Perez, head of the village artists' cooperative.

C

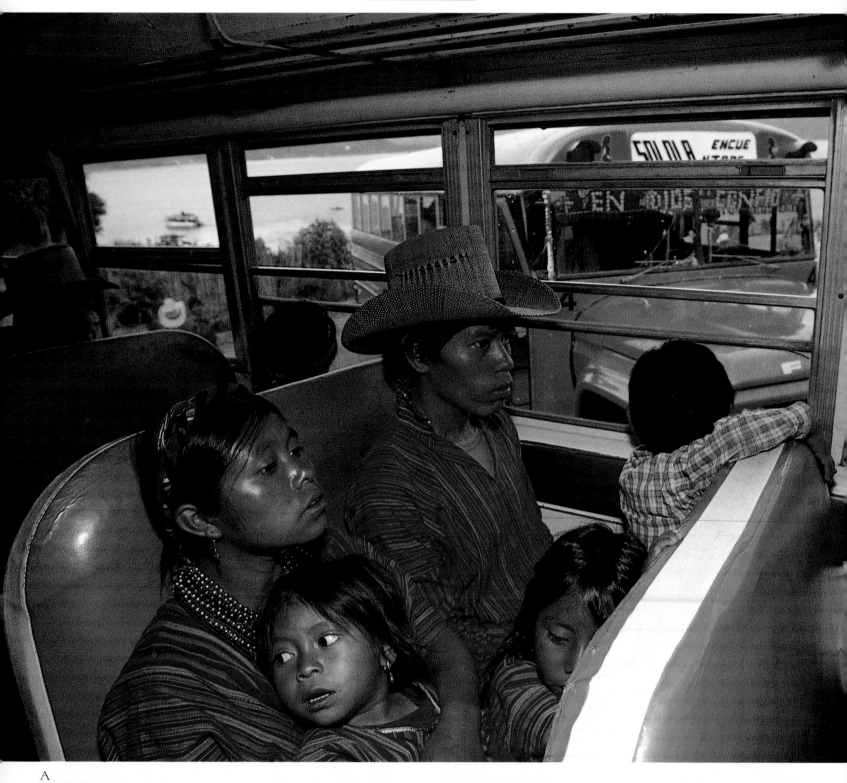

A

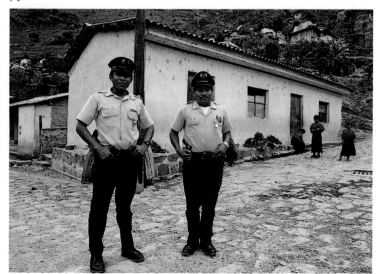

D C

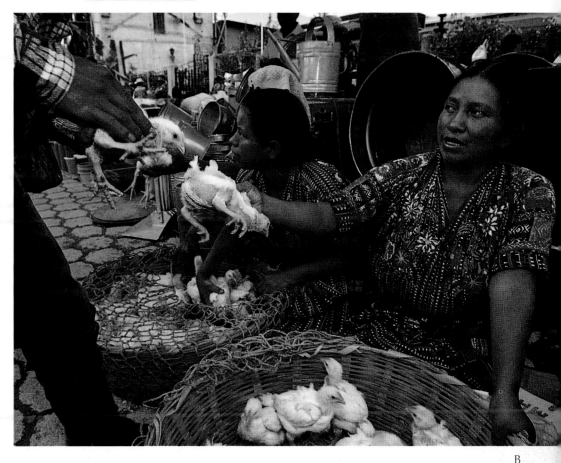

B

NEEDING TO BUY dishes at the market in Solola, the family leaves on the early bus (A). As the buses takes off with their loads of intent adults and sleepy children, Lake Atitlán gleams behind them. Although the *mercado* (B) is a center for social life, Lucia places more importance in the Confradia of San Antonio del Monte, patron saint of the village. Located near her home, the Confradia is a group of sacred objects, including an altar, which local families take care of on a rotating basis (C, *with current caretakers*). The saint is needed: Having little trust in the Spanish-speaking police (D), 60 village Mayans formed a vigilante group to guard the streets after a resident was murdered.

CALABAY SICAY FAMILY

Size of household
5

Size of dwelling
216 sq. ft. (20 sq. m.)
One-room house with detached
100 sq. ft. (10 sq. m.) kitchen

Workweek
60 hours (Father)
"Constantly" (Mother)

Most valued possession
Religious painting, Bible (Mother)
Portable tape player (Father)
Dolls (Daughters)
Soccer ball (Son)

Number of
Radios: 1, Telephones: 0
Televisions: 0, Automobiles: 0

Per capita income ($US)
$944

Percentage of Calabay Sicay family income spent on food
66%

Possessions family would like to acquire
Television, pots and pans, kitchen table

Number of times family has been more than 30 miles from home
0

Wishes for future
"To stay alive" (Father)

PHOTOGRAPHER'S NOTES
MIGUEL LUIS FAIRBANKS

San Antonio de Palopó is inhabited by Cakchiquels, one of the 22 Mayan groups indigenous to Guatemala. It is a beautiful place to photograph: a pueblo rising from the shore of a volcanic lake, terraced plots of corn and onions on the slope above the adobe homes. My greatest difficulty was the Mayans' entrenched reluctance to get involved with foreigners and their cameras—deservedly, I suppose. Dealings with foreigners have not worked out well for the Mayans recently. I was lucky to meet Santos Perez, president of the local artisans' cooperative, who both embraced the project and helped in translation (I speak Spanish, but not the Cakchiquel dialect). The Calabay Sicays graciously put aside their fears and invited me in. Even so, they insisted that I stop at 5:00 p.m. every day because thieves had recently killed a man nearby, and they didn't want the *bandidos* to think that my expensive equipment and I were staying with them. I photographed the Mexican and Brazilian families as well, and was surprised that the families in all three countries chose the same favorite possessions — stereos for the men, religious items for the women, toys for the kids. Then it occurred to me that my stereo is one of my favorite possessions, too. Maybe we're not so different after all.

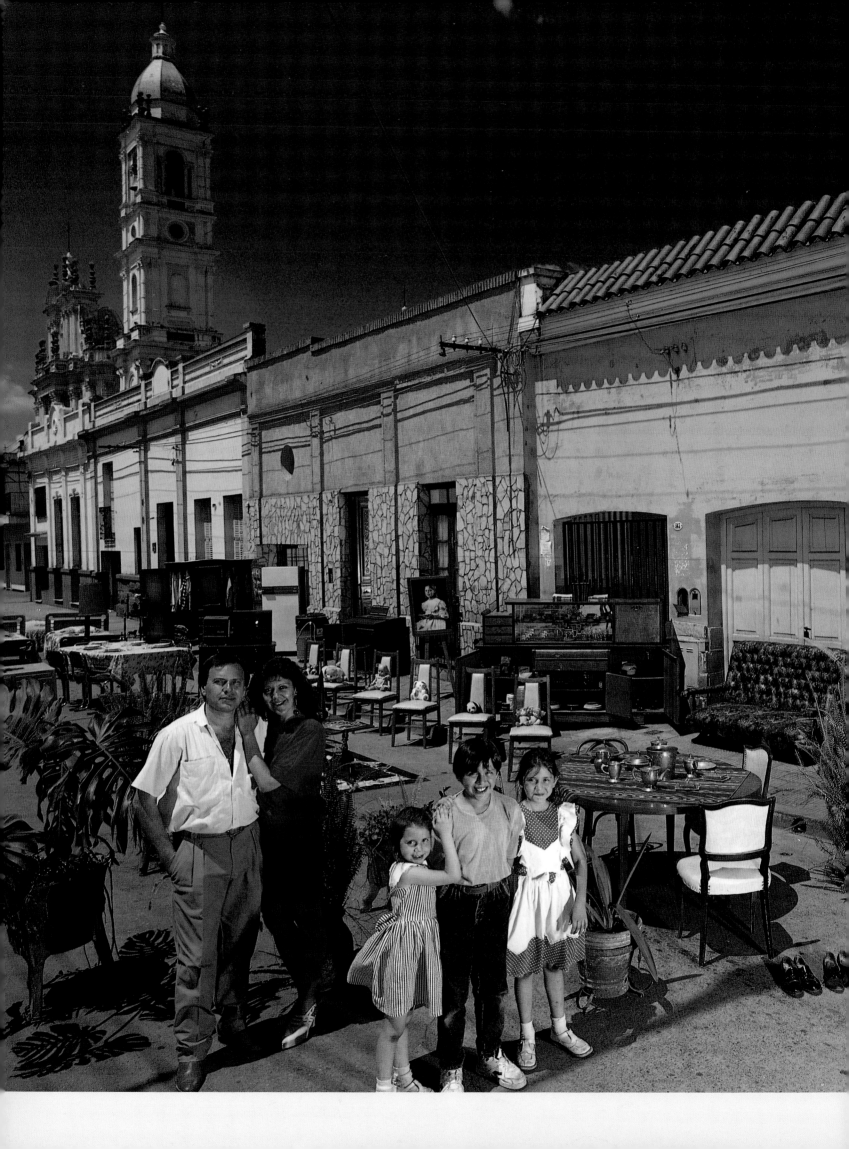

Stability — At a Price

The Carballo Family

2:30 P.M., NOVEMBER 27, 1993
SALTA, ARGENTINA

BIG PICTURE BY PETER GINTER

DAILY LIFE PHOTOGRAPHS
BY DIEGO GOLDBERG

KEY TO BIG PICTURE

1. Juan Carlos Carballo, father, 42
2. Marta Elizabeth Iniguez, mother, 31
3. Nahuel Carballo, son, 9
4. Maria Belen Carballo, daughter, 8
5. Maria Pia Carballo, daughter, 6

OBJECTS IN PHOTO

(Foreground, left to right)

- Houseplants (8, most just behind family)
- Dining tables (2, 2nd far left behind plants)
- Silver tea set (atop 1st dining table)
- Miscellaneous chairs (3, around table)
- Shoes (20 pairs)
- Sewing machine and table

(Background, left to right)

- Office-style desk (far left, directly behind plants)
- Beds (3, behind desk)
- Floor lamp
- Tableware (atop 2nd dining table)
- Chairs (4, around 2nd dining table)
- Curio shelf
- Armoire and clothes
- Dresser
- Stereo and TV (atop dresser)
- Refrigerator
- Washing machine (on casters)
- Stereo speakers (right of washing machine)
- Piano
- Photo-portrait (by Juan Carlos)
- Dining chairs (6)
- Dolls and stuffed animals (on chairs, bear in center is youngest daughter's favorite possession)
- End table (in front of chairs)
- Rug (under end table)
- Home (yellow building, family occupies semi-separate apartment)
- Sideboard for china (against building)
- Couch (against building)
- Cabinet for glassware (against building)

(Rear)

- Catholic church (adjacent to family residence)

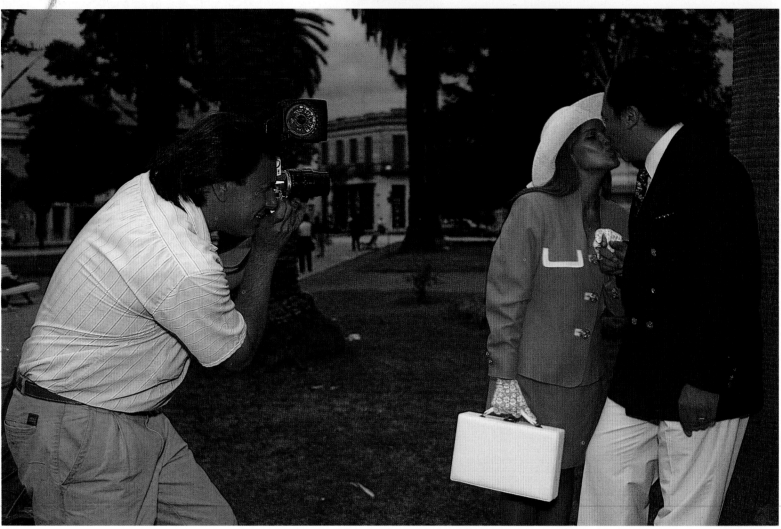

A

HOPING TO CATCH just the right moment, Juan Carlos clicks the shutter at the instant the betrothed couple kisses in the central park of the city of Salta (A). Both he and his wife are photographers — Marta with video, her husband with stills. Shooting the actual pictures is just a portion of the job. For this wedding, the couple and their two daughters not only posed the pictures but came early on the Saturday of the wedding to the Greek Orthodox church to set up their lights and equipment. The Carballos themselves are Roman Catholic — indeed, the next day they attended Mass in the Salta cathedral (D). Because work is slow, Marta has to spend much more time on housework than she likes, though the load is sometimes lightened by 6-year-old Maria Pia (B, behind window screen), an expert folder of laundry. A reluctant cook, Marta is an equally reluctant shopper (C). Here she is buying cheese, chopped meat, and corn on the cob to make corn and meatballs, a meal that would serve as both lunch and dinner.

CARBALLO FAMILY

Size of household
5

Size of dwelling
3 rooms and patio
in mother's aunt's apartment
950 sq. ft. (110 sq. m.)

Workweek
30-35 hours (Father)
40 hours (Mother, includes 16
hours as paid photographer)

Number of
Radios: 1, Telephones: 3,
Televisions: 1, VCRs: 1,
Video-game players: 1

Most valued possessions
Photo processor (Father)
Heirloom silver (Mother)
Video-game player (Son)
Stuffed animal (Daughter)
Stroller for doll (Daughter)

Per capita income ($US)
$3,966

**Percentage of Carballo family
income spent on food**
25%

**Percentage of Carballo family
income spent on clothing,
household goods**
25%

**Percentage of Carballo family
income in savings**
0%

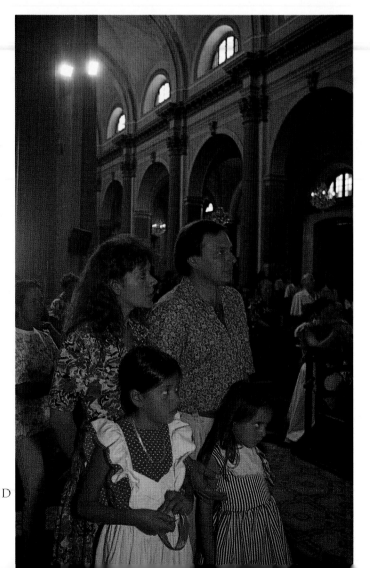

D

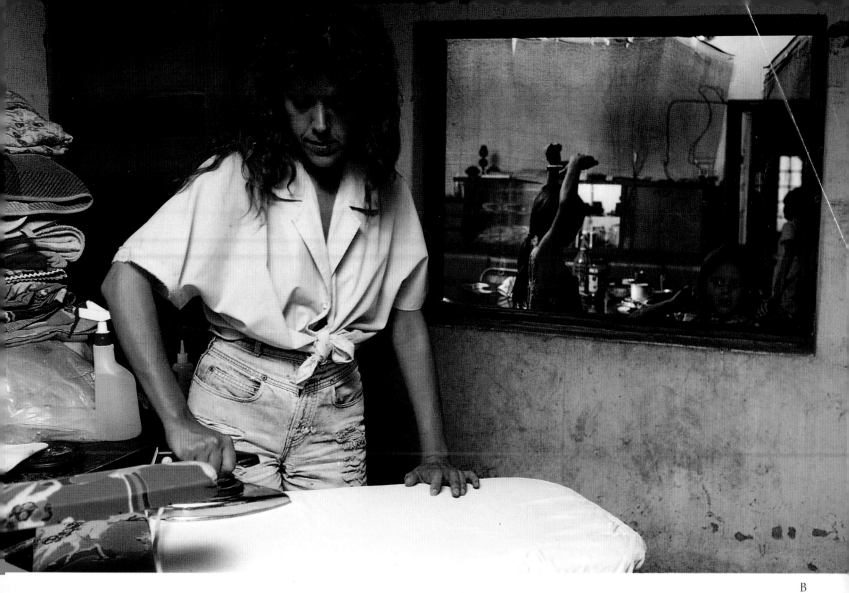

B

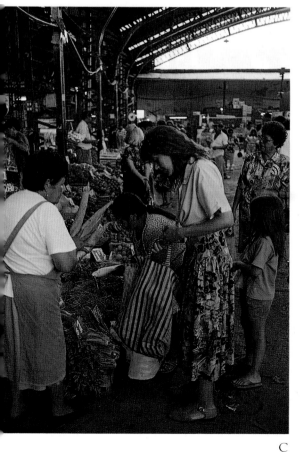

C

ARGENTINA

STATS

Area
1,073,395 sq. mi. (2,780,072 sq. km.)

Population
34.3 million

Population density
32.0 per sq. mi. (12.3 per sq. km.)

Total fertility rate
2.8 children per woman

Population doubling time
60 years

Percentage urban/rural
88% urban, 12% rural

**Percentage of land used
for cattle grazing**
51%

**Rank of meat consumption
among world nations**
1

Life expectancy
Female: 75, Male: 68

**Rank of affluence among
the 183 U.N. members**
42

To many 19th-century Europeans, Argentina represented the fabled Land of Opportunity, a place where ranchers galloped over vast holdings of arable land. Immigrants poured in by the millions, especially from Italy and Spain. By the dawn of the 20th century, Argentina was a modern, European-style nation — the world's leading exporter of corn and meat. The Depression hit especially hard, because it wrecked the export trade on which Argentina depended. In response, successive Argentine governments demonstrated the perils of Keynesian-style intervention. After World War II they pumped money into the economy, creating wild inflation, which was tamed by harsh austerity measures, creating recessions, which led to further money-pumping. Matters were further complicated during this time by the presence of Juan Perón, a charismatic populist whose artful maneuverings kept him in or near power from the 1940s until his death in 1974. He was succeeded by his wife, Isabel, who was soon ousted in a coup. The junta killed thousands of opponents, leading to international condemnation. In another sphere, it courted a war with Britain, which Argentina lost. Resigning in disgrace, the military left behind a ruined economy. Despite a rocky start, the civilian government has made impressive strides — enough so that economists believe that the nation may ultimately prosper, though its people are suffering now from reform-caused unemployment.

A

DESPITE HARD TIMES, the Carballos try to keep up a middle-class life. Although they are tucked into a single bedroom in Marta's aunt's house, they have been able to adorn the beds and curtains with the snickering, saw-toothed head of Bart Simpson (A), a particular favorite of the Carballo offspring. And the afternoon is pleasant indeed at a Sunday gathering at the country house of Marta's uncle Miguel and aunt Tati to celebrate the couple's 42nd wedding anniversary (B). After the traditional barbecue, Tati puts on her wedding dress, the signal for everyone in the family to dance. Good-humoredly accepting her professional role, Marta videotapes the entire proceedings. Afterward, 8-year-old Maria Belen relaxes in the family pool (D), content in the knowledge that her 2-1/2-month-long summer vacation is not yet over. Not that the realities of life can be entirely kept at bay — Juan Carlos will load his gun at dusk, as he does every night to protect his family against the city's increasingly aggressive thieves. Unwilling to leave a loaded weapon in a houseful of children, he empties it every morning before going to work (C).

D

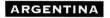

B

PHOTOGRAPHER'S NOTES
DIEGO GOLDBERG

The Carballos do not feel particularly safe, secure, or comfortable. They moved to Bolivia in 1988 and lived well there, but they missed their family and country so much that they decided to come back. It's been a roller coaster ever since. Now they've been robbed twice and are scrambling economically and have moved around so much that they feel like they have few friends. The family is not poor — they were able to replace their stolen stereo, TV, VCR, and video-game player — but times are hard. They have had to move in with Marta's aunt. I am from Argentina myself and I know how difficult life has become with the austerity measures, unemployment, and so on. Juan Carlos pinned his hopes on a Kreonite machine that could develop large transparencies for commercial use — the only machine like it in their town of Salta. But demand for it was low, and later I was told that he was thinking of selling it and moving the family back to Bolivia. It was odd for me, a photographer, to end up working with a family of photographers; I hope things work out for them.

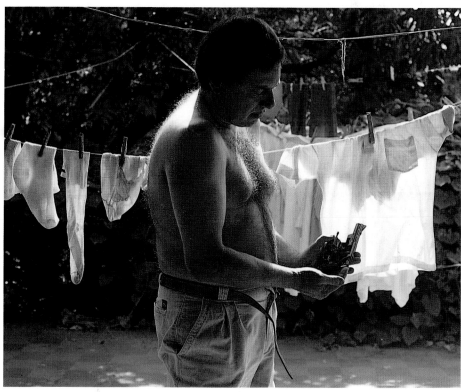

C

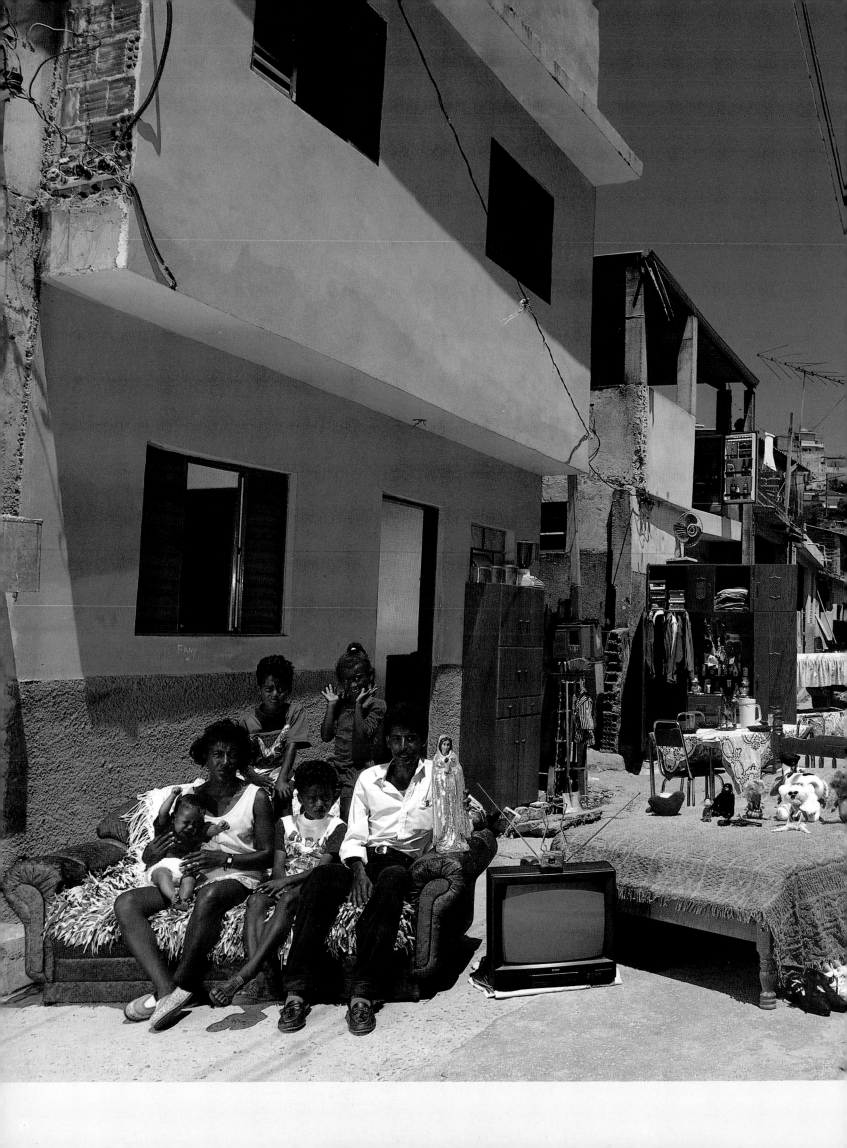

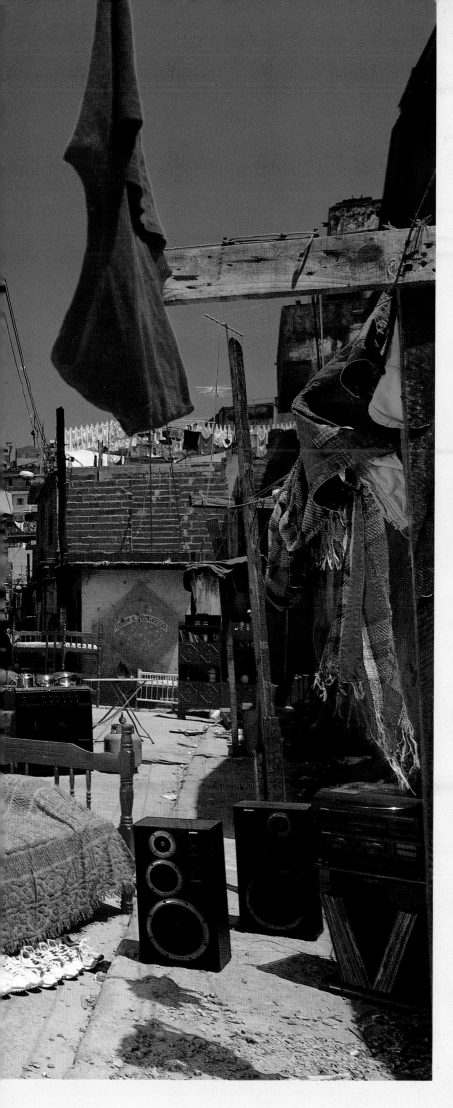

BRAZIL

Southern Superpower?

The de Goes Family

2:00 P.M., NOVEMBER 31, 1993
SÃO PAULO, BRAZIL

BIG PICTURE BY PETER GINTER

DAILY LIFE PHOTOGRAPHS
BY MIGUEL LUIS FAIRBANKS

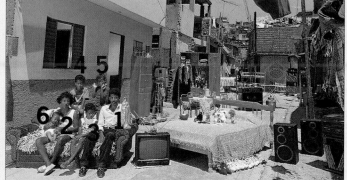

KEY TO BIG PICTURE

1. Sebastião Alves de Goes, father, 35
2. Maria dos Anjos Ferreira, mother, 29
3. Eric Ferreira Santos de Goes, son, 7
4. Ewerton Ferreira de Goes, son, 7
5. Elaine Ferreira de Goes, daughter, 6
6. Priscila de Goes, daughter, 6 mos. (rebelling in mother's arms)

OBJECTS IN PHOTO

(Clockwise from far left)

- Home (newly painted)
- Kitchen cabinet
- Blender, storage tins, plates (atop cabinet)
- Dustpan, broom (pink), apron, ladder (leaning up against electrical junction box)
- Father's extra shoes (3 pairs, atop electrical junction box)
- Wardrobe with clothes, shoe boxes for storage, mirror, cosmetics
- Electric fan (atop wardrobe)
- Refrigerator (above fan, on next-door construction site)
- Dining table with 4 chairs, plastic pitcher, glass vase (with flowers), tablecloth, plates, bowls, and family cutlery
- Bunk beds (2, for children)
- Couch (between beds)
- Stove/oven with aluminum pots and pans
- Ironing board with iron
- Propane tank (by stove)
- Crib (against wall with painted Brazilian flag)
- Storage cabinet with books, figurines, vase, portable cassette tape player
- Red shirt and blanket (drying on clothes line)
- Stereo (on LP record box)
- Stereo speakers (2)
- Parents' bed
- Children's dolls and toys (on parents' bed)
- Extra shoes (6 pairs — for all but father, whose shoes are atop junction box)
- Television
- 2nd sofa (beneath family)
- Statue of Virgin of Guadalupe

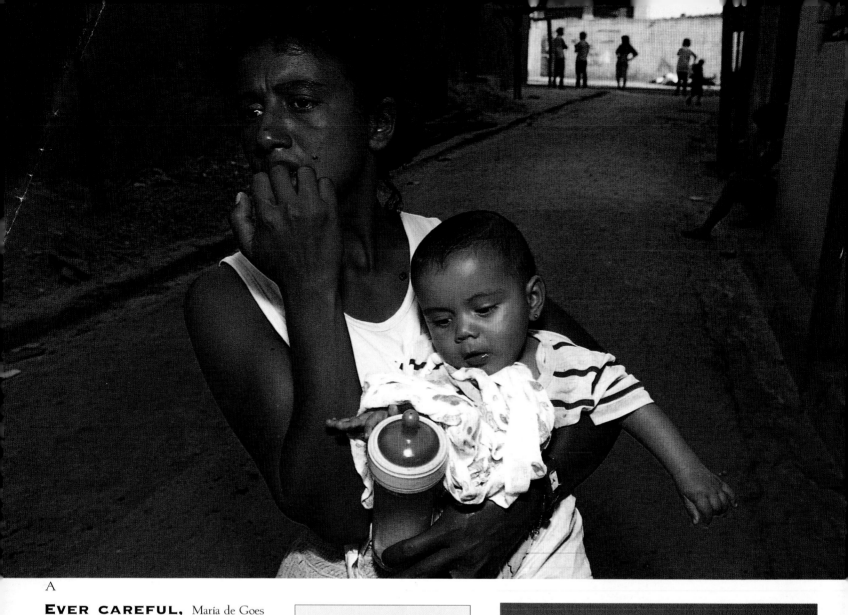

A

EVER CAREFUL, Maria de Goes accompanies Elaine and the twin boys, Eric and Ewerton, every morning as they ride to school on the public bus *(B)*. (Fortunately for the family, the bus line is not as crowded as a lot of others in São Paulo.) Although the family has not been robbed itself, Maria is careful walking around her neighborhood, which she considers unsafe *(A, carrying 6-month-old Priscila)*. "The world has too much violence and corruption," she says. She concentrates her hopes on her children and her faith. The sculpture and religious images on her bedroom table are her most treasured possessions *(D, statue of Virgin of Guadalupe at right)*. The children, of course, have different preferences. Seven-year-old Ewerton says that *his* favorite possession is his toy pistol *(C)*.

NEXT SPREAD: Bent over the bleaching, Maria and her sister Magna, a frequent visitor, try to converse over the cheerful bellows from a soccer game in the alley fronting their house.

DE GOES FAMILY

Size of household
6

Size of dwelling
1,100 sq. ft.
(2 bedrooms, living room, kitchen, bathroom)
Owner-occupied apartment

Workweek
60 hours (Father)
"Constant" (Mother)

Number of
Radios: 1, Stereos: 1,
Televisions: 1, VCRs: 1,
Automobiles: 1

Per capita income ($US)
$2920

Percentage of de Goes family income spent on food
55%

On automobile
15%

Used for savings
0%

Dreams for future (not in rank order)·
Better car
Better stereo
Better home

D

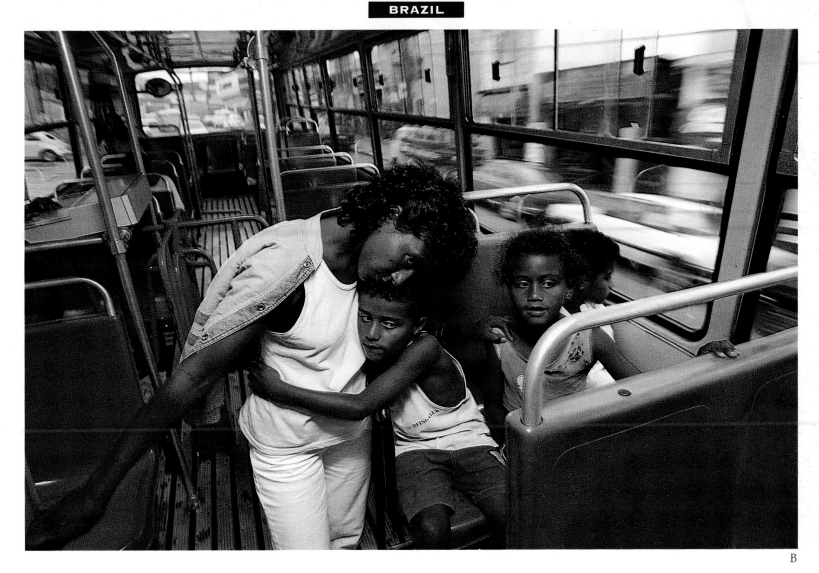

B

C

BRAZIL
BRASIL

STATS

Area
3,286,485 sq. mi.
(8,511,930 sq. km.)

Population
161.4 million

Population density
49.1 per sq. mi. (19.0 per sq. km.)

Total fertility rate
2.8 children per woman

Population doubling time
44.0 years

Percentage urban/rural
79% urban, 21% rural

**Percentage of forest lost
between 1981-1990**
0.6%

**Ratio of forest loss in 1981-85
to loss in 1986-90**
2.21 to 1

Life expectancy
Female: 69, Male: 63

**Rank of affluence
among the 183 U.N. members**
52

A nation of superlatives, Brazil has the Earth's biggest river system, the Earth's biggest tropical forest, and the Earth's second-biggest city (São Paulo). Melding cultures from Native Americans, African slaves, and European migrants, Brazil has long been known for its syncretic art, music, and literature. Recently, though, other nations have focused on a second feature of this burgeoning nation: its great forestland, which may hold half the world's species. Subsidized logging and farming have destroyed big swaths of that forest, presumably causing many extinctions. To most Brazilians, though, non-biological issues are more immediate. After booms in the 1960s and 1970s turned Brazil into the world's tenth-largest economy, it struggled in the 1980s to stay even. Reeling from debt and inflation, the military government gave up power in 1985. New civilian rulers faced the task of restarting economic growth, addressing environmental perils, and narrowing the terrible abyss between rich and poor. Thus far, they have floundered. President Fernando Collor de Mello was impeached in 1992 because of a bribery scheme; similar scandals in the legislature followed. Worse, the mistrusted politicians may have to draw up a new constitution — Brazil's eighth since it became independent in 1822. As a consequence, the future of this nation and its matchless natural endowment is difficult to predict.

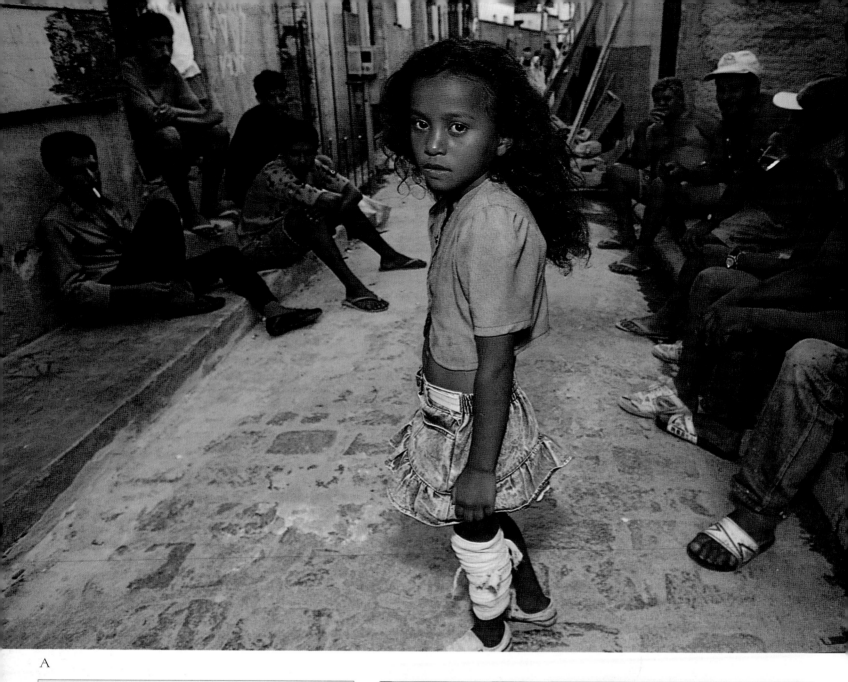

A

PHOTOGRAPHER'S NOTES
MIGUEL LUIS FAIRBANKS

The de Goes home is always open to family and friends. In addition to Sebastião, Maria, and the children, I saw a regularly changing cast of people sleeping in the house — Maria's sisters, friends of Sebastião, you name it. Yet despite this amazing openness, the neighborhood is full of fear inspired by exorbitant levels of theft, violent crime, and corruption. The result was that the de Goes family, like the others that I visited, had installed heavy metal bars over doors and windows. Inside, the house was spotless, the floors mopped daily, the walls scrubbed weekly, the aluminum pots and pans shined to brilliance, and all belongings put neatly in place. São Paulo is so huge and its transit system so dysfunctional that two-thirds of its people own cars, much more than the rest of Brazil. Sebastião and Maria scrimp and save to pay for their vehicle, and told me they even knew people who go without eating to pay for their cars. Little wonder that the air is so bad in this city! Although the couple sometimes struggles, the two are content with their lives and love their children deeply.

D

SEBASTIÃO'S JOB as a city bus driver has its drawbacks, chiefly that he must be at work by 3:30 a.m. On the other hand, his early-morning departure means that he returns early in the afternoon, which allows him to relax on the street with his friends (A, *seated at left with cigarette*). Conversation flows, with the adults gently teasing the children who walk by. (Bandages like those on this girl are common: With few parks to play in, children constantly bang themselves up in São Paulo's hard streets.) Often Sebastião's friend Rodrigo comes by and stays for a while, tranquilly watching the television (D) in a visit that might stretch over a night or two. Such impromptu visits are relished by the children because they often become the center of attention when guests are present. An affectionate father, Sebastião (C, *blue shirt*) dandles Rodrigo's baby, while Rodrigo hoists Priscila up on his comfortable paunch. Curiously, the ever-present Rodrigo managed to miss the family's monthly shopping expedition to the supermarket (B).

B

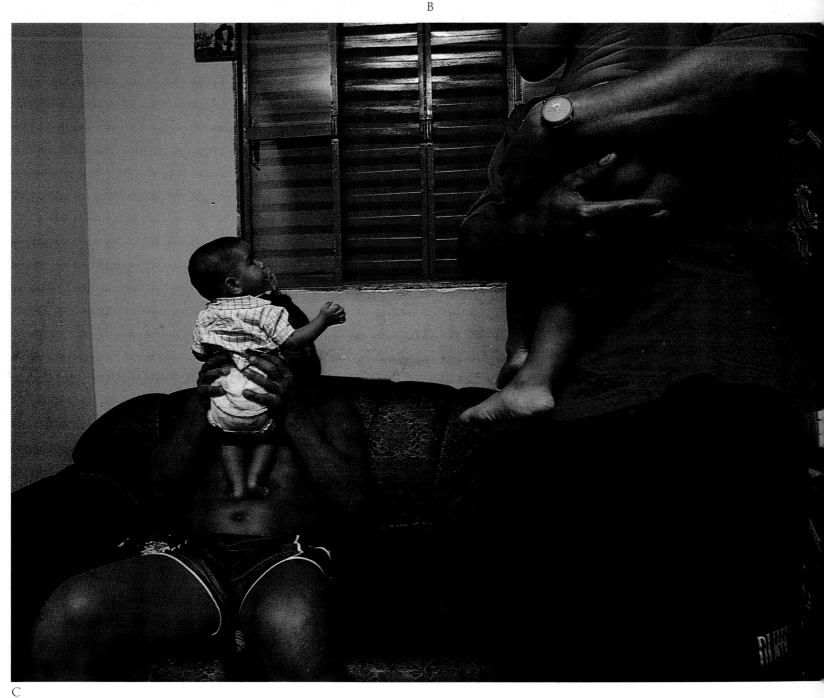

C

CHANGING OIL
PEARLAND, TEXAS, U.S.A.
PHOTOGRAPH BY LYNN JOHNSON

MERICA

Moral Dilemma

The Skeen Family

6:30 A.M., AUGUST 4, 1993
PEARLAND, TEXAS, U.S.A.

BIG PICTURE BY PETER GINTER
AND PETER MENZEL

DAILY LIFE PHOTOGRAPHS
BY LYNN JOHNSON

KEY TO BIG PICTURE

1. Rick Skeen, father, 36
2. Pattie Skeen, mother, 34
3. Julie Skeen, daughter, 10
4. Michael Skeen, son, 7

OBJECTS IN PHOTO

(Foreground)

- Family Bible (held by mother)

(Left to right)

- Dog (Lucky, tied to real fire hydrant—souvenir of father's years as fireman)
- Sewing machine (antique, treadle-style)
- Easy chair
- Photo lights for shooting Big Picture (scattered throughout scene)
- End table with lamp
- Living room couch
- Coffee table (marble-topped, with books)
- Storage cabinet
- Television (on cabinet)
- 2nd easy chair
- Stereo (on matching marble-topped table)
- Speakers (4, on either side of secretary)
- Dining table, chairs (6), place settings, bowl of fruit
- Curio cabinet (with china)
- Secretary (behind cabinet)

- Bicycles (behind secretary)
- Bookshelf (visible through window behind bicycles)
- Computer and computer storage unit (obscured by father's head)
- Motor vehicles (3, Ford F350 pickup, Ford Aerostar minivan, dune buggy)
- Storage shelving (in garage)
- Stuffed deer heads (2, above garage door)
- U.S. flag (between heads)
- Dressers (2)
- Dollhouse (on file cabinet)
- Cane-backed chair, 2nd end table, toys, U.S. map, globe
- Refrigerator
- Desk (with chair, toy train)
- 2nd TV (on table)
- Washer, range, dryer (with food processor, mixer, coffee maker, pots, etc.)
- Microwave (atop dishwasher)
- Beds (3, parents' with guitar)
- Ironing board and iron
- Piano and piano bench
- 2nd sewing machine (electric, with table, chair)
- Family portraits

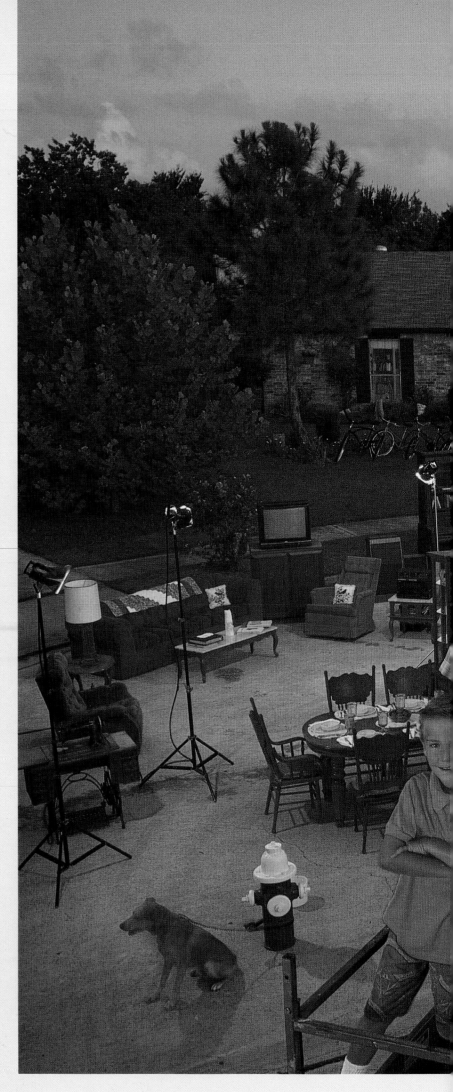

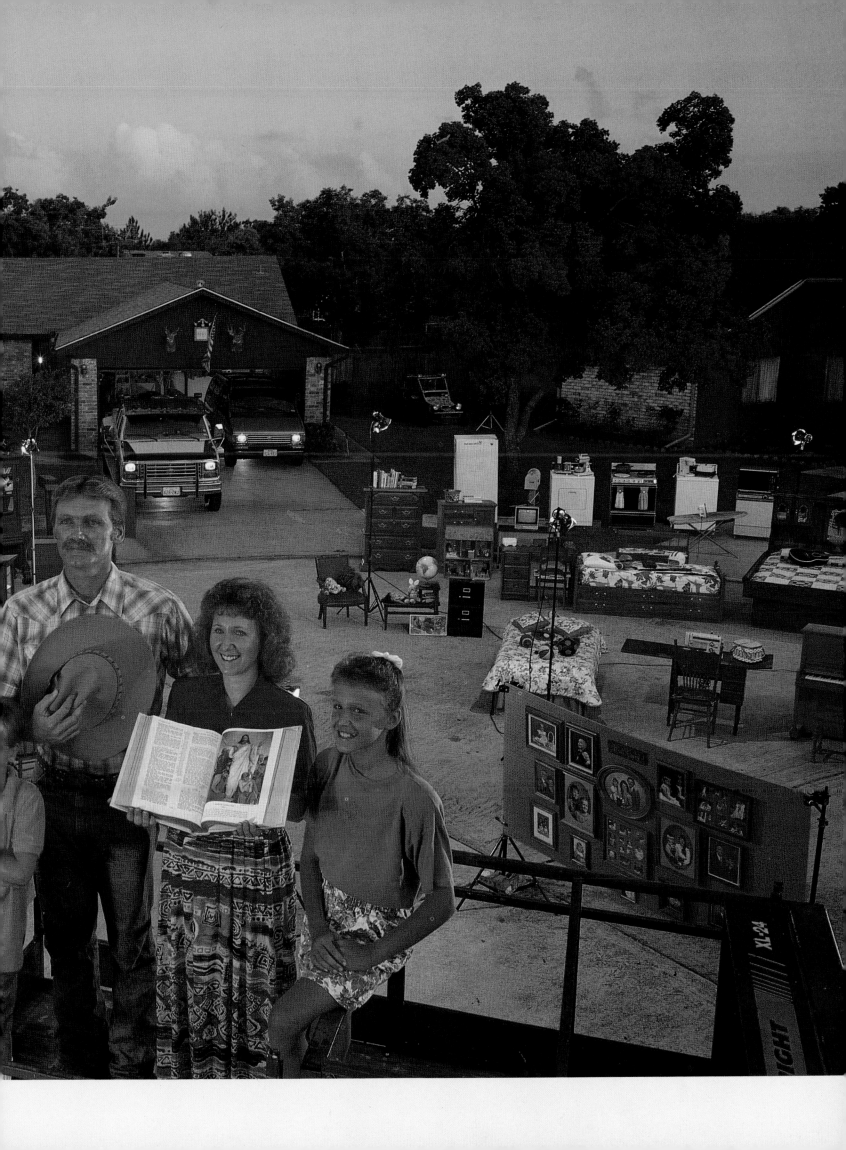

SKEEN FAMILY

Size of household
4

Size of dwelling
1,600 sq. ft. (148.6 sq. m.)

Workweek
40 hours (Father)
20 hours (Mother — does not
include housework)

Number of
Radios: 3, Stereos: 3, Telephones: 5
Televisions: 2, VCRs: 1, Computers: 1,
Vehicles: 3 (truck, car, dune buggy)

Most valued possessions
Bible (Father)
Bible (Mother)

Per capita income ($US)
$22,356.

**Percentage of Skeen family
income spent on food**
9%

**Precautions family takes
against crime**
Locking doors, alarm system,
mace (in mother's purse), lock bar
for car steering wheel

**Number of times family
has been robbed**
0

Wishes for future
Tools, new carpet, camping trailer

U.S. STATS

Area
3,618,000 sq. mi.
(9,370,548 sq. km.)

Population
263.1 million

Population density
72.7 per sq. mi. (28.1 per sq. km.)

Total fertility rate
2.1 children per woman

Population doubling time
67 years

Percentage urban/rural
76% urban, 24% rural

Life expectancy
Female: 79, Male: 72

Infant mortality
8 per 1,000 births

Literacy rate
Female: 95%, Male: 96%

**Rank of divorce rate
among First World nations**
2 (Behind Liechtenstein)

**Rank of murder rate
among First World nations**
3 (Behind Bermuda
and the Netherlands)

**Rank of regular church
attendance among
First World nations**
1

**Rank of affluence
among the 183 U.N. members**
9

A

AS THANKSGIVING approaches, the children begin their vacation *(C, Michael downing some juice from the refrigerator)*. The family gears up for the holiday with a drum roll of phone calls to family members *(D)*, including Rick's parents and brother, and Pattie's brother, sister-in-law, and niece, all of whom will accept the invitation to come for the holiday dinner. After stocking up at the supermarket in Pearland *(A)*, the Houston suburb in which the Skeens live, Pattie puts together the big meal. The holiday menu: turkey and family prayer *(E)*. The Skeens' Christian faith is a touchstone in their lives. Family members pray together for safety and success in the morning, and at the end of every day parents and children take time to thank Jesus *(B, 10-year-old Julie in foreground)* for the gift of the past 24 hours.

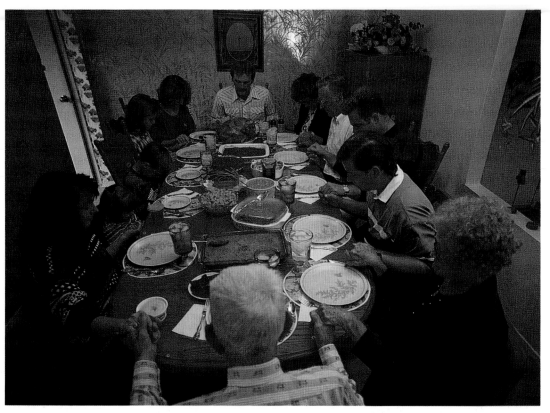

E

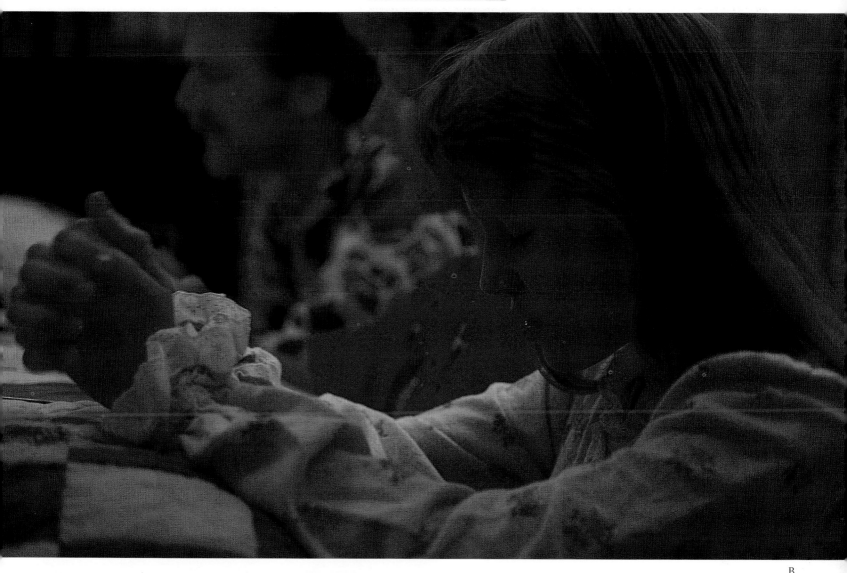

B

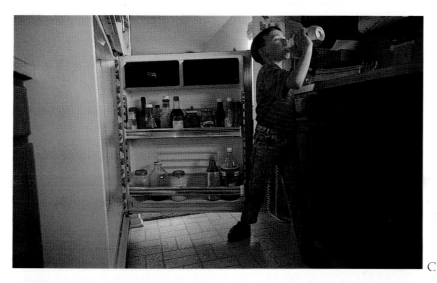

C

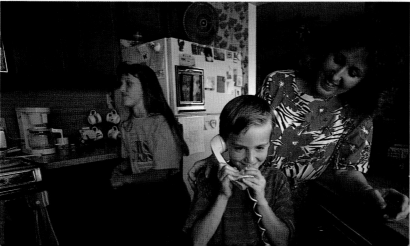

D

UNITED STATES

The strains between religious beliefs and secular ideals have always marked U.S. history, but they have rarely been more evident than now. Although most citizens enjoy the media-saturated prosperity of the middle class, they are increasingly alarmed by the signs of what might be called "moral decay": crime, drug abuse, urban disintegration, high rates of divorce, abortion, and teenage pregnancy. Alarming, too, is another form of decay, environmental degradation. The United States has sharply decreased the air and water pollution caused by its pell-mell growth in the first half of this century, but many ecosystems still face the threat of continued economic expansion. The worst effects of ecological damage are experienced by poor urban communities of minorities — an example of the way most U.S. social problems are complicated by the legacy of slavery. Although reforms in the 1960s created a black middle class, continued racial trauma seems likely. In a demographic shift, the percentage of whites in the populace is declining, which will likely lead to profound changes in a racially uneasy nation. Such uneasy possibilities are one reason that the exhilaration of winning the Cold War has been short-lived. Yet the certainty of future change is nothing new to the United States, which for better or worse has made lack of tradition into a kind of tradition. Indeed, it is perhaps the only nation on Earth whose founders described its creation as an "experiment."

A

PHOTOGRAPHER'S NOTES

LYNN JOHNSON

After so many years photographing homelessness, poverty, AIDS, and dysfunctional families, the caring and happy Skeen family was a salutary shock. At first they seemed so ordinary — their neat suburban house on a cul-de-sac is the very image of America — that I wondered whether I would be able to see them as individuals. The worry increased when Rick asked me not to use their last name, and I imagined pictures of the anonymous-sounding "S—" family. But my fears disappeared quickly when I got to know them, and I saw how hard Rick and Pattie worked to keep their family strong and close. At the same time they had great respect for their children's privacy, knocking on their bedroom doors if they were closed. Discipline was important, but the Skeens also let their hair down. For almost 2 hours one evening adults and children abandoned their chores to shoot rubber bands at each other and put ice down each other's backs. It was about this time that Rick, who worried for obvious reasons about having me there, decided that we could use their last name after all. I think they decided that it would be a way to show their Baptist faith. That faith is the center of the Skeens' lives — a deep, abiding belief that is always there. I saw this on Thanksgiving, which I had thought would be the highlight of my visit, photographically speaking. In fact, it was low-key. There was mega food, but prayer was the important thing. After the meal Rick read the Bible and then asked everyone to tell the group what they were thankful for. Most of the folks cried — quietly — grateful for the love of family and God. As I sat there with my camera, I knew that the lens could never capture the feeling in that room.

B

LIKE FAMILIES throughout the developed world, the Skeens scatter during the day to their various destinations. Rick, a cable splicer (*A, with utility pole decorated for Christmas*), seems to spend as much time in the air or below the surface as on the ground itself. Pattie teaches school at a Christian academy. Seven-year-old Michael spends part of the afternoon with a coloring book given to his school by the National Rifle Association (*C*). The book was intended to teach firearm safety to children — a matter of great concern to his father, Rick, who owns several guns and likes to hunt deer. In the afternoon and evening, the Skeens reconnect. One night a week, they attend evening worship, in preparation for which Rick gives Michael a final touch-up on his hair (*B*).

C

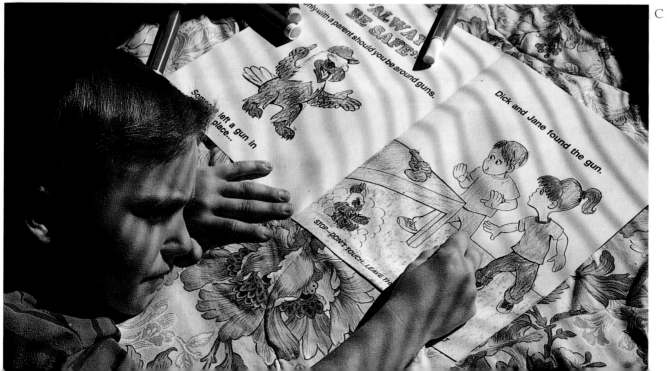

143

Vaulting into the Middle Class

The Castillo Balderas Family

6:30 P.M., AUGUST 28, 1993
GUADALAJARA, MEXICO

BIG PICTURE BY PETER MENZEL

DAILY LIFE PHOTOGRAPHS
BY MIGUEL LUIS FAIRBANKS

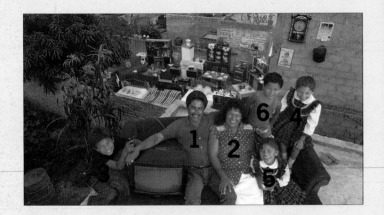

KEY TO BIG PICTURE

1. Ambrosio Castillo Cerda, father, 29
2. Carmen Balderas de Castillo, mother, 25
3. Cruz Castillo Balderas, 1st son, 10
4. Nayalit Castillo Balderas, 1st daughter, 8
5. Brenda Castillo Balderas, 2nd daughter, 7
6. Marco Antonio Castillo Balderas, 2nd son, 5

OBJECTS IN PHOTO

(Foreground)

- Toy pistol (held by 1st son)
- Couch
- Television (color)

(Courtyard, clockwise from lower left)

- Wardrobe (with clothes)
- 2nd couch, love seat, easy chair (set with 1st couch)
- Potted plants (7, on wall)
- End table (with figurines)
- Coffee table (with plastic flowers)
- Stereo cabinet (with 1st stereo, figurines)
- Electric fan
- Arc welder (on wall)
- Refrigerator (with onion bowl)
- Table (with tiny wine barrel, mixer, mortar and pestle)
- Water bottles (2, on wall)
- Washing machine
- Stereo speakers (with model bulls)
- Stereo shelf (with 2nd stereo, tapes, LP records)
- Tables (2)
- China cabinet with china
- Small bookcase (behind cabinet)
- Broom, tapes, clocks (2), shoes (6 pairs), mirror, calendar, welding mask, prints (on walls)
- Stove (with pots and pans)
- Kitchen utility cabinet (with iron, utensils, dry food)
- Dresser (with beauty items)
- Beds (3, 1 with toys)

(On roof)

- Clothesline (with clothes), potted plants (3), bicycles (3), dog (Tori)

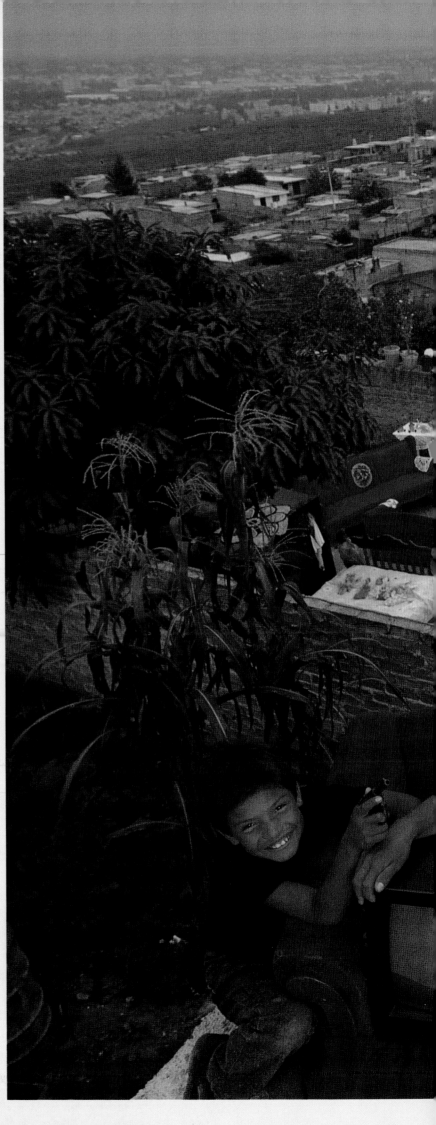

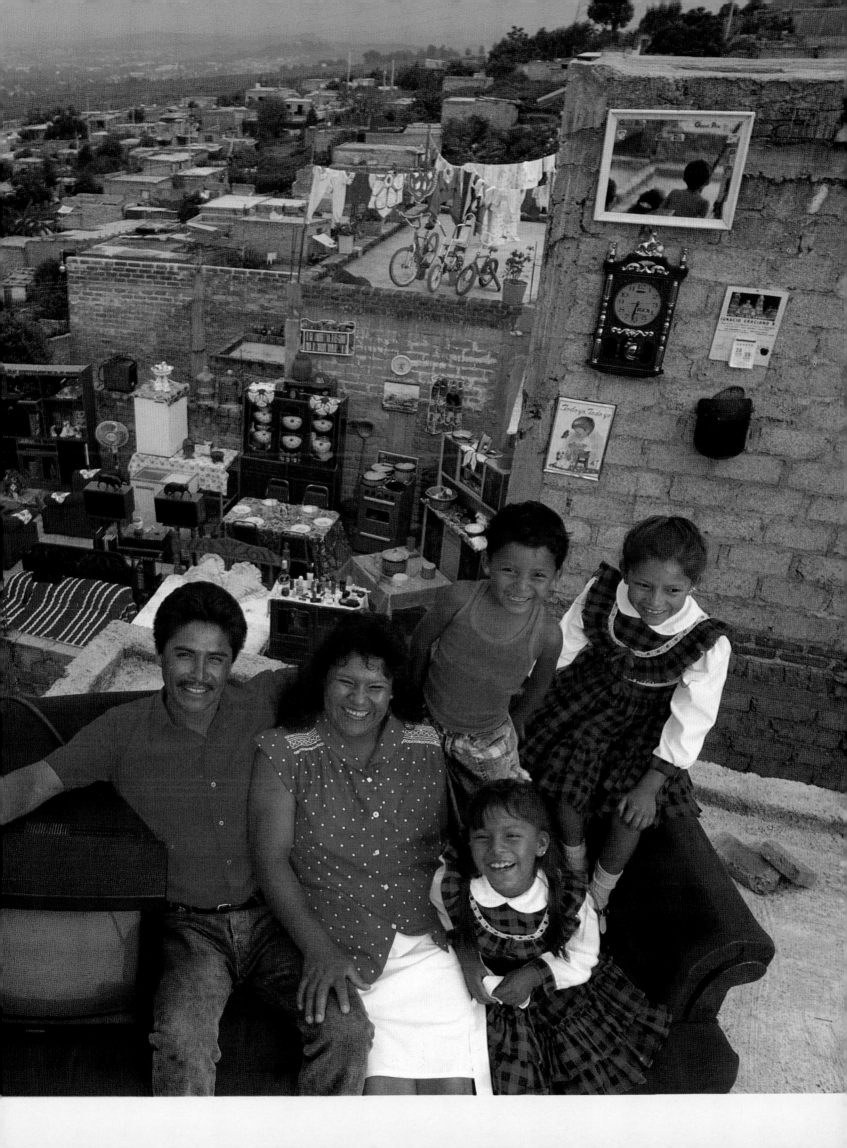

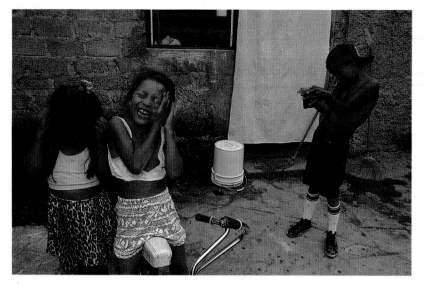

A

THE WALLED COURTYARD behind the house is the focus of daily activity in the Castillo Balderas household. It is where Ambrosio has his welding set-up and works on construction projects around the home. Carmen's washing machine is there, because the courtyard is the site of the family's water supply (a garden hose connected to a public water main several hundred yards away). On school mornings, the courtyard is the scene of the girls' pre-school hair and clothing inspection (B, braiding Nayalit's hair). And it provides the children with a safe playground in a rough neighborhood (A, Cruz squirting his sisters).

MEXICO

STATS

Area
755,985 sq. mi.
(1,957,986 sq. km.)

Population
93.7 million

Population density
124 per sq. mi. (47.9 per sq. km.)

Total fertility rate
3.2 children per woman

Population doubling time
34 years

Percentage urban/rural
75% urban, 25% rural

Life expectancy
Female: 73, Male: 67

Infant mortality
35 per 1,000 births

Population per physician
1,001

Literacy rate
Female: 85%, Male: 90%

Number of years ruling party has governed Mexico without interruption
65

Rank of affluence among the 183 U.N. members
51

At the time Columbus sailed, the Americas had about as many inhabitants as Europe. Most of them were in Mexico; with its 2 million people, the Aztec capital of Tenochtitlán may have been the biggest city in the world. The arrival of the Spaniards brought smallpox and other diseases, which wiped out more than 90 percent of the original inhabitants. Indeed, Mexico's population did not reach pre-colonial levels until the middle of this century. By that time, prospects had changed. Now a republic, Mexico was on the course that would lead it to become an industrial power. The transformation, which is rapidly occurring, has led to staggering disparities, much as it did in the United States, its neighbor to the north. Even as the middle class swells, services stagger to keep up, and the shanties of the underclass circle big cities. Birth rates, once high, are falling. Meanwhile, the southern forests are vanishing, the northern rivers are thick with pollution, and, in the center, Mexico City has what may be the world's worst air. Willy-nilly, the nation will test the assertion that the best preventive of environmental collapse is economic prosperity.

B

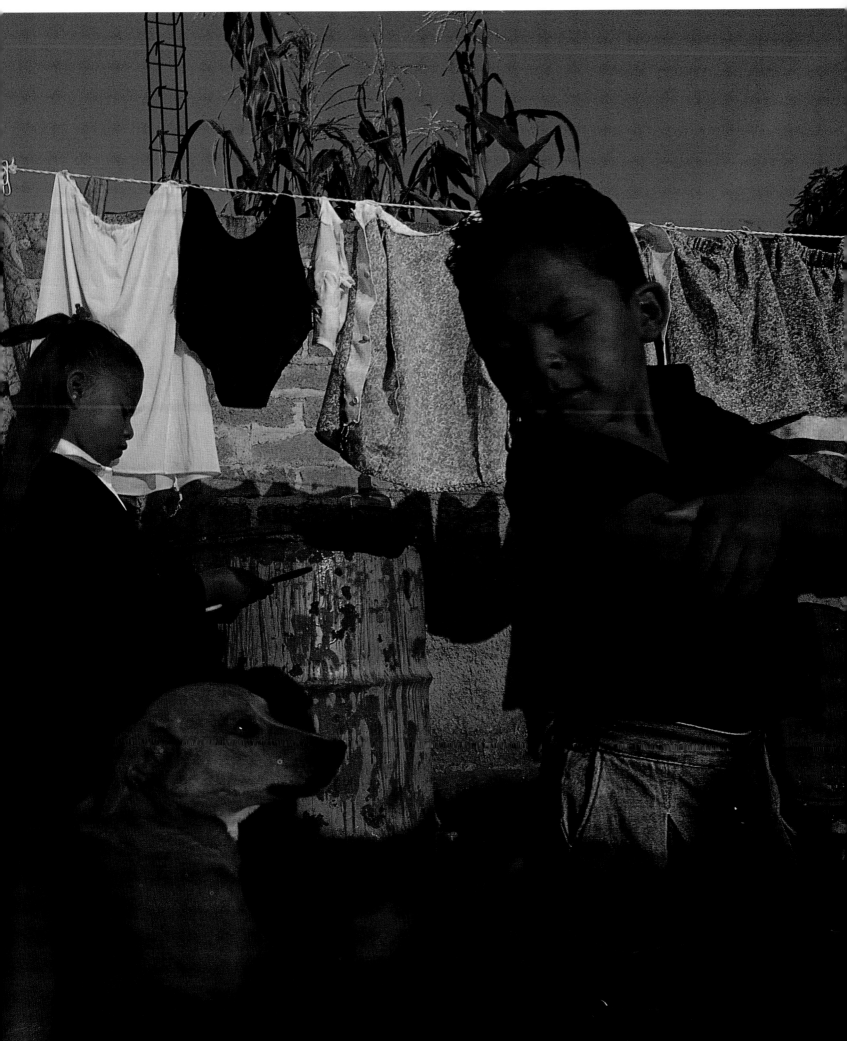

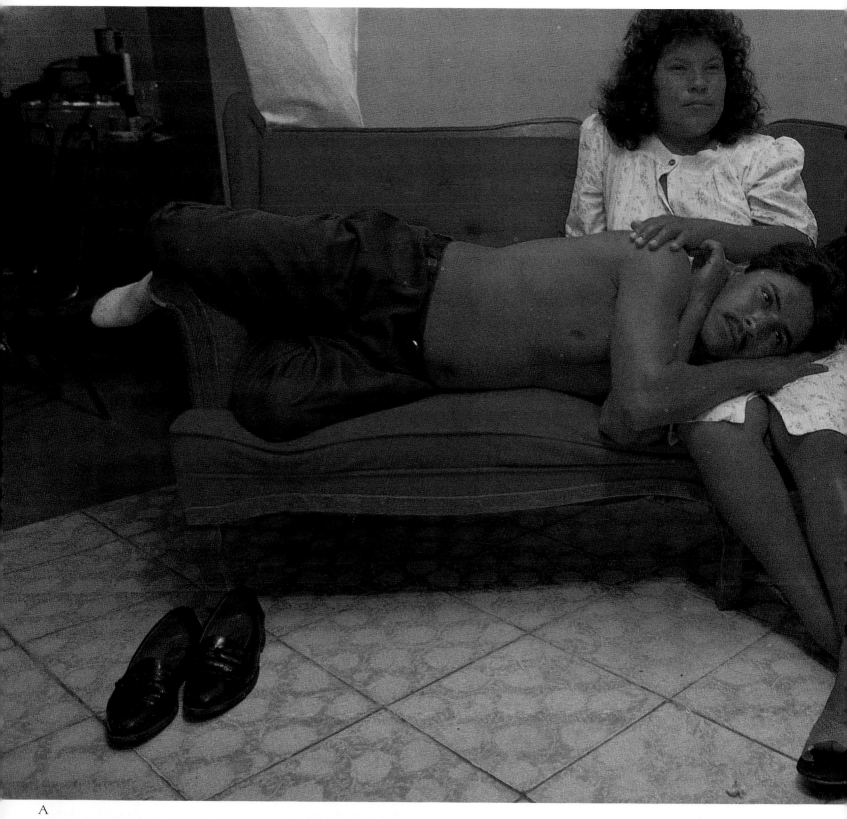

A

E

D

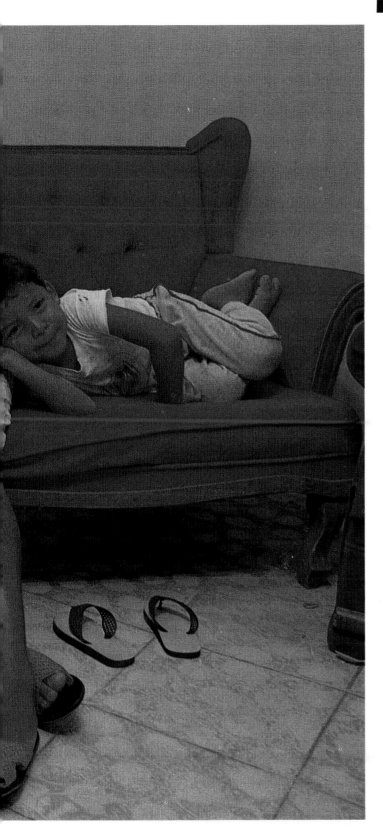

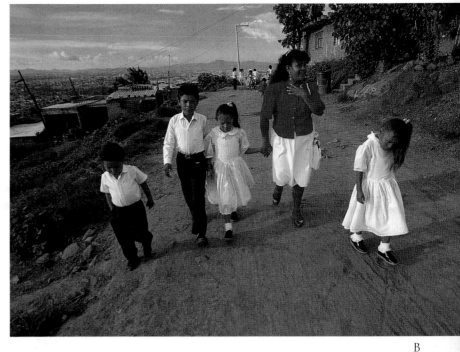

B

A MAN IN PERPETUAL MOTION, Ambrosio is simultaneously finishing the family house, working on free-lance welding jobs, and holding down his day job at a wholesale produce distributor (*E, taking a 10-second break*), where he loads boxes of carrots, chiles, eggs, and tomatoes into trucks bound for Michoacàn, the neighboring state to the south. He leaves for work at about 4:00 a.m., and after a hard day is glad to spend the evening in front of the television with his family *(A)*. Carmen does not work outside the home, but has plenty to keep her busy. Meticulous by nature, she keeps the household spotless and tightly organized. Sometimes that's not easy — in the parents' upstairs bedroom (*C, Carmen changing the sheets*), the doorway opens onto a 10-foot drop, because Ambrosio has not yet constructed the requisite stairs. For now, they climb up through a hole in the floor on a cramped temporary spiral staircase welded together by Ambrosio. The children attend Mexican Heroes elementary school, named after a group of children who died in the Mexican revolution of 1910. The first day of kindergarten for 5-year-old Marco Antonio becomes briefly tragic when his mother leaves the classroom *(D)*. Five days later, he is all smiles as he walks with his mother to the Jehovah's Witness storefront church attended by the family *(B)*.

PHOTOGRAPHER'S NOTES
MIGUEL LUIS FAIRBANKS

On the fifth day that I spent with the Castillo Balderas family, Ambrosio said, "I still can't believe I agreed to have you guys do this project on my family — it's so unlike me." A shy, private man, Ambrosio wouldn't let me photograph him at work, claiming (accurately, I'm sure) that his coworkers would laugh at him for weeks. Finally I came up with a plan. I would show up and photograph his coworkers, thus shifting all the chiding and jokes onto *them*. I wouldn't even acknowledge Ambrosio, but sneak a few shots of him in the hustle. It went off without a hitch, and to his vast relief nobody suspected a thing. The kids, by contrast, were thrilled to have me around, especially at school. Carmen and I took Antonio to his first day of kindergarten. He was all right until she left the classroom. Then he suddenly wailed and clutched *my* hand. The teacher asked if I were his father. "No," I said, "just a friend."

C

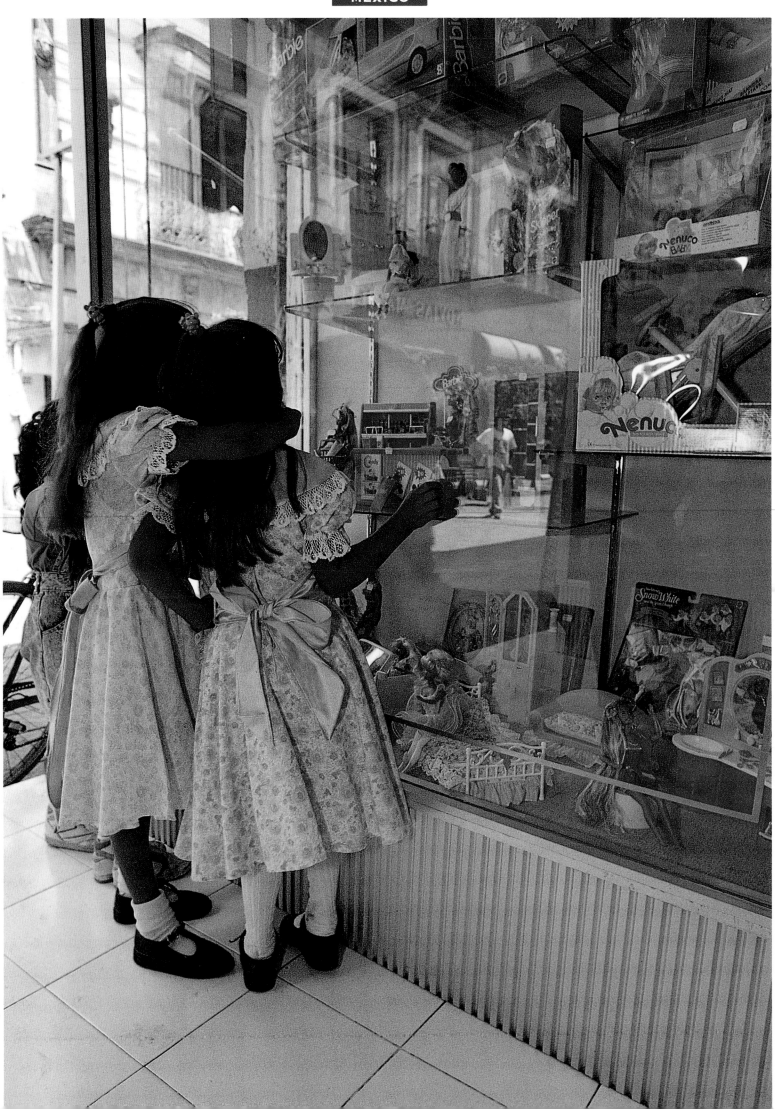

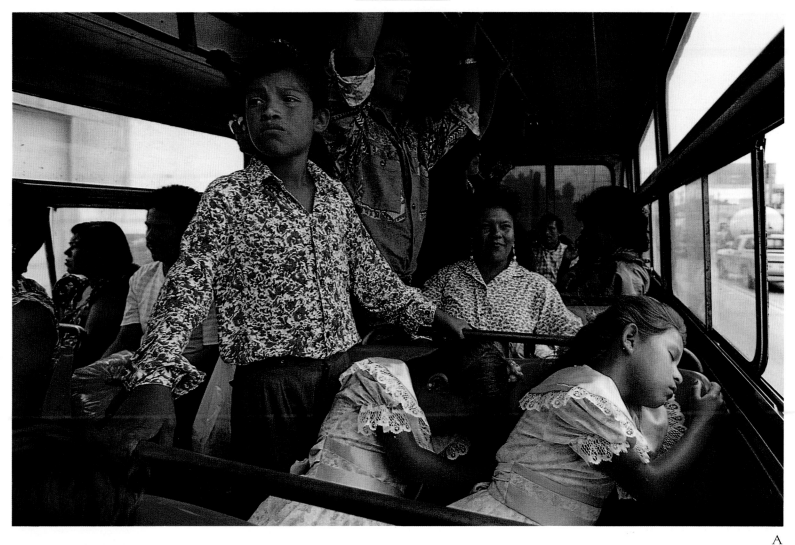

A

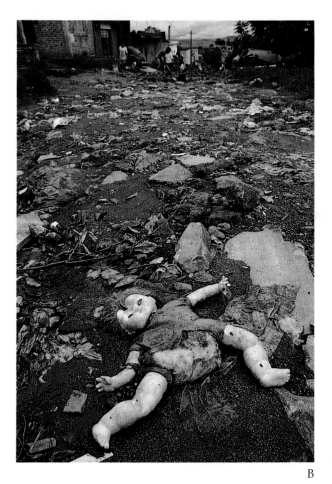

B

CASTILLO BALDERAS FAMILY

Size of household
6

Size of dwelling
700 sq. ft. (65 sq. m.)
(2 bedrooms, kitchen, living room)

Workweek
36 hours (Father —
salaried work only)
60 hours (Mother — in home)

Number of
Stereos: 2,Telephones: 0,
Televisions: 1, VCRs: 1,
Automobiles: 0

Most valued possessions
Television (Family as whole)
Stereo (Father)
Bible (Mother)
Bicycle (1st son)

Per capita income ($US)
$2,971

**Percentage of Castillo Balderas
family income spent on food**
57%

**Percentage of Castillo Balderas
family income spent on clothing**
28%

Wishes for future
Truck

SHOPPING for school supplies, the entire Castillo Balderas family boards the bus (A) from Buenos Aires, the neighborhood in which they live, to a shopping district in downtown Guadalajara. After much enjoyable window-shopping *(facing page)*, the children get shoes, school backpacks, and — a special treat — ice cream cones. On the way home with their bundles, they pass from the glass and pavement of the old city to the littered and impassable dirt roads of their own district *(B, a typical street there)*. Like many Mexican neighborhoods, Buenos Aires began as a squatters' camp. As its residents acquired jobs, it became more permanent. People built homes and jury-rigged a water supply. They voted, causing politicians to pay attention. As a result, the infrastructure has been catching up — slowly. Meanwhile, the Castillo Balderas family must make the daily transition between the tidy order of their home and the civic confusion immediately outside their walls.

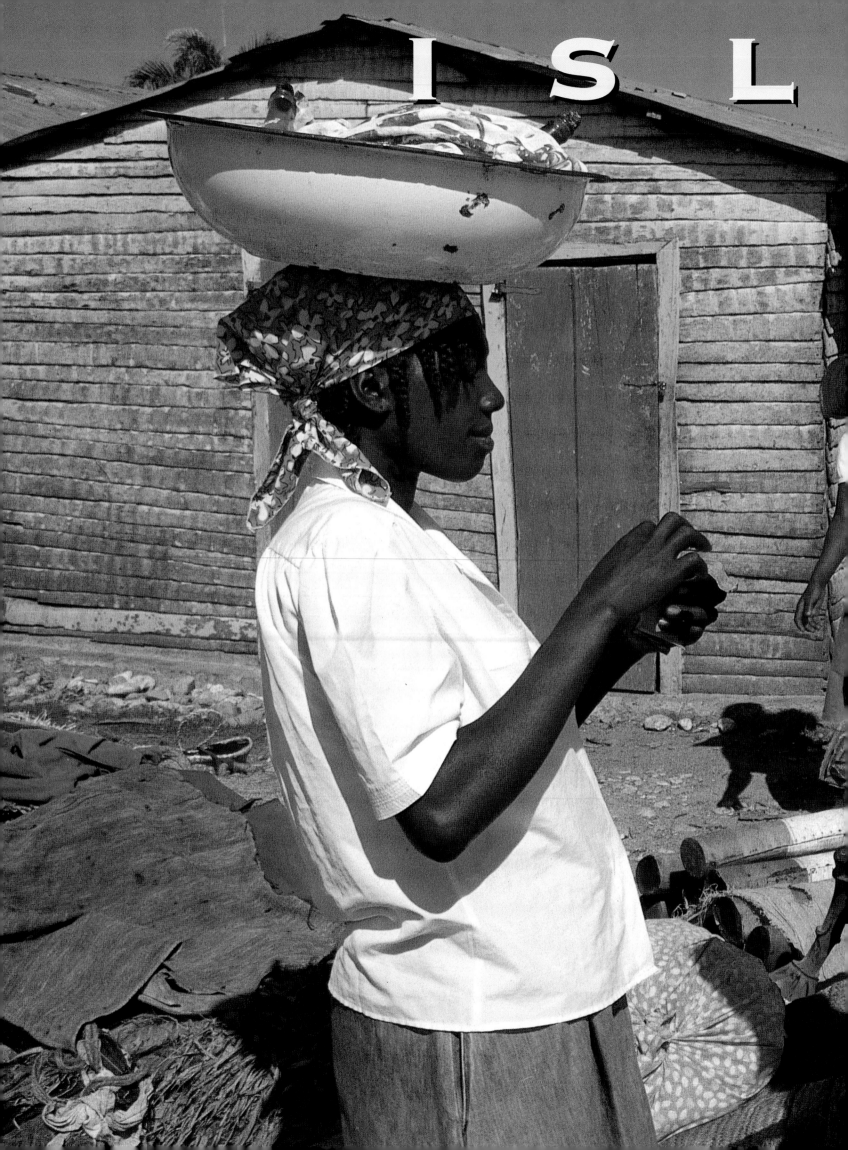

A N D S

FRIENDS TALKING AT MARKET
MAISSADE, HAITI
PHOTOGRAPH BY ROBB KENDRICK

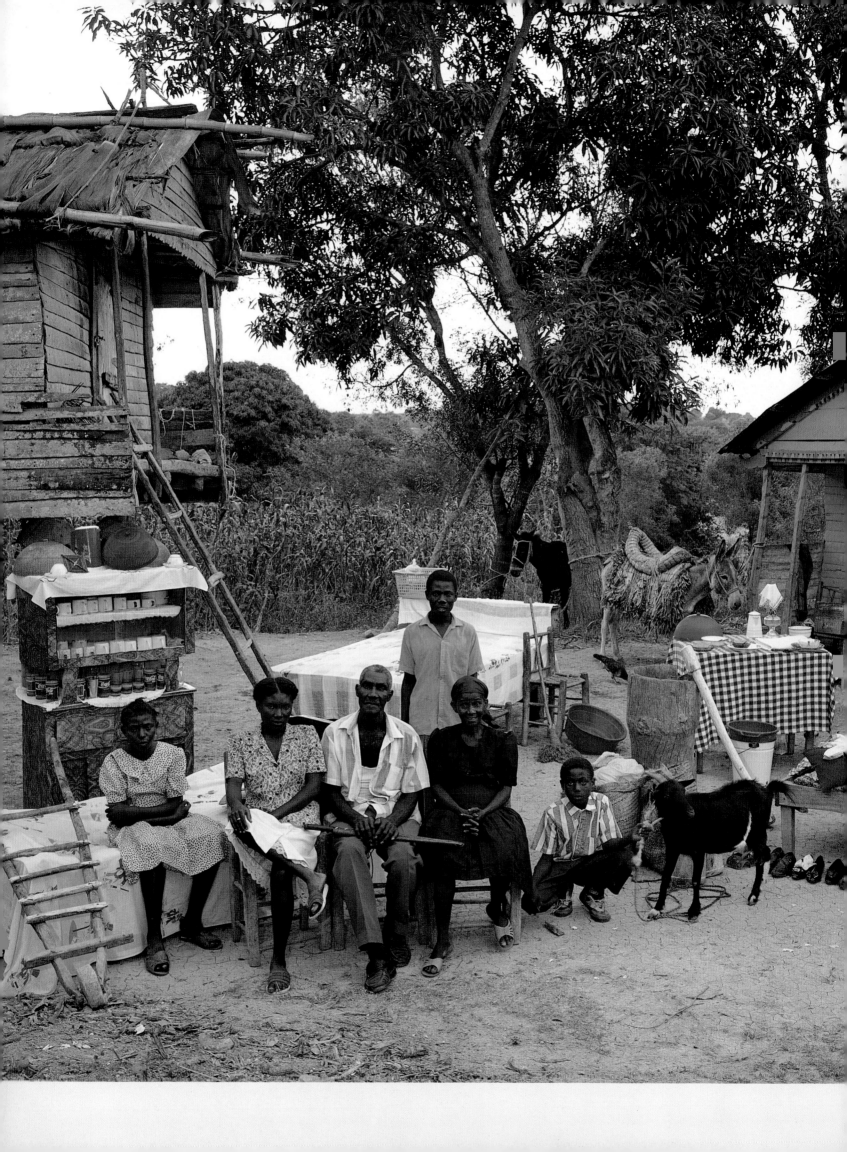

HAITI

Tragedy upon Tragedy

The Delfoart Family

4:30 P.M., JANUARY 20, 1994
MAISSADE, HAITI

BIG PICTURE BY ROBB KENDRICK

DAILY LIFE PHOTOGRAPHS
BY ROBB KENDRICK AND SHAWN G. HENRY

KEY TO BIG PICTURE

1. Dentes Delfoart, father, 54
2. Madame Dentes Delfoart, mother, 40 (after marriage, no longer uses her first name)
3. Jean Donne Delfoart, son, 18
4. Lucianne Delfoart, daughter, 15
5. FiFi Delfoart, daughter, 14
6. Soifette Delfoart, son, 8

OBJECTS IN PHOTO

(Foreground, left to right)

- Wheelbarrow (used by kids to play; occasionally to carry water)
- Bed (beneath 2nd daughter)
- Machete (held by father)
- Chairs (3, beneath parents, eldest daughter)
- Goat (held by youngest son)
- Saddle bags for donkey and bag of millet (behind goat)
- Toy VW bug (below goat, missing 4 wheels)
- Extra shoes (4-1/2 pairs)
- 2nd bed (old clothes used as mattress)
- Hoe and pestle (leaning on bed)

(Rear, left to right)

- Pantry cabinet with glasses (most with Coca-Cola logo), coffee mugs, trivet, plastic pitcher, plastic covers for food

- Storage hut for grain and clothes (raised to avoid rodents, ladder to enter)
- 3rd bed
- Chairs (2, one behind eldest son)
- Plastic washtub, wood and rope mop (leaning on chair)
- Horse, chicken, and donkey with saddle
- Mortar (looks like tree stump) and pestle
- Plastic buckets (2, one inside the other)
- Plastic basket (green, in buckets)
- Tables (2)
- Crockery, coffeepot, oil lamp (on left table)
- Thermos, 4 felt hats (on right table)
- Chairs (2, boxes on them)
- Towel and dress (on chair to right of house)

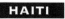

A

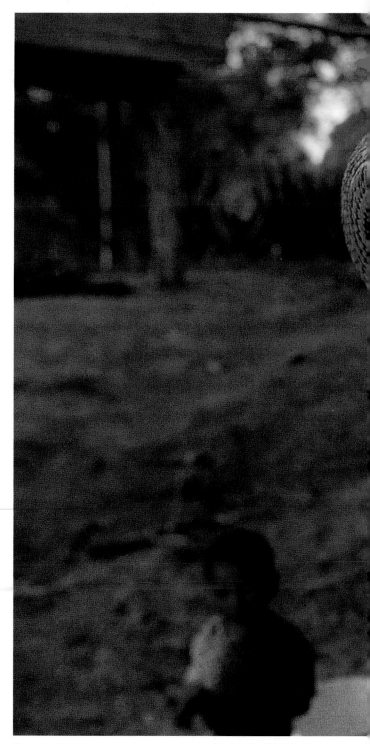

B

HAITI
HAÏTI

STATS

Area
10,811 sq. mi. (28,000 sq. km.)

Population
7.2 million

Total fertility rate
4.8 children per woman

Population doubling time
34.5 years

**Percentage of change
in per-capita food production
from 1979-81 to 1990-92**
−18%

**Percentage of energy generated
by traditional fuels
(wood, charcoal, dung)**
85%

Life expectancy
Female: 56, Male: 53

**Rank of death rate
among American nations**
1

Literacy rate
Female: 47%, Male: 59%

**Rank of affluence
among the 183 U.N. members**
147

The forested western end of the island of Hispaniola, Haiti has been the scene of almost unrelieved tragedy since it was observed by Columbus in 1492. Within a century, Spain slaughtered the original inhabitants. After Haiti was ceded to France, it became the richest colony in the Americas, though 9/10ths of its people were slaves. After a slave revolt, Haiti became, in 1804, the second American nation to gain independence. A line of despots ensued, and revolts against them; in 1915 the U.S. came in. Only in the 1940s did Washington cede control. François Duvalier, elected in 1957, turned Haiti into a police state that he ruled until his death in 1971. After an interregnum, the army took over, promising reform but delivering repression. Jean-Bertrand Aristide, a populist priest, won elections in 1991 but the military soon ousted him. International condemnation led to a trade embargo, concessions by coup leaders, the reneging on those concessions, and renewed embargoes. Nobody knows what will happen, but history gives little reason for optimism.

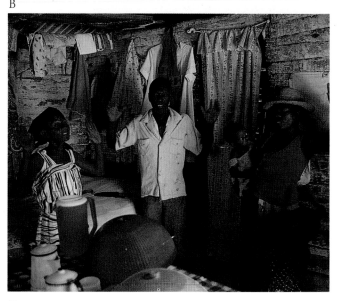

D

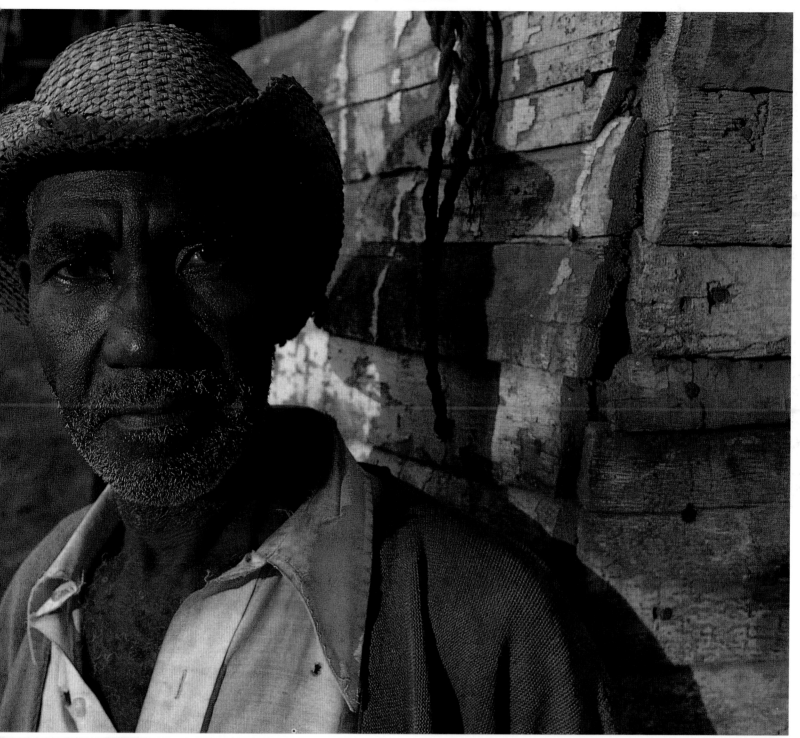

C

AT THE AGE OF 54, Dentes *(B)* does not expect to see radical changes in his life. He makes what money he can, buying what he needs when the family has the cash; with prices seeming to rise constantly, he has little ability to envisage a sunny future for his children *(A, Soifette pushing a friend in the wheelbarrow)*. On difficult days the family's Baptist faith is a major comfort. The Delfoarts pray at meals, sometimes hosting one of Haiti's many traveling preachers *(D, standing to give blessing, Madame at left, her nephew's wife at right with her baby)*. All meals are cooked in the separate kitchen *(C)*, a dirt-floored shelter with a hole in the roof to let out smoke. The intent is to prevent the soot and smoke of the cooking fire from making life unpleasant in the main house — a scheme that works for everyone but the cook (usually Madame). Fed by charcoal or wood, the fire burns in the cookhouse 3 to 4 hours per day. Fortunately for the family, they live in one of Haiti's more wooded areas, and fuel is as yet not in short supply.

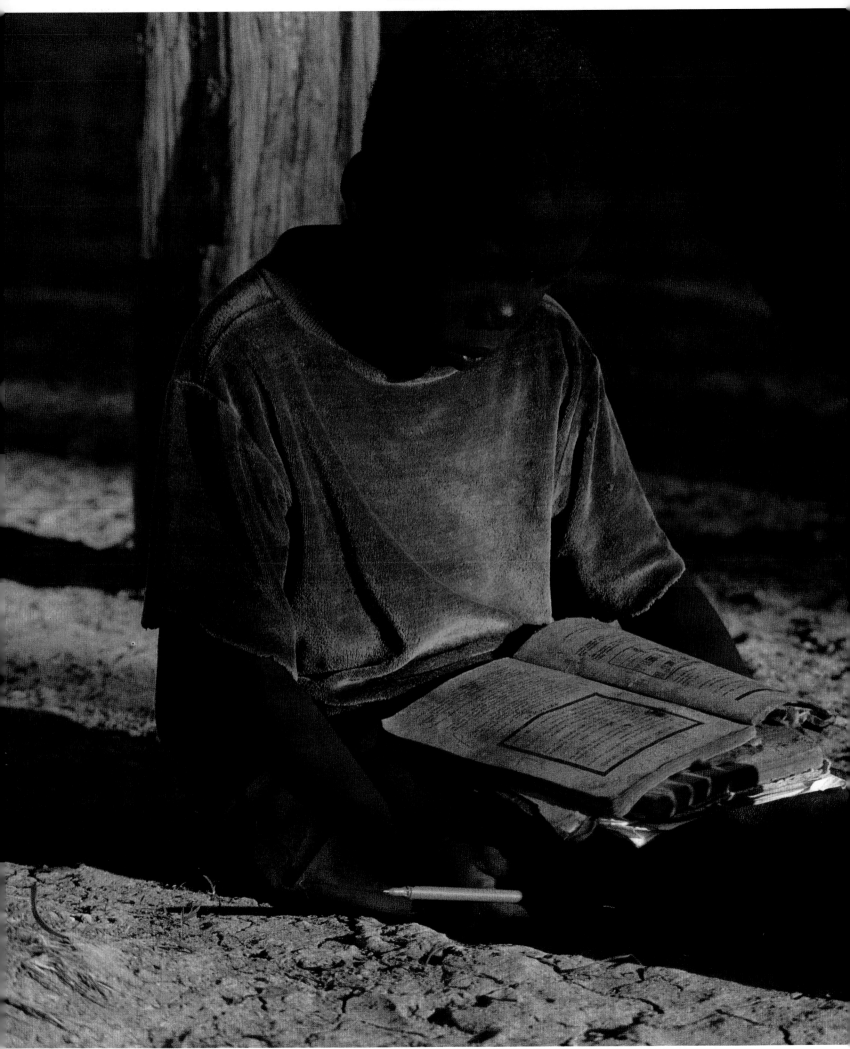

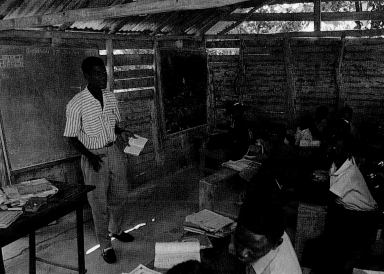

B

IN THE ONE-ROOM SCHOOLHOUSE, students ranging in age from 6 to 18 listen attentively to the lesson *(B)*. Because the textbooks are written in French, Haiti's second official language, Jean Donne, Lucianne, and Soifette have picked up some of that language, though Creole is exclusively spoken at home by their parents. The school is only a 400-yard (370-m.) walk away from the Delfoarts' home, but the distance might as well be light-years for 14-year-old FiFi. Shy and slow to learn, she has been chosen by the parents as the child who will stay at home and help them with the tasks they cannot perform themselves. As a result, she pounds grain, fetches water from the well, and scours the dishes with sand *(C)* while her siblings attend classes and pore through their tattered textbooks. The books have been read nearly to pieces; the pages of the local children's primers *(A)* are crackling and almost transparent with age. But to FiFi, who wishes that life would make it possible for her to be in school, these shabby books seem desirable indeed.

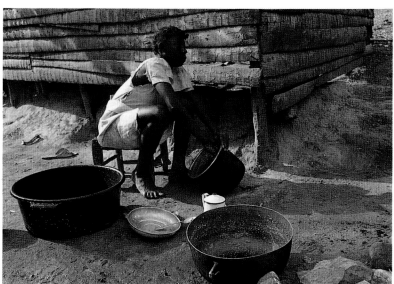

A C

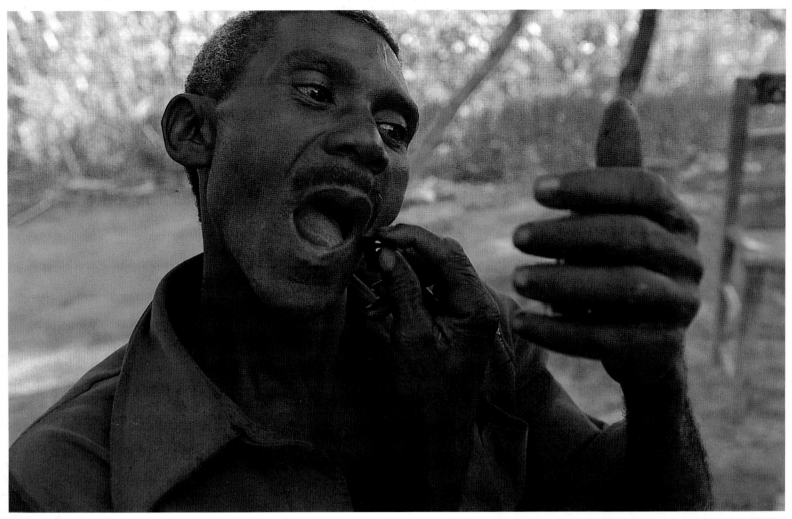

A

DELFOART FAMILY

Size of household
6

Size of dwelling
325 sq. ft. (30 sq. m.)
(3 buildings: 2-room main house,
detached kitchen, storage shed)

Workweek
60 hours (Father)
55 hours (Mother)
30 hours (Each child)

Number of
Radios: 0, Telephones: 0,
Televisions: 0, VCRs: 0,
Automobiles: 0

Most valued possessions
None (Father — says he owns no
possession of value)
None (Mother — same reason)

Per capita income ($US)
$374

**Percentage of Delfoart family
income spent on food**
80%

Typical breakfast
Manioc, potatoes, smoked fish, coffee

Typical lunch
Potatoes

Typical dinner
Nothing

PHOTOGRAPHER'S NOTES
ROBB KENDRICK

The Delfoarts grew up unschooled and illiterate and wanted better for their children. It didn't work out that way. Their children did go to school and learned to read, but other than that life is not better. Nonetheless, they had come to terms with their lives, I thought. And they were wonderfully kind to me, though they got scared when my interpreter told them threateningly that helping us would draw the attention of the military and the Tontons Macoutes (the paramilitary squads set up by the Duvaliers to enforce their orders). Fortunately, the threat turned out to be empty, although it caused a commotion at the time. The interpreter got his own back, I guess. On the night-time return trip to Port-au-Prince, a jeepload of soldiers drove by us and suddenly stopped. Then they got out and searched us and the car at riflepoint. There was no contraband of any kind, so they let us go. We all got an adrenaline surge, but the most frightened of all was the interpreter. It sounds unkind, but after what he said to the Delfoarts I was glad to see him get the shakes.

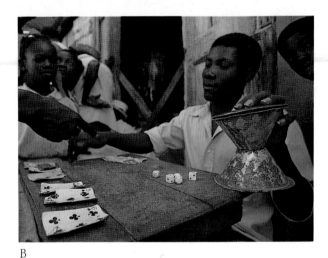

B

EVERY THURSDAY is market day in Maissade, the inland town just outside of which the Delfoarts live. Before setting off, Dentes and a neighbor suffer through their weekly shave with a dry blade and a shard of mirror (A, *neighbor shaves in Delfoarts' yard*). Then Dentes dons his best sweater and a straw hat, going off to the Maissade market with friends to socialize. Meanwhile, Madame carries sugar and millet into town to sell (or, sometimes, trade for items like tobacco). On this morning the roads are crowded with people coming to buy and sell (*facing page*). The market is large and well organized, with a place for everything — even the gambling (B) that attracts the young men.

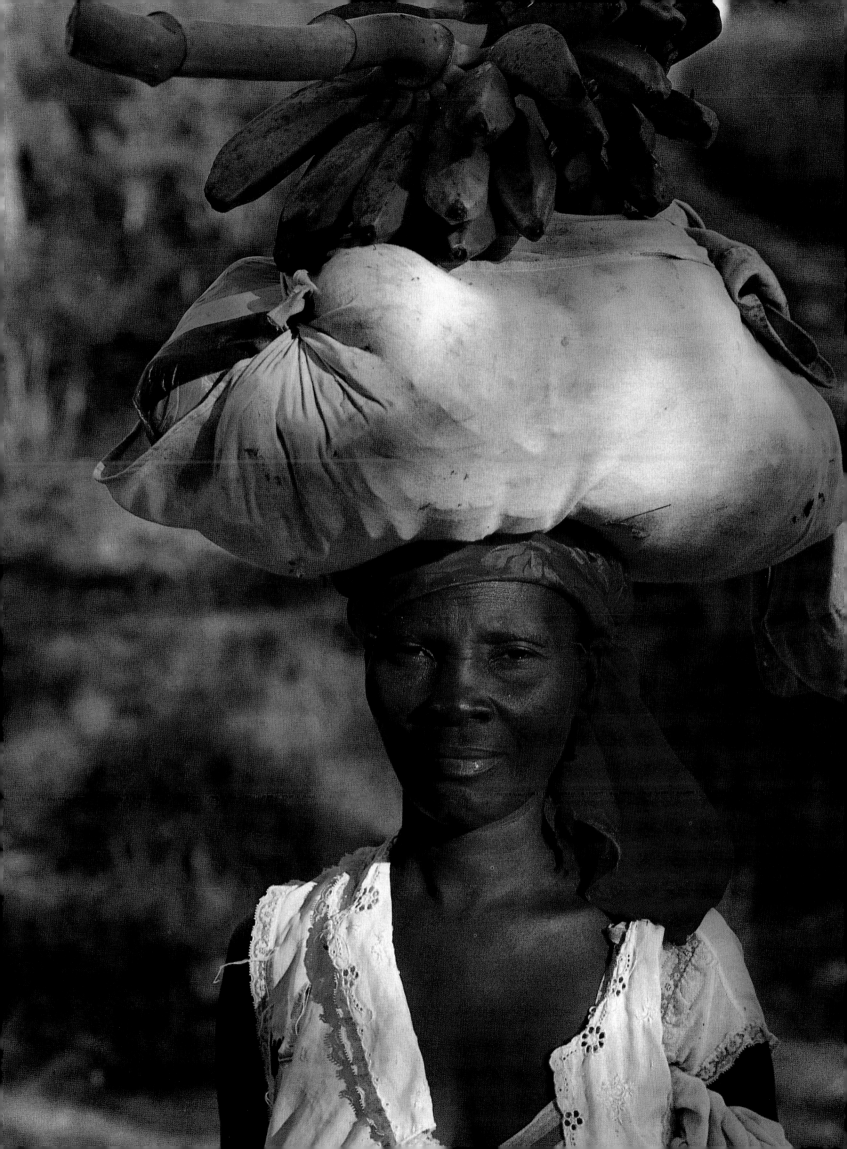

Fire and Ice

The Thoroddsen Family

4:00 P.M., DECEMBER 15, 1993
HAFNARFJÖRDUR, ICELAND

BIG PICTURE BY PETER MENZEL

DAILY LIFE PHOTOGRAPHS
BY MIGUEL LUIS FAIRBANKS

KEY TO BIG PICTURE

1. Björn Thoroddsen, father, 57
2. Margret Gunnlaugsdóttir, mother, 42
3. Sif Hauksdóttir, daughter from mother's 1st marriage, 18
4. Gunnlaugur Björnsson, son, 13
5. Gestur Björnsson, son, 11
6. Thórdis Björnsdóttir, daughter, 7

OBJECTS IN PHOTO

(Left to right)

- Icelandic-breed horses (2 of 4 owned by mother)
- Rug (obscured by horse)
- 150-year-old desk
- Loveseat, chair, and sofa (matching set)
- Damascus-style table
- Swivel chairs (2, one by corner of house)
- 2nd sofa (behind 1st sofa)
- Cars (BMW and Citröen, lights on)
- 2nd desk (for children)
- Toy airplane and helicopter (on 2nd desk)
- Tall shelves with knickknacks
- Parents' bed (queen-size)
- Stroller (not currently in use)
- Cellos (2, with music stand and sheet music)
- 2nd rug (beneath cellos)
- Antique chair (beneath boy)
- Music stool (beneath girl)
- Chest of drawers filled with toys, stuffed animals
- Portable cassette tape player, pink plastic doll house (on chest)
- Childrens' beds (3, around chest of drawers)
- Doll, doll bed, big black toy truck (leaning on foot of nearest bed)
- Toy guns (2), Tony the Tiger bedroom slippers (leaning on head of nearest bed)
- Washing machine, dryer, refrigerator, mixer, toaster, food processer (on patio)
- Stove/oven, pots and pans
- Dishwasher, storage tins
- Storage cabinet
- Eating tables (2, one with lamp and crockery)
- Kitchen chairs (3)
- Tool chest (red)
- Televisions (2, on TV stands)
- VCR and stereo (under right TV)
- Christmas tree
- Shovel (behind tree)
- Bicycles (3, at rear)
- Clothesline with clothes

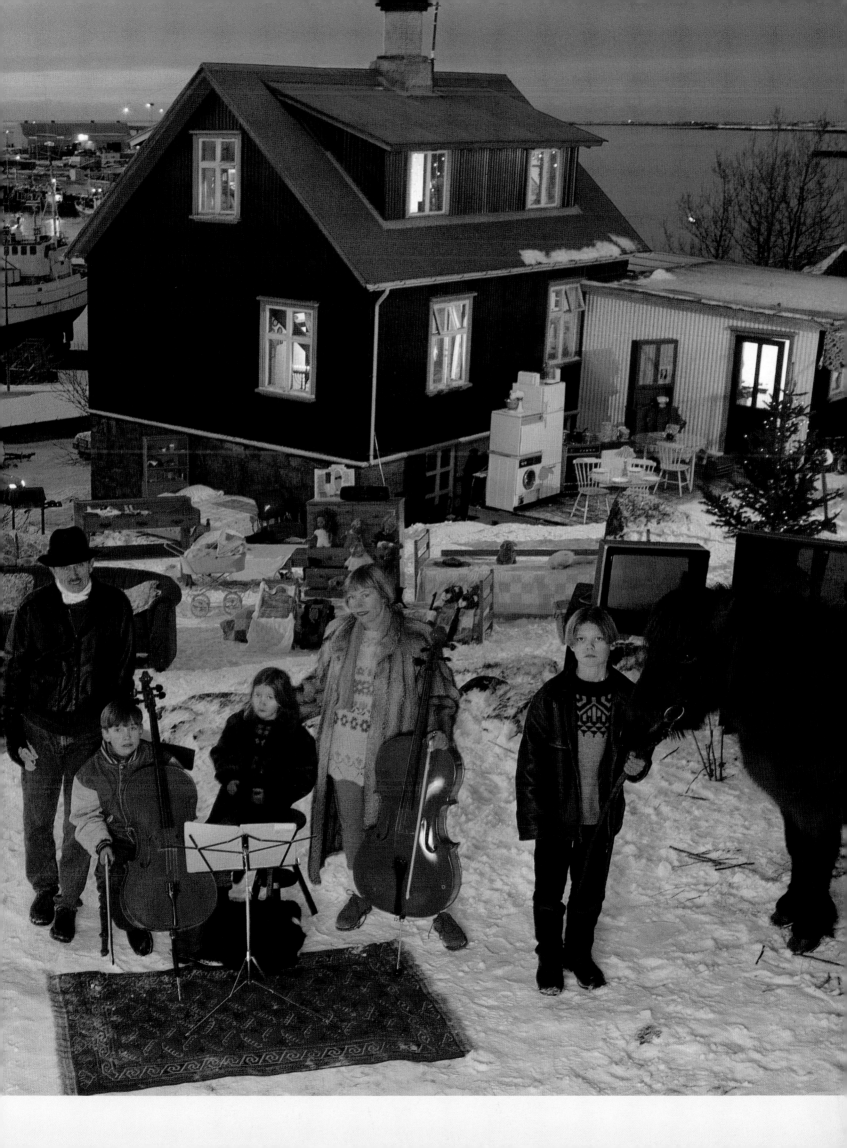

A

B

ICELAND
ÍSLAND

STATS

Area
39,758 sq. mi. (102,972 sq. km.)

Population
0.26 million

Population density
6.5 per sq. mi. (2.5 per sq. km.)

Total fertility rate
2.2 children per woman

Population doubling time
67 years

Percentage urban/rural
92% urban, 8% rural

Rank of per capita electricity use among world nations
2

Rank of fish consumption among world nations
1

Rank of per capita health-care spending among world nations
1

Rank of life expectancy among world nations
2

Rank of affluence among the 183 U.N. members
8

Iceland meets almost all of its energy needs by tapping the heat of its 200 volcanoes and the flow of the rivers on their slopes. Partly as a result, its people enjoy one of the world's highest standards of living while breathing some of its cleanest air. Historically, this state of affairs is a change. Norway and Denmark occupied Iceland for 600 years and kept it in penury. Only in the 20th century could it create a real fishing industry, which became the mainstay of its economy. Independence occurred in 1944, followed by a relatively stable coalition government. Recently a national preoccupation has been protecting the fisheries. Extending territorial waters to a 200-mile limit provoked the "cod war" of 1975, in which Britain severed diplomatic relations. Although mediation resolved the dispute, Iceland and its neighbors will now have to face a larger issue: overfishing. The same fisheries technology that accounts for one-seventh of Iceland's gross national product is wiping out the harvest, and the nation faces a sharp conflict between its long-term and short-term interests.

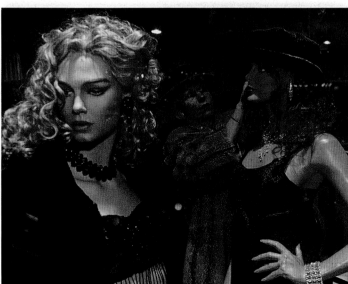

D

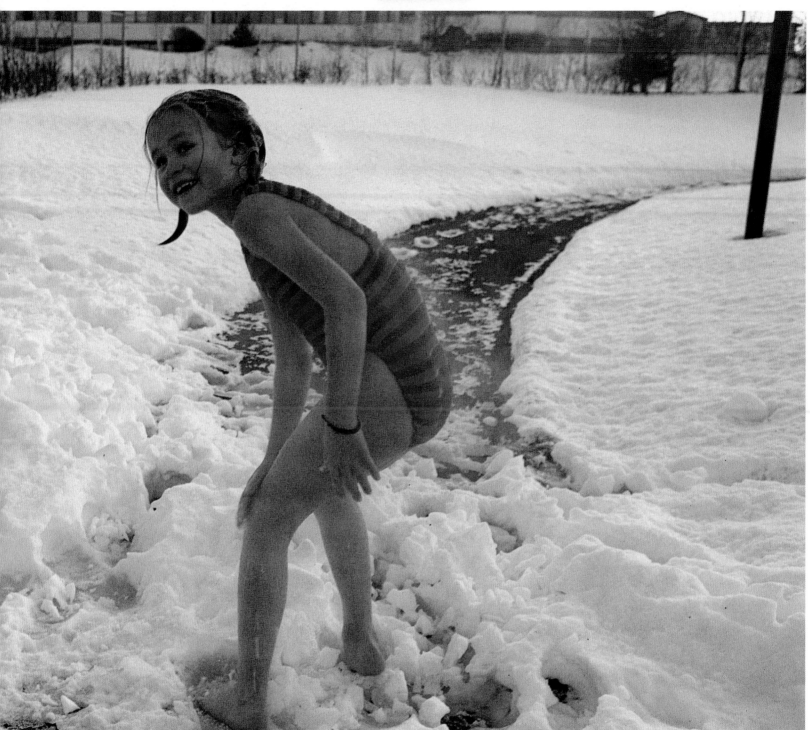

IN THE COCKPIT of an Icelandair 757, Björn *(A)* readies for take-off on a flight to Orlando, Florida. Because he spends so much time either in the air or on the ground in other nations, the majority of the housework and childcare falls to Margret, who balances the chores with a thriving business in custom millinery. In winter, Margret, like many of her neighbors, seldom ventures outside without her furs *(D, at a mall store 15 minutes from their home, one of a growing number of boutiques that take her hats on consignment)*. A conspicuous exception takes place during a weekend expedition to the hot-springs pool in Hafnarfjördur, the family's town, which is 5 miles (8 kilometers) from Reykjavik. Scampering in the snow at the water's edge, 7-year-old Thórdis grins at her daring *(B)*. Afterward, Gestur, her 11-year-old brother, gets in some time with his Super Mario Brothers video game *(C)*. Visible through the windows is the briny clutter of the boats and the fish processing plant about 250 feet away.

C

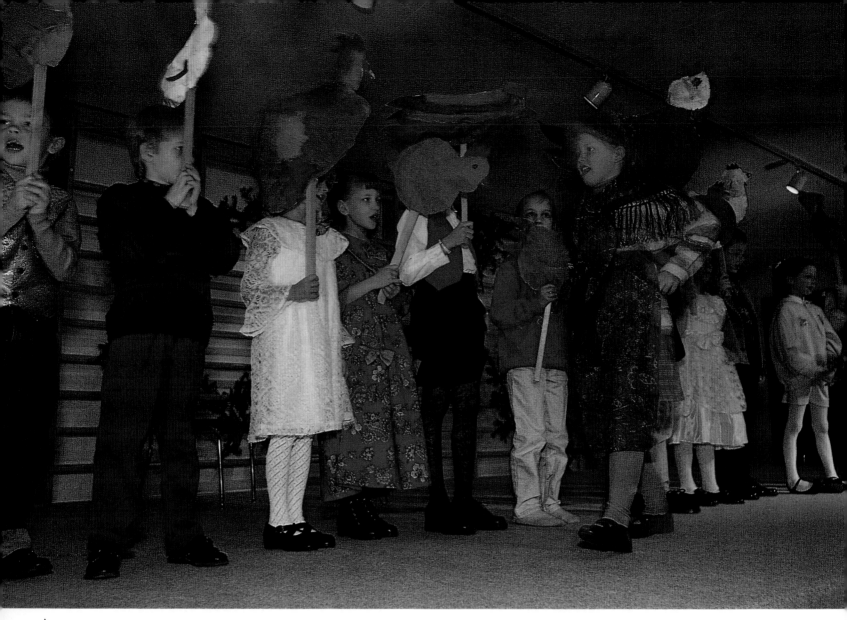

A

PHOTOGRAPHER'S NOTES
MIGUEL LUIS FAIRBANKS

The Thoroddsens have a sense of adventure — Björn flies in his airplane, Margret races around on her Icelandic horses — so they seemed completely unfazed when Americans they had just met ordered a moving crew to empty their house. "You have to take chances in life," Björn told me, and they did with us. It was Margret's birthday, and she seemed quite content to share coffee, gifts, and birthday wishes with her friend as the mayhem erupted around her. Complicating matters considerably was the fact that Iceland has only four hours of sunlight a day in December. At 10:00 a.m. it was still dark, and when we finished the Big Picture at 3:30 it was dark again. Fortunately, the horses were willing to stand patiently throughout the entire episode (I'd never heard of Icelandic horses before — they're a chunky, shaggy breed with an unusual gait called the *tölt* that is a kind of super-smooth trot). Because there is no wood to burn, houses in Iceland rarely have fireplaces. Instead, the heat comes from the volcanic activity beneath Iceland — natural heat, straight from the earth. The geothermal heat creates hot springs, and we saw platoons of people swimming outside in December with 2 feet of snow on the ground. Looking at the glaciers and tundra not far from where these people were contentedly swimming, I couldn't help thinking of the marvelous human ability to adapt. Life on this small, cold, sparsely settled island is pleasant indeed — except (in my opinion) for the fish-liver oil that people here swallow to obtain vitamin D, which no amount of tooth-brushing would remove during the day I sampled it.

EIGHT DAYS before Christmas, the three youngest children return to Olduhinsskoli Elementary School for the annual Christmas pageant (A). With anxious mothers and fathers, including Margret and Björn, watching from folding chairs, the children retell Nordic winter tales in their high, piping voices. When each class has had its turn and the room fills with applause, the children are at last completely free. Thórdis (C, at left) spends much of the vacation with her best friend, Rebecca (center). In a bit of luck, Rebecca's mother is also one of Margret's best friends; the two women can visit while their children play in the other end of the house (B). At their feet, Scotty the dog alertly watches for any morsel of food that might fall to the floor.

NEXT SPREAD: Half an hour away from the Thoroddsens' home is the Blue Lagoon, a surreal-looking spa created by the Svartsengi power plant. Pumping 470°F (243°C) water from up to 1-1/4 miles beneath the earth, the plant generates electricity — and a somewhat cooler runoff that is rich in the kind of silicates and salts loved by devotees of mineral baths. Bathing is permitted only in the 2.5-acre (1 ha.) patch of the lake in which the water temperature is tolerable.

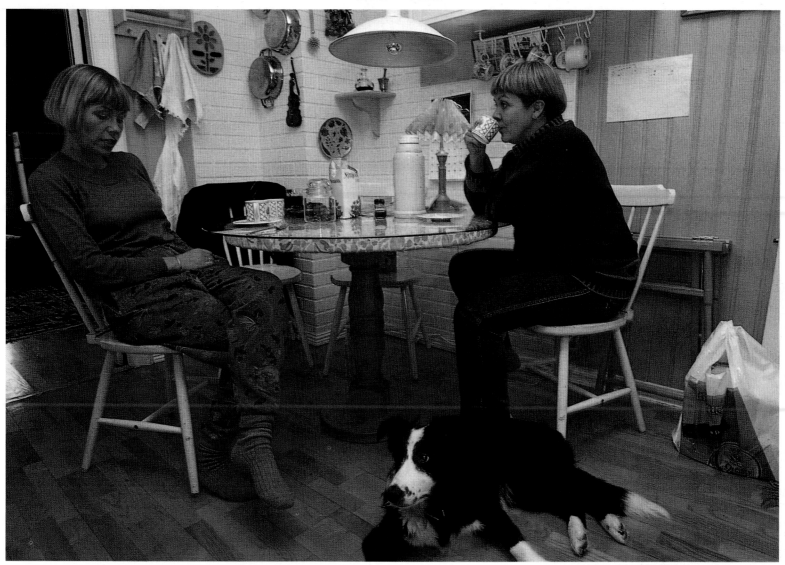

B

THORODDSEN FAMILY

Size of household
Approx. 2,000 sq. ft. (186 sq. m.)
(3 bedrooms, kitchen, living room,
den, bathroom)

Work schedule
(Father–pilot's rotation)
22 days per month in winter,
18 days per month in summer
(Mother–variable, makes hats)

Number of
Radios: 2, Stereos: 1, Televisions: 2,
VCRs: 1, Computers: 1,
Automobiles: 2, Horses: 4

Most valued possessions
Private airplane (Father)
Cello (Mother)
Horse (Elder daughter)
Knife (Elder son)
Antique pistol (Younger son)
Not sure (Younger daughter)

Per capita income ($US)
$23,324

**Percentage of Thoroddsen
family income spent on food**
22%

On taxes
56%

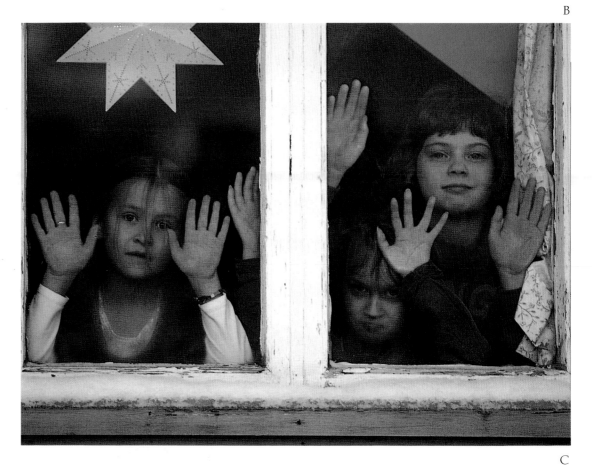

C

167

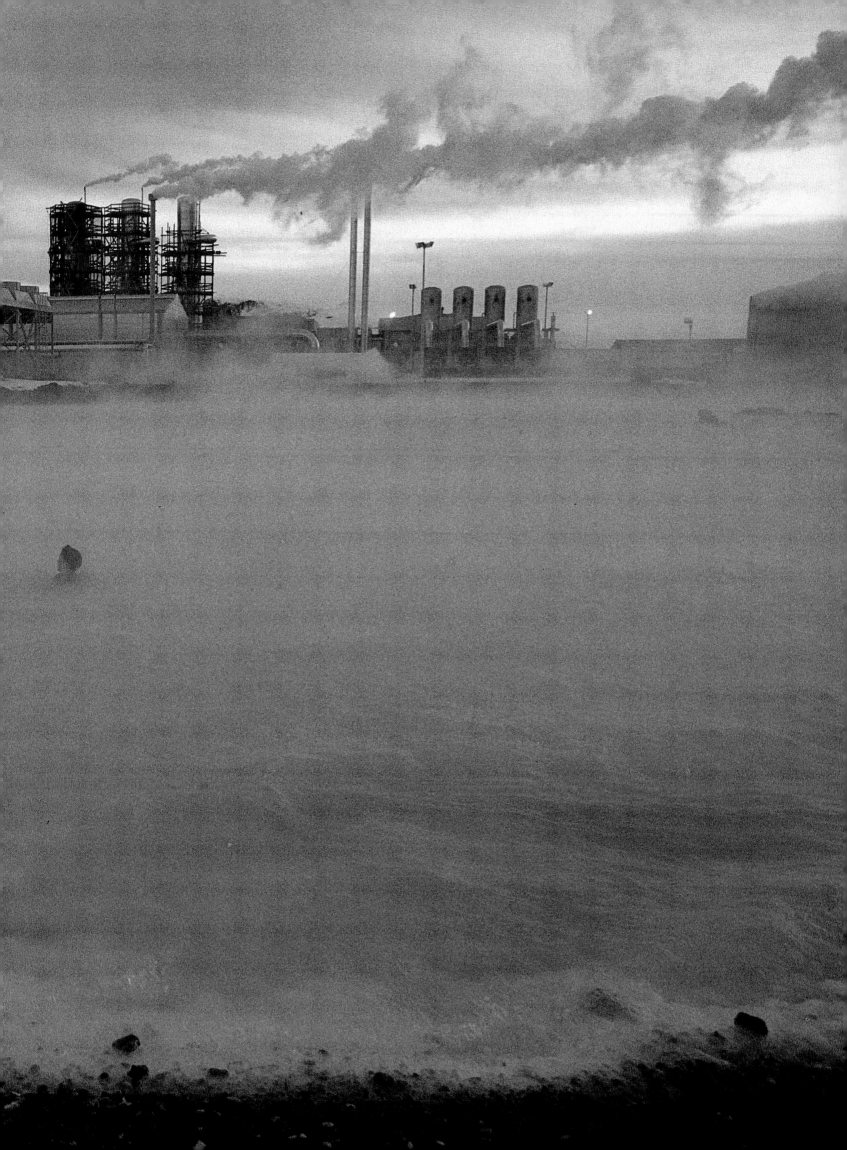

Paradise Lost?

The Lagavale Family

5:OO P.M., OCTOBER 8, 1993
POUTASI, WESTERN SAMOA

PHOTOGRAPHS BY PETER MENZEL

KEY TO BIG PICTURE

1. Auseuga Lagavale, father, 65
2. Faaleo Lagavale, mother, 60
3. Fuao Lagavale, 2nd daughter, 13
4. Laufafa Alatupe, 1st daughter, 31
5. Alatupe Alatupe, her husband, 37
6. Teuila Alatupe, their 1st daughter, 10
7. Pauline Alatupe, their 2nd daughter, 5
8. Faaleo Alatupe, their 3rd daughter, 4
9. Junior Alatupe, their son, 11 months

Uiti Lagavale, 1st son of Auseuga and Faaleo, 21 (not shown)

OBJECTS IN PHOTO

(clockwise from lower left)

- Plaited pandanus-leaf mats (1, beneath mother)
- Plaited coconut-leaf mat (1, beneath other mat)
- Materials for making mats (on mats)
- Wood-framed chairs (4, beneath people)
- Electric radio-cassette player (held by older daughter)
- Table (behind son-in-law)
- *Fale* (open Samoan house with blinds gathered beneath eaves)
- Coconut-leaf sleeping mats (8, scattered around house)
- Beds with mosquito netting (2)
- Outrigger canoe (hewn from log)
- Calves (2)
- Cooking pots (3, on mat in front of canoe)
- Coconut-leaf mats (3, rolled up at entryway)
- China cabinet
- More mats (2, rolled up to right of cabinet)
- Storage chest (for clothes)
- *Tanoa* (on chest, wide wooden bowl used in ceremonies to hold *kava*, nonalcoholic drink made from pepper roots)
- Pandanus-leaf mat for *kava* ceremonies (on canoe)
- Table with fabrics and books
- Soccer ball, tennis balls, old rolling pin (on mat)
- Pigs (2, in wire pen)
- Chicken (sitting on pen)

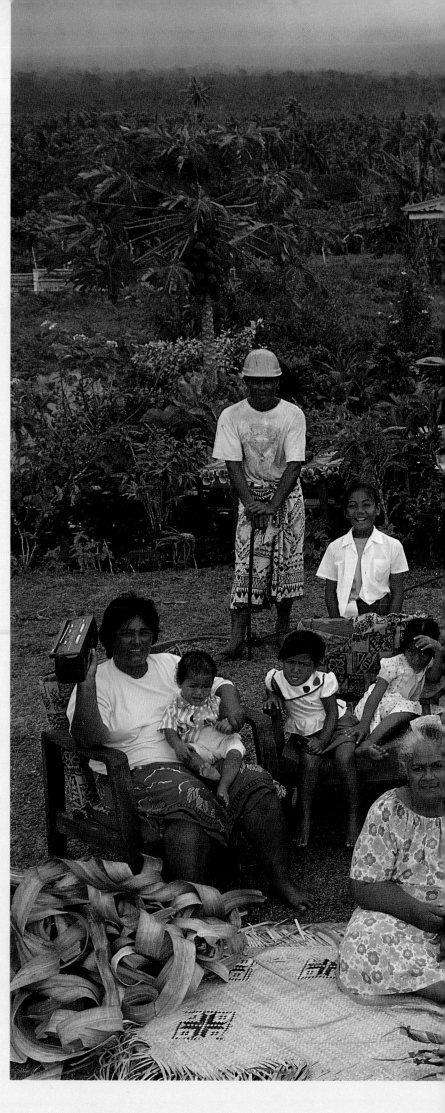

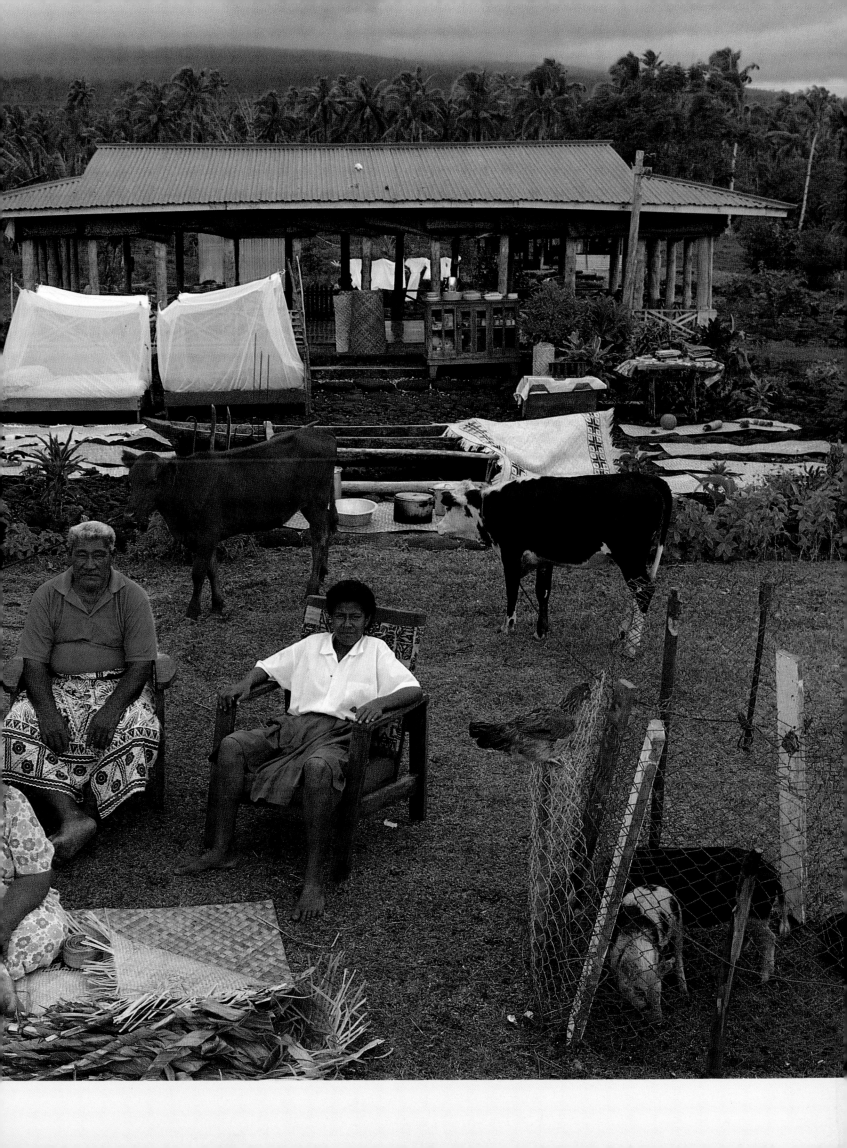

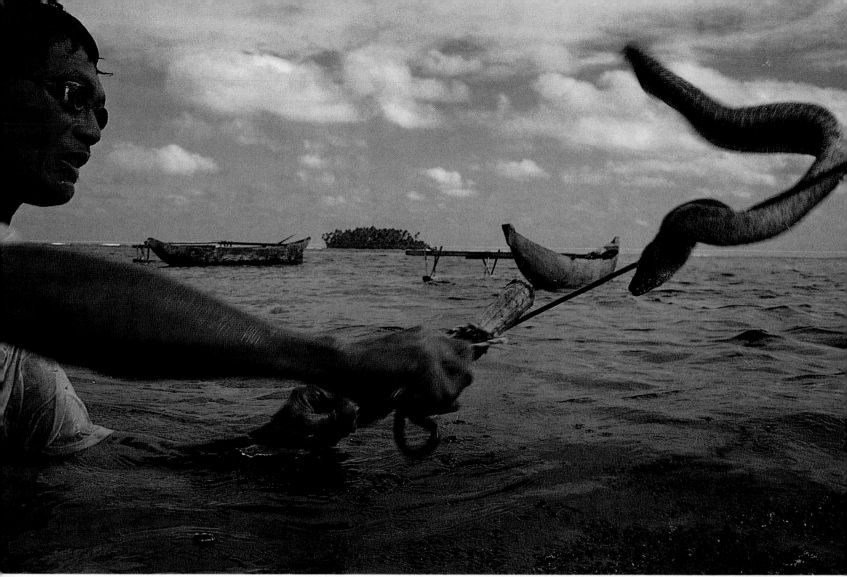

A

MUCH OF THE DAY is devoted to preparing food — often taking it first from the lagoon just outside their home *(A, son-in-law Alatupe spearing an eel, with the family dugout canoe behind)*. But perhaps no day is more kitchen-oriented than White Sunday, the second Sunday in October, when Samoans celebrate their children with presents, toasts, and a special feast. Everyone pitches in. At dawn, Laufafa begins cooking beneath the glow of the single electric bulb in the detached cookhouse *(B)*. By noon, Auseuga, the *matai* (head) of the extended family, is making his favorite sauce *(E)*. The recipe: wring out fresh coconut meat with the fibers from the husk, boil juice in pot by dropping in rocks heated by fire, dribble in sugar, stir constantly. Nearby, fist-sized taro root — its bitter peel freshly scraped — cooks on a pile of volcanic rocks heated by the fire *(D)*. Behind them steams the main course, a freshly killed pig (the liver at right is a Lagavale family favorite). When older daughter Paugata *(C, on right)*, arrives home from college with a friend, both are pressed into service plucking chickens. Four hours later, dinner is served.

LAGAVALE FAMILY

Size of household
10

Size of dwelling
720 sq. ft. (67 sq. m.) house,
192 sq. ft. (18 sq. m.) cookhouse

Workweek
35 hours (Father, mother)
48 hours (Daughter, son-in-law)

Number of
Radios: 1, Telephones: 0,
Televisions: 0, Automobiles: 0

Most valued possessions
Pigs (Father)
Hand-woven mats (Mother)
Radio (Oldest daughter)
Weed-eater (Oldest son—
"It reduces the grass-cutting
time from a week to 3 hours")

Per capita income ($US)
$930

**Percentage of Lagavale
household income spent on
food**
50%

**Percent of Lagavale family
income paid in taxes**
0%

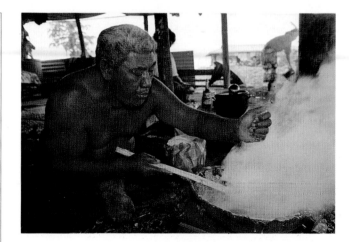

E

D

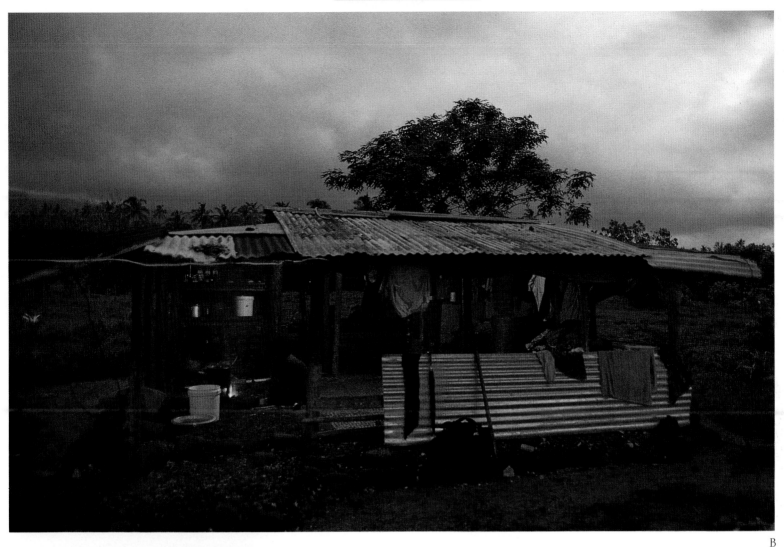

B

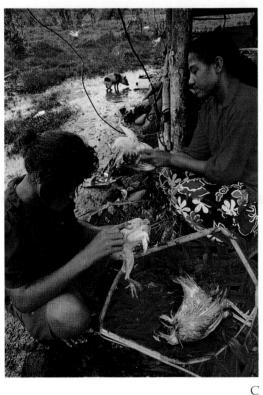

C

WESTERN SAMOA

STATS

Area
1,093 sq. mi. (2,831 sq. km.)

Population
0.195 milllion

Total fertility rate
4.8 children per woman (1988)

Population doubling time
27 years

Adult literacy
90% (combined)

**Percentage of 20-24 year-olds
in college**
6.9%

Infant mortality
40 per 1,000 births

Life expectancy
Female: 70, Male: 65

**Percentage of population
in military**
0%

**Rank of teen suicide rate
among world nations**
1

**Rank of affluence among
the 183 U.N. members**
117

A famously beautiful tropical place, the nine volcanic islands of Western Samoa are struggling to reconcile their ancient Polynesian traditions and the imperatives of 20th-century mass culture. Two to three thousand years ago the first people arrived on these fertile shores. Accompanied by rats and dogs, they laid siege to the local ecosystems, quickly driving many species of bird extinct. But they also established an enduring culture based on fishing and farming. In an unusual semi-democratic tradition, extended family groups elected a head, or *matai*, who then wielded strong powers. Christian missionaries arrived in 1830, and within a decade Samoa was converted. There ensued nearly a century of struggle among colonial powers and an increasingly irate Samoan resistance. In 1962 Western Samoa became the first Polynesian nation to regain its independence. With its government dominated by *matai*, the new state fell into debt-laden decrepitude; remittances from Samoan emigrés in New Zealand and the United States created up to 90 percent of the national income. And the islands' fragile environment was increasingly hit by tourism and logging. Economic discontent, slowly building, led to universal suffrage in 1991, though the parliament still consists mainly of *matai*. Change may not come rapidly, or without cost: The strain of trying to change Western Samoa into a prosperous modern nation while preserving its way of life has led to great cultural conflict, especially among the young.

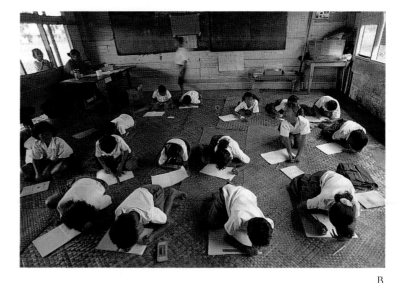

B

DRESSED FOR CHURCH on White Sunday *(A)*, the Lagavales pose cheerfully for the camera before heading to their second church service of the holiday. The children are especially excited: They are in the church choir, and have practiced their White Sunday songfest for months. Religious beliefs are central to the Lagavales' lives. The family begins the day by reading the Bible and singing English and Samoan hymns together; it ends the evening with another round of hymns. Equally essential, Auseuga says, is education. In 10-year-old Teuila's math class *(B, center of 2nd row)*, the children study geometry in their school uniforms. The mats beneath them, like the ones in Teuila's home, are plaited from coconut leaves. The family women create the fine mats used in ceremonies from the leaves of pandanus palms, which takes months of intermittent effort. The work is worth it: Good mats last for decades, and people pass them down from hand to hand as dowries and inheritances.

PHOTOGRAPHER'S NOTES
PETER MENZEL

Samoans take Christianity very seriously indeed — I've never seen so many churches in one place as I saw on the 10-mile stretch of road from Faleolo International Airport to Apia, the capital. Most people I saw pray at home mornings and evenings. Samoans generally are Protestant, but Mormons made their presence known, too. So did the weather. When I drove to Poutasi with the wife of the village chief, the rain was flooding the road. Eventually it ripped out the bridge to Poutasi, and I had to wade across with my equipment. I started to cross in my underwear, offending my companion, who insisted I put on the spare *lava-lava* (men's wrap-around skirt) that she was carrying. Life in Poutasi was as close to pure Marxist-style communism as I've ever seen. If you ask relatives for something, they more or less have to give it. That's the Samoan way. Nobody ends up with too many possessions, because if they do others will ask for them. People with very little mooch off their relatives, who have to oblige them. I was happy to be there for White Sunday, the one day in the year when the children eat before their parents. About 75 kids sang at a church service, but only about 40 parents and grandparents showed up. I wondered why so few adults came until I recalled that each family has 4 to 8 children. If Samoans weren't constantly emigrating, these beautiful little islands would be completely swamped.

A

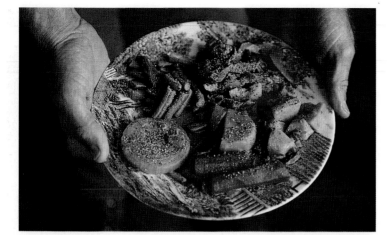
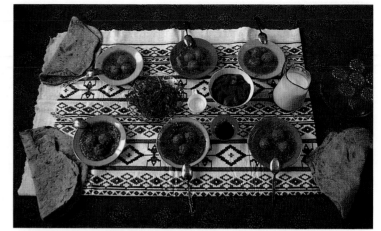

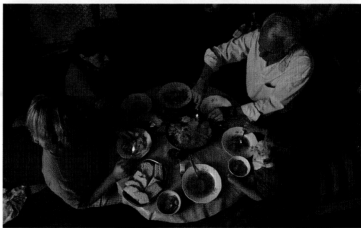
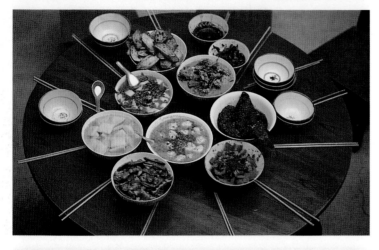

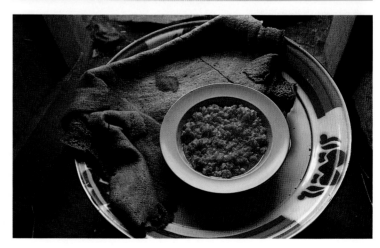

USA *meat, potatoes, carrots, onions, green beans, pepper*
CHINA *soup, fish, celery, beans, radish, lotus root, tofu, pork, chilies, dip*
MALI *rice (cooking in pot), fish (lower left)*
GUATEMALA *tortillas, rice with chilies*

IRAQ *kuba (vegetable soup with dough balls), beets, lassi (yogurt drink)*
ICELAND *ham, paté, sausage, lamb, black bread, milk*
BOSNIA *bread, potatoes, soup, tomato and onion salad*
ETHIOPIA *injara and wat of eggs and red chili powder*

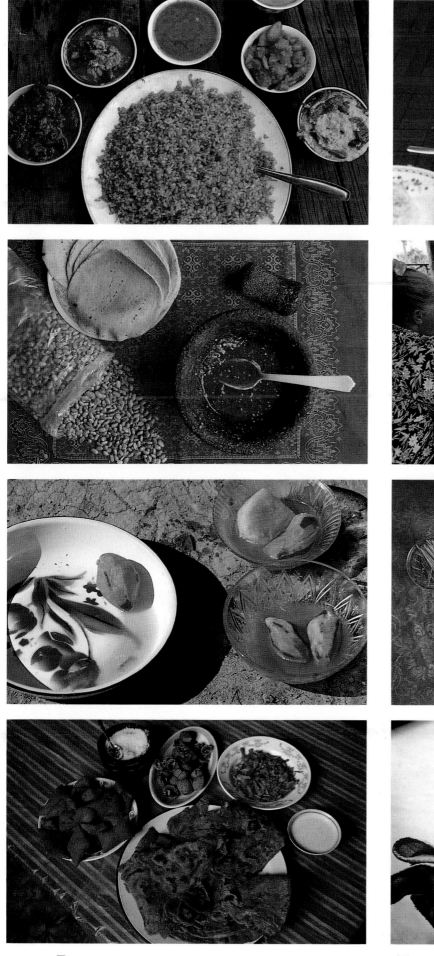

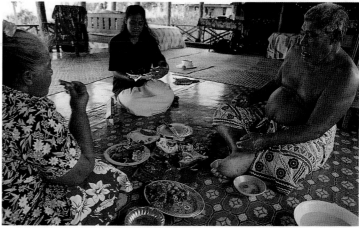

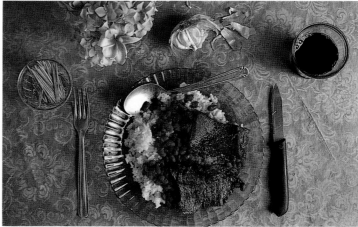

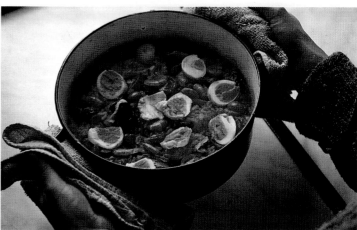

BHUTAN *red rice, chilies with potatoes, eggs, cheese*
MEXICO *tortillas, dry beans and salsa*
HAITI *sweet potatoes*
UZBEKISTAN *hatmah (bread), boursak, salt, nuts, potatoes, milk*

THAILAND *rice, shrimp paste, bamboo shoots, red pork and cucumbers*
WESTERN SAMOA *roast pig, sausage, soup, rice noodles*
BRAZIL *rice, beans, meat, soft drink*
SPAIN *paella*

EUROPE

FASCHING (CARNIVAL)
COLOGNE, GERMANY
PHOTOGRAPH BY PETER GINTER

GERMANY
DEUTSCHLAND

STATS

Area
137,838 sq. mi.
(356,998 sq. km.)

Population
81.3 million

Population density
589.8 per sq. mi.
(227.7 per sq. km.)

Total fertility rate
1.5 children per woman

Population doubling time
158 years

Percentage urban/rural
87% urban, 13% rural

Population per television
2.7 persons per set

**Annual per capita
consumption of beer**
152 quarts (144 liters)

**Percentage of native
freshwater fish that are
extinct or threatened**
72%

**Percentage of trees
with more than 1/4 of leaves
lost to acid rain and pollution**
25.2%

**Number of people seeking
asylum in Germany**
536,000 (1992)

Life expectancy
Female: 79, Male: 73

Infant mortality
7 per 1,000 births

**Rank of affluence
among the 183 U.N. members**
14

Europe's biggest, most powerful nation, Germany has been at the uncomfortable center of European politics since Otto von Bismarck oversaw its unification in 1871. Seemingly overnight, city-states that had squabbled for centuries became a powerful force — technologically, commercially, imperially. Tensions led to the almost accidental flare-up of World War I. When Germany lost, the vengeful Allies imposed a humiliating peace treaty that led to vast inflation and social turmoil. Capitalizing on popular anger, a deranged, anti-Semitic agitator managed to seize power, launch a war, and oversee the extermination of Germany's Jews. When Germany lost again, the vengeful Allies divided it. Moscow controlled the smaller eastern part; the bigger western part was tied to its western neighbors. West Germany rebuilt its war-torn cities and became an economic behemoth. Indeed, it became so rich that when Communism fell most "westies" believed that they could easily absorb the "easties." Instead the eastern economy collapsed, and the west couldn't prop it up — leading to the kind of nationalist discontent that Germany's neighbors have learned to fear. At the same time, the country faces ecological limits. The east has some of the world's worst pollution, and the west has acid rain and water contamination. As a result, Germany finds itself once again in the center of the European prospect.

Uneasy Unity

The Pfitzner Family

1:30 P.M., FEBRUARY 13, 1994
COLOGNE, GERMANY

PHOTOGRAPHS BY PETER GINTER

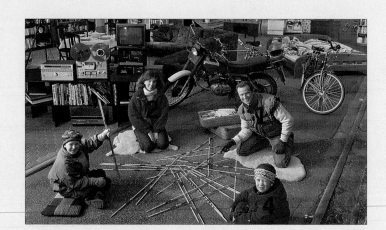

KEY TO BIG PICTURE

1. Bernhard Pfitzner, father, 38
2. Brigitte Klose-Pfitzner, mother, 36
3. Manuel Pfitzner, son, 7
4. Christian Pfitzner, son, 4

OBJECTS IN PHOTO

(Clockwise from center left)

- Bookshelf for picture books
- Video-cassette recorder (below bookshelf)
- Stereo and tape recorder (on bookshelf)
- Television, turntable, speakers (behind bookshelf)
- Dining table with chairs and 4 place settings
- Tripod with video camera (hooked up to TV, live image is of photographer from *Material World*)
- Bookshelf with books
- Antique cupboard for china and glassware
- Painting (through window of Pfitzners' apartment)
- Armoire (with clothes for parents and children)
- Corner sofa
- Kitchen cupboard (for china, spices, utensils)
- Potted plants (4, on entry to apartment)
- China hutch (behind stairs)

- Ceramic statuary (on hutch)
- Desk (for boys, with lamp, clock, pencil jar, etc.)
- Toy shelves with toys
- Kitchen table and chair (behind desk)
- Plastic castle, little trucks, miniature dinosaurs (on table)
- Loft beds (2, for boys)
- Bookshelf (between beds)
- Station wagon (behind beds)
- Stove/oven with pots
- Dishwasher (full of dishes)
- Microwave (on dishwasher)
- Refrigerator (with stickers)
- Cabinet
- Dresser
- 2nd toy castle (on dresser)
- Parents' bed
- Bicycles (4, one behind 3rd bookshelf)
- Father's motorcycle
- Basket filled with items from family's history
- Sheepskin and pillows
- Game ("Monster-Mikado," like pick-up sticks)

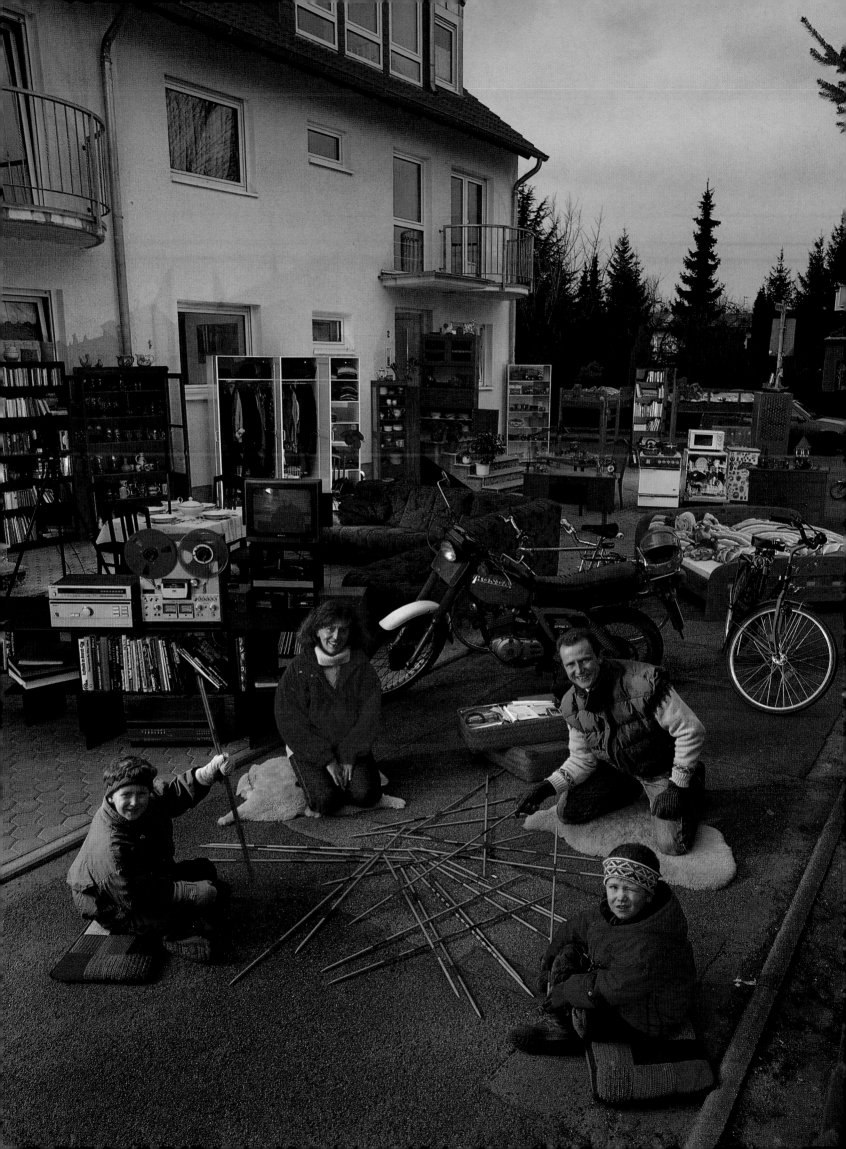

A

PHOTOGRAPHER'S NOTES
PETER GINTER

Right from the very beginning I knew that this was going to be difficult. I'm German myself, and I knew that my fellow Germans would not like letting the outside world look at their possessions in the Big Picture because that would be telling the world what their income is. I thought it would be much easier if an American photographer tried to convince them, but it ended up being me anyway. As I imagined, it *was* hard to find the family — I owe a huge debt to the marvelously kind Pfitzners. The logistics of scheduling meant that we had to take the Big Picture during Carnival, which meant in turn that we had to convince the city of Cologne to let us close the street during the busiest holiday of the year. Finally they did, and then the area was hit by a cold snap — 10°F (minus 12°C). A few weeks before, I had thrown out my back, and so that morning I swallowed who knows how many painkillers and started unloading furniture in a light snow. Fortunately, it was so cold that the snow did no damage to the Pfitzner's things — we just blew it off. When it finally stopped we brought out the good furniture. The wind immediately knocked over the first piece we put on the sidewalk. Crash! I cringed, but again we were lucky; no damage. Ultimately, we had to have people standing behind all of the big pieces of furniture to prevent the wind from blowing them over. We shot one-and-a-half rolls, warmed up for two hours, then shot two more rolls. The only casualties were one inexpensive shelf, which we replaced, and a pot of the family's flowers, which to my horror died immediately. Throughout, the Pfitzners were very relaxed. The smiles in the photograph are real — all the anxieties were mine.

B

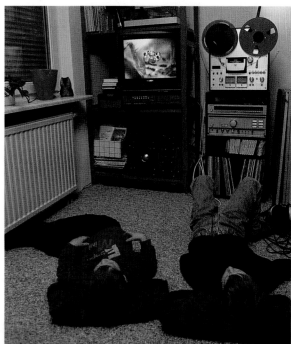

D

182

A PHYSICAL THERAPIST who works at a clinic in the nearby town of Neuss, Bernhard spends his days wrestling — almost literally — with the consequences of other people's injuries (A, *stretching the leg of a man recovering from knee surgery*). The work is tiring, and Bernhard is delighted when he can soak with the kids in a family bath, though his schedule usually limits this to occasional Friday evenings (B). Brigitte, who supervises the cleaning operations during the rest of the week, steps off-stage this night; she is putting together a big dinner with the vegetables she purchased at the market a few hours before (C). The market, in the big Turkish section of Cologne, is always crowded. After dinner, the two boys spend their precious daily thirty- to sixty-minute allotment of television on a nature program about spiders (D).

C

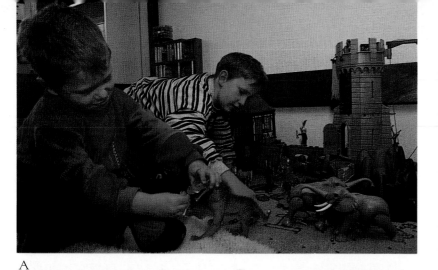

A

C

B

WORRIED ABOUT the blare of television they see and hear around them, Bernhard and Brigitte hope to ensure that Manuel and Christian will never find it difficult to entertain themselves by non-electronic means. To judge by the hours the two boys spend pushing their toy knights into battle against invasions of plastic dinosaurs (A), the parents may succeed. Seven-year-old Manuel spends the mornings in kindergarten, learning to read (C); his envious 4-year-old brother Christian, meanwhile, must stay at home, helping Brigitte with the ironing (B). Here he is applying a warm, child-sized iron to a pile of handkerchiefs. Not shown is the window from which Brigitte monitors Manuel's progress home from school, a 2-minute walk away.

RUSSIA
ROSSIJA

STATS

Area
6,592,664 sq. mi.
(17,074,868 sq. km.)

Population
149.7 million

Population density
22.7 per sq. mi.
(8.8 per sq. km.)

Total fertility rate
2.1 children per woman

Life expectancy
Female: 74, Male: 64

Infant mortality
19 per 1,000 births

Population per physician
210

Percentage decrease in birth rate between 1989 and 1993
Approximately 38%

Percentage increase in death rate between 1989 and 1993
Approximately 30%

Rank of affluence among the 183 U.N. members
48

Having given up a system in which ordinary citizens cheated to survive, Russia now finds itself overwhelmed by criminals. The Soviet Revolution of 1917 established a Communist government that planned almost all economic decisions. This vast social experiment created jobs and healthcare for all. But it also brought into being a police state marked by black markets that made up for the shortfalls endemic to central planning. When the system fell apart in 1989-91, the Soviet Union fragmented into its constituent parts, the largest of which was Russia. The collapse left a terrible roster of social, economic, and ecological troubles to the Russian president, Boris Yeltsin. As national output fell, a sizable part of the bureaucracy, which controlled state goods, merged with the criminal class, which knew how to convert those goods into money. Coupled with political instability, the criminalization of the economy has made it impossible for Russia to confront its long-term problems — especially the poisoned air, water, and land bequeathed by Communist industrial plans.

IN MEMORIAM

LESS THAN A MONTH after Eugeny Kapralov posed with his family and possessions, he was beaten to death by unknown assailants. The circumstances remain unclear, but robbery may have been a motive — the windows of his car were smashed. In sorrow, the Kapralovs placed a glass of vodka, a piece of bread, a jar of dry rice, and his portrait on the table for the customary forty days of mourning — a traditional Russian ritual that comforted Joanna and the children during what had suddenly become the coldest winter of their lives.

Remains of Empire

The Kapralov Family

2:00 P.M., DECEMBER 1, 1993
SUZDAL, RUSSIA

BIG PICTURE BY LOUIS PSIHOYOS
AND JOHN KNOEBBER

DAILY LIFE PHOTOGRAPHS
BY SCOTT THODE

KEY TO BIG PICTURE

1. Eugeny Kapralov, father, 37 (murdered 12/25/93)
2. Joanna Kapralov, mother, 36
3. Xenia Kapralov, daughter, 14
4. Anastasia Kapralov, daughter, 6

OBJECTS IN PHOTO

(Clockwise from lower left)

- Piano
- Samovar (heirloom urn to make tea)
- Dresser
- Full-length mirror (on dresser)
- Living room chairs (2)
- Sewing machine and table
- Sewing machine toolbox
- Quilt (on sewing machine)
- Rugs (2)
- Framed picture
- Sofa beds (2, 1 by each rug)
- Vacuum cleaner
- Ironing board and iron
- Garage (blue door)
- Tables (2)
- Kitchen utensils, storage bins, pepper grinder (on table near 1st sofa bed)
- Wicker basket (on 2nd table)
- Refrigerator
- Large cabinet with china, serving utensils, stereo,

books, icons (2), doilies (4)
- Family car
- Bicycles (2)
- Armoire for linens and blankets
- Domra
- Skis, hula-hoop, badminton rackets, saw, cuckoo clock (leaning against tree)
- Teddy bear and doll (on 2nd sofa bed)
- Ottoman (matches 2nd sofa bed)
- End table
- Televisions (2, on table)
- Child's table and chair
- Doll collection (on table)
- Sled

(Background)

- The Suzdal Kremlin (citadel), first built in 12th century
- Cathedral of the Nativity of the Mother of God

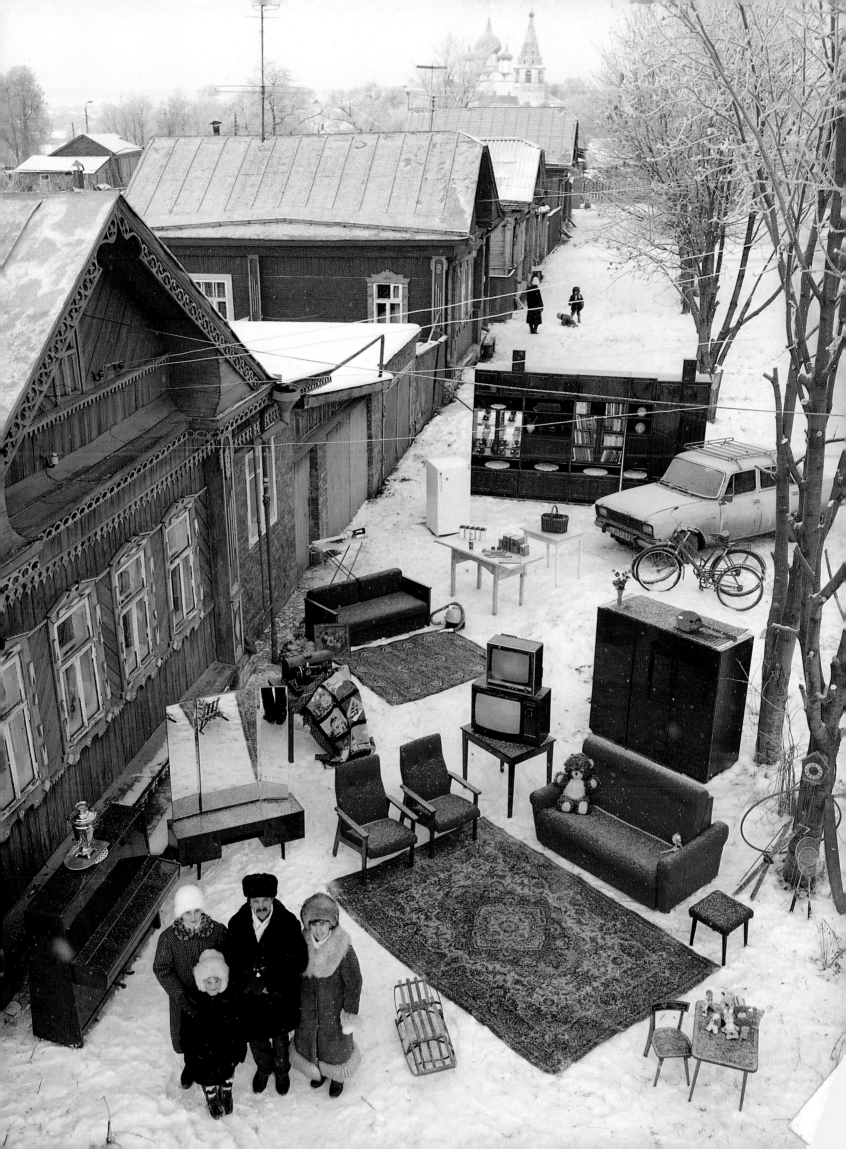

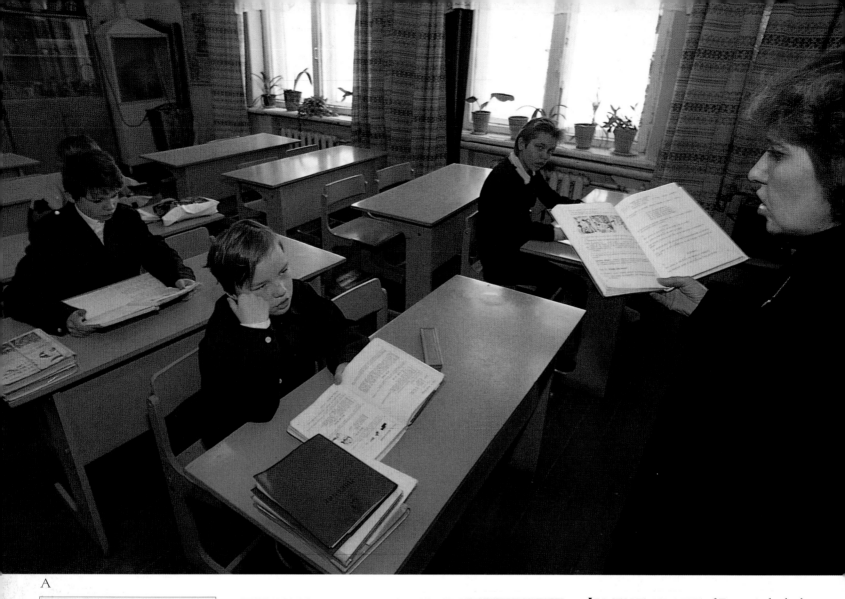

A

B

KAPRALOV FAMILY

Size of household
3

Size of dwelling
1,500 sq. ft. (140 sq. m.)

Workweek
42 hours (Mother, plus housework)

Number of
Radios: 2, Stereos: 1,
Telephones: 2 Televisions: 2,
VCRs: 0, Automobiles: 1
(Broken from time of father's murder)

Most valued possessions
Domra (Mother)
Video games, Conan Doyle novels
(Oldest daughter)
Stuffed animal, Barbie doll
(Youngest daughter)

Per capita income ($US)
$3,469

**Percentage of Kapralov family
income spent on food**
60%

On clothing, household goods
30%

Wishes for future
To repair car, which will cost
$2,500 – $3,000 (Mother)
To have children live in society
that has joined "mainstream of
human civilization" (Mother)

IN THE WAKE of Eugeny's death, the Kapralovs have to continue with their lives. Joanna still goes to work, teaching German at a boarding school for children from broken homes (A) and music at the Suzdal music school. Six-year-old Anastasia (B, center) still plays outside in the snow, assembling a snowwoman one day with her older sister, Xenia, and their friend from the neighborhood, Ilya Konotopov. The construction takes place on the grounds of the nearby Suzdal Museum of Wooden Architecture, which displays the windmill in the background. For her part, 14-year-old Xenia keeps going to high school and working on her music lessons. Because Joanna teaches at the same school, she is sometimes able to pop in and watch the session from the back of the room (facing page). Music is important to the whole family — Joanna's *domra* (a traditional Russian stringed instrument) is her most treasured possession. Indeed, after posing for the Big Picture, Xenia and Joanna broke into an impromptu concert in the snow. Eugeny looked on, beaming proudly.

A

PHOTOGRAPHER'S NOTES
SCOTT THODE

Five days before I flew to Russia, I learned that the father of the family I was supposed to photograph had been murdered. I was shocked and felt terrible for the family. My first thought was to stay home. Then I realized that my photographs could help people remember Eugeny. I ended up arriving on his birthday. That night we all drank many vodka toasts to his memory. Joanna said, "I have my life now and I have my life after." Yet Eugeny's presence was everywhere: the kitchen cabinets he hadn't yet completed, the incredible wood carvings that decorated the house, the pile of lumber that he bought to finish everything. Joanna told me that she had been happy when Eugeny quit his risky job in the mines and they moved to Suzdal because he would no longer be in danger all the time. This used to be a safe place, she said, but no more. Crime is everywhere. The police did nothing — when I got there, weeks after the event, they had not even interviewed Joanna. After photographing Eugeny's car I couldn't sleep. I kept seeing the smashed windows and thinking of how he lay dying in a doorway for a day or two while people walked by. Just before I left, Joanna gave me a carving by Eugeny and said that she hoped the story would not be a "tear-puller." I told her that it would be hard not to be moved, but that I hoped my photographs would show that she and the girls are pushing forward.

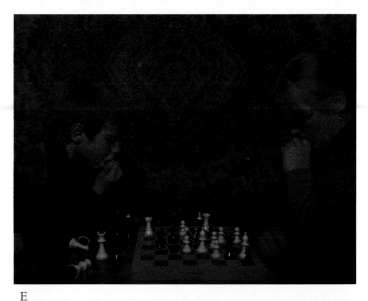

E

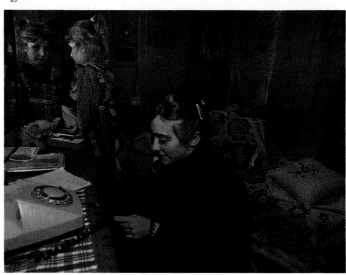

D

FAMILY MEALS without Eugeny are lonelier — three people at a table full of bread, canned meat-and-potato salad, pickled tomatoes, cabbage, carrots, and cucumbers (A). The bench and upper shelf in the kitchen were carved by Eugeny, a skillful carpenter who always had a dozen projects going around the house. Joanna, too, is constantly active: The clutter in her quilting room surrounds Xenia and Nastia as the former calls a friend on the phone (D). One of Xenia's special interests is chess, a particularly Russian enthusiasm that she shares with Ilya, the neighbor boy (E). But telephones, chess, and quilting are small comfort on Eugeny's birthday, which arrives with painful speed just weeks after his death. Joanna and the children visit the local Orthodox church to light a candle for his soul (B), then steel themselves for the cold, painful, utterly necessary visit to Eugeny's grave (C) in the church cemetery. Now, facing the cold mound strewn with plastic flowers, the family huddles together against a life that has become even harder.

B

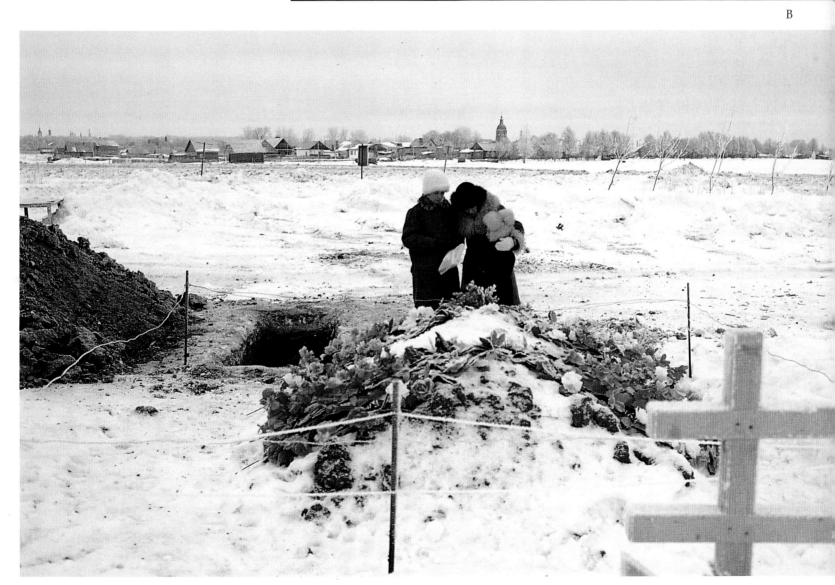

C

ALBANIA

Out of Isolation

The Cakoni Family

2:30 P.M., NOVEMBER 24, 1993
OUTSIDE BURREL, ALBANIA

BIG PICTURE BY LOUIS PSIHOYOS
AND JOHN KNOEBBER

DAILY LIFE PHOTOGRAPHS
BY GUGLIELMO DE'MICHELI

KEY TO BIG PICTURE

1. Hajdar Cakoni, father, 44
2. Hanke Cakoni, mother, 37
3. Armond Cakoni, son, 14
4. Ardian Cakoni, son, 12
5. Artila Cakoni, daughter, 6
6. Aurel Cakoni, son, 5

OBJECTS IN PHOTO

(Clockwise from lower left)

- Donkey with saddle
- Butter churns (2)
- Hoes, rakes, other farm implements
- Dining table with 4 chairs
- Crockery, pepper grinder (on table)
- Storage cabinet for dishes
- Rooster (on top of storage cabinet)
- Containers used to wash dishes outside (against lower left corner of house)
- Garden trellis (left on hill behind house)
- House (built by father)
- Drying tobacco (hanging on front of house)
- Barn for goats & chickens (visible behind house)
- Goats (6)
- Parents' bed
- Children's bedding (folded at head of bed)
- Cradle (currently not in use)
- Calf (tied to stake at bottom right)
- Extra shoes (1 pair — belongs to father)
- Rug
- Couch (family is sitting on it — doubles as children's bed)
- 2nd storage cabinet (directly behind family)
- Television
- Radio and youngest son's toys (on top of TV)
- Father's mandolin

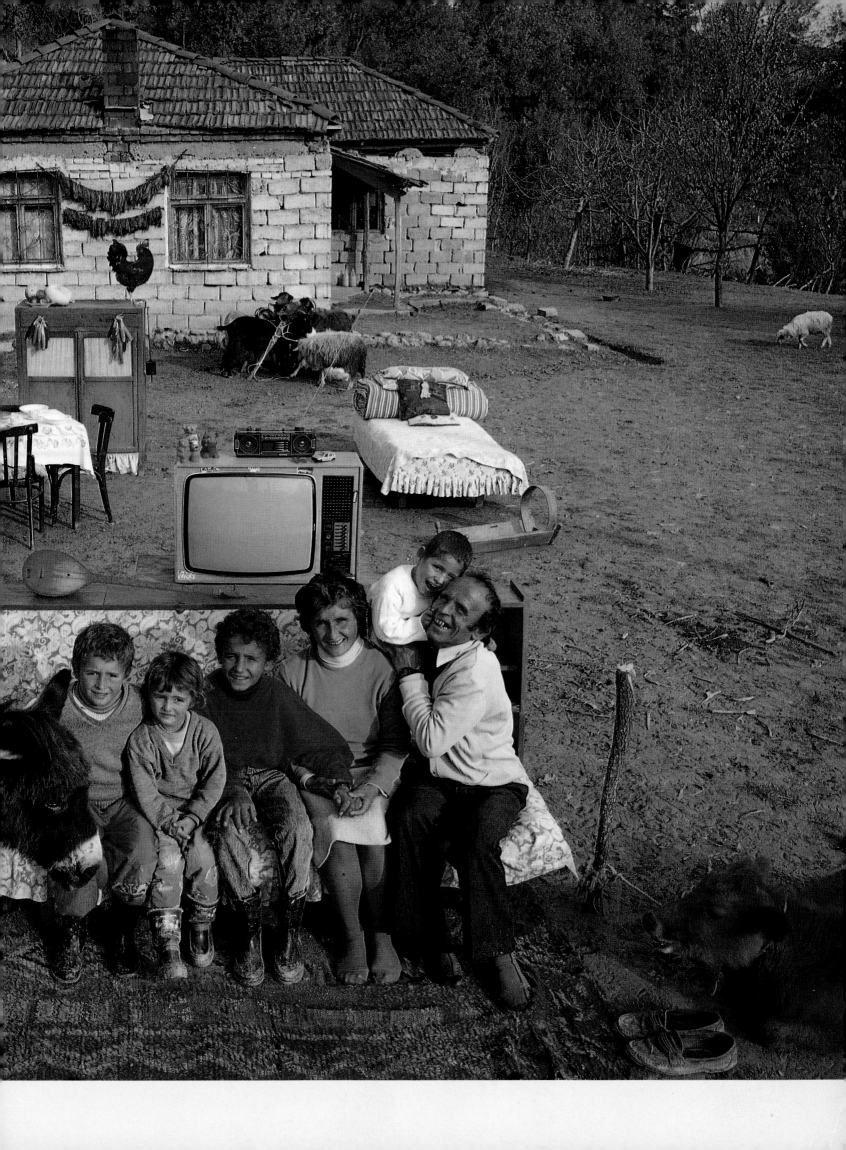

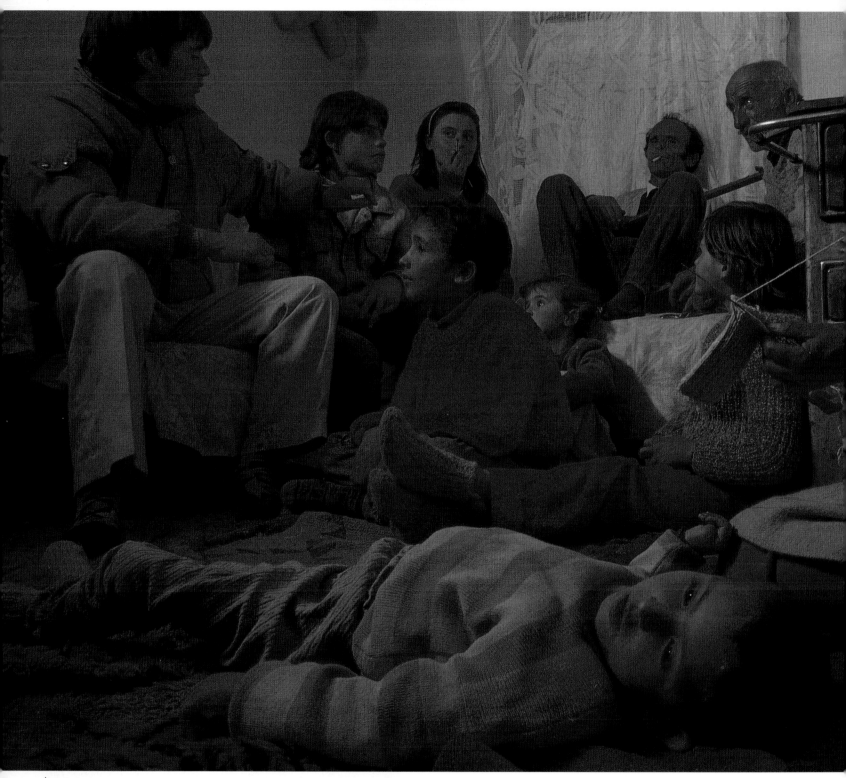

A

D

AS COLD WEATHER CLOSES IN, the Cakonis stay in the kitchen, entertaining visitors like Hanke's brother (*A, partly obscured to rear*) by the warmth of the wood stove. Five-year-old Aurel (*foreground*), who is disabled, is always included — institutionalization is virtually unknown. When visitors are not around, the flicker of the television tube is constant; it beams affluent imagery from nearby Italy at Hanke's back (*C*) as she cooks dinner in pots made from tin cans. The cooking water is brought home daily by 14-year-old Armond on the family donkey (*B*) from the well half a mile away. Lunch typically consists of (*D, from left to right*) leeks, cabbage, eggs and cheese (flavored by the salt in the dish behind), more cabbage, and home-made *raki*, an Albanian distilled liqueur that bears some resemblance to Italian *grappa*.

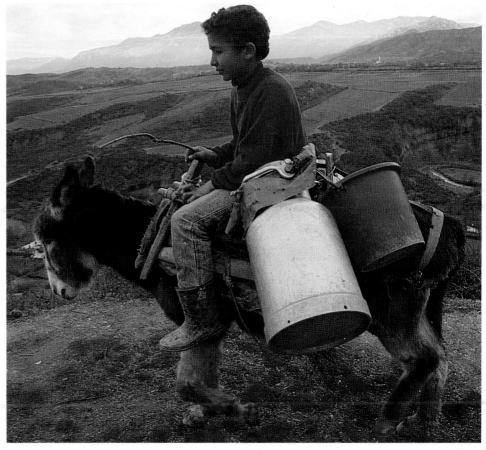

B

ALBANIA
SHQIPËRI

STATS

Area
11,197 sq. mi. (29,000 sq. km.)

Population
3.4 million

Population density
303.7 per sq. mi.
(117.2 per sq. km.)

Total fertility rate
2.7 children per woman

Population doubling time
46.2 years

Percentage urban/rural
37% urban, 63% rural

Life expectancy
Female: 79, Male: 72

Adult literacy rate
Female: 99%, Male: 99%

Major religious affiliation
Muslim

**Rank per capita among world's
nations in cigarette consumption**
1

**Rank among the 32 European
nations in electricity use**
32

**Rank of affluence
among the 183 U.N. members**
103

Long Europe's poorest and most isolated state, Albania was ruled by Enver Hoxha, a tyrannical Communist, from 1944 until his death in 1985. During that time he executed thousands, installed a network of spies, banned all foreign contact, and suppressed Albania's Muslim traditions (a legacy of occupation by the Turks). Hoxha, a purist of sorts, brooked no criticism. He cut off relations with other dictators when they moderated their policies, eventually becoming the sole Communist leader to break with both the Soviet Union and China. Soon after his death came the fall of Communism in Eastern Europe and then the Soviet Union. True to its instinct for independence, the Albanian Communist party tried to resist, but after an economic collapse it was pushed out in 1992. The new, non-Communist president, Sali Berisha, began the difficult task of trying to rebuild the economy. It will not be easy: The nation cannot grow enough food for its people, and has almost nothing to trade. Little wonder that Albanians by the thousands are fleeing their mountain villages.

C

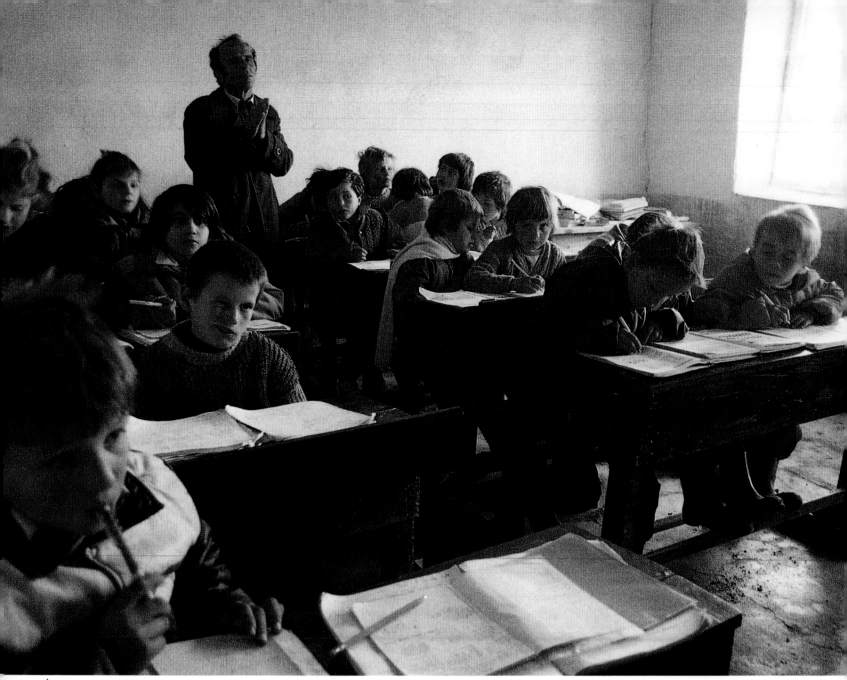

A

PHOTOGRAPHER'S NOTES
GUGLIELMO DE'MICHELI

Albania is just an hour by air from Rome, but geography is deceiving. Arriving at the airport in Tirana you realize that history stopped in this country for more than 40 years and has just started up again. Although the visit had been prearranged, the Cakonis had no idea when we were coming because they do not have access to a telephone. Still, they were very welcoming. Hajdar kissed us, as expected by tradition, and his wife, Hanke, went to toast and grind some coffee for us. And then the smell of this incredibly good coffee came floating from the house. Time has another meaning here: 3 hours a day to go back and forth to school, 40 minutes a day to get water with the donkey, 4 hours' walking every two weeks to the market in the nearest town. Decades of Communism did little to change Albanian traditions. Many marriages are still arranged, and we were told that the parents of the bride give the groom a bullet, symbolizing his power of life and death over her. The influx of consumer Capitalism may change that. The Cakonis now watch Italian TV every night and discontentedly compare what they see with what they have. For good reason — meat is rare, houses have no running water, jobs are scarce, health care is rudimentary. Although I believe that their lives close to the earth have value, the Cakonis want to live elsewhere, and have more. Who would argue with them? Their youngest child, Aurel, is disabled, and they have no doctor able to diagnose his condition, let alone help him progress through life.

LECTURING BEFORE LUNCH, Hajdar faces the task of elementary-school mathematics teachers everywhere: imparting knowledge to a roomful of sleepy, recalcitrant children (A). School runs from 9:00 to 1:00 Monday to Friday, 9 months a year; the Cakonis, children and master alike, must walk 1-1/2 hours each way. Such treks play a big role in daily life. Every two weeks Hajdar and Hanke hike for 4 hours from their valley through the hills to the town of Burrel, 7 miles away. Sometimes accompanied by 6-year-old Artila (C), they buy staples like coffee, bread, and soap at the informal markets that have sprung up mushroom-style in Burrel since the end of Communism. Bargaining is sharp; the Cakonis do not consider themselves rich, and resent the rising prices. And they, like many others in Albania, understand full well that they stand at the fringes of consumer society. Hour after hour, night after night, television images pour into the receptive satellite dishes in Burrel apartments (B).

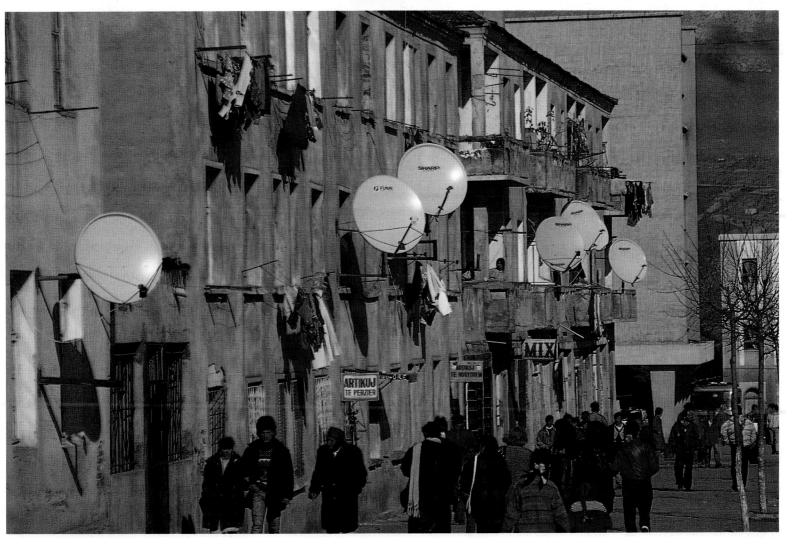

B

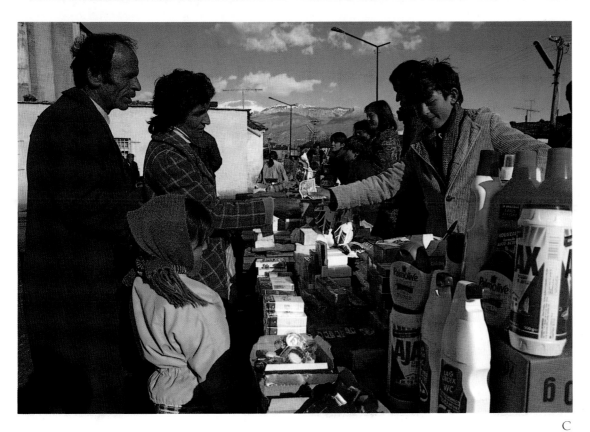

C

CAKONI FAMILY

Size of household
6

Size of dwelling
3 rooms, 432 sq. ft. (48 sq. m.)
Owner-occupied single dwelling

Workweek
84 hours a week (adults)
21-28 hours a week (children)

Number of
Radios: 1, Telephones: 0,
Televisions: 1, Automobiles: 0

Most valued possessions
TV (Father)
TV (Mother)
TV (Children)

Per capita income ($US)
$1,200 (1989)

**Percent of Cakoni family income
spent on food**
Approximately 100%

Percent spent on health care
0%
(Provided by government)

Family savings ($US)
$0

**Percent of Cakoni children
their parents believe
will eventually emigrate**
100%

Shrinking Families

The Pellegrini Family

3 P.M., OCTOBER 19, 1993
PIENZA, ITALY

BIG PICTURE BY PETER GINTER

DAILY LIFE PHOTOGRAPHS
BY GUGLIELMO DE'MICHELI

KEY TO BIG PICTURE

1. Fabio Pellegrini, father, 45
2. Daniela Ciolfi, mother, 40
3. Caterina Pellegrini, daughter, 3

OBJECTS IN PHOTO

(Clockwise from lower left)

- Tricycle (for daughter)
- Racing bicycle and skis (for father)
- Dining table, chairs (4), tablecloth, china, cutlery, glasses
- Potted plants (on either side of and above family's garage door)
- Car (Renault R4)
- Television (on end table)
- Bench seat
- Desk
- Books, ceramic articles (on desk)
- Bureau
- 2nd TV, books (on bureau)
- Parents' bed and bedding (behind bureau)
- Armoire with parents' clothing
- Gas stove/oven, electric refrigerator (end of alley)
- 2nd bureau
- Antique metal scale (on 2nd bureau)
- 3rd bureau (marble topped)
- Books, sculpture of horse (on 3rd bureau)
- China cabinet (with china, glassware)
- Large doll (sitting in chair)
- Wooden chest
- Stereo and records (on chest)
- Antique dolls (on chest — French and German, collected by mother)
- Mirrors (2, standing behind chest, with swinging frames)
- Occasional chairs (2, parents seated in them)
- Children's chairs (2, daughter seated in one)
- Mandolin (on other child's chair)
- Doll (clutched by daughter)

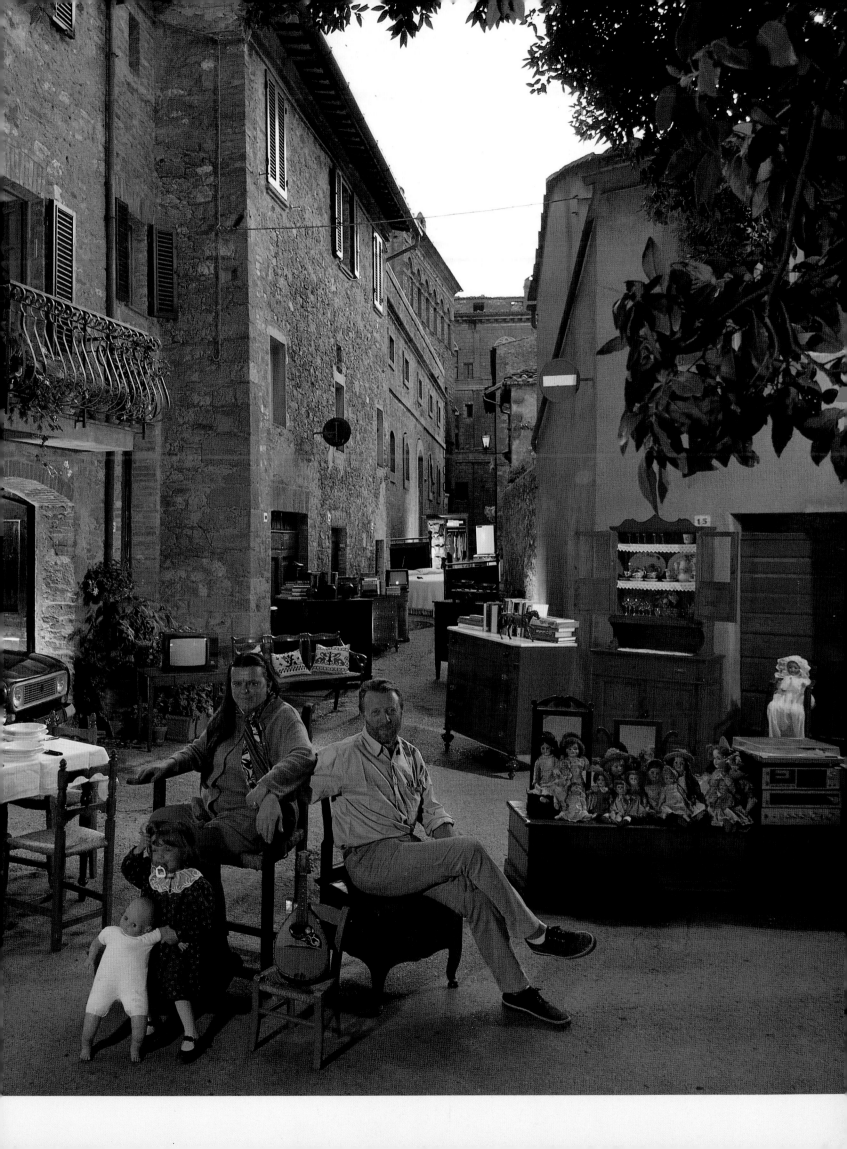

A

D

C

PELLEGRINI FAMILY
Size of household 3
Size of dwelling 1292 sq. ft. (120 sq. m.) (5 rooms, garage, inherited from father's parents)
Workweek 24 hours (Father — teacher) 40 hours (Mother — clerical worker)
Number of Radios: 1, Stereos: 1 Telephones: 2, Televisions: 1 VCRs: 0, Automobiles: 1
Most valued possessions Mandolin (Father) Antique dolls (Mother)
Per capita income ($US) $18,588
Percentage of Pellegrini family income spent on food 30%
Religious observance None
Wishes for future VCR, farm

B

IN THE COOL of a late fall afternoon, Fabio, Daniela, and their friend Dario *(B, on right)* relax with some red wine and a fire. Three-year-old Caterina, tucked into her little chair by the hearth, fingers a toy radio, her small red lips working around the pacifier in her mouth. After the visit, Caterina retreats to the mound of educational toys in her room *(C, playing with a train that is supposed to help children learn their letters)*. Meanwhile, the couple cooks dinner, which usually features pasta. Caterina consumes her portion, then joins her father in the vital task of giving a bath to the Barbie doll. The final touch — blow-drying Barbie's hair *(A)* — is a joint effort that requires intense concentration from both parent and child. Not long afterward, the same treatment in the same sink is meted out to Caterina, as Daniela soaps her down before bedtime *(D)*.

ITALY
ITALIA

STATS

Area
116,216 sq. mi.
(300,997 sq. km.)

Population
57.9 million

Population density
498.2 per sq. mi.
(192.4 per sq. km.)

Total fertility rate
1.3 children per woman

**Rank of fertility rate
among the 183 U.N. members**
183

Population doubling time
771 years

Percentage urban/rural
71% urban, 29% rural

Ratio of people to automobiles
2 to 1

Life expectancy
Female: 81, Male: 74

**Annual per capita
consumption of wine**
107 standard bottles per year

**Rank of affluence
among the 183 U.N. members**
17

After World War II, Italy was governed by one of the world's most paradoxically stable regimes. Although the 52 government collapses between 1945 and 1993 convinced foreigners that the state was in turmoil, Italians knew that by world standards the upheaval was more apparent than real. The reason: one party, the Christian Democrats, dominated all of those governments. Similar paradoxes characterized much else Italian. True, the state was swamped by corruption, bureaucratic ineptitude, budgetary red ink, and political infighting. Yet all the while Italians grew wealthier, especially in the north, enjoying a way of life that people from more frenetic nations could only envy. Italians began to wonder at the underpinnings of these paradoxes in the 1990s, when the nation was ravaged by crime, inflation, and recession. It turned out that the Christian Democrats' long rule had created a web of politically controlled enterprises — banks, industries, television channels — that functioned as an enormous kickback scheme. After more than 3,000 of Italy's most powerful people, including 200 senators and deputies, were jailed or under investigation, the citizenry passed a referendum in 1993 that ended the system that had kept the country in political stasis. But what would happen next remained unclear. Elections in 1994 gave a parliamentary majority to a billionaire media mogul and his neo-fascist allies — not a recipe for stability.

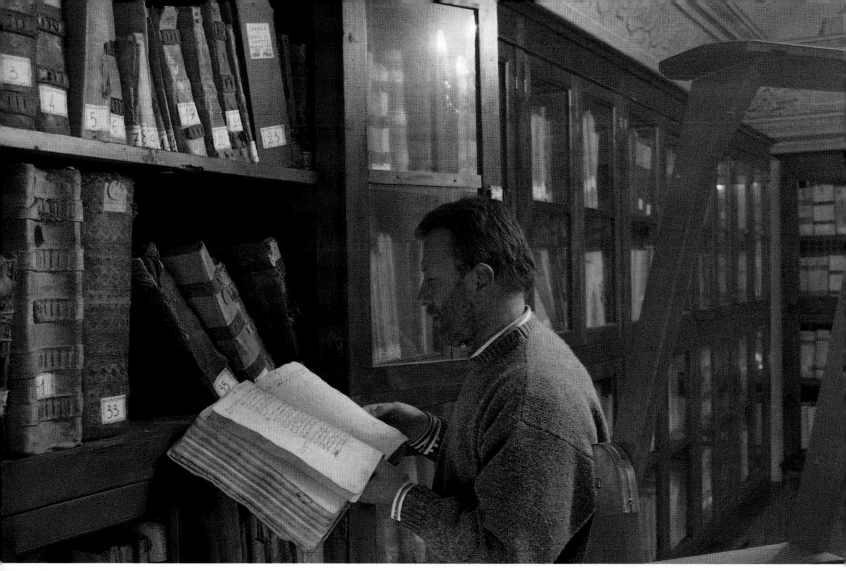

A

PHOTOGRAPHER'S NOTES

GUGLIELMO DE'MICHELI

Pienza, the Tuscan town where the Pellegrinis live, is not very well known by tourists. You don't see thousands of noisy people walking around with their noses bobbing between their guidebooks and the bell towers. Instead, Pienza, like the other small cities in which so many Italians live, is quiet and friendly. When Fabio and Daniela walked their daughter to the public gardens across town, it seemed like every person they passed was a friend. Of course this has its drawbacks: While we set up the Big Picture, the neighbors thought the Pellegrinis were having a tag sale (all of the stuff so neatly laid out on the street). They kept wandering around picking up items and asking how much they were. More than once I wished I could stop shooting and join the Pellegrinis in their life. The recession is here, too, so Fabio and Daniela have problems like everyone else. But I'd rather have financial problems in a place like Pienza than be wealthy in a place where you have to drive an hour to show your kid a tree.

E

IN ADDITION TO TEACHING, Fabio is trained as a lawyer, serves on the Pienza city council (representing the Green party), and writes books — all of which require occasional spells in the town library (A). The clutter of the shelves finds a certain echo in the Pellegrini's cozy but overflowing apartment. Caterina's clothes cabinet (B) is one center of inundation, as is the laundry room (C), where Daniela observes that peculiarly modern phenomenon, the endlessly multiplying laundry basket. Part of the overflow is due to Caterina's birthday party (D), where a gaggle of small girls watch her blow out the candles. Meanwhile, the religious imagery (E) of a long-ago Italy drifts toward the back of the shelf for this busily secular family.

B

C

D

After the Boom

The de Frutos Family

5:30 P.M. SEPTEMBER 26, 1993
SEGOVIA, SPAIN

PHOTOGRAPHS BY JOSÉ MANUEL NAVIA

KEY TO BIG PICTURE

1. José Maria de Frutos, father, 25
2. Paloma Vazquez Pedrero, mother, 23
3. Sheila de Frutos, daughter, 5

Family apartment in distance, obscured by hill

OBJECTS IN PHOTO

(Clockwise from lower left)

- Bicycles (3, 2 mountain bikes)
- Dishwasher
- Microwave oven
- Ceramic dog
- Hunting rifle
- Framed pictures (5, throughout picture)
- Potted plants (3)
- Washing machine
- Espresso machine
- Sports trophy
- Dining sets (2, dining room and kitchen)
- China
- Armoires (child's on left; parents' on far right)
- Beds (2)
- Bedroom end tables
- Dressers (2, child's and parents')
- Table lamps (4)
- Basket with toys
- Free-standing mirror
- Rug
- Couch
- Easy chairs (2)
- Living room cabinets (5, with television and flower vase)
- Amphorea (tall two-handled jars)
- Wooden amphorea stand
- Stereo system
- Two stuffed birds
- Automobile
- Dog
- Roman aqueduct (in background)

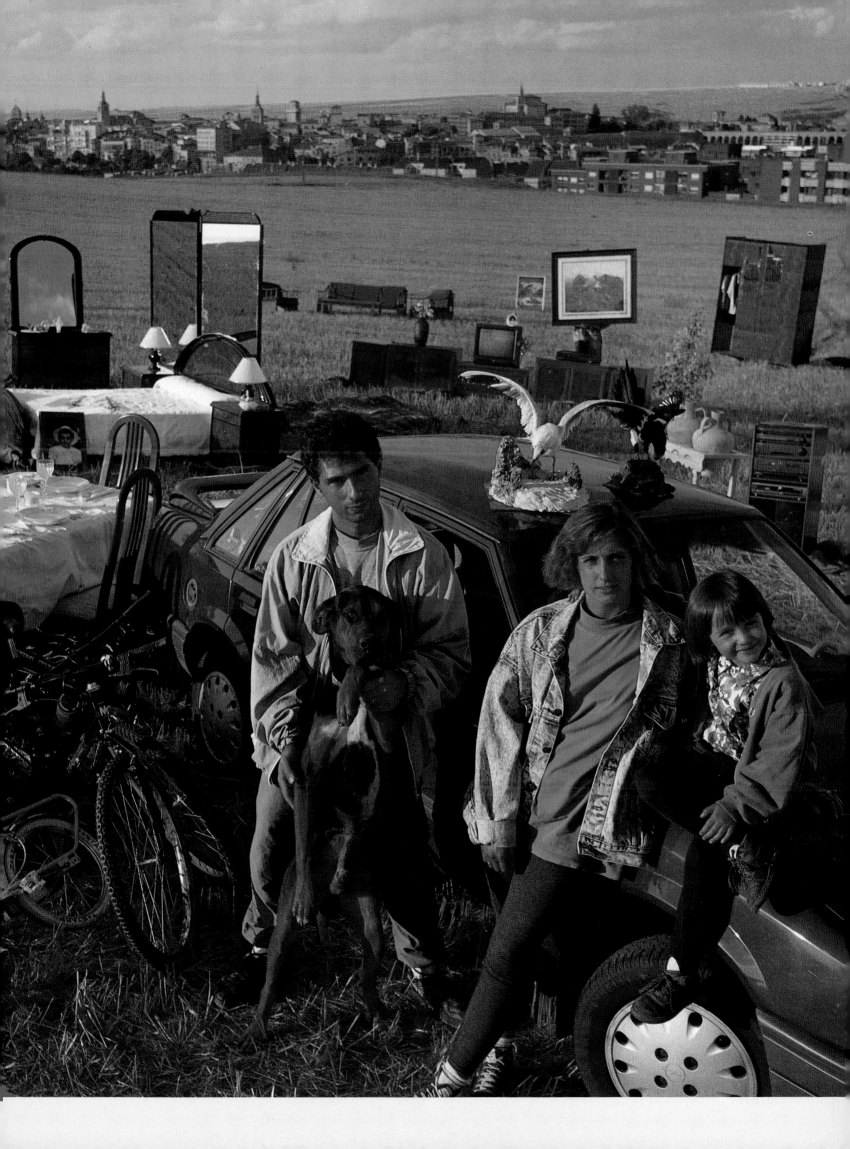

A

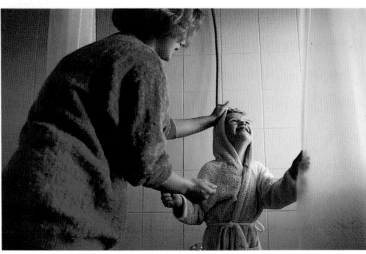

TRADITIONAL IN MANY WAYS, José Maria believes that the male of the household should be the provider and that the female should stay at home with the children. To a large extent, this is exactly what happens. When José Maria leaves the house for work, Paloma gives 5-year-old Sheila her morning bath *(D)* and takes her to kindergarten, where she is learning to read *(B, teacher holding copy of Disney version of* Beauty and the Beast*)*. Returning home, Paloma cleans the house *(A)* to the accompaniment of televised soap operas called *culebrones* — the word comes from the Spanish word for "snake," which is suggestive of their long, serpentine plots. At the same time, the lives of José Maria and Paloma are not like those of their parents. They met when they were teenagers and married when their daughter Sheila was two. They do not go to church unless there is a wedding or a christening. And far from shunning household chores, José Maria is comfortable cooking for the family *(C, having Paloma taste paella)* He does it often, partly because he has worked as a cook in Segovia's booming tourist industry.

D

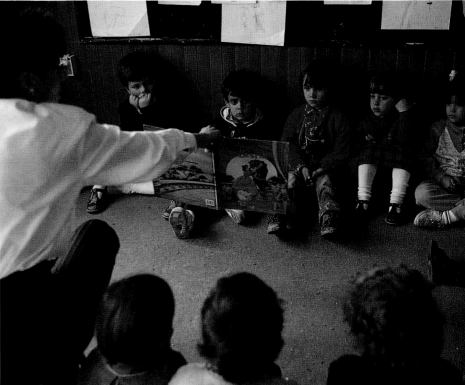

B

C

SPAIN
ESPAÑA

STATS

Area
194,981 sq. mi.
(504,997 sq. km.)

Population
39.3 million

Population density
201.6 per sq. mi.
(77.8 per sq. km.)

Total fertility rate in 1992
1.4 children per woman

Total fertility rate in 1970
2.9 children per woman

Population doubling time
434 years

Percentage urban/rural
81% urban, 19% rural

**Rank in number of visiting
tourists among world nations**
1

Life expectancy
Female: 80, Male: 74

Infant mortality
6 per 1,000 births

Population per physician
280

Literacy rate
Female: 93%, Male: 97%

**Rank of affluence
among the 183 U.N. members**
24

The only nation in western Europe ever dominated by Islam, Spain until recently was odd man out on the continent. Its unique path began in the 10th century, when this former possession of the Roman and Visigoth empires was conquered by Muslim Morocco. Under the Umayyad dynasty, al-Andalus, as Spain was called, became the richest, most sophisticated part of Europe. Islamic scholars preserved the knowledge of the Greeks even as the rest of the continent languished in the Dark Ages. After returning to Christian rule in the 15th century, Spain acquired a huge empire in the New World, which it ruled with brutal abandon. After colonial revolts, the nation sank into decline. By the dawn of the 20th century, it was poor and unstable. General Francisco Franco seized control during the 1936-39 civil war. The peninsula's relative isolation did not truly end until his death in 1975. Spain then leaped to economic prosperity and at last became an integral part of Europe. In the process it has acquired a full panoply of European problems: recession; inflation; unemployment; factional discontent; and loss of biodiversity, the last perhaps most alarming in the long run. Less than a fifth of the nation is forested, and many wild species have vanished, especially birds. Although conservation groups exist in Spain, as elsewhere in Europe, it is unclear whether the celebrated landscape will survive the rocky national ascent to modernity.

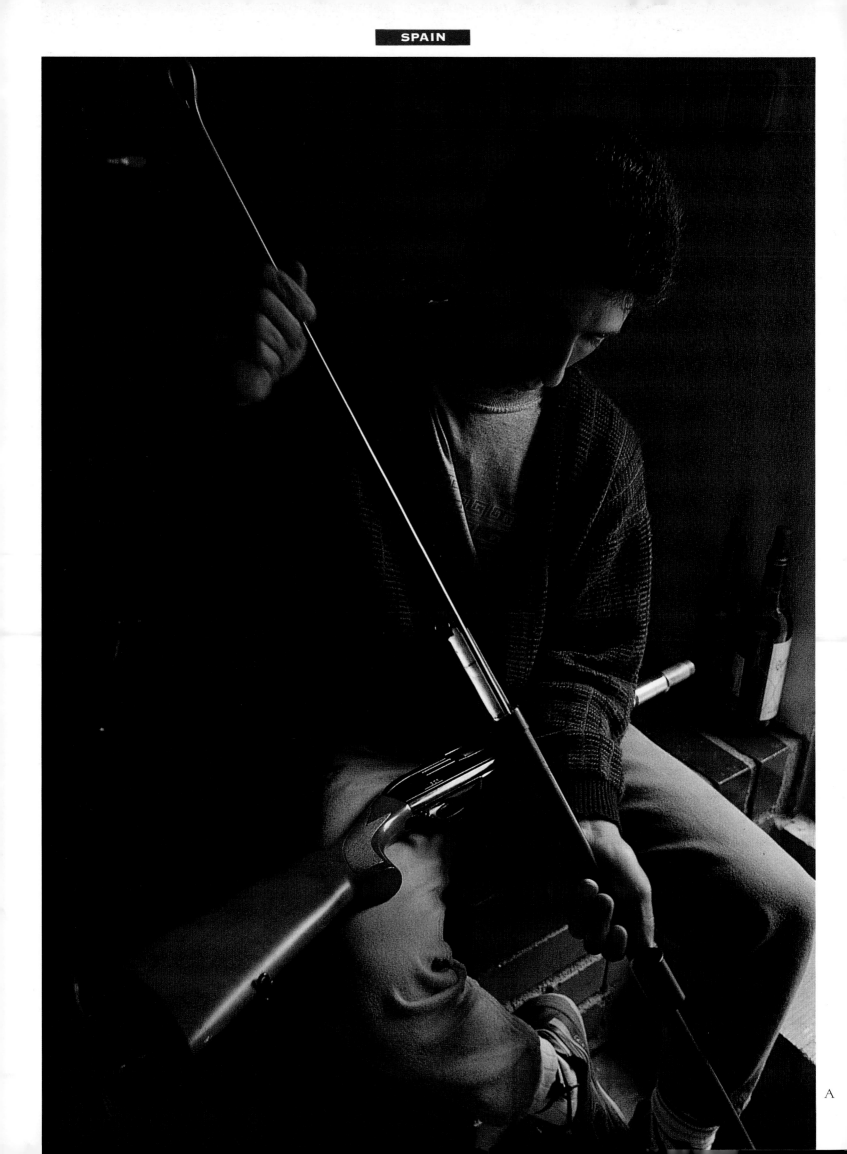

A

B

C

A TAXIDERMIST, José María stuffs, preserves, and mounts birds in a workshop in the basement of his apartment building *(C)*, which also doubles as the family wine cellar. On weekends, he searches for his own trophies — he hunts for rabbit and boar with his friends in the hills around town *(A, cleaning one of his two guns)*. When he is away, Paloma and Sheila have the apartment to themselves *(B, reflected in mirror, toy on bed given as wedding present)*.

DE FRUTOS FAMILY

Size of household
3

Size of dwelling
775 sq. ft. (72 sq. m.)
Living room, kitchen, 2 bedrooms

Workweek
35 hours (Father)
50 hours (Mother — includes work outside the home)

Number of
Radios: 1, Stereos: 1,
Telephones: 1, Televisions: 1,
VCRs: 1, Automobiles: 1

Most valued possessions
Refrigerator full of food (Father)
Stereo (Mother)

Per capita income ($US)
$12,482

Percentage of de Frutos family income spent on food
40%

Wishes for future
4 wheel drive vehicle (Father)
Dress, new shoes (Mother)
A brother (Daughter — parents say they have all the children they need)

PHOTOGRAPHERS' NOTES

JOSÉ MANUEL NAVIA AND ANNA SEVER

The tourist brochures say that Segovia belongs to *la España profunda* — deep Spain, where the days are saturated by the passage of time. But the Segovia in which the de Frutos family lives is not part of *la España profunda*. They are part of the first generation of Spanish to be Europeans, doing things the European way. They don't want any more kids for now, a change from the days when families were "as big as God wants them to be." Of course, their lives are not totally different from those of their parents. As Spanish women have always done, Paloma passes the day at home, enjoying the times when her female friends come to visit. José María spends most of his free time with his male friends, and didn't want *Material World* around then. We were happy to agree — it had been unbelievably hard to find a family in Spain that would consent to our visit on any terms. European or no, the cynical pride of the Castillians created a wide moat around their homes. Life indoors at home was sacred and not revealable. Indeed, when it came time for the de Frutos family to put out their belongings in full view of the neighbors, that was just too much. We collaborated and took the Big Picture way outside of town so that nobody could see.

GREAT BRITAIN

Cold Island

The Hodson Family

3:30 P.M., FEBRUARY 10, 1994
GODALMING, ENGLAND

PHOTOGRAPHS BY DAVID REED

KEY TO BIG PICTURE

1. Richard Hodson, father, 43
2. Fenella Hodson, mother, 43
3. Alice Hodson, daughter, 15
4. Eleanor Hodson, daughter, 13

OBJECTS IN PHOTO

(Clockwise, from left to right)

- Tea and crumpets (on dining table)
- Boat tiller
- Clothes
- Stereo, CDs, records, television, log basket (on and around kitchen table)
- Mirrors (2)
- Cars (2)
- Bicycles, (4)
- Gas grill
- Wheelbarrow, garden tools, lawn mower
- Enterprise sailing dinghy
- Sitting room set (2 couches, 2 chairs, coffee table, end table, table lamp)
- Pictures (3, on couch and chair)
- Chair (with portrait of daughter)
- Music stand, hall desk with stationery holder, lamp (behind mirror)
- Bookcase, lamp, pictures
- Bottled drinks, squash raquet (atop chest of blankets)
- Knapsack (from father's Boy Scout days) and walking stick (on kitchen chair)
- Parents' bed
- Table, chair, candlesticks, painting (in front of bed)
- Chest of drawers with lamp
- Bookcase
- Excercise machine
- Table with lamp
- Cat basket (next to gate)
- Temptations Greatest Hits album (father's first musical purchase, left corner of garage)
- Montage of newsclippings about Bobby Moore (British soccer star)
- New York poster (below Temptations album)
- Pictures (5, on frame in front of garage)
- Cricket bat, pads and gloves, boogie board
- Deep freezer (in garage)
- Refrigerator, washing machine, dryer, stove
- Radio, tea kettle, vacuum cleaner, food processor, microwave, pepper mill and salt shaker, pots (atop appliances)
- Towel rack
- Bed (with radio, records, Bible, teddy bear slippers)
- Chair with portrait of daughter
- Flute (in daughter's hands)

A

B

D

GREAT BRITAIN

STATS

Area
94,595 sq. mi.
(244,999 sq. km.)

Population
58.1 million

Population density
614.2 people per sq. mi.
(237.1 people per sq. km.)

Total fertility rate
1.9 children per woman

Population doubling time
289.2 years

**Percentage of urban/rural
population**
90% urban, 10% rural

**Percentage of trees
with more than 1/4 of leaves
lost to acid rain and pollution**
56.7%

Life expectancy
Female: 79, Male: 72

Infant mortality
7 per 1,000 births

Literacy rate
Female: 99%, Male: 99%

**Rank of affluence
among the 183 U.N. members**
19

Great Britain has been struggling to find the best role for itself at a time in which it has changed from a somewhat isolated, racially homogeneous imperial island to a multiracial society that forms a piece of the linguistic mosaic that is Europe. The adaptation has been difficult, partly because the nation's deep class divisions helped exhaust its industrial base, and partly because that industrial base was created at a time when the United Kingdom was the center of a vast colonial empire. In the 1980s the Conservative government tried to rejuvenate the economy by creating, almost from whole cloth, a more entrepreneurial system. The attempt aroused visceral fears, because it threatened the English way of life. As a result, it was only partially successful — leaving the economy still weak. At the same time, that way of life was under attack from other forces, including the tabloid press, the anomie caused by long-term unemployment, the increasing demands of foreign-born Britons to be heard, and, in 1994, the completion of the first direct rail link between Britain and the Continent.

WHEN THE "BELLS GO DOWN" at the Fulham fire station in London, Richard (A, *on left*), and his crew find that a light snowfall has made weaving at high speed through rush-hour traffic even more hazardous than usual. A veteran of the force, Richard received his twenty-year service medal, which merited a special trip for the family to London (B) for the awards ceremony. He likes the work — no one questions whether firemen are useful to society — but has never completely reconciled himself to the irregular schedule. He is not the only family member to work nights, though — 15-year-old Alice (C) babysits for regular clients as often as four nights a week. Her mother, Fenella, is a part-time nurse at the Royal Surrey Hospital (D). Though the family's expenses leave only a small amount for savings, as Richard says, "We survive without debts."

C

A

D

C

B

UNDAUNTED BY BRITAIN'S famously bad weather, Richard has become a passionate sailor, racing his Enterprise sailing dinghy every weekend that he can (B). While Richard is collecting his third-place finish, Fenella has tea with her parents (A) who, like the Hodsons, live in the small town of Godalming. The weekend finds Eleanor busy with dancing classes (C, on right). Meanwhile, 15-year-old Alice takes private flute lessons (D). In the evening, family members return from their separate pursuits for a supper of rib roast, Yorkshire pudding, and lots of vegetables.

HODSON FAMILY

Size of household
4

Size of dwelling
861 sq. ft. (80 sq. m.)

Workweek
42 hours (Father)
17-27 hours (Mother — does not include housework)

Number of
Radios: 5, Stereos: 3,
Telephones: 4, Televisions: 2,
VCRs: 0, Automobiles: 2

Most valued possessions
Enterprise sailing dinghy (Father)

Per capita income ($US)
$16,606

Percentage of Hodson family income spent on food
25%

PHOTOGRAPHER'S NOTES
DAVID REED

Although it rained almost all the time, giving the daily life photographs a true British feel, the bad weather managed to hold off for the Big Picture. In the middle of setting up, Richard Hodson arrived from staying up all night on his job as a fireman. I worried that he was not going to make it, but instead he was enthusiastic. He kept finding new things for us to put in — a rucksack he has had since he was a Boy Scout, and his Bobby Moore photo montage (Bobby Moore was England's World Cup soccer captain in 1966, when England won). The Hodsons were wonderfully patient about waiting in the bitter cold while we fussed about, even when I made them come back for "just another roll" of film when at last the sun came out. I found myself hoping for a fire when I went to photograph Richard at his job, but instead we had the longest string of false alarms he could remember. Still, I learned that it is a good idea to have a flashing blue light on your vehicle when you want to get somewhere in London in a hurry.

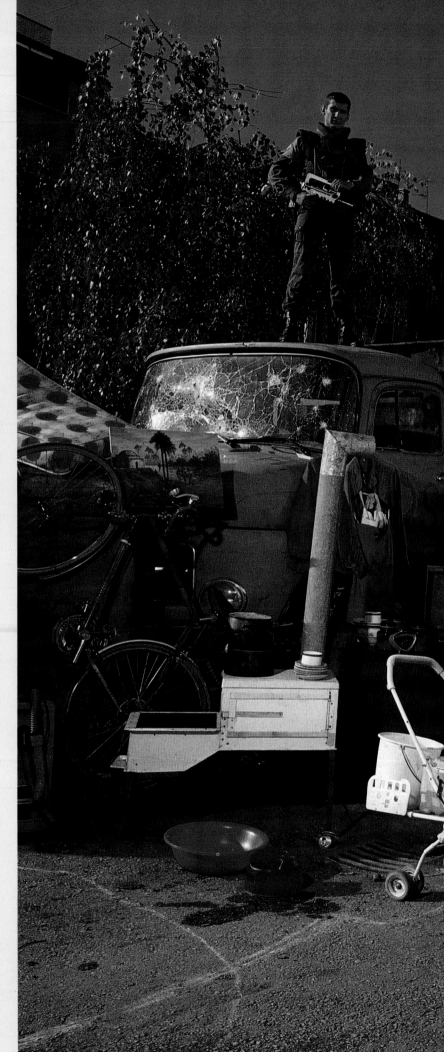

BOSNIA

Siege Mentality

The Demirovic-Bucalovic Family

2:00 P.M, OCTOBER 11, 1993
SARAJEVO, BOSNIA-HERZEGOVINA

PHOTOGRAPHS BY ALEXANDRA BOULAT

KEY TO BIG PICTURE

1. Lokman Demirovic, father, 67
2. Nafja Demirovic, mother, 65
3. Arina Bucalovic, daughter, 26
4. Nedzad Bucalovic, her husband, 23
5. Nadja Bucalovic, their daughter, 2
6. U.N. soldier (not part of household)
7. U.N. soldier (not part of household)
H. Family home

OBJECTS IN PHOTO

(Clockwise from left)

- Plastic basin, chamber pot (yellow and red)
- New wood-fueled oven
- Pots (3, sooty from fire)
- Vacuum cleaner
- Bicycle (10-speed)
- Mattress (now used as sniper barricade in living room)
- Landscape painting (bought on vacation in Libya)
- Wrecked truck (does not belong to family; city streets are full of them)
- Daughter's clothes (hanging from truck)
- Sideboard (in front of truck)
- Television, porcelain basket, plastic flowers, crockery, sugar and flour storage cans (on top of sideboard)
- Refrigerator (basket on top contains medicine, tapes, and instructions)
- 2nd landscape painting
- Mirror (hanging on 2nd mattress/barricade)

- Crib
- Toy stuffed tiger (below crib)
- Shirt (son-in-law's)
- Grandfather's clothes (hanging on 2nd wrecked truck)
- Bed sheets and spreads
- Rented apartment (3rd story, potted plants on railing)
- Playground equipment (public)
- Armored U.N. vehicle
- 3rd landscape painting (on public refuse container)
- Broom
- Chest of drawers
- Portable cassette-tape player
- Potted plants (5, cabbage and tomatoes, from balcony garden)
- Chairs (2, under people)
- Dining table
- Tricycle
- Couch (under grandmother)
- Mortar shell (souvenir of front line)
- Baby carriage (used to transport plastic bottles of water)

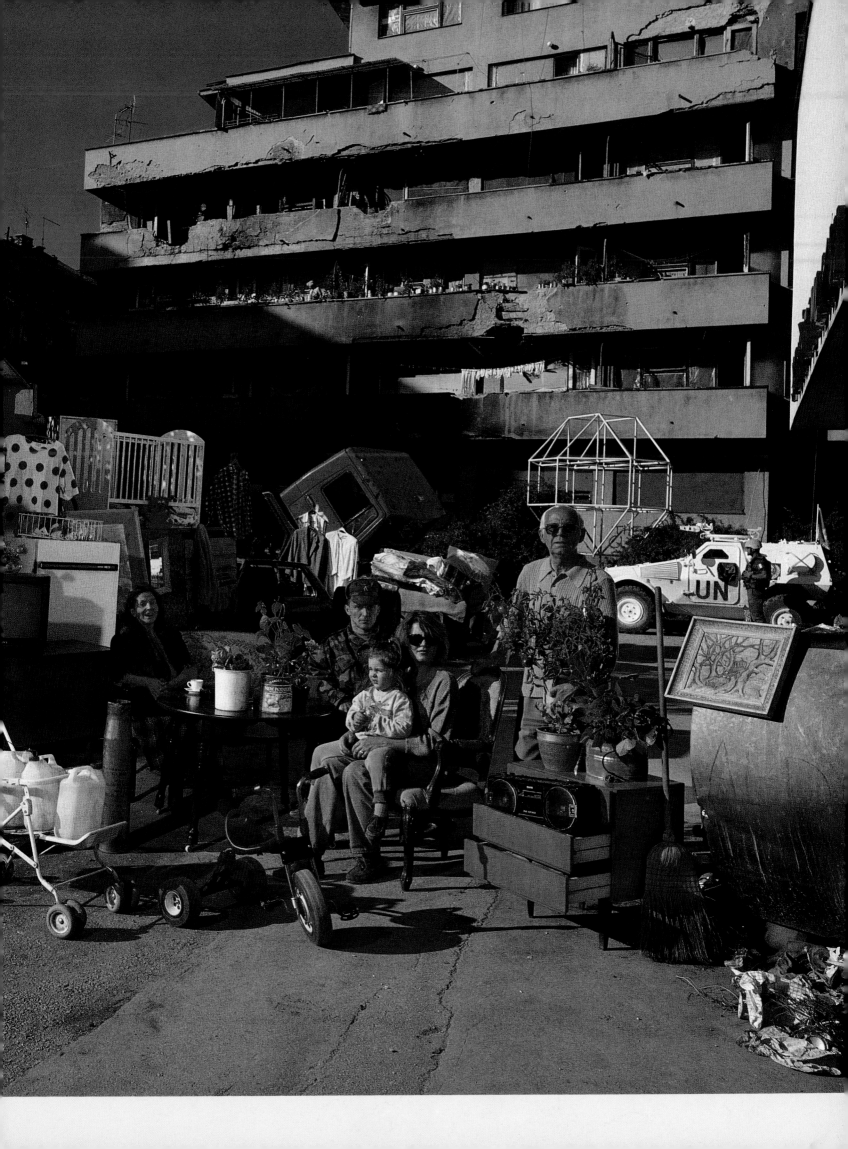

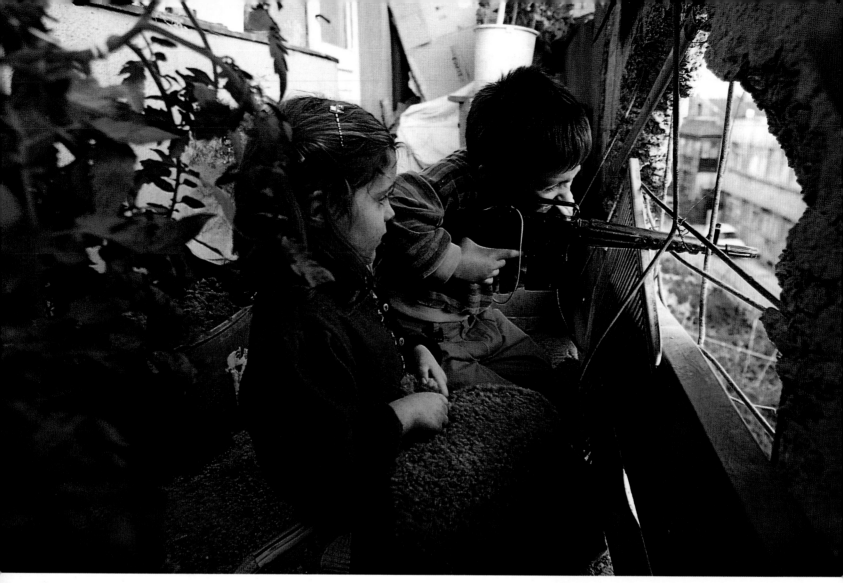

A

UNDER THE CONSTANT THREAT

of gunfire from the hills surrounding the city, the Demirovic household struggles to keep some semblance of its former middle-class existence. Imprisoned in his home by snipers, Lokman, a retired neurosurgeon, now spends his days listening to the radio and making emergency fuel from trash *(D)*. He gathers waste paper and cardboard, soaks it in water for a day, mixes in bits of plastic, mashes the result into a ball around a chestnut, and dries the result on the windowsill. His daughter Arina has learned how to light the wood stove *(E)* the Demirovics were forced to install in their high-rise apartment when the gas went out. She and her family fled with the clothes on their backs from the hills to downtown Sarajevo. Nedzad, Arina's husband, was once a hairdresser in a Holiday Inn near Sarajevo; now he only practices his trade at kitchen sessions with his family *(C, with Nafja)*. Two-year-old Nadja *(A, foreground)* is growing up in a world where the boys next door imitate adults by playing sniper through a shell-hole. Of course, they must also dodge the real thing. Having successfully traversed a dangerous street, one woman *(B)* celebrates her survival. A few months after these pictures were taken, threats from Western powers forced an armistice on Sarajevo, at least briefly. This is little help to the Demirovics, who are still engulfed in a war that seems unlikely ever to reach a real end.

DEMIROVIC-BUCALOVIC FAMILY

Size of household
5

Size of dwelling
650 sq. ft. (60 sq. m.)

Workweek
0 hours (Adults, paid civilian labor)

Most valued possessions
Anatomy book, radio (Grandfather)
Lamp (Grandmother — sign that power has come back on)

Number of
Radios: 1, Portable cassette-tape players: 1, Stereos: 1, Televisions: 1, Automobiles: 1 (destroyed by shell)

Family income ($US)
Approximately $25 per month

Cost of 2 lbs. (1 kg.) meat ($US)
$32

Cost of wood necessary to provide heat for one winter ($US)
$570

E

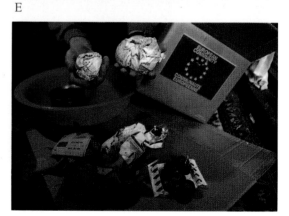

D

B

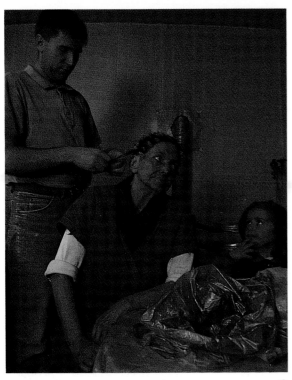

C

BOSNIA-HERZEGOVINA
BOSNA I HERCEGOVINA

STATS

Area
98,842 sq. mi.
(255,999 sq. km.)

Population
4.366 million

Population density
17.2 per sq. mi.
(44.5 per sq. km.)

Ethnic composition
Muslim Slavs, 44%
Eastern Orthodox Serbs, 31%
Catholic Croatians, 17%

Literacy rate
Female: 88%, Male: 97%

Infant mortality
15 per 1,000 births

Life expectancy
Female: 76, Male: 70

**Rank of affluence among
U.N. Members**
60

*(All statistics are from former
Yugoslavia except for population,
population density, and infant mortality)*

History has been exceptionally unkind to this mountainous piece of central Europe. Occupied by successive waves of Hungarians, Turks, and Austrians, forced into an unsuccessful union with Communist Yugoslavia, populated by Eastern Orthodox Serbs, Roman Catholic Croats, and the continent's biggest native Islamic population, Bosnia-Herzegovina has long exemplified the unhappy inability of Europe to cohere. Its many peoples have long kept themselves apart, like quarrelsome neighbors whose mutual jealousies are barely balanced by ordinary social courtesies. After an economic slump and the collapse of Yugoslavia's Communist government, these tensions exploded in the 1990s into open warfare. Bosnia, as the union of Bosnia and Herzegovina is generally known, became the most wretched point in a band of ethnic conflict that stretches from the Adriatic deep into the former Soviet Union. Sarajevo, Bosnia's capital, turned into a Muslim enclave. Serbian militia in the surrounding hills besieged it for years. Meanwhile, the countryside echoed with gunfire as Muslims fought Croats and Croats fought Serbs. Although a flurry of threats from Europe and the United States forced an armistice onto Sarajevo in the spring of 1994, the area seems mired in a conflict that will not end soon.

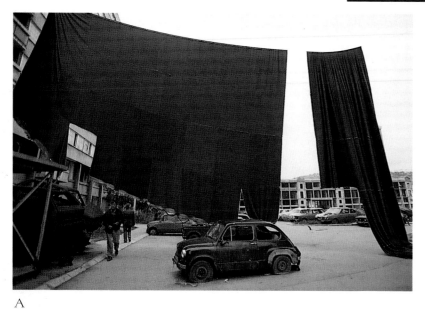

A

WARFARE IS PART OF LIFE in encircled Sarajevo. To hide from Serb guns in the hills, city-dwellers put up huge makeshift barriers (A) along heavily traveled routes. Materials range from cloth to piles of trash to fantastic barricades of wrecked automobiles — sometimes all at once, as here. Not that such methods can ever be totally effective. When a shell struck an apartment in the Demirovics' building (C), the explosive force instantly smashed that middle-class home to ruins. As hard to endure as the constant danger is the constant deprivation. No one in the family ever thought they would have to live without electricity, gas, or running water. Food is so scarce that the Demirovics and other families have turned apartment balconies and roofs into impromptu truck gardens. Everyone has their snapping point. For Arina, it is the lack of an electric hair-dryer. In the damp, unheated apartment, she is constantly walking around with wet hair. With a hairdresser in the family, the option of dirty hair seems completely untenable. Nedzad misses his job at the hotel and the social anchor it provided. Now he commutes between fighting in the mountains and scrounging for food in Sarajevo — eight days on the front, then six days with his family. During his time in the city he is always trying to make connections on the black market. Sometimes transactions take place in the dead of night; other times, as with this man (B), the black market is in the open. The vendor sells 2 kilograms (about five lbs.) of apples for the equivalent of $12; the two carrots are $3 apiece. It's more than the Demirovics can afford; Nedzad's army pay is $3 per month.

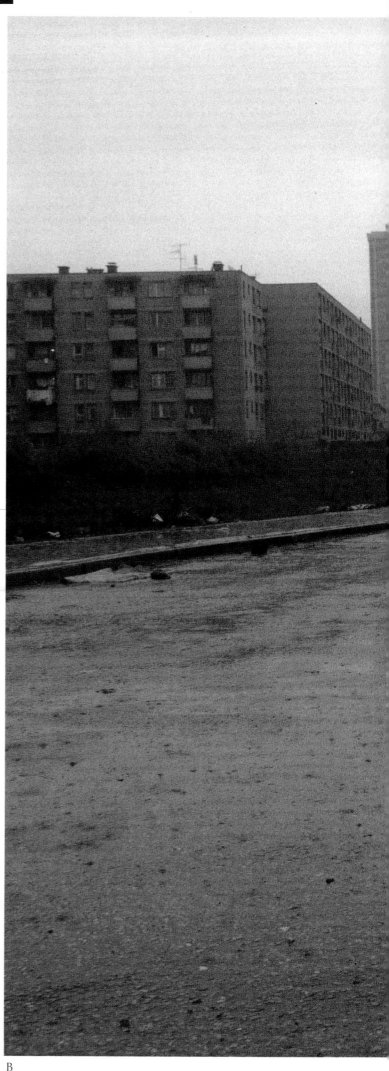

C B

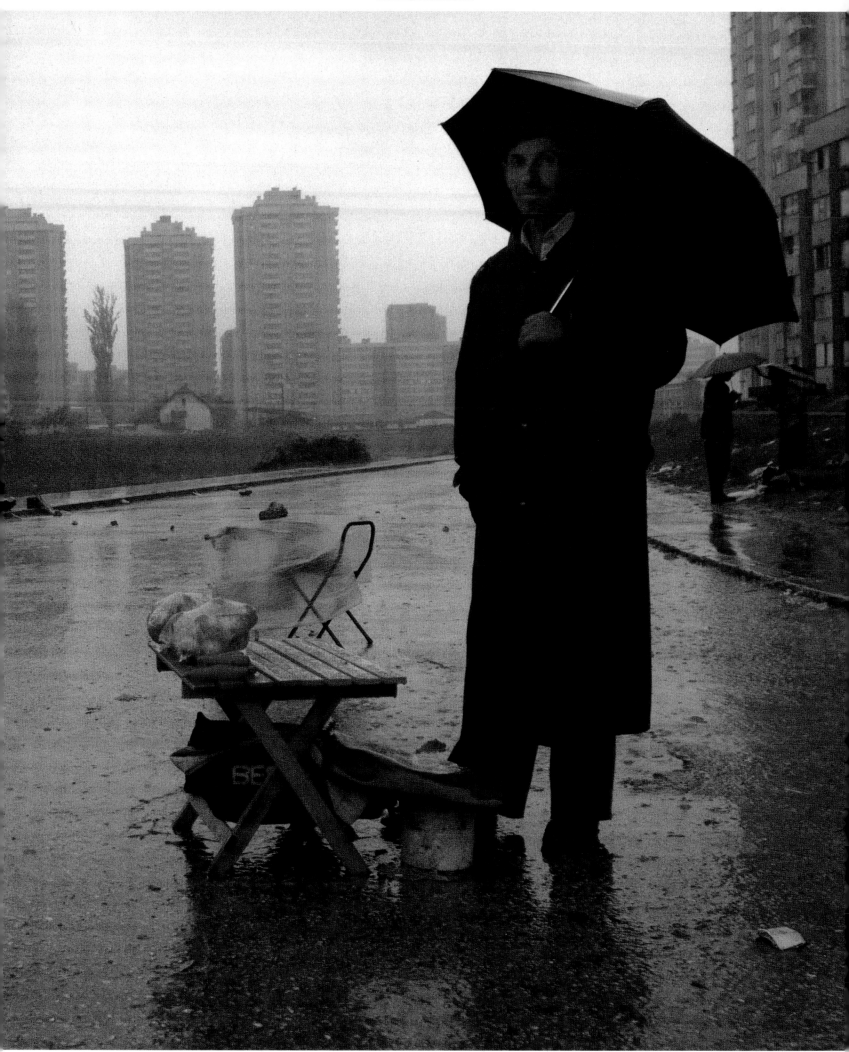

A

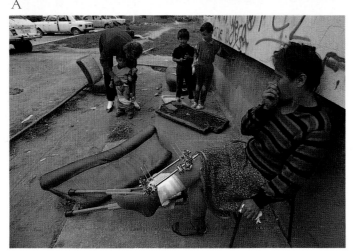

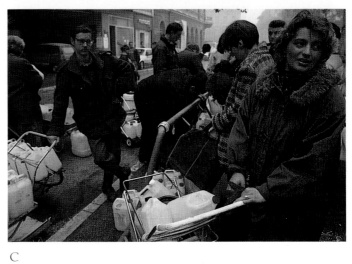

D C

WITHOUT ELECTRICITY, the family is ruled by the sun. Rising at dawn, Arina (C) walks a mile to the public water source (there's no gas, and the family's Yugo was destroyed by shrapnel). She fills 15 plastic jugs, loads them into her daughter's baby carriage, and treks home. Soon she will have to say good-bye for another week to Nedzad (B), who is returning to the front. The parting, as always, is grim; it has never escaped Nedzad's attention that he is leaving his family in a dangerous place. Victims of war are visible everywhere: This woman (D) was caught in the same attack that injured her child. At night the noises stop and Lokman tries to think and read a little by candlelight (A) before turning in. He usually sleeps on the couch, with his daughter and her husband using a makeshift mattress on the floor. To give the couple some privacy, he sometimes spends the night in the kitchen. The situation enrages him — it is not the life he envisioned when he retired in 1988 from a successful career in medicine. "We live like primitives," Lokman says.

PHOTOGRAPHER'S NOTES
ALEXANDRA BOULAT

Everyone I met in Sarajevo was exhausted. They had lived in a valley under continuous artillery and automatic-weapons fire for almost two years and were tired of trying to survive. The road from the airport to the center of town is called Sniper's Alley. The modern high-rise apartments that line it have been shot up until they look like one rat's nest after another. Life without electricity and water makes Sarajevo's people feel like animals — they can't shower, use a stove, see indoors at night. My household of five was jammed together in a three-room, 650-square-foot apartment meant for two. All were ordinary middle-class Europeans before the war: they owned stereos and TVs, took vacations in Italy, wore the latest fashions and make-up from America. Now they are trapped in Sarajevo. Their balcony, where they grow vegetables, was hit by a shell in 1992 and the rooms inside are full of bullet holes — two bullets cut through the apartment in the week I was there. Because of her frail health and the constant sniping, Nafja (the grandmother) hadn't been outside for almost three years before I took the Big Picture. She was scared and didn't want to do it at first. After I talked her into it, she put on her makeup and went out. And then she spent the whole afternoon outside, talking with her friends. At the end of the day her eyes were shining! For a couple of hours, at least, she forgot the war.

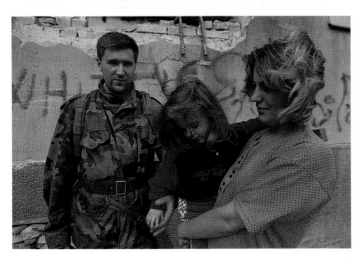

B

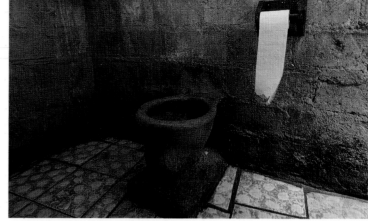

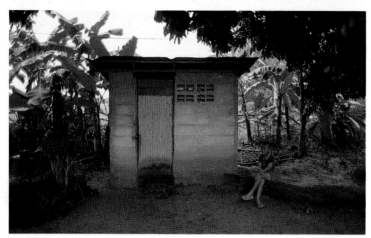

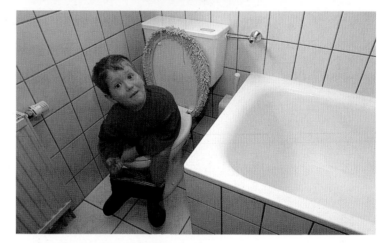

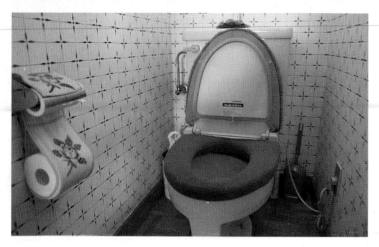

KUWAIT
THAILAND
JAPAN
SOUTH AFRICA

MEXICO
GERMANY
ETHIOPIA
CUBA

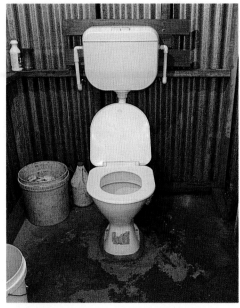
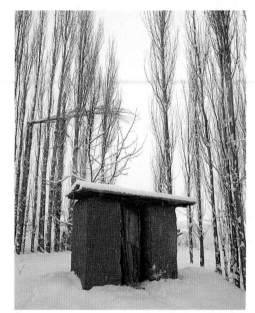

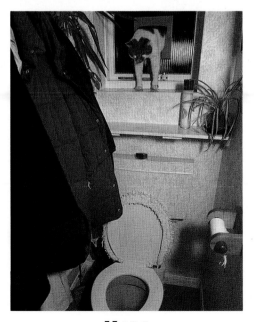
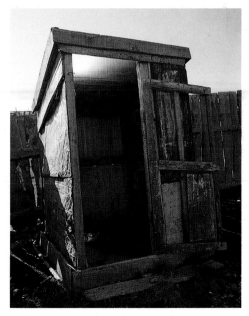

GUATEMALA
ALBANIA
VIETNAM

MALI
WESTERN SAMOA
GREAT BRITAIN

BHUTAN
UZBEKISTAN
MONGOLIA

M I D D L

IRAQ

Postwar Blues

The Saleh and Ali Families

4:00 P.M., JANUARY 25, 1994
BAGHDAD, IRAQ

PHOTOGRAPHS BY ALEXANDRA BOULAT

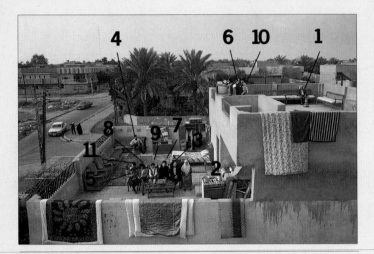

KEY TO BIG PICTURE

(Grandparents' household)

1. Mahdi Saleh, father, 74
2. Shaïmaa Saleh, mother, 59
3. Amira Saleh, 2nd daughter, 34
4. Falah Saleh, son, 21

(not shown) Ikhlas Saleh, 3rd daughter, 27

(1st daughter's household)

5. Alia Saleh Ali, 1st daughter, 42
6. Abed Ali, husband, 45
7. Wasan Ali, 1st daughter, 19
8. Sahar Ali, 2nd daughter, 17
9. Hala Ali, their 3rd daughter, 12
10. Ahmad, son, 7
11. Suher, their 4th daughter, 18 months

OBJECTS IN PHOTO

(Terrace, clockwise from left)

- Trellis (above entrance to household)
- Set of easy chairs (4) and couches (2)
- Coffee tables (3)
- Rug
- Guitar (being strummed) and guitar case
- Dining chairs (6, under family)
- 4th coffee table (with coffee set, statue, Koran on stand)
- Dresser with mirror, iron, candlestick, cosmetics, family photos, Saddam Hussein calendar

- Armoire with clothes, jewelry
- Suitcase (on top of armoire)
- Bed (with curios)
- Sewing machine
- Bed cover (folded)
- Kitchen stove (with pots)
- Broken furniture (storage area)
- Quilts (3), thin mattress (gray and black)

(On roof, clockwise from left)

- Television and clock
- Couches (3)
- Hot water reservoir (gray)
- Quilt and blankets (2)

NOTE: THIS HOUSEHOLD, UNLIKE THE OTHERS IN *MATERIAL WORLD*, WAS SELECTED BY GOVERNMENT REPRESENTATIVES.

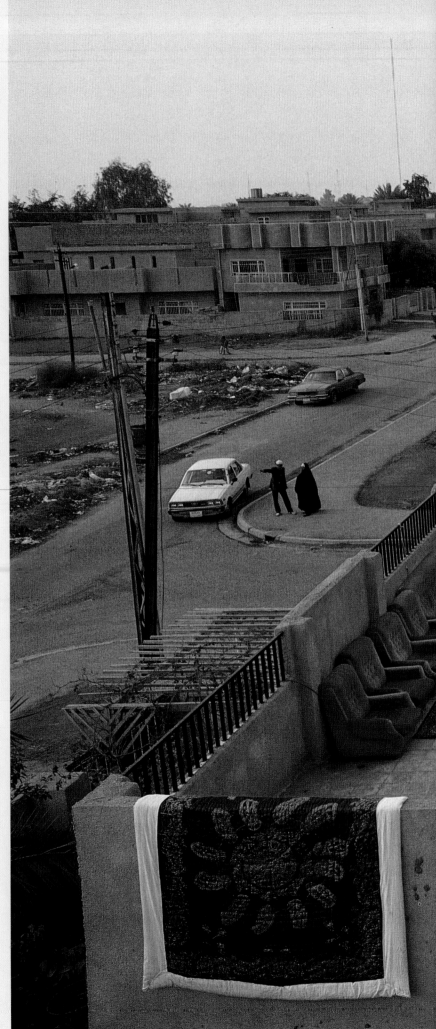

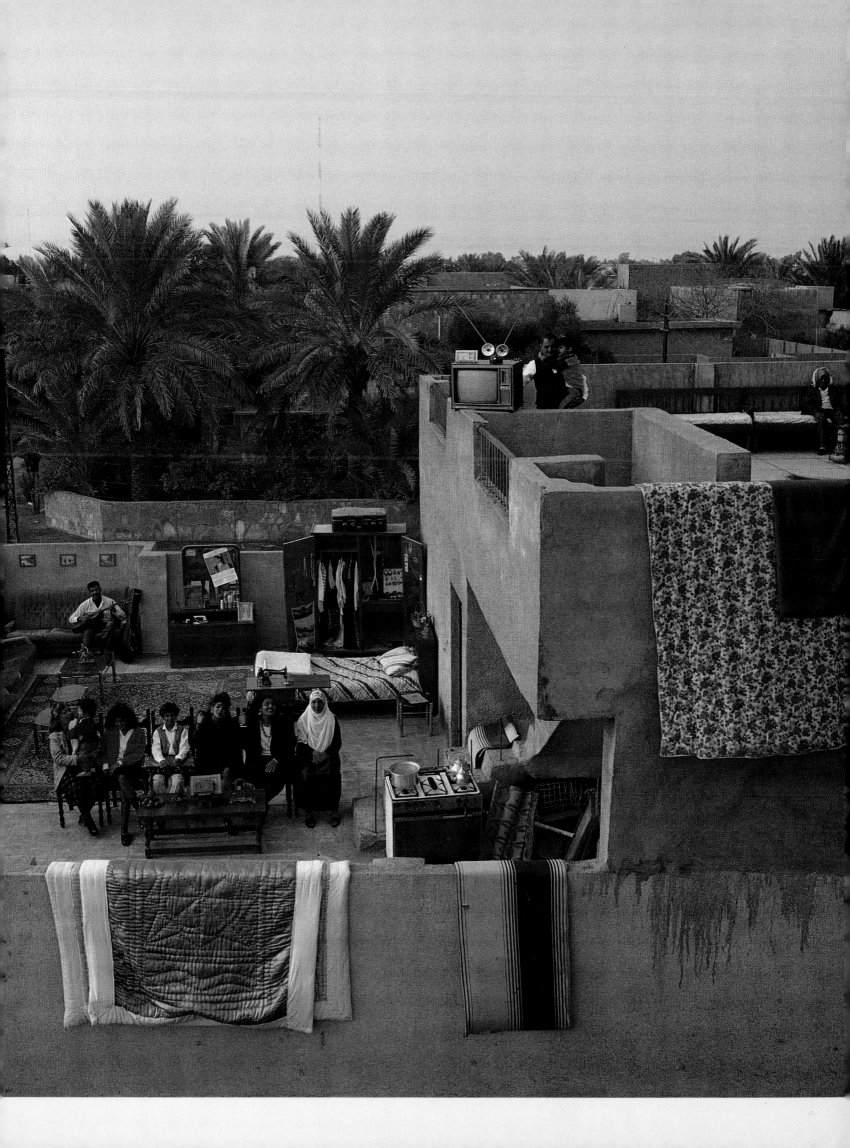

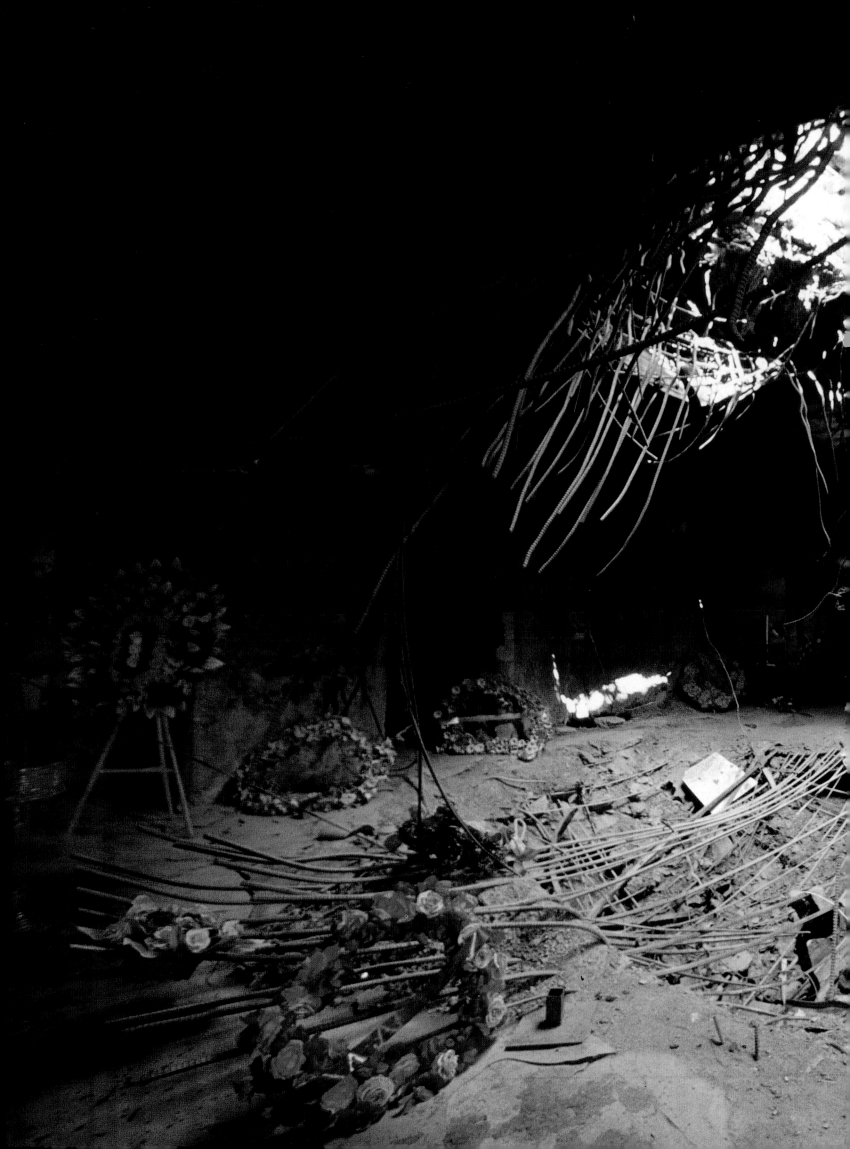

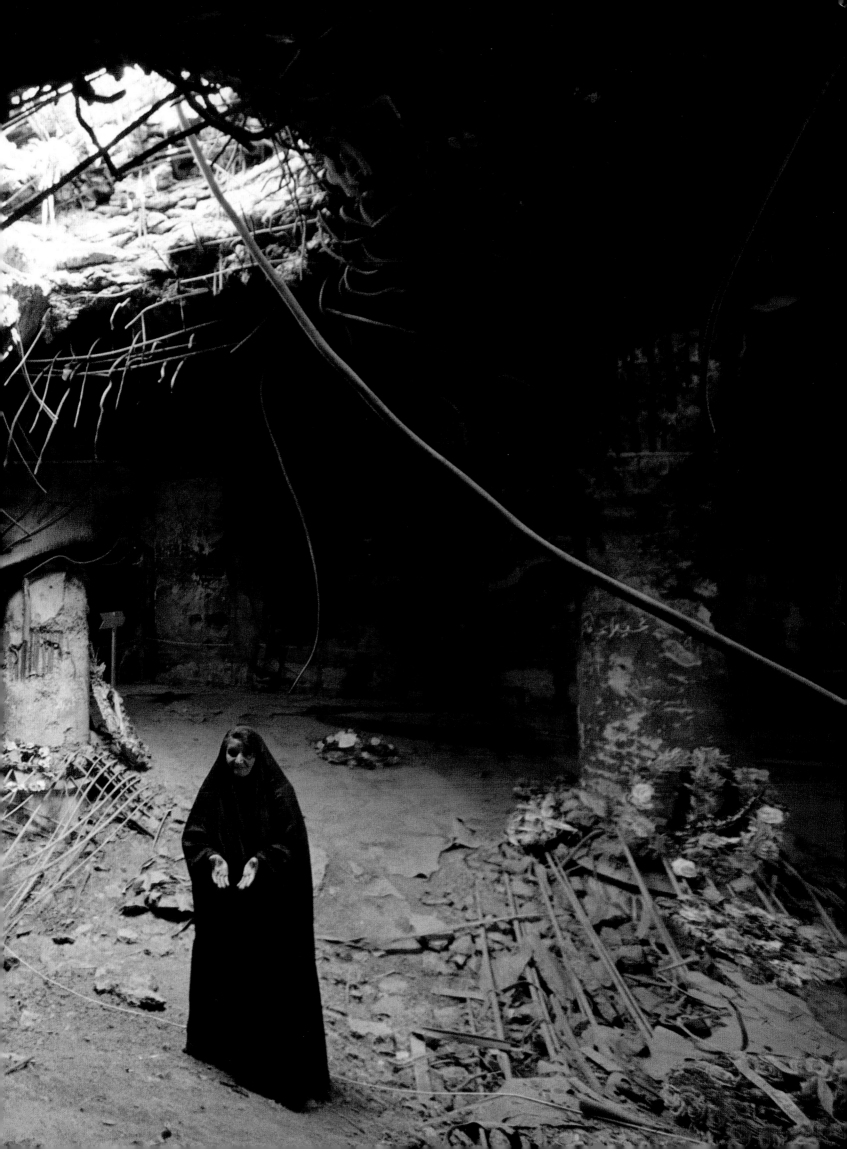

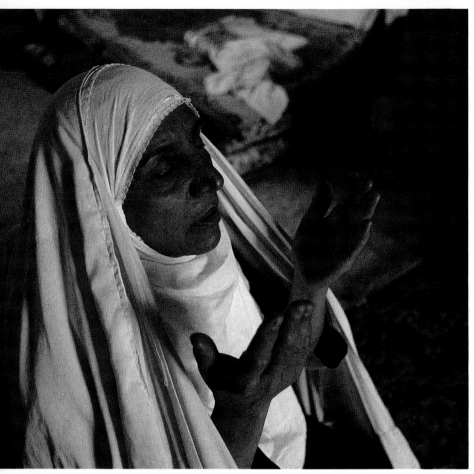

A

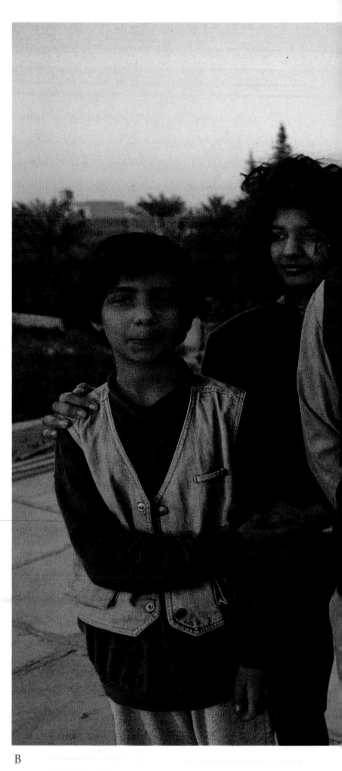

B

IRAQ

STATS

Area
169,000 sq. mi. (437,707 sq. km.)

Population
21.2 million

Total fertility rate
5.7 children per woman

Population doubling time
22 years

Percentage urban/rural
75% urban, 25% rural

**Rank of size of military
among world nations in 1991**
14

**Rank of size of military
among world nations in 1985**
8

**Rank of per capita greenhouse
gas emissions among nations
with highest total emissions**
1

Life expectancy
Female: 66, Male: 61

Literacy rate
Female: 49%, Male: 70%

**Rank of affluence
among the 183 U.N. members**
77

Modern Iraq centers on the valleys of the Tigris and Euphrates rivers, scene of the Earth's longest and bloodiest historical pageant. Ten millennia ago, the nomads in the hills north of these rivers learned how to domesticate plants and animals. Moving down to the valleys, these Mesopotamian cultures developed astronomy, mathematics, writing, and centralized states that ran big irrigation schemes. Sumeria, Akkad, Babylon, Assyria — the empires violently appeared, violently disappeared. Islam came in 642, followed by the Mongols, the Ottomans, and the British. In 1932 Iraq became independent. Years of instability ended in 1968, when Saddam Hussein seized power. He nationalized the oil industry and used the revenues to create a huge army. The army invaded Iran in 1980. After an inconclusive, seven-year war that caused more than a million deaths, Iraq attacked another neighbor, Kuwait. An international coalition repulsed the assault in 1991 and established an embargo that remains in force. Meanwhile, the government pushed development and quashed dissent. A striking example of both is its plan to drain the confluence of the Tigris and Euphrates, which will create a million acres of arable land while wiping out rebel hideouts and the Mideast's biggest wetland.

D

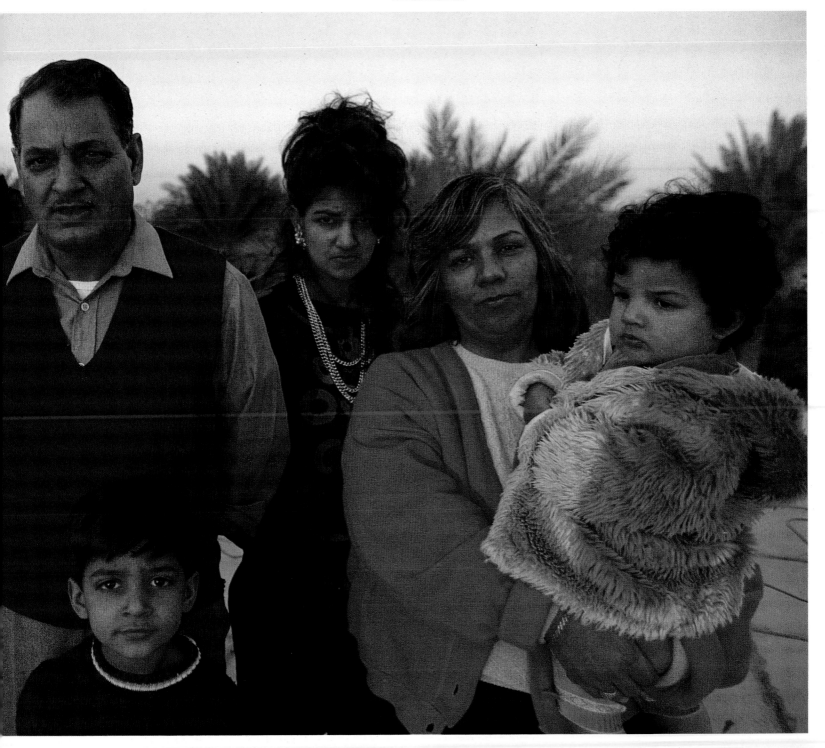

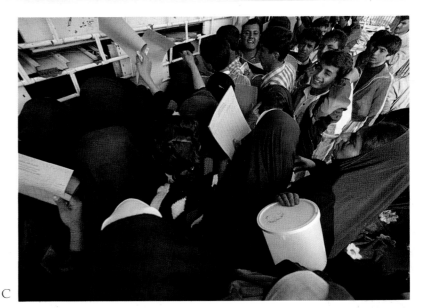

PRAYER FIVE TIMES A DAY orders life for Shaïmaa *(A)*, as it has all her life. She and her husband, Mahdi, have eight adult children. Three, still unmarried, live with their parents. Five are married, of whom one, Alia, lives so close that the two homes essentially form a single extended family. Her husband, Abed Ali *(B, center, with, from left, Hala, Wasan, Ahmad, Sahar, Alia, and Suher)*, works for the army, still the nation's most powerful institution. His position, though, does little to insulate his family from the consequences of the U.N.-sponsored international trade embargo on Iraq. Once a week, they must stand in line for their allotment of dairy products *(C)*. And the school attended by 7-year-old Ahmad *(D)* has no heat, so that on cold days students wear gloves inside.

PREVIOUS SPREAD: In the same district as the Saleh-Ali family's home, the Amiria shelter (hit by a U.S. bomb in the Gulf War) has been converted to an impromptu memorial for the 410 killed inside. A woman who lost nine children there acts as a custodian.

C

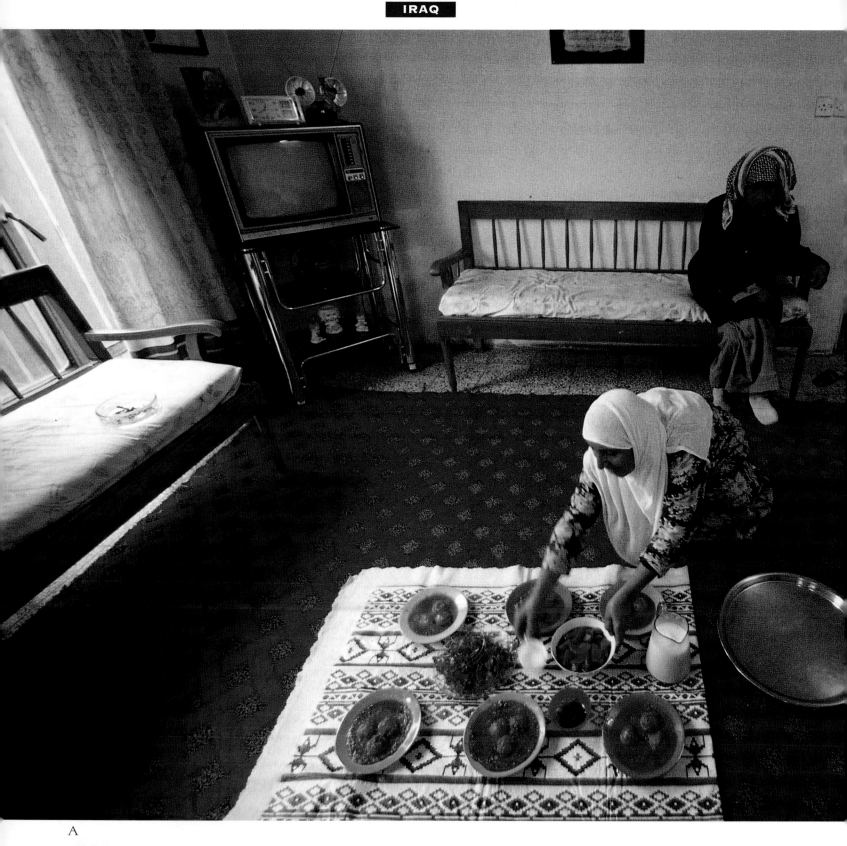

A

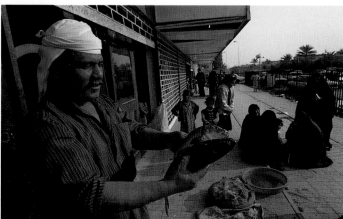

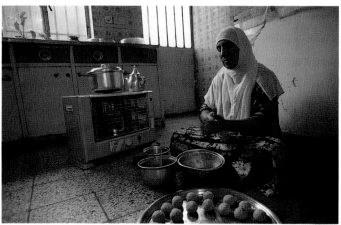

D

C

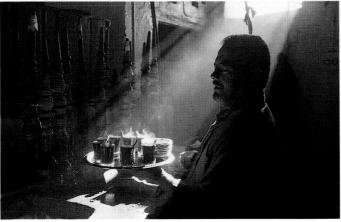

ALTHOUGH SHE LIVES in a house based on Western design ideas, Shaïmaa prefers to live closer to the floor, in the style she finds more comfortable. Ignoring the counters, she puts a hot plate on the floor and cooks vegetable soup, adding in cumin-flavored dumplings *(C)*. When the food is ready, she lays out a spread of soup, cilantro, and beets on the rug *(A, with her husband Mahdi looking on)*. Although meals are tighter since the embargo, the pinch is not overwhelming — nobody has to do without. The markets in Baghdad still feature fresh fish, meat, and produce *(D)*. The city's famous cafes still serve sweet Iraqi tea *(B)*. But now the prices have climbed to such heights that Alia was recently astonished to learn that a new shirt for her husband would cost more than a third of his monthly salary.

PHOTOGRAPHER'S NOTES
ALEXANDRA BOULAT

All journalists are requested to register at the Ministry of Information Press Center when they arrive. So after driving 600 miles from Jordan — the only way into Iraq — that's what I did. All journalists are requested to be accompanied by a guide whenever they want to film. So I was. All photographers are requested to ask for written permission 24 hours in advance before taking any pictures. So I did. The government is trying to control its image. It wants to show the damage created by the war and the embargo, but it doesn't want to show any actual deprivation. Because the intent is contradictory, the rules get confusing. Some sites can be photographed only from the north side; others, only from the south side. I was not allowed to take pictures of the beautiful horse-drawn carriages that home-deliver fuel, because the guide thought they were too old-looking. Nor could I photograph the Saddam Clock, a very kitschy monument with a shiny square clock on top built to glorify Saddam Hussein, because it is unfinished and too new-looking. And so on. The government chose the Saleh and Ali families for me and I was always escorted by a guide, but despite the unavoidable awkwardness and lack of intimacy I tried to capture something of the flavor of their lives. Although it was not in any way the fault of these nice people, working in Iraq was the most frustrating experience of my photographic career.

KUWAIT

Oil Rich, Worker Poor

The Abdulla Family

5:30 P.M., DECEMBER 10, 1993
KUWAIT CITY, KUWAIT

BIG PICTURE BY PETER MENZEL

DAILY LIFE PHOTOGRAPHS
BY PETER ESSICK

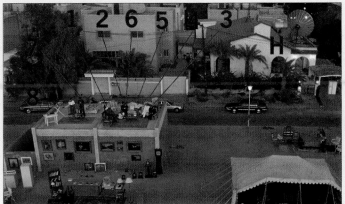

KEY TO BIG PICTURE

1. Saif Abdulla, father, 52
2. Zainab Abdulla, mother, 44
3. Lubna Abdulla, daughter, 29
4. Lail Abdulla, daughter, 26
5. Abla Abdulla, daughter, 16
6. Ali Abdulla, son, 2
7. Agnes Fernandes, servant, 25
8. Zavier Fernandes, servant, 30

H. Family home (with refrigerator in entry, satellite dish)

OBJECTS IN PHOTO

(Selected items, clockwise from left)

- 45-foot-long sofa (from basement)
- Glass-topped coffee tables (3, with magazines)
- Carpets (4, beneath sofa, chest)
- Gas barbecue grill
- Low table (with fishing poles, various sporting equipment)
- Kitchen table (with microwave oven, toaster oven, high chair, 6 chairs)
- Bedroom set
- Washer and dryer
- Refrigerator
- Home-office furniture (includes telephone, fax machine, computer, printer, 2 leopard skins, 2 lamps)
- Oil paintings, stained-glass windows (on wall of municipal pumping station)
- Duck decoys (3)
- Antique clocks (6)

- Ironing board, iron, end table, radio, chairs (2), twin bed, carpet (on roof of pumping station, used by servants)
- Sofa, chairs (6), coffee table, jumbo jet tricycle (on roof, near family)
- Lectern, carpets (2), cushions, coffee pot collection (in family tent)
- Living room sets (3, two with color televisions)
- Bedroom sets (3, one with vanity, one with crib, one with long basketball trophy ribbons and guitar)
- Cars (4: 1992 Mazda, 1989 Mercedes Benz, 1990 Honda, 1992 Mitsubishi)
- Antique Chinese urns (2)
- Dining room table with chairs (6)
- Tiffany lamp, collection of antique coffee pots (on table)
- Silver tea set (on tea cart)
- End table with statue

A

B

KUWAIT
KUWAYT

STATS

Area
6,880 sq. mi. (17,819 sq. km.)

Population
1.2 million
(Figure includes "guest-workers")

Population density
174.4 per sq. mi.
(67.3 per sq. km.)

Total fertility rate
3.7 children per woman

Population doubling time
Impossible to state
(Country has been ejecting
non-Kuwaiti workers faster
than natural population increases)

Percentage urban/rural
97% urban, 3% rural

Life expectancy
Female: 76, Male: 72

Infant mortality
14 per 1,000 births

Literacy rate
Female: 67%, Male: 77%
(Figure includes "guest-workers")

**Rank of affluence
among the 183 U.N. members**
21

Small, hot, flat Kuwait has long been a symbol of the petroleum wealth that has transformed the Arab world — and the conflicts exacerbated by that wealth. The shiekhdom, originally a collection of fishing families, emerged from isolation in the 20th century, when it fell under the sway of the British. But Kuwait only came to prominence after World War II, when Western corporations tapped its vast reserves of low-cost, high-grade oil. In a startlingly short time, one of the harshest environments on Earth became one of the most comfortable, as the coastal cities turned into a rich suburban sprawl. Its hardscrabble people soon acquired mansions and servants; today, foreign "guest-workers" outnumber Kuwaitis by 3 to 1. Water comes from the world's biggest desalinization complexes; food is mostly imported. Wealth could not buy tranquility. The Iraq-Kuwait border, a legacy of colonialism, was never established to both nations' satisfaction. Indeed, Iraq claimed all of Kuwait after Britain declared the latter independent in 1961. Years of threats led to an actual invasion in 1990, which five months later was repulsed by a U.S.-led international coalition. But the invasion had long-lasting effects — the Iraqis left the desert full of deadly land-mines, and set the oil fields on fire (they burned for ten months). Kuwait's vast financial holdings were depleted, and in 1992 a reform party won Parliamentary elections for the first time. The future of this rich nation is surprisingly uncertain.

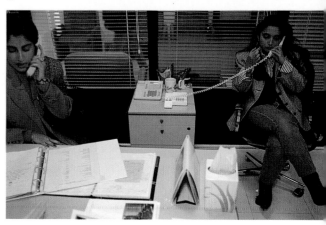

D

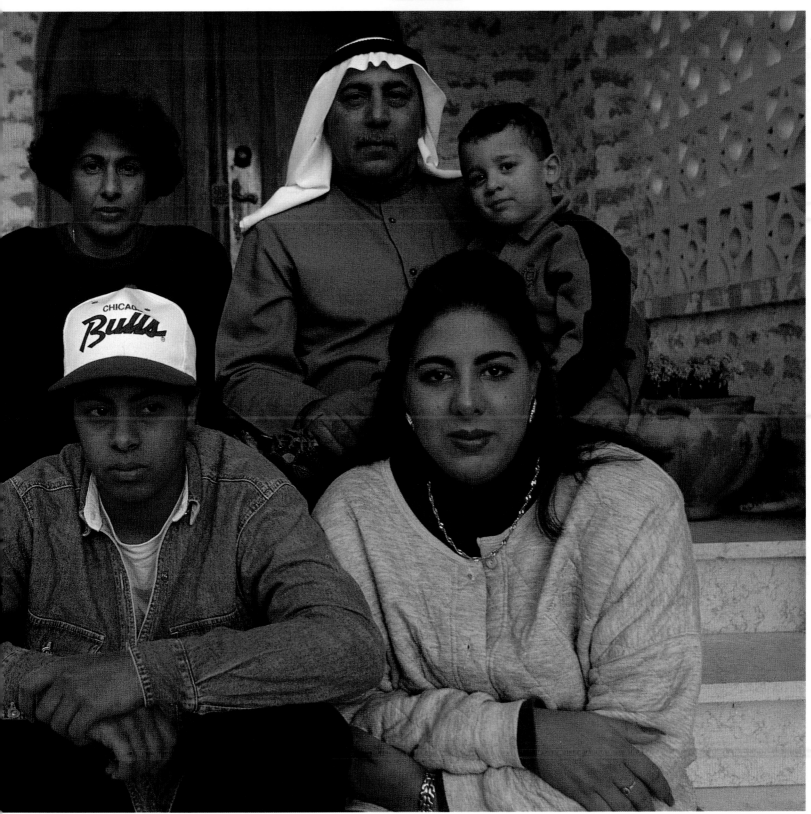

A PROFESSOR OF POLITICAL SCIENCE at Kuwait University, Saif (C, *teaching a class*) received his Ph.D. from Indiana University. He has kept up the family connection to the United States by sending his children (B, *from left, Lubna, mother Zainab, Saif himself, Ali, Lail, and Abla in Chicago Bulls hat*) to college there. Lubna, the eldest of the three daughters, is a graphics designer for Kuwaiti television (D, *at work on left*), The next, Lail, a marine biologist (A, *getting ready for work*), works for the Kuwait National Petroleum Company. High-school senior Abla attends the American School of Kuwait, where she is a high-scoring player on the girls' basketball team. Although she regards herself as a believing Muslim, she is not sanguine about her future options in an Islamic society. "The way women are seen in Islam," she says with adolescent directness, "well, you get sort of sick of it."

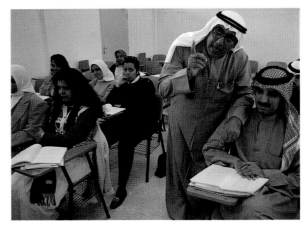

C

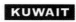

A

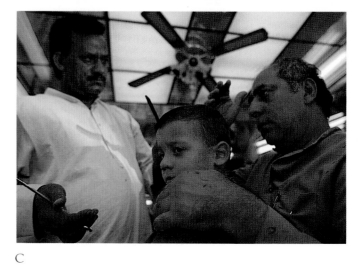

D C

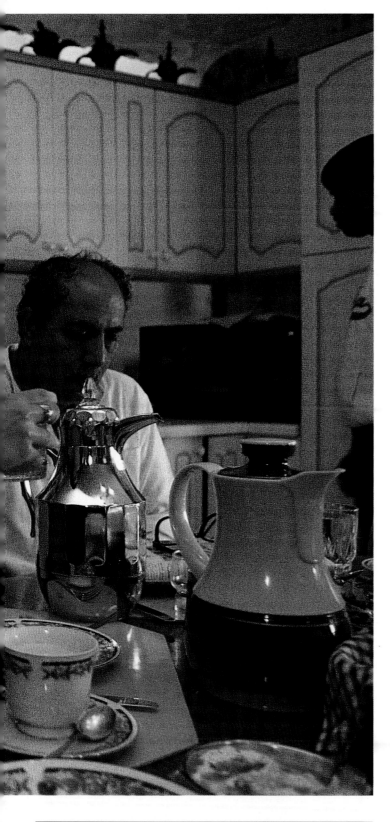

ABDULLA FAMILY

Size of household
7
(One son is a student in the U.S.)

Size of dwelling
4850 sq. ft. (450 sq. m.)
4 bedrooms, living room, sitting room, kitchen, dining room, 4 bathrooms, servants' quarters, basement with office, bar, and indoor swimming pool

Workweek
50 hours (Father)
60 hours (1st daughter)
45 hours (2nd daughter)

Number of
Radios: 4, Telephones: 5,
Televisions: 2, VCRs: 2,
Computers: 1, Automobiles: 4

Most valued possessions
Not stated (Father)
Photograph of son in U.S. (Mother)

Per capita income ($US)
$16,380
(Figure includes "guest-workers")

**Percentage of Abdulla family
income spent on food**
29%

On house payments
0%
(Mortgage forgiven by Kuwaiti government after war)

Wishes for future
Fishing boat, more income and leisure time for vacations.

BREAKFAST COMMOTION at the Abdullas begins with Zavier and Agnes Fernandes, the family's two Indian servants (A, *Zavier on right in sweatshirt*), rising at 5:15 a.m. and preparing coffee. By the time breakfast is cooked, the family is clattering into life. After getting something to eat, Lubna drives downtown to the television station (B, *in office parking lot*). Before classes begin at Ali's Montessori school, Saif takes the 2-1/2-year-old boy to the barbershop, where he carefully supervises the haircut (C). Zavier and Agnes (D, *in their quarters*) are left behind when the family goes to its various destinations. They have an hour-long break at 3:00 p.m., but cannot leave the house. Back in Goa, they have a 1-year-old boy whom they have not seen for months.

PHOTOGRAPHER'S NOTES
PETER ESSICK

In terms of income and circumstances, the Abdulla family could be considered average, although their standard of living is upscale even by First World standards. But in other respects they are extraordinary. Saif, a university professor, was a leader in the anti-Iraq resistance abroad; his two oldest daughters were among nine Kuwaiti women who joined the U.S. army during the war. The youngest daughter is a star high-school basketball player. Sometimes their days are much like the days of a monied and mobile family in North America: watching MTV on the satellite dish, shopping till they drop in the mall, cruising the freeways while chatting on the cellular phone — once I rode with one of the daughters on a playful high-speed chase with a man she liked. I often found the kids knew more about American popular culture than I did — strange, considering that I was born in Hollywood. At the same time, Kuwait is very restrictive by Western standards; I was constantly being told not to photograph things. Frustrating! The Abdullas, like many Kuwaitis I met, worried about what a consumer society Kuwait has become. "The desert has become a parking lot," Saif said. He quoted an American joke to me: When the going gets tough, the tough go shopping. "The Kuwaitis don't know this saying," he said. "But they live it."

Fractious Peace?

The Zaks Family

5:30 P.M., JUNE 21, 1993
TEL AVIV, ISRAEL

PHOTOGRAPHS BY PETER GINTER

KEY TO BIG PICTURE

1. Dany Zaks, father, 32
2. Ronit Zaks, mother, 29
3. Yariv Zaks, son, 4
4. Noah Zaks, daughter, 9 mos. (sitting on mother's lap)
H. Family home

OBJECTS IN PHOTO

(Rear)

- Family-owned apartment (top story, center set of window railings)
- Water storage tanks and solar water heating panels (on roof above apartment)

(On crane platform, left to right)

- Side table with books
- Dining table, chairs (4)
- Family shoes and slippers (17 pairs)
- High chair (behind table)
- Playpen (folded behind table)
- Electric fan
- Electric radiator
- Double bed
- Automobile (Alfa Romeo)
- Dresser (partly obscured by car)
- Television (on dresser)
- Clothes (mother's, hanging on rope)
- Couch (below clothes)
- Chair (facing away)
- Coffee table (between couch and chair)

- Guitar (leaning against couch)
- End table (with potted plant and books)
- Bicycle (with training wheels)
- Potted plant, computer, LP records (against cabinet)
- Cabinet (with stereo amplifier, tuner, pre-amp, turntable)
- Menorah, computer keyboard, typewriter (on cabinet)
- Stereo speakers (4)
- 2nd couch (beneath family)
- Pillows (3, on couch)
- Plastic basket with toys
- 2nd bed (behind family)
- Clothes cabinets (2) with clothes
- Short bookshelf with books
- Refrigerator
- Rattan rack (with dishes)
- Baseball hat (on rattan rack)
- Desk (with papers and books)

(Behind rattan rack)

- Office chair
- Electric range
- Washing machine and dryer

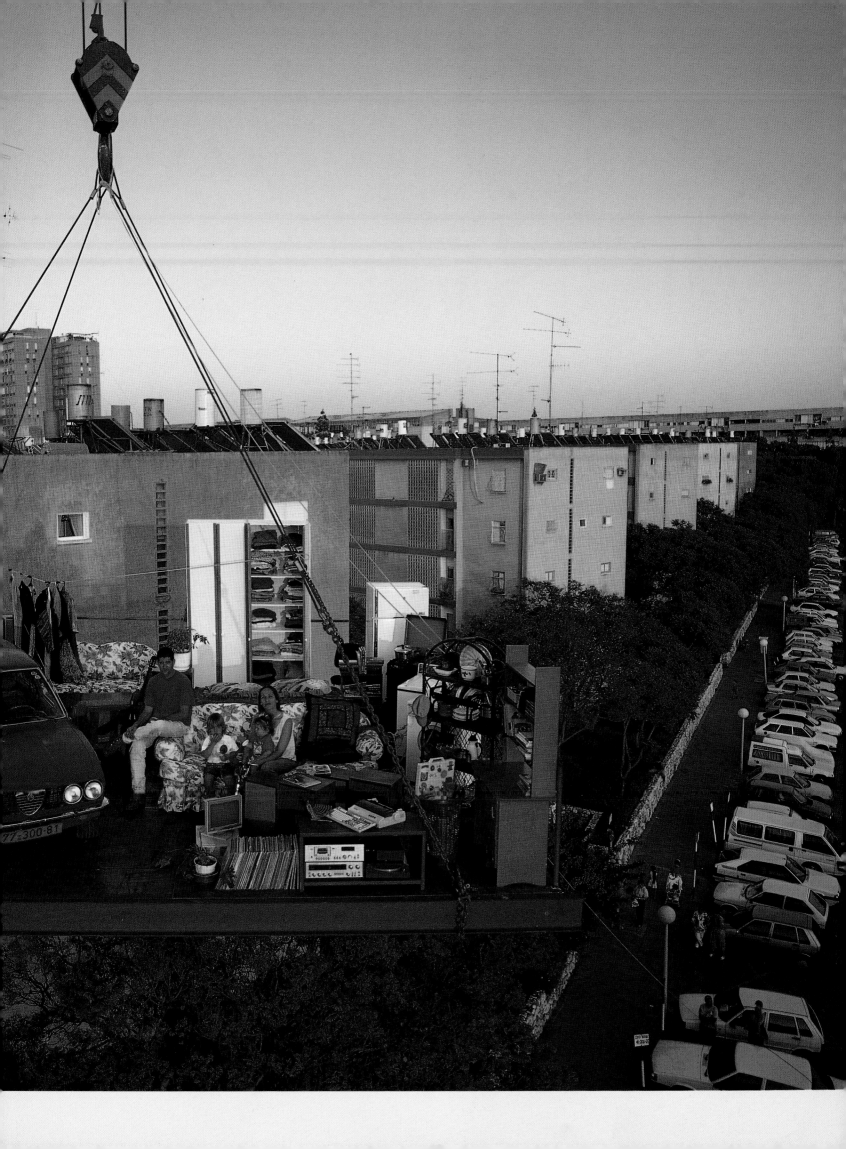

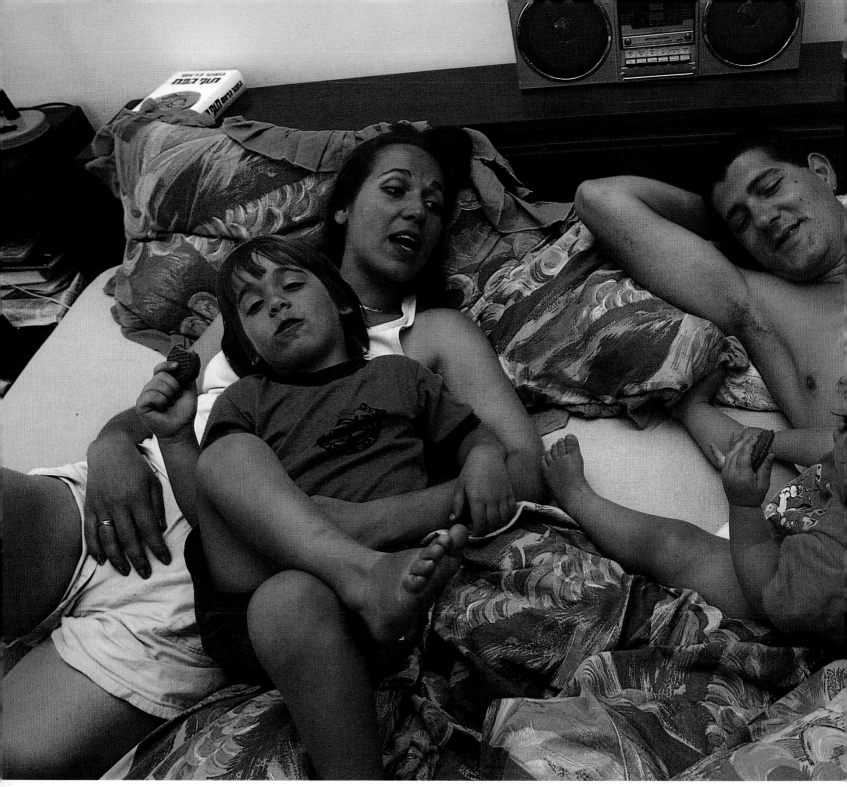

A

ONCE A CHEF at a big hotel on the prestigious Ha'yarkon Boulevard on the other side of Tel Aviv, Dany left that position because the intractable traffic turned his commute into a two-hour nightmare. Now he cooks at a lunch spot five minutes' walk from the apartment. Crammed with as many as four other workers into a 10' by 10' (3m. by 3m.) kitchen *(D)*, he whips up orders and passes them through a tiny window into the dining room outside. At home, Ronit oversees the children and earns extra income by typing reports *(C)* on the computer for a private investigator. After a week at this hectic pace, the couple is glad to leave with the kids for their regular Friday afternoon at the city beach *(B)*. Usually this pleasant family ritual is augmented by other family members and friends, this time including Ronit's 19-year-old sister, celebrating her last weekend of freedom before induction into the army. The next morning Dany and Ronit rise early, as usual, and do housework while the children sleep. When Noah wakes up, they change her diapers. And when Yariv gets up, he jumps onto his parents' bed with the rest of his family *(A)*.

D

B

C

ISRAEL
MEDINAT YISRA'EL, DAWIAT ISRA'IL

STATS

Area
7,847 sq. mi. (20,324 sq. km.)

Population
5.9 million

Population density
751.9 per sq. mi.
(290.3 per sq. km.)

Population doubling time
15.2 years

**Percentage urban/
rural population**
93% urban, 7% rural

**Places that depend on water
from Jordan River basin**
Israel, Jordan, Lebanon, Syria,
occupied territories

**Number of treaties successfully
concluded among them**
0

**Rank of Israeli per capita income
among Middle Eastern nations
(except oil-rich Persian Gulf
states)**
1

**Rank of foreign aid receipts per
capita among those nations**
1

Life expectancy
Female: 78, Male: 74

**Rank of affluence
among the 183 U.N. members**
26

Born in fire after the Second World War, modern Israel has spent almost all of its existence in turmoil. Its creation as a homeland for Jews outraged Arabs in neighboring nations, who felt that the new state had been imposed on them by outsiders. Amid undiminished animosity, brief wars flared in 1948, 1956, 1967, and 1973; there have also been innumerable raids, sorties, and bombing runs. Aided by Western powers, Israel prevailed in all major conflicts, seizing Arab territory in 1967 and 1973. A convulsion of negotiation that began in 1992 led to an interim Israeli-Palestinian agreement a year later; it may end by lessening or even ending hostilities. Even as it fought its neighbors, this small desert state had to create an economy, more or less from scratch, that could absorb hundreds of thousands of immigrants from dozens of cultures. It also had to reconcile tensions between incoming Jews and resident Arabs, and among Jews from differing strains of Judaism — all the while managing the priceless archaeological and religious heritage of Jerusalem and the rest of the Holy Land. Unsurprisingly, the nation has not completely succeeded at any of these tasks, though some aspects of Israeli life, such as its medical system, could be the envy of more comfortable nations.

A

ALTHOUGH YARIV IS NOW in school for
much of the day, Ronit's workload at home has hardly
diminished. Nine-month-old Noah is so active that when-
ever Ronit has to pay attention to something else for a few
seconds she holds the baby *(A)* to make sure that she stays
in one place. Most alarming to Dany, both Noah and Yariv
are enthralled by the stereo and records that are his pride
and joy. Only under maternal supervision are the children
allowed to play with the few LPs that Dany has carefully
selected to be sacrificial victims *(C, with Ronit, who is watch-
ing television, not pictured)*. A couple of times a week Ronit's
mother comes over to help for a few hours, providing Ronit
with a chance to catch up on the typing and the ever-present
mound of laundry *(D)*. This week the chores are especially
important — Ronit's cousin is getting married *(B, watching
the groom pour)*, and Ronit wants to ensure that everyone
looks their best at the wedding.

D

B

ZAKS FAMILY

Size of household
4

Size of dwelling
667.4 sq. ft. (62 sq. m.)
3-room apartment

Workweek
70 hours (Father)
28 hours (Mother — salaried work
only, does not include housework)

Number of
Radios: 1, Stereos: 1,
Telephones: 1, Televisions: 1,
VCRs: 0, Automobiles: 1

Most valued possessions
Nothing, except the children
(Father, Mother)

Per capita income ($US)
$12,293.

**Percentage of Zaks family
income spent on food**
22%

Wishes for future
To have one — if so, then a VCR,
camera, more income

PHOTOGRAPHER'S NOTES

PETER GINTER

The Zaks family and their friends in Tel Aviv were
some of the "most alive" people I have ever met.
Friends would drop by in the afternoon or the mid-
dle of the night: they were always welcome and we
all spent many hours around the kitchen table drink-
ing and talking. On weekends the sidewalk cafes
were jammed at 2:00 a.m. When I asked the family
about their favorite possessions, Dany refused to
choose one. He said he'd been in a war and didn't
give a damn about anything except his children's
lives and future. Like many Israelis I met, they worry
about their future quite a bit. On a much smaller
scale, my stay in Israel was also full of worry —
about the Big Picture. We had to get permission from
the police, arrange insurance, get the platform engi-
neered, and take care of uncooperative neighbors
(one man was outraged because the crane took up his
favorite parking place on the street). At last, it was
time to take the picture. Except that Ronit was still
saying, as she had all along, that she was not sure she
could overcome her fear of heights. Finally, 4-year-
old Yariv jumped onto the platform and said, "Let's
go." Shaking her head in disbelief, she stepped on.

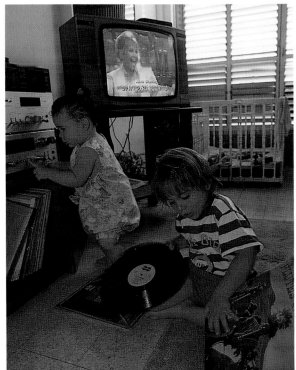

C

MATERIAL WORLD AT A GLANCE

Country	Area (sq. mile)	Area (sq. km)	Population (M's)	Population density (per sq. mile)	Population density (per sq. km.)	Total fertility rate (children per woman)	Population doubling time (years)	Population in urban/ rural areas (%)	Commer- cial energy use (oil equiv.,kg. per capita)	Per capita income (US$)	Household expenditure on food (%)
Albania	11,197	29,000	3.4	303.7	117.20	2.70	46.2	37/63	1,152	1,200	not available
Argentina	1,073,395	2,780,072	34.3	32	12.30	2.80	60	88/12	1,764	3,966	35
Bhutan	18,147	47,000	1.7	93.7	36.20	5.90	30.1	6/94	15	174	not available
Bosnia	98,842	255,999	4.366	44.5	17.20	1.90	278	34/66	2,296	2,490	27
Brazil	3,286,485	8,511,930	161.4	49.1	19.00	2.80	44	79/21	908	2,920	35
China	3,696,100	9,572,825	1,238.3	335	129.40	2.20	49.2	30/70	602	364	61 incl. bev & tobacco
Cuba	42,830	110,929	11.1	259.2	100.10	1.90	78.2	76/24	1,102	2,000	not available
Ethiopia	471,815	1,221,991	58	123	47.50	7.00	23.1	13/87	20	123	50
Germany	137,838	356,998	81.3	589.8	227.70	1.50	158	87/13	3,463	19,204	12
Guatemala	42,085	108,999	10.6	251.9	97.30	5.40	24.4	42/58	171	944	36
Haiti	10,811	28,000	7.2	666	257.10	4.80	34.5	32/68	49	374	not available
Iceland	39,758	102,972	0.26	6.5	2.50	2.20	67	92/8	5,122	23,324	not available
India	1,269,498	3,287,974	931	733.4	283.20	3.90	37.1	27/73	337	330	52
Iraq	169,000	437,707	21.2	125.4	48.40	5.70	22	75/25	774	1,940	not available
Israel	7,847	20,324	5.9	751.9	290.30	2.90	15.2	93/7	1,931	12,293	21
Italy	116,216	300,997	57.9	498.2	192.40	1.30	771	71/29	2,756	18,588	19
Japan	145,946	377,997	125.9	862.7	333.10	1.70	183	78/22	3,552	26,824	16
Kuwait	6,880	17,819	1.2	174.4	67.30	3.70	-21	97/3	6,414	16,380	not available
Mali	478,841	1,240,189	10.8	22.6	8.7	7.10	22.2	27/73	23	251	57
Mexico	755,985	1,957,986	93.7	124	47.90	3.20	34	75/25	1,383	2,971	35 incl. bev & tobacco
Mongolia	604,250	1,564,995	2.5	4.1	1.60	4.60	27	61/39	1,227	1,820	not available
Russia	6,592,664	17,074,868	149.7	22.7	8.80	2.10	347	not available	not available	3,469	not available
S. Africa	471,429	1,220,992	42.7	90.6	35.00	4.10	29.6	51/49	2,262	2,543	34
Spain	194,981	504,997	39.3	201.6	77.80	1.40	434	81/19	2,229	12,482	24
Thailand	198,070	512,997	58.3	294.3	113.60	2.20	55	25/75	438	1,697	30
U.K.	94,595	244,999	58.1	614.2	237.10	1.90	289.2	90/10	3,688	16,606	12
U.S.A.	3,618,000	9,370,548	263.1	72.7	28.10	2.10	67	76/24	7,681	22,356	13
Uzbekistan	172,587	446,997	22.8	132.1	51.00	4.40	33.4	not available	not available	978	not available
Vietnam	127,400	329,963	73.8	579.3	223.70	3.90	34.5	21/79	100	215	not available
W. Samoa	1,093	2,831	0.195	178	68	4.80	27	21/79	not available	930	59

SOURCES
(All data for Bosnia-Herzegovina is from former Yugoslavia, except for: population, population density, % of population in urban/rural areas, and infant mortality. This data is reported in *The Statesman's Yearbook*, 1993-1994.)
Population: from the United Nations Population Division (1992) as reported in *World Resources*, 1994-1995.
Exceptions: Bosnia (1992), from *The Statesman's Yearbook*, 1993-1994; and Western Samoa (1992), as reported in *Grolier's Academic American Encyclopedia*, 1993.
Population density/square km: calculated using data from *World Resources*, 1994-1995.
Population density/square miles: calculated using data from *World Resources*, 1994-1995.
Total fertility rate: from the United Nations Population Division (1992) as reported in *World Resources*, 1994-1995.
Exceptions: Russia (1985-1990) and Uzbekistan (1985-1990) as reported in *World Resources*, 1994-1995; and Western Samoa (1988) as reported in *Britannica World Data*, 1990.
Population doubling time: calculated using data from the United Nations Population Division (1992) as reported in *World Resources*, 1994-1995.
Exceptions: Bosnia-Herzegovina (1992) as reported in *The Statesman's Yearbook*, 1993-1994; and Western Samoa (1992) as reported in *Grolier's Academic American Encyclopedia*, 1993.

Population in urban/rural areas (%): from the United Nations Population Division as reported in *World Resources*, 1994-1995.
Exceptions: Western Samoa (1989) as reported in *Grolier's Academic American Encyclopedia*, 1993.
Commercial energy use (oil equivalent, kg per capita): from the United Nations as reported in the *World Development Report*, 1993.
Exceptions: Albania (1990), Kuwait (1990), Mongolia (1990), and Vietnam (1990) as reported in the *World Development Report*, 1992.
Note: German data for the Federal Republic of Germany is pre-unification.
Per capita income ($US): from the United Nations Population Division and the World Bank as reported in *World Resources*, 1994-1995.
Exceptions: Albania, Bosnia, Cuba, Iraq, and Kuwait (1989) as reported in *World Resources*, 1992-1993; Uzbekistan (1991) as reported in *World Resources*, 1994-1995, and Western Samoa (1991) in *Europa World Yearbook*, 1993.
Household expenditures on food (%): from the World Bank (1980-1985) or the United Nations Population Division as reported in *World Resources*, 1994-1995.
Exceptions: Western Samoa (1988), as reported in *Britannica World Data*, 1990.
Daily caloric supply (% of minimum daily requirement): from the United Nations Population Division, the

MATERIAL WORLD AT A GLANCE

Daily caloric intake (% of MDR)	Life expectancy females/males (years)	Leading cause of death	Infant mortality (per 1000 births)	Population per physician	Adult literacy female/male (%)	Mean years of school for people aged 25+ female/male (years)	Population in the military (%)	Number of people in the military	Major religious affiliation	Rank of affluence among U.N. members (out of 183)
107	79/72	not available	23	719	99/99	5/7	1.18	40,000	Muslim	103
131	75/68	circulatory diseases	29	370	95/96	8.9/8.5	0.19	65000	Roman Catholic	42
128	49/47	communicable diseases	129	13,110	25/51	0.1/0.3	not available	not available	Mahayana Buddhist	174
140	76/70	non-comm. diseases	15	not available	88/97	not available	not available	not available	Orthodox Christian	60
114	69/63	circulatory diseases	57	2,030	80/83	3.8/4	0.18	296,700	Roman Catholic	52
112	71/67	non-comm. diseases	27	730	62/84	3.6/6	0.24	3,030,000	Chinese folk-religionist	149
135	79/74	circulatory diseases	14	267	93/95	7.7/7.5	1.58	175,000	Roman Catholic	74
73	50/47	communicable diseases	122	32,650	63 combined	0.7/1.5	0.55	320,000	Ethiopian Orthodox	180
not available	79/73	cancer	7	370	not available	10.6/11.7	not available	not available	Protestant	14
103	66/61	communicable diseases	48	2,256	47/63	3.8/4.4	0.42	44,600	Roman Catholic	114
89	56/53	not available	86	6,539	47/59	1.3/2	0.10	7,400	Roman Catholic	147
134	80/75	circulatory diseases	5	385	99.9	9/8.8	not available	not available	Evangelical Lutheran	8
101	60/60	non-comm. diseases	88	2,460	34/62	1.2/3.5	0.14	1,265,000	Hindu	152
128	66/61	not available	58	1,724	49/70	3.9/5.7	1.80	382,500	Shia Muslim	77
125	78/74	circulatory diseases	9	345	89/95	9/10.9	2.97	175,000	Judaism	26
139	81/74	circulatory diseases	8	210	96/98	7.3/7.4	0.62	361,400	Roman Catholic	17
125	82/76	circulatory diseases	5	610	99/99	10.6/10.8	0.20	246,000	Shintoist & Buddhist	2
127	76/72	not available	14	238	67/77	4.7/6	0.98	11,700	Sunni Muslim	21
96	50/47	communicable diseases	159	19450	24/41	0.1/0.5	0.07	7,300	Muslim	162
131	73/67	circulatory diseases	35	1001	85/90	4.6/4.8	0.19	175,000	Roman Catholic	51
97	64/61	not available	60	403	86/93	7.2/7.6	0.62	15,500	Nonreligious, traditional beliefs	80
127	74/64	non-comm. diseases	19	210	99 combined	not available	not available	not available	Eastern Orthodox	48
128	66/59	not available	53	1640	not available	3.7/4.1	0.17	72,400	Black independent churches & other Christian churches	58
141	80/74	non-comm. diseases	6	280	93/97	6.5/7	0.55	217,000	Roman Catholic	24
103	72/66	not available	26	5000	90/96	3.3/4.3	0.49	283,000	Buddhist	87
130	79/72	non-comm. diseases	7	611	99/99	11.6/11.4	0.51	293,500	Anglican	19
138	79/72	non-comm. diseases	8	630	95/96	12.4/12.2	0.73	1,913,800	Protestant	9
127	73/66	non-comm. diseases	43	280	99 combined	not available	not available	not available	Sunni Muslim	113
103	69/64	not available	36	2857	84/92	3.4/5.8	1.41	1,041,000	Buddhist	165
108	70/65	circulatory diseases	40	3685	90 combined	11	0	0	Congregationalist	117

United Nations Children's Fund, or the World Bank, as reported in World Resources, 1994-1995.
Exceptions: Kuwait and Western Samoa (1984-1986), as reported in Britannica World Data, 1990.
Life expectancy: from the United Nations (1991) as reported in the World Development Report, 1993.
Exceptions: Albania, Iraq, Kuwait, Mongolia, and Vietnam (1990) as reported in the World Development Report, 1992; and Western Samoa (1992), as reported in Grolier's Academic American Encyclopedia, 1993.
Leading cause of death: from the World Health Organization (WHO) as reported in World Health Statistics Annual, 1993.
Exceptions: Argentina (1989), Brazil (1986), Cuba (1990), Germany (1990), Iceland (1991), Israel (1989), Italy (1989), Japan (1991), and Mexico (1991) as reported in World Health Statistics Annual, 1992.
Infant mortality rate: from the United Nations Population Division (1992) as reported in World Resources, 1994-1995.
Exceptions: Bosnia, as reported in The Statesman's Yearbook, 1993-1994; and Western Samoa (1992) as reported in Grolier's Academic American Encyclopedia, 1993.
Population per physician: from the World Health Organization (WHO) as reported in the World Development Report, 1993.
Exceptions: Iraq (1984) and Kuwait (1984) as reported in the World Development Report, 1992; and Argentina (1984), Guatemala (1984), Great Britain (1981), Haiti (1985), Iceland (1986), Israel (1986), Mexico (1983),

Mongolia (1987), and Western Samoa (1988) as reported in Britannica World Data, 1990.
Adult literacy rate f/m: from UNESCO (1990) as reported in World Resources, 1994-1995.
Exceptions: Ethiopia (1987), Great Britain (1980), Iceland (1985), Israel (1992), Japan (1989), Mongolia (1980), and U.S.A. (1980) as reported in Britannica World Data, 1990; and Western Samoa (1988) as reported in Grolier's Academic American Encyclopedia, 1993.
Mean years of school for people 25+ (f/m): from UNESCO (1989) as reported in World Resources, 1994-1995.
Exceptions: Western Samoa, as reported by the United Nations Development Program, 1994.
Population in the military (%): calculated using data as reported in World Resources, 1994-1995.
Number of people in armed forces: from International Institute for Strategic Studies, World Priorities, U.S. Committees for Refugees, or the World Bank as reported in World Resources, 1994-1995.
Religion: As reported in The Statesman's Yearbook, 1992-1993.
Rank of affluence: as reported in World Resources, 1994-1995.
Exceptions: Bosnia, from the World Bank as reported in World Resources, 1992-1993; Albania, Cuba, Iraq, and Vietnam (1989) from CIA estimates as reported in World Resources, 1993-1994; Kuwait (1989) from the World Bank as reported in World Resources, 1992-1993; Mongolia (1986), as reported in Britannica World Data, 1990; and Western Samoa (1989-1991), as reported in Europa World Book, 1993.

PHOTO CREDITS

ALEXANDRA BOULAT: pages 36 (Iraq), 37 (Bosnia), 176 (Bosnia), 176 (Iraq), 216-223, 228-235

PHILLIPPE DIEDERICH: pages 108-111, 224 (Cuba)

PETER ESSICK: pages 37 (Kuwait), 224 (Kuwait), 226-227, 238-241

MIGUEL LUIS FAIRBANKS: pages 36 (Brazil), 36 (Mexico), 112-119, 128-133, 146-151, 164-169, 176 (Guatemala), 176 (Iceland), 177 (Brazil), 177 (Mexico), 224 (Mexico), 225 (Guatemala)

PETER GINTER: front cover (USA), pages 11, 64-71, 120-121, 126-127, 136-137, 178-179, 180-185, 198-199, 224 (Germany), 242-247, 254, back cover (Israel)

DIEGO GOLDBERG: pages 112-125

SHAWN G. HENRY: pages 28-35, 157 (C), 159 (C), 160, 176 (Ethiopia), 224 (Ethiopia)

LYNN JOHNSON: pages 134-135, 138-143, 176 (USA)

ROBB KENDRICK: pages 152-156, 157 (B), 158, 159 (B), 161, 177 (Haiti)

LEONG KA TAI: pages 37 (Mongolia), 37 (Vietnam), 38-39, 40-42, 43 (D), 44-47, 56-63, 88-95, 176 (China), 225 (Mongolia, Vietnam)

PETER MENZEL: front cover (Bhutan), front cover (USA), pages 6, 12-27, 36 (Japan), 36 (Kuwait), 36 (Thailand), 37 (South Africa), 40-41, 43 (B), 43 (C), 48-55, 72-87, 104-107, 136-137, 144-145, 162-163, 168-175, 176 (Mali), 177 (Bhutan), 177 (Thailand), 177 (Western Samoa), 224 (Japan), 224 (South Africa), 224 (Thailand), 225 (Bhutan, Mali, Western Samoa), 236-237

GUGLIELMO DE'MICHELI: pages 36 (Albania), 37 (Italy), 194-197, 200-203, 225 (Albania)

JOSE MANUEL NAVIA: pages 37 (Spain), 177 (Spain), 204-209

LOUIS PSIHOYOS: pages 96-97, 102-103, 186-187, 192-193

DAVID REED: pages 36 (Great Britain), 210-215, 225 (Great Britain)

SCOTT THODE: pages 37 (Russia), 98-103, 177 (Uzbekistan), 188-191, 225 (Uzbekistan)

TOM VAN SANT: pages 2-3. Satellite composite view of Earth by Tom Van Sant and the Geosphere™ project, Santa Monica, California. With assistance from NOAA, NASA, Eyes on Earth. Technical direction from Lloyd Van Warren. Source data derived from NOAA/TIROS-N Series Satellites. Completed April 15, 1990. All rights reserved by Tom Van Sant, Inc., 146 Entrada Drive, Santa Monica, CA 90402. © 1990 Tom Van Sant and the Geosphere™ project, Santa Monica, California.

SOURCES FOR ADDITIONAL STATISTICS

ALBANIA
pg. 195 Cigarette consumption: For 1985, from *International Marketing Data and Statistics* as reported by *The New Book of World Rankings*, 1991.
pg. 195 Electricity use: For 1986, from the *United Nations Energy Statistics Yearbook* as reported by *The New Book of World Rankings*, 1991.
ARGENTINA
pg. 123 Land used for cattle grazing: For 1989-1991, from the Food and Agriculture Organization of the United Nations as reported in *World Resources*, 1994-1995.
pg. 123 Meat consumption: For 1984, from *International Marketing Data and Statistics* as reported by *The New Book of World Rankings*, 1991.
BHUTAN
pg. 76 Land covered by forest: For 1990, from the Food and Agriculture Organization of the United Nations as reported by *World Resources*, 1994-1995.
pg. 76 Number of cattle: From the Food and Agriculture Organization of the United Nations as reported in *World Resources*, 1994-1995.
BOSNIA
pg. 219 Ethnic composition: As reported in *Grolier's Academic American Encyclopedia*, 1993.
BRAZIL
pg. 129 % of forest lost, 1981-1990: From the Food and Agriculture Organization of the United Nations as reported in *World Resources*, 1994-1995.
pg. 129 Ratio of forest loss: 1981-85/1986-90: From the Food and Agriculture Organization of the United Nations as reported in *World Resources*, 1994-1995.
CHINA
pg. 58 Rank of number of soldiers: For 1991, from the International Institute for Strategic Studies as reported in *World Resources*, 1994-1995.
CUBA
pg. 108 Foreign aid lost: For 1991, from the Organization for Economic Cooperation and Development, the World Bank, and The United Nations Population Division as reported in *World Resources*, 1994-1995.
pg. 108 Rank of Child Immunizations: For 1990, from the United Nations Children's Fund as reported in *World Resources*, 1994-1995.
ETHIOPIA
pg. 31 Contraception use: For 1993, from the Contraceptive Use Database as reported in *World Resources*, 1994-1995.
pg. 31 Government debt as % of GNP: For 1989-1990, from the Organization for Economic Cooperation and Development, the World Bank, and the United Nations Population Division as reported in *World Resources*, 1994-1995.
pg. 31 Ratio of people to cars: For 1991, from *Interpolated National Populations*, 1992, as reported in *World Resources*,

1994-1995.
pg. 31 Ratio of people to cattle: For 1990-1992, from the Food and Agriculture Organization of the United Nations as reported in *World Resources*, 1994-1995.
pg. 31 Drinking water safety: For 1990, from the World Health Organization as reported in *World Resources*, 1994-1995.
pg. 31 Rank of people per physician: From the United Nations Secretariat: *Report on the World Social Situation*, 1993.
GERMANY
pg. 180 Consumption of beer: For 1990, from *International Marketing Data and Statistics* as reported in *The New Book of World Rankings*, 1991.
pg. 180 Native fish extinct or threatened: From "Biological Diversity and Biological Integrity: Current Concerns for Lakes and Streams," *Fisheries*, 1992, as reported in *World Resources*, 1994-1995.
pg. 180 Tree leaves lost to acid rain: For 1992, from the Swedish NGO Secretariat on Acid Rain as reported in *World Resources*, 1994-1995.
pg. 180 Number of asylum-seekers: For 1992, from the U.S. Committee for Refugees as reported in *World Resources*, 1994-1995.
pg. 180 Population per television: For 1986, from *UNESCO Statistical Yearbook* as reported by *The New Book of World Rankings*, 1991.
GREAT BRITAIN
pg. 212 Tree leaves lost to acid rain: For 1992, from the Swedish NGO Secretariat on Acid Rain as reported in *World Resources*, 1994-1995.
GUATEMALA
pg. 114 % of forest lost, 1981-1990: From the Food and Agriculture Organization of the United Nations as reported in *World Resources*, 1994-1995.
pg. 114 Leading causes of death: From the World Health Organization (WHO) as reported in *World Health Statistics Annual*, 1993.
pg. 114 Energy use ratio, U.S. to Guatemala: From the *World Development Report*, 1993.
HAITI
pg. 156 Death rate comparison: For 1990, from the United Nations Population Division as reported in *World Resources*, 1994-1995.
pg. 156 Food production gain: For 1990-1992, from the Food and Agriculture Organization of the United Nations as reported in *World Resources*, 1994-1995.
pg. 156 % of use of traditional fuels: For 1991, from the Food and Agriculture Organization of the United Nations as reported in *World Resources*, 1994-1995.
ICELAND
pg. 164 Rank of electricity use: For 1986, from the United Nations Energy Statistics Yearbook as reported in *World*

Resources, 1994-1995.
pg. 164 Rank of fish consumption: For 1988-1990, from the Food and Agriculture Organization of the United Nations as reported in *World Resources*, 1994-1995.
pg. 164 Rank of per capita health care spending: For 1988, from *Britannica World Data*, 1990 as reported by *The New Book of World Rankings*, 1991.
pg. 164 Rank of life expectancy: For 1991, from the *World Development Report*, 1993.
INDIA
pg. 68 Food production gain: For 1990-1992, from the Food and Agriculture Organization of the United Nations as reported in *World Resources*, 1994-1995.
pg. 68 % of population without adequate nutrition in 1972: From Tata Services, *Statistical Outline of India*, 1992-1993, as reported in *World Resources*, 1994-1995.
pg. 68 % of population without adequate nutrition in 1992: From Almas Ali, "Nutrition," *Health for the Millions* as reported in *World Resources*, 1994-1995.
pg. 68 Abortion rate ratio, U.S. to India: For 1985, from the *World Development Report*, 1993 as reported in *The New Book of World Rankings*, 1991.
IRAQ
pg. 232 Rank of military size: For 1991, from the International Institute for Strategic Studies as reported in *World Resources*, 1994-1995.
pg. 232 Rank of per capita greenhouse emissions: For 1991, from *World Resources*, 1994-1995.
ISRAEL
pg. 245 Countries dependent on Jordan River basin: From *World Resources*, 1994-1995.
pg. 245 Rank of Israel in per capita income among Middle Eastern nations: for 1991 from the World Bank as reported in *World Resources*, 1994-1995.
pg. 245 Rank of foreign aid receipts per capita among Middle Eastern nations: From the Organization for Economic Cooperation and Development, the World Bank, and United Nations Population Division as reported in *World Resources*, 1994-1995.
ITALY
pg. 201 Ratio of people to cars: For 1991, from *Interpolated National Populations*, 1992, as reported by *World Resources*, 1994-1995.
pg. 201 Wine consumption: For 1984, from *International Marketing Data and Statistics* as reported by *The New Book of World Rankings*, 1991.
pg. 201 Rank of fertility rate: From the *United Nations Statistical Yearbook*, 37th issue, 1993.
JAPAN
pg. 51 Rank of infant mortality: From the United Nations Population Division, the United Nations Children's Fund, and the World Bank, as reported in *World Resources*, 1994-1995.

MALI
p. 17 % of forest lost, 1981-1990: From the Food and Agriculture Organization of the United Nations as reported in *World Resources*, 1994-1995.
RUSSIA
pg. 186 % decrease in birthrate, 1989-93: From Russia State Committee on Statistics as reported in the *New York Times*, March 6, 1994.
pg. 186 % increase in death rate, 1989-93: From Russia State Committee on Statistics as reported in the *New York Times*, March 6, 1994.
SPAIN
pg. 207 Rank of number of tourists: For 1984, from the *United Nations Statistical Yearbook* as reported in *The New Book of World Rankings*, 1991.
pg. 207 Total fertility rate: For 1970, from the United Nations Population Division as reported in *World Resources*, 1994-1995.
THAILAND
pg. 82 % of forest lost, 1981-1990: From the Food and Agriculture Organization of the United Nations as reported in *World Resources*, 1994-1995.
UNITED STATES
pg. 138 Rank of divorce among 1st world nations: For 1988, from the *United Nations Demographic Yearbook* as reported in *The New Book of World Rankings*, 1991.
pg. 138 Rank of murder rate among 1st world nations: For 1988, from *Interpol: International Crime Statistics* as reported in *The New Book of World Rankings*, 1991.
pg. 138 Rank of regular church attendance among 1st world nations: From *Churchnews International*, 1993.
UZBEKISTAN
pg. 98 Annual inflation rate since independence: From the World Bank as reported in *World Resources*, 1994-1995.
VIETNAM
pg. 90 % of forest lost, 1981-1990: From the Food and Agriculture Organization of the United Nations as reported in *World Resources*, 1994-1995.
WESTERN SAMOA
pg. 173 College education among Samoans, ages 20-24: For 1991, from the Department of Statistics: Population Census, as reported by the Department of Trade, Commerce and Industry, 1994.
pg. 173 Rank of teen suicide rate: *South Pacific Handbook*, 1993.
pg. 173 % of population in military: From the Samoan Mission to the United Nations.

CONTRIBUTORS' BIOGRAPHIES

PAUL KENNEDY

Paul Kennedy is Yale University's current J. Richardson Dilworth Professor of History. A fellow of the Royal Historical Society, Dr. Kennedy is a frequent reviewer and contributor for *The New York Times, The New York Review of Books, The New Republic, The Washington Post, The Atlantic Monthly,* and *The Economist.* Dr. Kennedy is the author of eleven books, including the 1988 international bestseller *The Rise and Fall of the Great Powers* and, most recently, *Preparing for the Twenty-first Century.*

CHARLES C. MANN

Charles C. Mann is a contributing editor for *The Atlantic Monthly* and a contributing correspondent for *Science.* His work has also appeared in publications such as *The New York Times, The Los Angeles Times, The Sciences, Smithsonian, GEO, Libération,* and *Panorama.* Mr. Mann's most recent book, coauthored with Mark L. Plummer, is the forthcoming *Noah's Choice,* an examination of the human impact on biodiversity in North America.

PETER MENZEL

Peter Menzel is the creator and executive director of *Material World: A Global Family Portrait* and one of its principal photographers. His photos have been published in *Life, National Geographic, Smithsonian, The New York Times Magazine, Time, Paris Match, Stern,* and *GEO.* He is known for his coverage of international feature stories on science and the environment.

ALEXANDRA BOULAT

Alexandra Boulat is a French photojournalist whose work has appeared in major magazines around the world, including *Time, Newsweek, Paris Match, Le Figaro,* and *The London Sunday Times Magazine.* Her work with Sipa Press has included projects on Japanese ghettos, the break-up of the former Soviet Republic, baby trading and adoption in Romania, ecological disasters and trends in Europe, and her continuing work on the war in Croatia and Bosnia. Ms. Boulat is also responsible for bringing the diary of Zlata Filipovic out of wartorn Bosnia.

GUGLIELMO DE'MICHELI

Guglielmo de'Micheli is a freelance photojournalist based in Italy. His work has appeared in several major U.S. and European publications, which include *Sports Illustrated, Forbes, Time, Life, A Tavola, Capital,* and three of the *Day in the Life* book series. For his work in *Day in the Life* of Ireland, Mr. de'Micheli received an Award of Excellence from *Communication Arts* magazine.

PHILLIPPE DIEDERICH

Phillippe Diederich is a young freelance photographer based in Miami, Florida, where he shoots for The Associated Press, *The New York Times, The Toronto Star,* and other national publications.

PETER ESSICK

Peter Essick is a freelance photojournalist based in Brooklyn, New York. He is a frequent contributor to *National Geographic* and his work has been published in *GEO, The New York Times Magazine,* and many other publications. Mr. Essick's work includes diverse topics ranging from the First Crusade to corn.

MIGUEL LUIS FAIRBANKS

Miguel Luis Fairbanks is a California-based photographer whose international work has led to steady assignments with *The New York Times Magazine* and *National Geographic.* His story on Brazilian youths who "surf" the tops of Rio de Janeiro commuter trains won him the 1990 World Press Award for Feature Photography.

PETER GINTER

Peter Ginter is an award-winning photographer based in Germany. Most recently, he received first place honors in the 1993 World Press Awards for science photography. He is a contract photographer for *Stern* magazine, and his work appears frequently in *GEO* and *Sports.*

DIEGO GOLDBERG

Diego Goldberg started his career in Latin America as a correspondent for Camera Press in 1971. He joined Sygma in 1974, moving to Paris in 1977, to New York in 1980, and then back to Argentina in 1985. His work has appeared in major news magazines including *Life, Sports Illustrated, Paris Match,* and *Stern.* Mr. Goldberg has also participated in all of the *Day in the Life* books.

SHAWN G. HENRY

Shawn Henry, a freelance photographer based in Massachusetts has been a member of SABA Press Photos since its inception. His work appears regularly in major U.S. magazines, including *National Geographic, Forbes, Business Week,* and *Time.* Mr. Henry has photographed in Cambodia, Haiti, the Philippines, Mexico, Thailand, and Vietnam.

LYNN JOHNSON

Lynn Johnson is a Pennsylvania-based photographer who has shot extensively for major publications such as *National Geographic, Life, Newsweek, Forbes,* and *Fortune.* A Black Star contract photograper since 1982, Ms. Johnson received seven Golden Quill awards during her seven years at *The Pittsburgh Press.* Ms. Johnson has also received the Robert F. Kennedy World Understanding Award and a World Press Photo Award.

ROBB KENDRICK

Robb Kendrick, born and currently based in Texas, photographs regularly for *Life, Fortune, Audubon,* and *Sports Illustrated.* His work has also been featured in *National Geographic,* including stories on rice, the restoration of an historic base in Antarctica, and the Sherpas in the Himalayan Mountains. Mr. Kendrick has participated in several book projects, which include the *Day in the Life* series, *Baseball in America,* and *Game Day USA.*

LEONG KA TAI

Leong Ka Tai is a Hong Kong-based photojournalist. Recent magazine projects include "China's Youth: Waiting for Tomorrow" for *National Geographic* and work for *GEO.* His photographs have appeared in books and magazines worldwide. Leong Ka Tai is chairman of the Hong Kong Institute of Professional Photographers.

JOSÉ MANUEL NAVIA

José Manuel Navia is a Spanish photojournalist based in Madrid. Since 1992, Mr. Navia's freelance work has covered issues in Spain and other Latin American countries. As a member of the Spanish agency Cover, his work has been published regularly in *El Pais, GEO Spain, L'Express,* and *Traveler.*

LOUIS PSIHOYOS

Louis Psihoyos is an internationally acclaimed magazine photographer. For the past 15 years he has worked primarily for *National Geographic* creating artistically crafted photographs for lead stories on such topics as sleep, the sense of smell, garbage, and the February 1993 cover story on dinosaurs.

DAVID REED

David Reed, a founding member of Impact Photo Agency, has worked for a variety of British and U.S. publications including *The London Sunday Times Magazine, The London Observer Magazine, Telegraph Magazine, Illustrated London News, Time,* and *Newsweek.* Mr. Reed has worked on projects for UNICEF in Colombia and El Salvador, and has produced books on Zambia, Zimbabwe, and Botswana for the International Union for Conservation of Nature.

SCOTT THODE

Scott Thode is a New York-based photojournalist whose photographs have appeared in major magazines in North America and Europe, including *Life, Newsweek, The Independent, GEO,* and *Il Venerdi.* His work has been included in exhibits at Visa Pour L'Image in Perpignan, France, and the Electric Blanket AIDS Project. Currently, he is finishing work on his book, *The Spirit Within,* a series of portraits and writings of people with AIDS or who are HIV positive.

Acknowledgments

Material World wishes to thank first and foremost the 30 *Material World* families for their participation, hospitality, and assistance.
Without their trust and support there would be no *Material World*.

Financial support for *Material World* was generously donated by the United Nations Population Fund,
United Nations International Year of the Family, Ellie Menzel, and Dorothy Wright.

For their editorial contributions, *Material World* would like to give special acknowledgment to:
Paul Kennedy, professor of history at Yale University,
and Charles C. Mann at *The Atlantic Monthly*.

A project of the size and scope of *Material World* could not have been realized without the tremendous dedication of many individuals.
The staff has given generously of their time and deserves further special acknowledgment:
Mary Schoenthaler, Elizabeth Partch, Jane E. Lee, Todd Rogers, Carol Martinelli, Laura Hunt, Robert Keller.

Special thanks go to Jon Beckmann, David Spinner, Susan Ristow, and Janet Vail at Sierra Club Books, San Francisco.

Many others have helped make the project a reality. In particular *Material World* wishes to thank the following:
Faith D'Aluisio and KTRK Channel 13, Houston; Robert T. Livernash at the World Resources Institute; Carrie Seglin at Microsoft;
Richard Harris and Dana Wolfe at *Nightline*; David Friend and *Life* magazine; Gigi Vesigna at *Noi* magazine; Tom Van Sant and The GeoSphere™ Project;
Tom Kennedy, Kent Koberstein, Al Royce, Larry Nighshwander, Bill Allen, and all our friends at *National Geographic*; Christiana Breustedt, Venita Kaleps,
Joseph Hurban, Ruth Eichorn, Brigitte Barkley and Wilma Simon at *GEO* magazine; Jim Colton at *Newsweek*; Michele Stephenson at *Time*; Peter Howe at
Audubon; Annie and Pierre Boulat at COSMOS; Maxine Resnick at *National Geographic* Television; Grazia and Michele Neri; Philippe Achache
and Sally Neal at Impact; Loup Langton and Bill Kuykendall at the University of Missouri; Anna Sever; Sandra Eisert; John Miller; Ray Kinoshita; Dick Teresi
and Judith Hooper; Doug Menuez; Frans Lanting; Zenobia Barlow; Fairview Market in Napa; Kinko's of Napa Valley; Bill Jersey and the Catticus Corporation;
Anne Page; Julie Winokur; Bill Gladstone; Dick Lemon, Esq.; Patti Richards; Linda Ferrer; Joe Matejcik; Lindley Boeghold; Matthew Nathons;
Lois Lammerhuber; Rick Rickman; Aron Schindler; Bob Stein; Tim Cullen; Beth Broday; Theo Westenberger; Jane Symons; Robert Azzi; Ed Kashi;
Sarah Leen; Katherine Wright; Lester Sloan; Kirk McKoy; Tom Walker; Jim Steinke; James Marti; Jamie Kim; John Knoebber; Vin Capone; David Yoon;
Dr. Charles Woerz; Alice Rose George; Annie Griffiths Belt; Marilyn Gibbons; Kevin Morrison; and Jack and Evan Menzel.

Material World has received special assistance from the following professionals:
John Palmer of Palmer Photographic, Sacramento; Sam Hoffman and The New Lab, San Francisco; John and Karen Leung and C. O. Lab, San Francisco;
A&I Color Lab, Los Angeles; Copy Service, San Francisco; Dan Mills and Digital Vision, San Francisco; Adair & Armstrong, San Francisco; Elizabeth Forbes
Wallace and Visa Advisors, Washington, D.C.; Brent Olson and InnerAsia Expeditions, San Francisco; Rukhsana Dossani and Five Star Travel, San Francisco;
Jean-François Leroy and Visa Pour L'Image.

The United Nations has contributed to the project on many levels. Special acknowledgment goes to:
Hirofumi Ando and Stirling Scruggs, United Nations Population Fund;
Søren Dyssegaard, Mary Lynn Hanley, and Sissi Marini, United Nations Development Programme; Henryk J. Sokalski and Eugene Rolfe,
The International Year of the Family, United Nations Office Vienna; Noel Brown, United Nations Environment Programme.

In each country we were helped by many:
Albania: Jean-Nicolas Marchal and Majlinda Kadriu/UNDP, Artan Kadriu, Professor Andrea Camperio Ciani.
Argentina: Juan Garff, Manfredo Uelewald, Mr. Christiansen, Andreas Wolfers. **Bhutan:** Terrence Jones and Jeff Avena/UNDP, Ugyen Rinzing,
Karma Jigme, Karma Lotey, Praitap Rai at Yangphel Tours and Travels, Sangay Phuba. **Bosnia:** Captain Dominique Deslandres.
Brazil: Marçal and Marilia Aquino, Bia Bansen. **China:** Shao Zi Bo, Wang Zhong Qiu, Wu Jia Lin, Wang Miao, Du Zhi Yuan.
Cuba: Joachim von Braunmuhl and Alberto D. Perez/UNDP. **Ethiopia:** Peter Simkin, Dr. P. Makolo, and Ruth E. Abraham/UNDP;
Worku Saharu, Hapte Selassie. **Germany:** Dieter Klein. **Great Britain:** London Fire Brigade, Surrey Constabulary,
The Royal Surrey County Hospital, Upstagers Theatre Group, St. John the Baptist Church, Busbridge, Godalming, Alain Le Garsmeur, Philippe Achache.
Guatemala: Bruno Guandalini/UNDP, Santos Perez, Iván Choto. **Haiti:** Jean Marie Adrian, Maggie Steber.
Iceland: Jón Óskar Sólnes, Bergdis Ellertsdottir, Linda Magnusdottir, Rögnvaldur Guomundsson, Finnbogi Kristinsson, Ólafur Sigurdsson, Björn B. Karlsson,
Sigurdur Stefán Jónsson. **India:** Deepak Puri at *Time* magazine, Rati Shankar Tripathi, Bärbel Ginter, Dr. Gautau.
Iraq: Kamal M. Taha, Hosam M. Taher, Riadh Al Adhami, Mr. Alasaoui. **Israel:** Lisa Perlman, Mrs. Efrat. **Italy:** Laura Cruciani,
Bernhard Pfitzner, Fee Swantje Schmidt, Alex Maiorli. **Japan:** Toyoo Ohta and Sanae-Lina Wang at Uniphoto Press International.
Kuwait: Khaled Philby/UNDP, Raaja and Waleed M. Al-Awadhi, Ahmad M. Quraishi, Hala A. Al-Ghanim.
Mali: Kya Kaysire Gitera and Paul Andre de la Porte/UNDP, Biatrice and Hevre of Togu-Na, Albert Gano and Chief Koukaino of Kouakourou.
Mexico: José Hernández-Claire, John Echave. **Mongolia:** Shun-Ichi Murata and Mashbilig Madrig/UNFPA,
Johannes Swietering/UNDP, Bayarbataar. **Russia:** Alexander Avanesov and Mr. Isakov/Permanent Mission of the Russian Federation to the UN,
Chuau Amunategi/UN, Valentin Romanov/UNHCR, Ludmilla Mekertycheva, Svetlana Chervonnaya, Oksana Kapitula, Kathy Ryan, Glen Mack.
South Africa: Jama Tshomela, Sapiwo Ralo, Sydney Mafilika. **Spain:** Anna Sever, Jose de Antonio. **Thailand:** Professor Prachaval Sukumalanand, Taweep
Putthanu, Pen Suwannarat, Riverview Lodge. **USA:** Faith D'Aluisio and Channel 13 in Houston, Richard Harris and *Nightline*, Gabriele Reinke Ginter.
Uzbekistan: Khalid Malik/UNDP. **Vietnam:** Tran Tien Duc, Dinh Van Quang, Trinh Anh Tuan, Nguyen Duc Vien Nguyen Thi Thang,
Do Quang Quyen, Nguyen Vinh Cat, Linda Demers/UNFPA. **Western Samoa:** Sarwar Sultana, Fagamalama Tuatagaloa and
Sealiitu Simi Sesega of the UNDP and Paugata, Tuatagaloa and Saina of Poutasi village.

ITEMS NOT SEEN IN THE BIG PICTURES:

ALBANIA: double bed (welded to wall), large armoire (built into barn), wood-burning stove, four chickens, dog, six throw rugs, wooden chamber pot (welded to wall), keg of wine.

ARGENTINA: Kreonite photo processing machine, two 35mm cameras, video camera, two strobes with stands, three bicycles.

BHUTAN: built-in altar, built-in earthen stove, rice milling machine, battery-operated radio (being repaired), woodpile, yoke for bulls, four cats, two dogs, chickens (even the family does not know how many), clothes (two changes each), dart game, candles.

BOSNIA: three shelves containing clothes and books (used to barricade living room from mortar attacks), broken closet in storage room, two couches, electric oven, carpets.

BRAZIL: particle board closet with clothes, shoes and blankets, three kitchen cabinets (attached to wall), narrow wooden trunk (used for storing clothes), washing machine, food processor, aluminum pots and pans, cooking utensils, plates, glasses, two plastic jugs, ninety-five empty beer and soda bottles, two dogs, dolls, two garbage cans, shoe boxes, B.B. gun.

CHINA: three pigs, three fish ponds, one hundred mandarin orange trees, vegetable patch.

CUBA: double bed, refrigerator, washing machine, two gas hot plates, two pigs, six chickens, two paintings, clothing, toolbox and tools.

ETHIOPIA: fireplace, four earthen grain containers, radio, shovel, plow (in the field), two donkeys (released to pasture), two pairs of rubber boots.

GERMANY: kitchen cabinet (attached to wall), book shelf (attached to wall in Manuel's room), washing machine, cleaning tools, canned food.

GREAT BRITAIN: cupboards and shelves (built into wall); shelves, desk and armoires in Alice's room; shelves, desk, and armoires in Eleanor's room; armoire in Richard and Fenella's room; stereo speakers; telephone; two cats; rabbit; two garden sheds.

GUATEMALA: three-shelf structure (in cooking hut), string of Christmas lights (nailed to wall above religious items), two hoes, broken garden tools, six clay cooking pots, two plastic water jugs, plastic jug with weaving implements, sack with clothes, rope, sitting mat (used by mother when cooking).

HAITI: goat, bull, five chickens, saddle, kitchen (in separate building), family's clothes (approximately thirty pieces), straw hat.

ICELAND: floor-to-ceiling bookcase (with hundreds of books wall-to-wall), two bookcases (with magazines and books), two built-in closets (with clothing), laundry room cabinets (with household items), bed, Czech baby-grand piano, two-hundred-year-old porcelain pedestal, two cages with six canaries, two horses, sewing machine, narwhal tusk, two acrobatic airplanes, several old pistols, shotgun, rug, pots and pans, dishes, crystal stemware, cleaning items (mop, broom, brushes), house plants.

INDIA: all possessions shown in picture.

IRAQ: living room cabinet (containing plates and clothes), Ikhlas' bed and closet, freezer, carpet in Ikhlas' room.

ISRAEL: kitchen sink.

ITALY: stone fireplace, cupboard (attached to wall), reference books (approximately two to three hundred), framed pictures.

JAPAN: built-in gas stove; gas heater; futon for guests; clothing: seven dresses, three suits, winter clothes; coin collection; photo albums; shovel; rake; tools.

KUWAIT: living room wall unit, three dressers, bedroom wall unit, antique secretary desk, stove, dishwasher, twenty-three-inch television, satellite receiver, VCR, vacuum cleaner, photo enlarger, stereo turntable, radio, calculator, two telephones, cooking utensils, coffee pots, china, dishes, bowls, plates, beer mugs, silverware, Tupperware, thermos, cookbooks, cutting board, glass bottles, soaps, family pictures, pencil holder, address book, foodstuffs, books, papers, knick-knacks, fishing rods and reels, fishing line, net, children's toys, pillows, bathroom accessories, step ladder, clocks, suitcases, tools, waste paper basket, two Iraqi shells, wall hangings, stained glass window, plants, wood screen, lamps, decorative gun, sea shells, camera, video tapes, paintings, magazine rack, statues, fireplace items, jewelry, swim fins, clothes, three dogs (Henry, Antar, and Shaboub), ten chickens.

MALI: two wooden mattress platforms, thirty mango trees, set of metal dishes (from second wife's apartment), mosquito netting, bags of rice (approximately four hundred pounds), mortar and pestle, clothes: two sets each for father and two wives, old radio batteries (used as toys by children), pile of sticks (used for fuel).

MEXICO: clothing, bedding.

MONGOLIA: knives for slaughtering sheep, pile of lumber, clothing (inside cabinets).

RUSSIA: benches for kitchen table (built into wall), hot water heater, gas stove (welded to wall), garage filled with: stacks of wood, broken tools and appliances, kitchen sink, sauna, clothes, broken ladder.

SOUTH AFRICA: broken black-and-white television, old blankets, foam mattresses, rags.

SPAIN: bar counter, glass wall in entryway, refrigerator, pots and pans, clothing, various small artifacts (too delicate to move), taxidermy tools, wine barrel, wine bottle collection (twenty bottles), second dog (small terrier for hunting).

THAILAND: stable behind house, elevated storehouse with rice (approximately six hundred pounds), nine chickens, school books, marbles.

USA: refrigerator-freezer, camcorder, various hand and power tools, woodworking lathe, air compressor, battery charger, computer, glass bell collection, glass butterfly collection, trampoline, picnic table, tire swing, swing and trapeze set, horseshoes, dart game, records, tapes, compact discs, photo albums, vegetable garden, fishing equipment, shotguns, rifles, clothing.

UZBEKISTAN: built-in wood burning stove, broken stove, dining room chairs, eight stools, two cows, dog, poster of Arnold Schwarzenegger (as the Terminator), poster of a car (Jaguar), broken mirror.

VIETNAM: chest of rice (approximately twenty-two hundred pounds), fifty banana trees, two star fruit trees, two pigs, two piglets, twenty chickens, eleven ducks.

WESTERN SAMOA: weed-eater, fifteen chickens, four pigs, five cats, swim goggles, clothing (in chests), books: Bibles and hymnals.

VARANASI, INDIA
photograph by Peter Ginter

AFTERWORD

PETER MENZEL

I T WASN'T photographing the oil well fires in Kuwait or the anarchy of war-torn Somalia that pushed me over the edge into *Material World*. It was hearing a National Public Radio story late in 1992 about the marketing of pop star Madonna's sex-fantasy book. The original material girl rode the crest of self-generated waves of publicity and consumerism for weeks. The book and the singer seemed to hold more interest for people than the pressing issues of our day. I thought the world needed a reality check.

Newspaper, magazine, and television stories almost always deal with the extremes: famine, flood, mass killing, and, of course, the lifestyles of the rich and famous. As a magazine photojournalist working in 52 countries over the past twenty-four years I, too, have covered the extremes. But showing only the best and the worst provides just one small part of the world picture. I wanted to give some insight into the rest of the world: to bring Westerners down from their high-rise tropical vacation towers into the living rooms of the hotel waitstaff; to take a manufacturer into the homes of the people who buy his products or work in his factories abroad; to let military planners see what the victims of the smart bombs look like; and to give my children the opportunity to meet their future neighbors.

We all have an understanding of what our own lives are like, but even as the countries of the world become more interconnected, we know very little about the lives of other people in other societies. What better way to begin to understand than to show average family life around the world and to base that examination around a unique photograph of a family with all its possessions outside its dwelling?

In the beginning I thought I should focus on twenty countries. I called my colleague and friend in Germany, photographer Peter Ginter, told him my ideas for the project, and suggested we take the photographs ourselves over the course of one year. He was enthusiastic, but skeptical. It wasn't the work, it was the proposed time frame. And he warned that my choice of Japan for a trial country was risky because of its very private culture, not to mention the winter weather.

Undeterred, I went to Tokyo in December to attempt to persuade a statistically average family to expose itself and its possessions for all the world to see. I reasoned that if I could get a family to participate in Japan,

then I could do it anywhere in the world. In retrospect, it was the hardest of the twelve family portraits I photographed: for one thing, in crowded Tokyo there was no place to put the family's possessions. But I persevered and pulled off the Big Picture just before Christmas.

With the Japanese family photos in hand, I stopped in Italy in January to show my idea to a magazine publisher. To my surprise and relief, he signed on to the project with only one country finished. From Italy it was on to South Africa and Mali to find and photograph two more families. Out of Africa, with three countries down, I asked Peter Ginter to join me for a planning session in California. We completed the lengthy process of choosing which countries to photograph from the list of 183 UN member nations and assembled a team of world-renowned photojournalists from seven countries. In Tel Aviv shortly thereafter, Ginter shot the Israeli family portrait on a crane outside their fourth-floor apartment. Over the following year we traveled the globe defining and redefining the project as we worked to develop the most compelling photographs and ideas, shooting 2,000 rolls of film and 112 hours of video for a variety of media: magazines, TV, and the emerging technology of CD-ROM. We photographed thirty families around the world. Only one country refused us permission: Egypt.

Skeptics nearly derailed us at times, but our supporters' confidence remained strong. *Life*, German *Geo*, and Italian *Noi* bought magazine rights to the story. The United Nations Population Fund, the United Nations Development Programme, and the United Nations Secretariat for the International Year of the Family strongly believed in and supported our project. We constantly revised our game plan, and quickly mastered deficit spending. I believe that in the end, however, *Material World* has stayed true to my original vision: a unique tool for grasping cross-cultural realities. We learned an incredible amount from the families we photographed. I hope we succeeded in sharing this knowledge.

PETER MENZEL
NAPA, CALIFORNIA
MARCH 24, 1994

A portion of the profits from Material World *will be used to create a scholarship fund established by the photographers for the children of the* Material World *families.*

Peace cannot be kept by force.
It can only be achieved by understanding.

—ALBERT EINSTEIN